White paradise

KAPON EDITIONS

To my grandson Jules

FRANCIS LATREILLE

White paradise

Journeys to the North Pole

Foreword by
Claude Lorius

Texts written in collaboration with
Catherine Guigon

Translated from the French by
Anthony Roberts

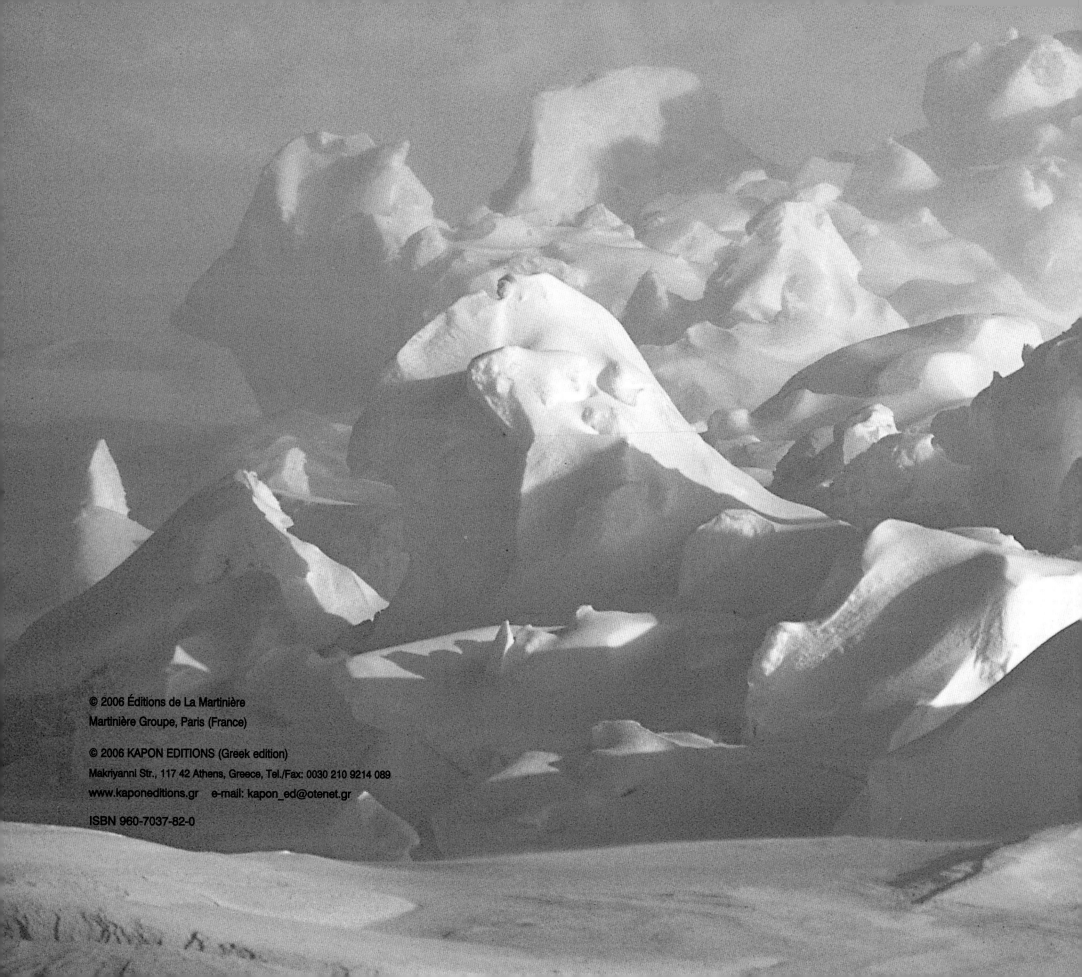

© 2006 KAPON EDITIONS (Greek edition)
Makriyanni Str., 117 42 Athens, Greece, Tel./Fax: 0030 210 9214 089
www.kaponeditions.gr e-mail: kapon_ed@otenet.gr

ISBN 960-7037-82-0

Contents

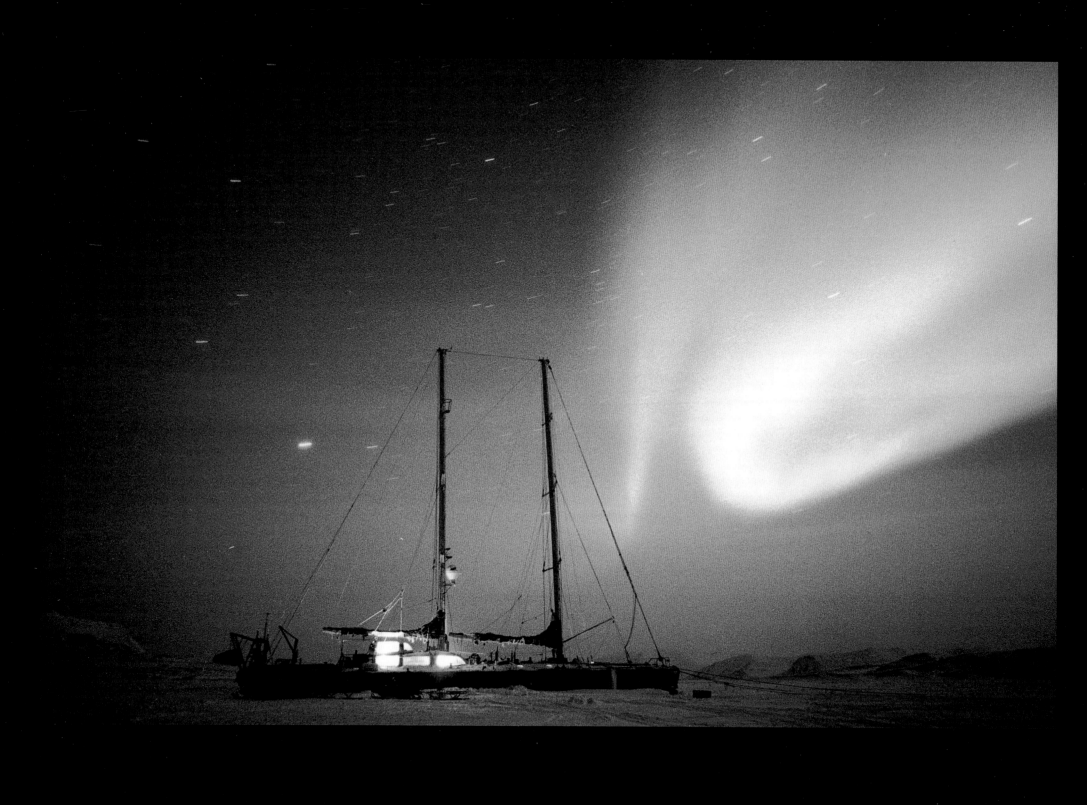

Introduction

UNBROKEN MONTHS OF WINTER NIGHT; sunshine so oblique that it must penetrate a far thicker atmospheric layer than anywhere else; snow and ice that hurl back nine parts in ten of the energy they receive… these are the main climatological characteristics of high latitudes, our planet's "poles of cold."

In the Arctic and Antarctic, rain becomes snow; water becomes ice; a hard shelf covers the oceans; the land is utterly frozen; and in places the ice caps are several miles thick. Creatures that exist nowhere else live in the magnificent polar landscapes: the polar bear in the North, the emperor penguin in the South. While tourists and researchers only visit the Antarctic, indigenous peoples, who have been present for many thousands of years, populate the Arctic.

Francis Latreille's superb images plunge us into the crystalline cold of the Arctic. The images also reveal an authentic paradise, one that is desperately fragile.

It took mankind a thousand years of effort and exploit to conquer the North Pole. The men who went there were drawn by a passion for adventure, by the yearning for fame or knowledge, and sometimes by sheer economic necessity. Their stories, a credit to our species, climaxed a century ago. The polar travelers of today add to these stories with each new sortie.

This book is rich in images of the peoples of the Far North and of the creatures associated with their lives and customs: the caribou, reindeer, seals, whales, bears, and husky dogs that have rendered the survival of nomads possible in an unforgiving, frozen world. The ancestral civilizations of the Far North are now reeling from the shock of contact with the cultures and economies of the so-called developed nations. Today, the smog released from mines, gas wells, and oil refineries intrude on the land and make protecting the environment problematic. In addition, the smog frequently dims the rav-

ishing colors of the aurora borealis. Other, stealthier environmental threats exist, from nuclear waste leaking from sunken nuclear submarines offshore to the pollution spewed from distant industrialized countries. The hole in the ozone layer affects the loftiest levels of the earth's atmosphere, while traces of the fallout from nuclear detonations, the toxic lead used in gasoline, and the nitrates and sulfates contained in agricultural fertilizers are all present in the snows of Greenland. A growing awareness of this has led to a more coherent plan to the preserve the Arctic environment.

The work of such pioneering researchers as Commandant Charcot and Paul-Émile Victor into the Arctic's animal and vegetable species, as well as the campaigns of their recent successors aboard the *Tara*, are described here in words and pictures. Likewise, the discovery and exhumation of an intact mammoth, frozen deep in the tundra for twenty thousand years, is documented in photographs eerily redolent of time travel.

In the section of the book entitled "Heat Wave in the Arctic," we can see the effects of global warming for ourselves, a phenomenon that has become detrimental in recent decades throughout the Arctic regions. Global warming now affects not just the ice shelf but the glaciers, the frozen earth, the fauna, and every aspect of the living conditions of local populations. The predictions are dire for the coming century.

Could it really be that the white paradise of the Arctic is threatened with disintegration by the warming of the atmosphere? The ice provides part of the answer. In climatic terms, permanent ice is at once an archive of the past, an agent in its development, and an accurate witness to the effects of change. Major advances have been made in the study of the history of the earth's climate as a result of evidence found in core samplings from the ice cap of Antarctica and Greenland. These ice samples record the exact periods of warming and cooling that took place in the last few hundred thousand years of the geological Quaternary era. Prompted by energy variations correlated to the earth's movement in relation to the sun, the ice samples seem to have been heavily influenced by the reflective power of our planet, in particular by the varying breadth of the ice cap that sends the sun's rays streaming back to space. The air bubbles contained in the deep polar *inlandsis* ("the inland ice") offer a vital archive of the composition of the earth's atmosphere; they have also demonstrated a link between the variations—which at the time were naturally induced—of climate and levels of greenhouse gases such as methane and carbon dioxide. This link goes a long way toward explaining the present warming effect.

The fact that a warming process took place during the twentieth century seems now to have been established beyond doubt by meteorological observations and data obtained by satellites. On average throughout the world, this warming seems to have been slightly less than 2°F over one hundred years, a substantial statistic given that sea levels rose by eight inches over the same period because of it. But just as one might expect, the effects of twentieth-century global warming was two or three times more significant in the Arctic. There, global warming has affected flora, fauna symbolized by the polar bear, and the Eskimo peoples.

Even though volcanic and industrial dust and the brightness of the sun may weigh on the overall radiative state of the planet and hence on its climate, researchers nonetheless broadly attribute the current warming to growing concentrations of greenhouse gases in the atmosphere. These concentrations, which apply to all parts of the earth, are measurable in the air imprisoned in the Arctic ice: Levels of carbon dioxide have increased by more than 20 percent in the course of the last century, and methane levels have more than doubled. The increase of carbon dioxide is due to the burning of

the fossil fuels (coal and oil) that are necessary to produce energy. Agriculture and the raising of livestock are the main culprits for the increased methane emissions.

Snow and ice are the yardsticks of global warming and its causes. Major expanses of snow; sea ice several feet thick floating on the surface of the ocean; bulkier glaciers formed on the continents and the *inlandsis* of Greenland where immense volumes of ice have accumulated—these solid masses give an exact measure of the sensitivity of the cryosphere to the evolution of the climate season by season, decade by decade, century by century, millennium by millennium. Ground observations and satellite images show the regression of the surfaces covered by snow and the ice cap over the last few decades. This withdrawal is leading to a greater absorption of the sun's rays, which increases the extent of global warming. We are observing the shrinkage of the continental glaciers of the Arctic; the first signs of melting are being seen in Greenland. Unlike the ice shelf, which has no effect on sea levels because it is afloat on the surface of the ocean, the melting of the continental ice cap is partially responsible for the measurable rise of sea levels.

On the basis of past data and projections made from climate patterns, the acceleration of global warming seems inevitable for the future, because at the moment we do not have sufficient clean energy sources to meet our global energy needs. The patterns, given our current energy production and our uncertainties about the complex workings of the climate, indicate a particularly warm end to the century in the Arctic region. The shrinking of the ice shelf will increase the warming effect, while the melting of the continental ice cap will raise sea levels significantly. This is a disaster in the making not only for the Arctic, but the rest of the planet, even though some regions may benefit in the short term.

This is precisely why global warming is the challenge of the century. Throughout history, man has had to fight extremes and adapt to natural variations of the climate. In the last hundred years, we have entered a new era, the "Anthropocene age," as the Nobel Prize–winner scientist Paul Crutzen has described it. Man's activities are directly affecting the climate and indirectly the conditions of life on Earth. The challenge is immense: We must somehow find answers that will reconcile ecological, political, economic, social, and civic approaches that are all too often diametrically opposed. We must have confidence in mankind's capacity to adapt and thrive. Nothing is irreversible, but the sooner this situation is reversed the better.

For now, the lovely Arctic images by Francis Latreille bear witness to a paradise that is not yet lost.

CLAUDE LORIUS
MAY 4, 2006

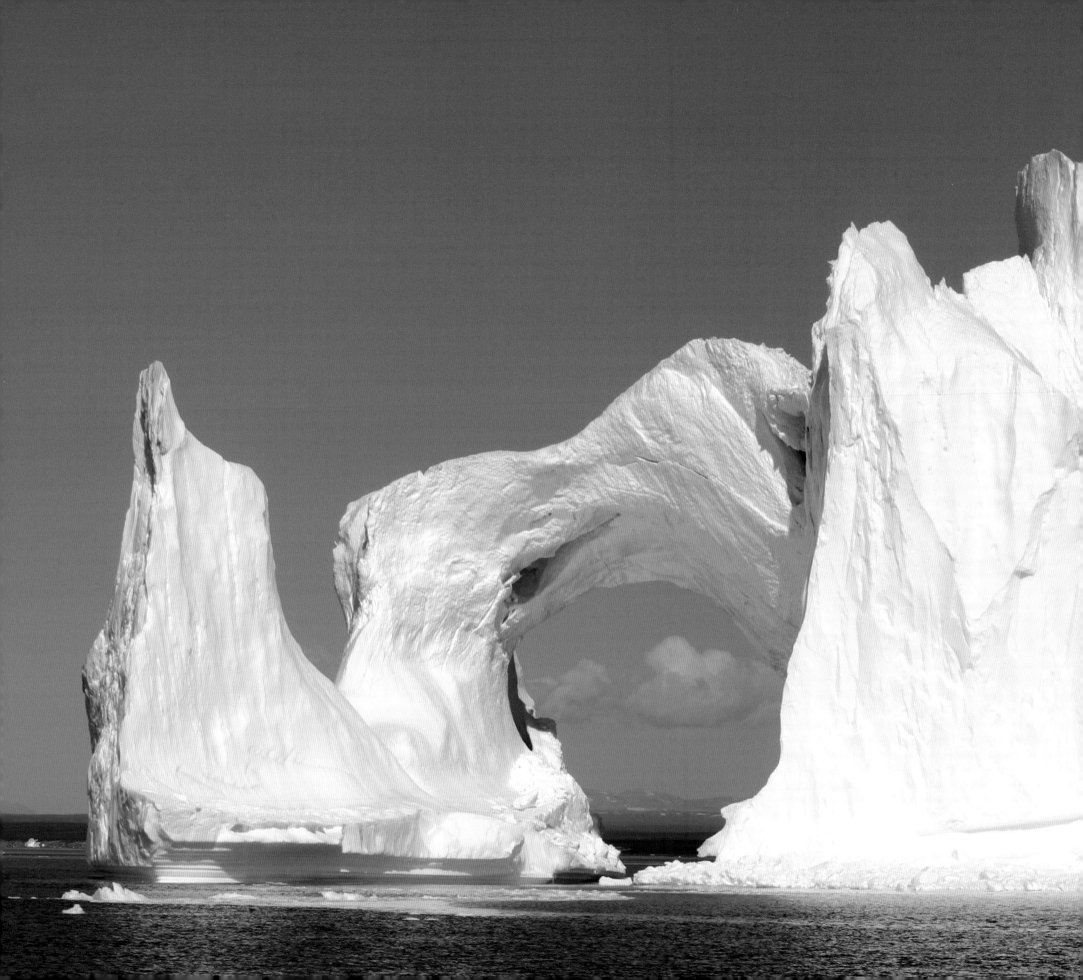

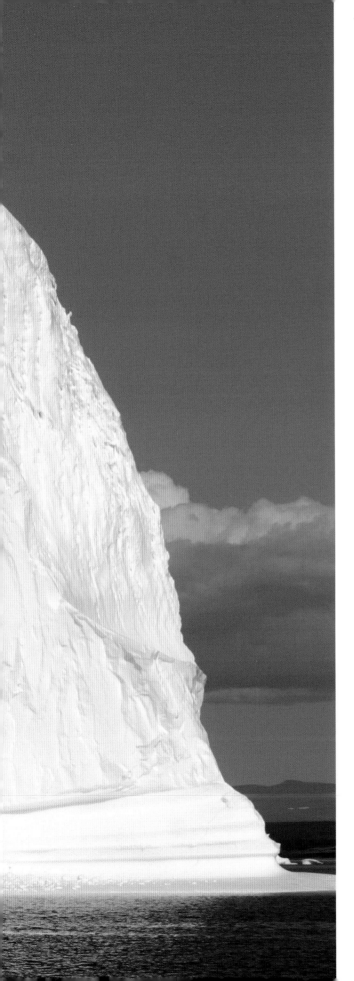

◁ Every day, icebergs tumble from the mighty glaciers of Greenland into the sea, where they are fashioned into ephemeral sculpture by the currents and swells.

▷ The polar schooner *Tara* noses her way through the Arctic ice.

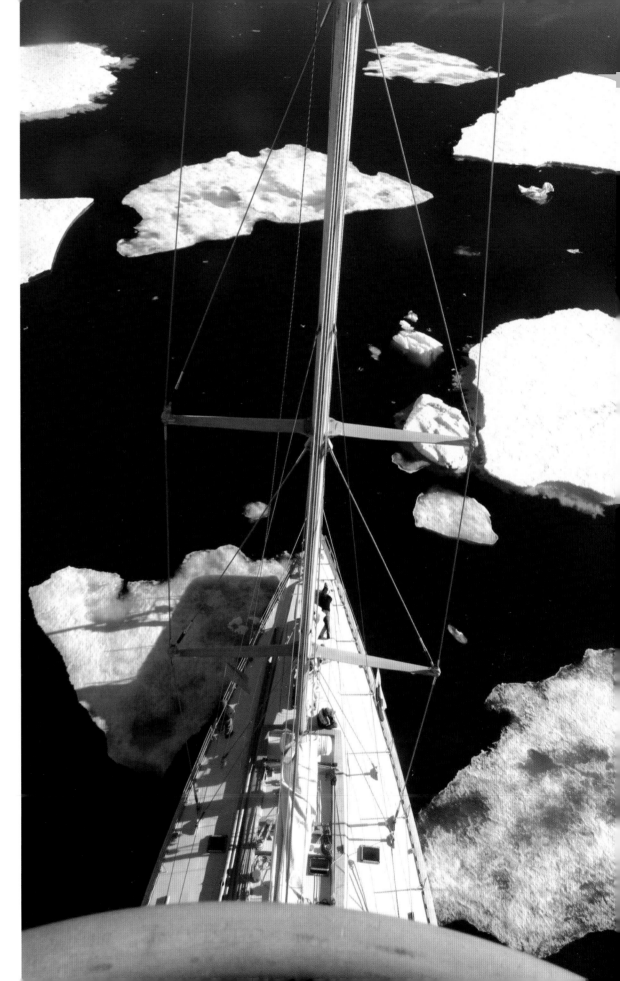

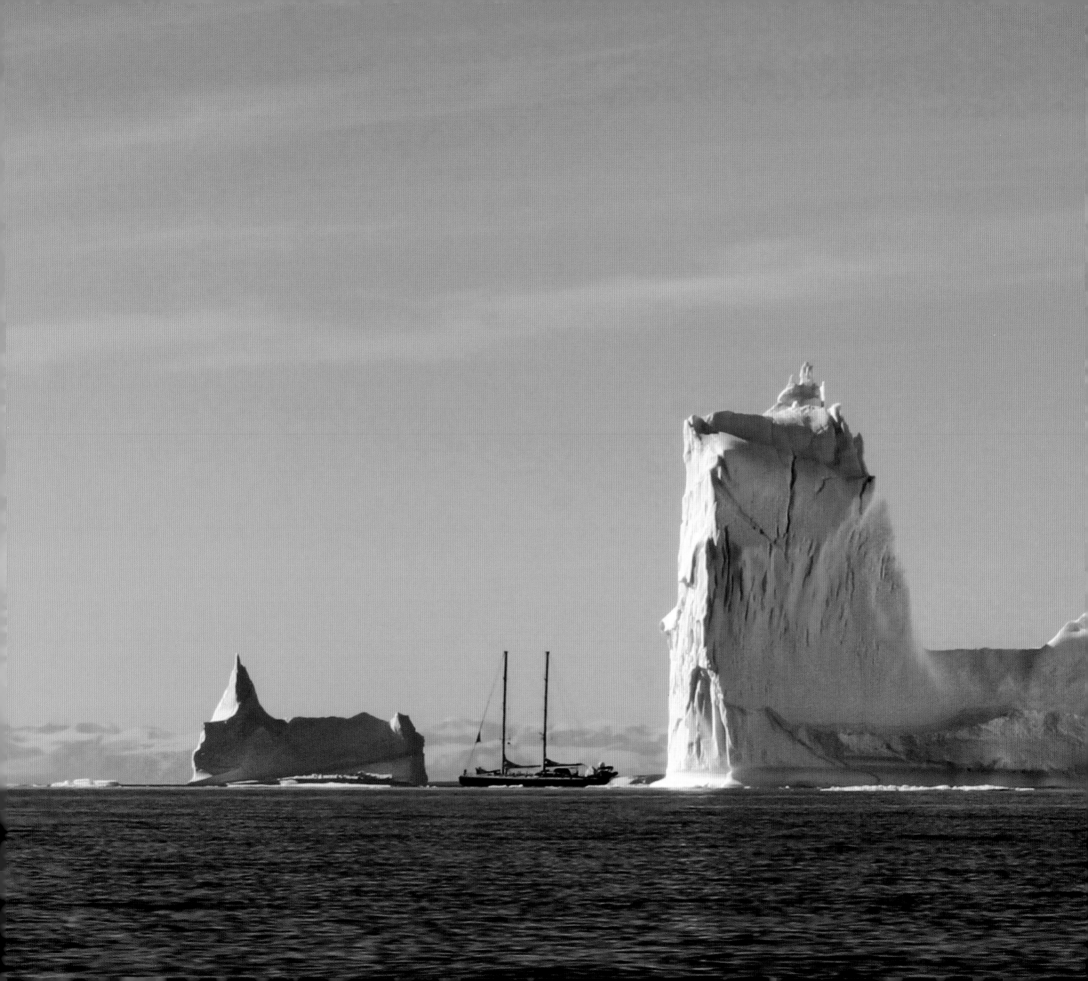

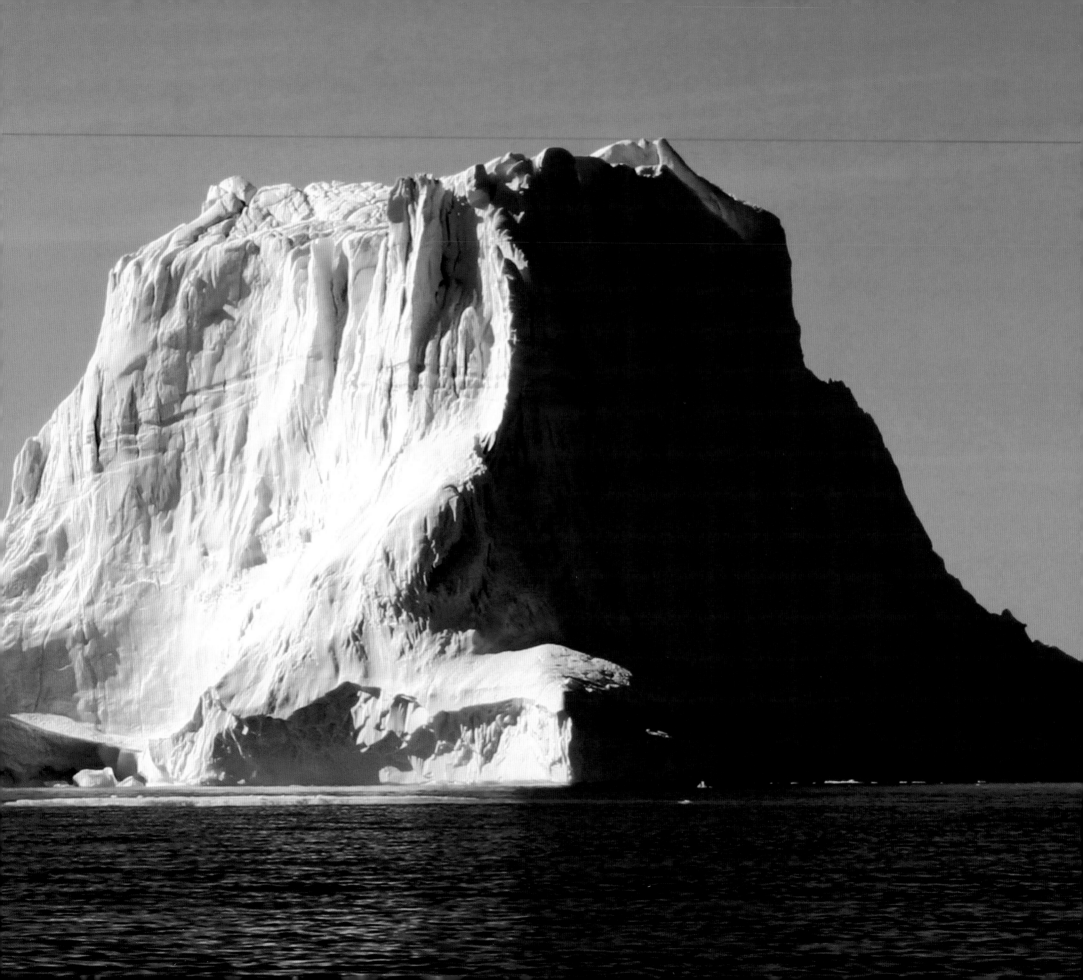

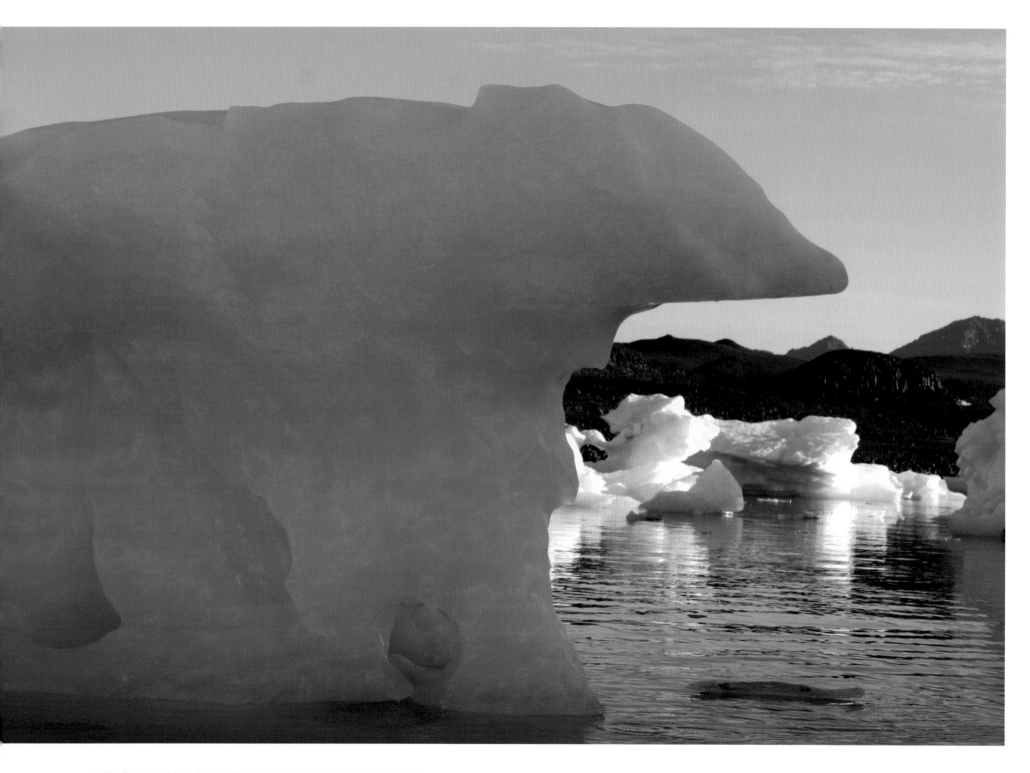

◁◁ The *Tara* cruised through a sea of icebergs in July 2004, following the route taken by Commandant Charcot's *Pourquoi Pas?*

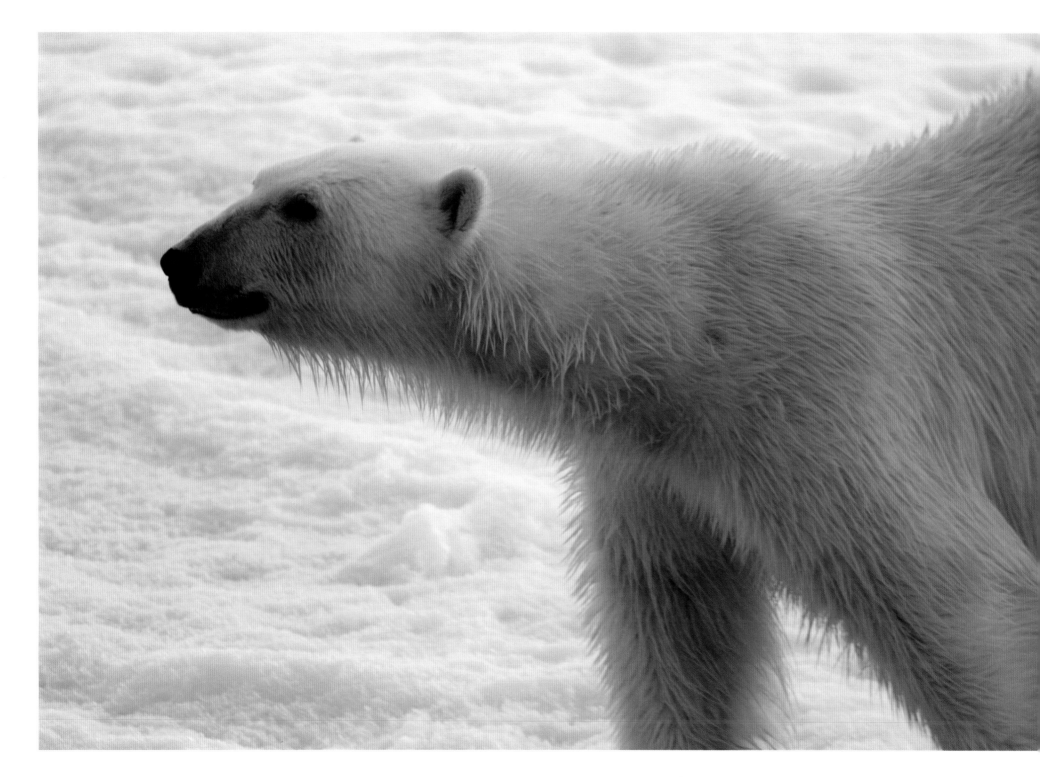

◁ △ The polar bear is the undisputed "Lord of the Arctic" and an enduring symbol of the North Pole regions.

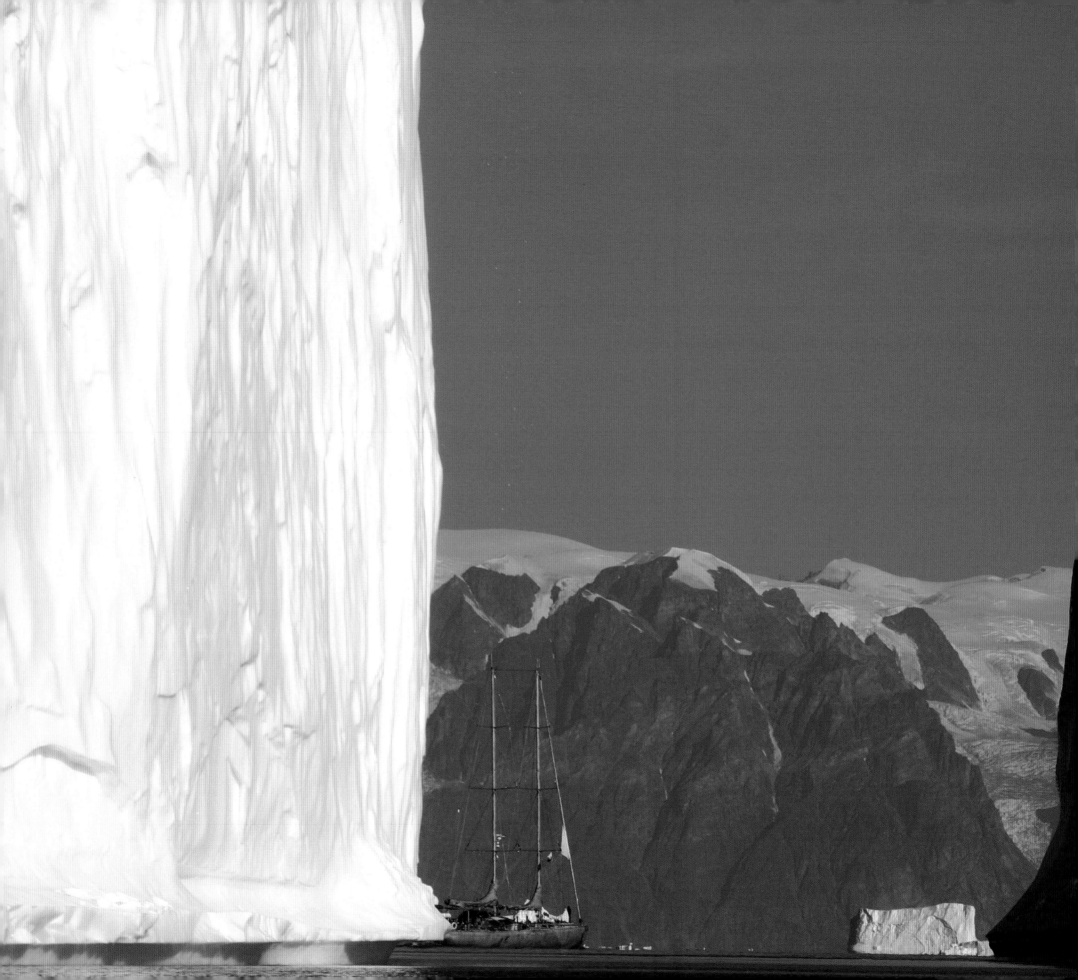

◁ *Tara*'s masts, which measure ninety feet tall, are dwarfed by the floating ice mountains surrounding her—an ever-present danger.

▷ Greenland glaciers cover the landmass with a cap of ice some nine thousand feet thick. When they reach the sea, they fracture into icebergs.

▷▷ Constant vigilance is the rule for any skipper who must face the swirling mists and ice fields of the Greenland Sea.

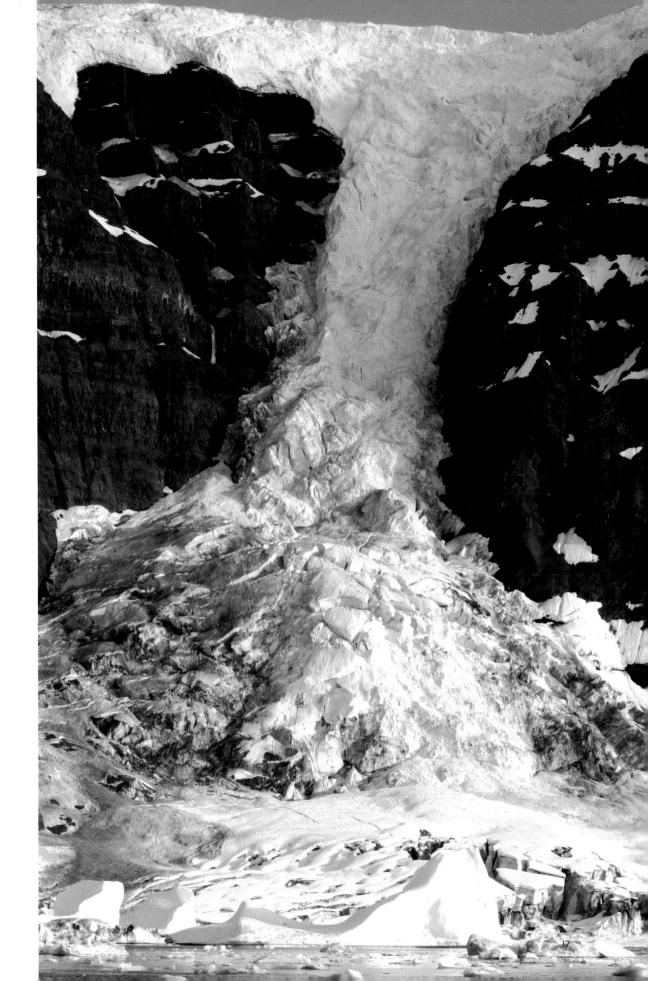

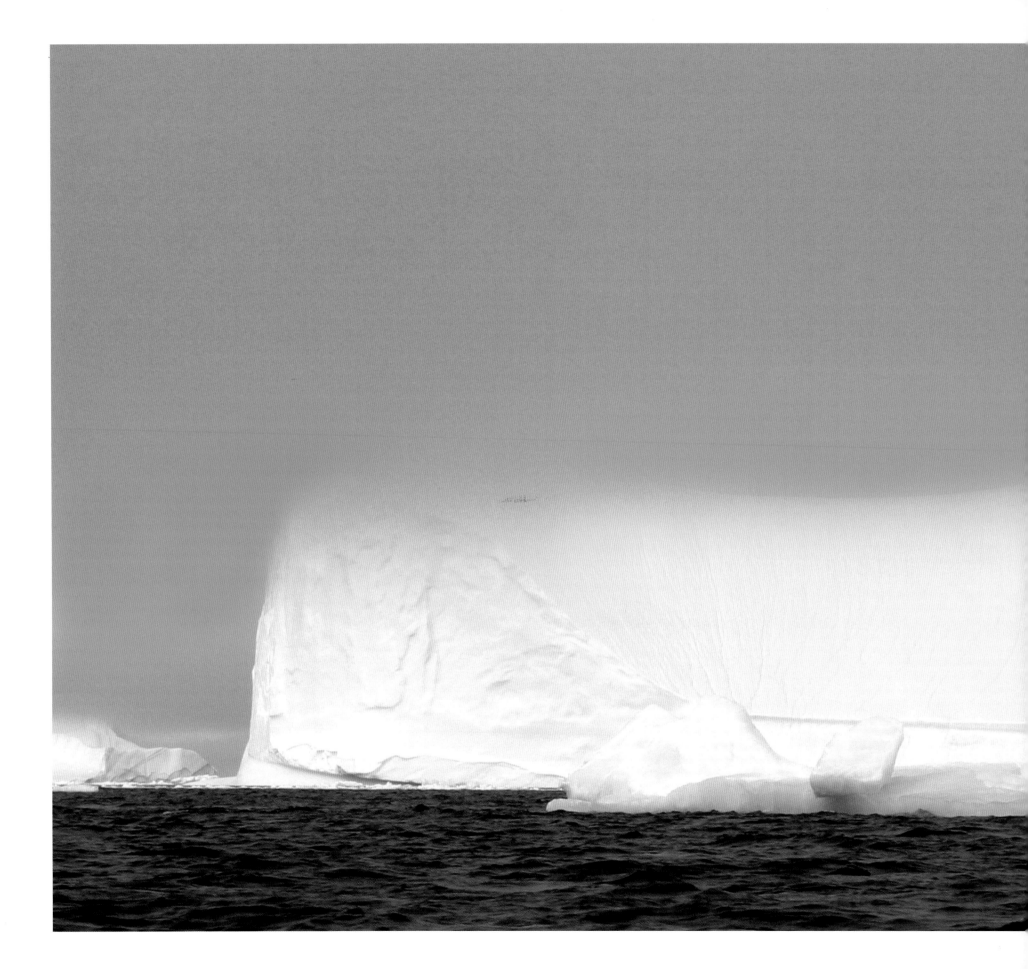

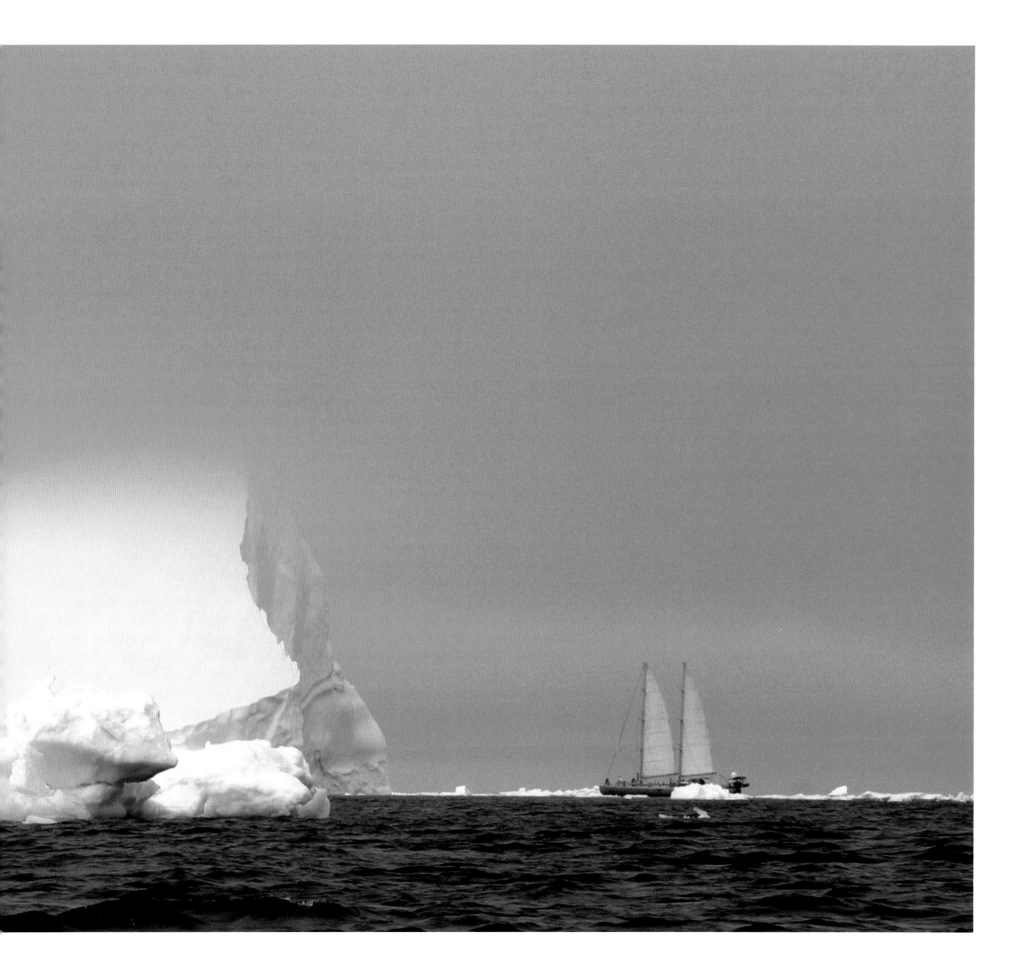

THE Conquerors OF THE North Pole

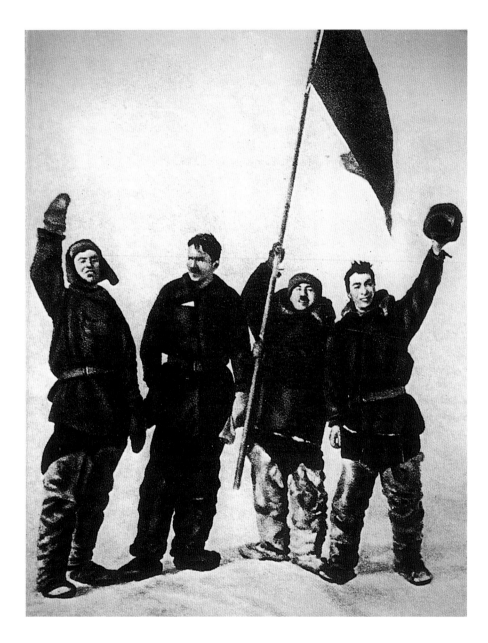

In May 1937, a four-man Russian expedition led by Ivan Dmitrievitch Papanine established the first floating research station on the polar ice cap, drifting with the ocean currents for nine months. The team was saved *in extremis* in February 1938, when their 90-by-30-foot ice raft was at the point of foundering.

EN HAVE ALWAYS BEEN FASCINATED BY EXTREMES. Very early on, the ancients began speculating about the existence of the magnetic poles, which they termed the "antipodes." Very early in mankind's history, daring navigators set out across the frozen seas to find these antipodes. And yet the path to the fabled latitude 90° north was among the last to be opened, and the exploration of the Arctic has continued uninterrupted to the present day despite centuries of terrible ordeals.

The first known navigator to find the sea route to the North was a Greek, Pytheas the Massaliot, who embarked from Marseille in his galley and reached the "Land of Thule" in about 330 BC. Thule was considered to be the last accessible frontier to the North; some placed it in the Shetland Islands; others in the Orkneys, the Faroes, even Iceland. Nobody really knows how far north Pytheas managed to penetrate, but on their return his crew claimed to have seen the "midnight sun" and the water around them turn to ice, becoming "a vast sea-lung." Pytheas himself was dismissed as a liar and accused of fabricating his story around the Greek myth of the Hyperboreans, whose land lay beyond the North Wind.

The Dane Eric the Red, a convicted murderer, owed his 982 discovery of Greenland to his forced exile—and a following wind. He arrived on the coast of Greenland at the height of the short northern summer and proclaimed it a "verdant country." He later founded a Viking colony.

Despite these early exploits, the conquest of the frozen seas of the North aroused scant enthusiasm among explorers before the period of the great discoveries. In 1569, Flemish cartographer Gerardus Mercator's charts depicted the North Pole as a towering black rock surrounded by islands. Nevertheless, the countries of the Old World were interested in these icy wastes, insofar as they might assist their trade in silks and spices. In 1585, the English navigator John Davis discovered the first indications of a northwest passage between Greenland and Baffin Island, which he speculated might lead through to the Indies. While Spain and Portugal were sending their ships around Africa and Cape Horn to the Far East, the Dutch United Provinces were financing an altogether different project to compete with them. In June 1594, the pilot Willem Barents steered northeast for Siberia, also hoping to discover a new sea route to the East Indies. In 1596, after three unsuccessful attempts, Barents discovered the Island of

Spitzbergen before the ice floes closed in on his ship at Nova Zembla. Forced to spend the nine winter months that followed at latitude 76° N, his crew were reduced to hunting foxes for food, somehow surviving the bitter cold and the attacks of marauding polar bears. When the drift ice at last began to break up in May 1597, they set out in their open longboats, trusting to Providence. Barents died on the voyage that followed, leaving his epic story to be told by Gerrit de Veer, one of the twelve survivors of the expedition. De Veer's *Prisoner of the Ice* was to become a classic of the genre.

The northeast was shown to be a chimera, but the Northwest Passage continued to invite speculation. In 1607, the English navigator Henry Hudson decided to try his luck on it, heading due north to within 660 miles of the Pole before his ship was stranded on the ice. His record was to stand for sixty-six years. In 1610, he sailed the *Discovery* into the immense sea that now bears his name, Hudson Bay, where he died. The failures continued: After the catastrophic expedition of Sir John Franklin, who in 1645 took HMS *Erebus* and HMS *Terror* into the region only to vanish without a trace shortly afterward, the Northwest Passage remained unconquered until the 1903–06 expedition led by the Norwegian explorer Roald Amundsen.

Yet the obsession with traveling eastward "in order to ascertain where the American coast began" persisted. In 1727, Czar Peter the Great, influenced by the spirit of the Enlightenment and the Academy of Sciences in Paris, resolved to underwrite an expedition to explore the farthest reaches of his empire. For this task he engaged a Danish mariner, Vitus Bering, who left St. Petersburg to cross Siberia, a distance of almost five thousand miles, to arrive three years later in Kamchatka. It was there that he built a sailing ship, the *Saint Gabriel*, aboard which he was able to discover, on August 13, 1728, that a narrow strait—later known as the Bering Strait—was all that separated Asia from America. Bering could go no farther due to persistent fog and was forced to retrace his steps. Nevertheless, the subsequent Great Northern Expedition (1733–43) finally made it possible for him to recognize and chart the Aleutian Islands and Alaska. Bering died on a desert island where his ship had been driven ashore. As for the full Northeast Passage, it was finally carried out with little difficulty by a Swede, Adolf Erik Nordenskjold, aboard the *Vega* in 1878–79.

Curiosity and the spirit of scientific research were the driving forces of subsequent polar expeditions, some of which bordered on the foolhardy. The British explorer Sir John Ross and his nephew James Clark Ross set out to prove the conclusions of the German physicist Carl Friedrich Gauss on the earth's magnetic fields, locating the magnetic North Pole in 1831. But the most daring scientific adventure of the nineteenth century was, without doubt, the astonishing discovery of the glacial Arctic Ocean by the Norwegian Fridtjof Nansen in 1893–96.

Nansen's epic began twelve years earlier with the shipwreck of the *Jeannette*, the property of an American press baron, commanded by Captain George Washington DeLong. The vessel was crushed by ice in 1881, northwest of the Bering Strait, close to the New Siberian Islands. Whence the astonishment of the scientific world when, two

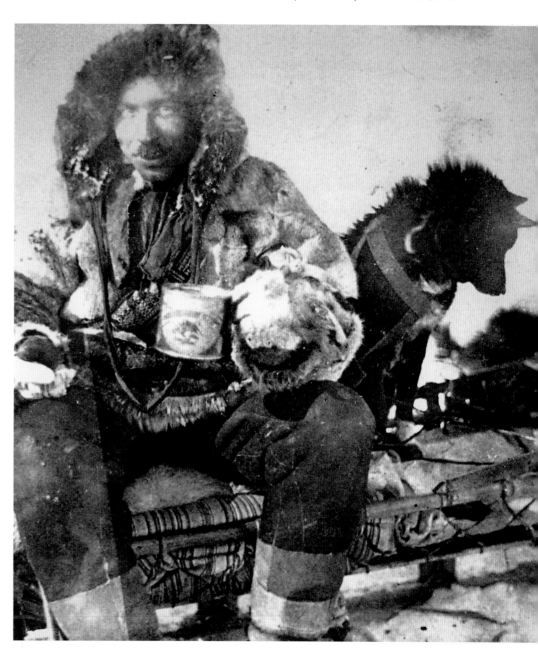

In 1931, the Russian explorer G. A. Ushakov charted the northernmost islands of the Arctic Ocean.

years later, a group of Eskimos sighted fragments of the wreck on the southeast coast of Greenland, more than three thousand miles from the scene of the shipwreck. It was at this juncture that Nansen, then curator of the Natural History Collection in Bergen, Norway, had a stroke of genius: Could it be that the North Pole was an ocean, not a continent? To find out for certain, he gathered funds to build the *Fram*, a pot-bellied vessel some 120 feet in length and 33 feet on the beam; its rounded hull was designed to resist the pressure of the ice. Nansen's complement for the expedition included twelve crew members (including a meteorologist and a botanist) and thirty-four sled dogs. The *Fram*'s objective was to surmount the ice jam and eventually be carried by the moving floe, in the hope—according to Nansen's calculations—that the ocean currents would carry her to the North Pole region in less than twenty-four months!

Duly encircled and trapped by the ice, the *Fram* began her long drift. She was undamaged as

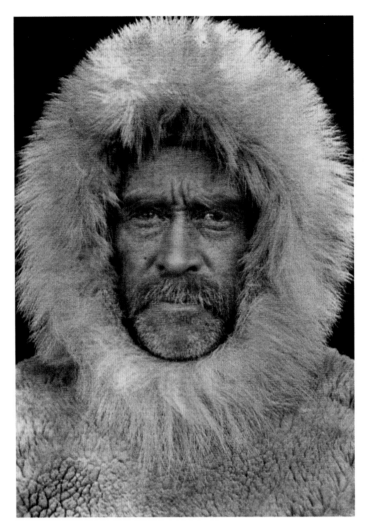

Nansen had hoped. On March 14, 1895, he finally came to a halt at 84° N, less than five hundred miles from the Pole. The temperature stood at –40°F, but Nansen refused to give up. Taking with him one sailor, Fredrik Hjalmar Johansen, he loaded three sleds pulled by a total of twenty-eight dogs. The two men took a couple of kayaks, a few scientific instruments, rifles with 180 cartridges, and enough dried meat and fish to last one hundred days. They also had a silk tent, a sleeping bag lined with reindeer skins, and thick woolen clothes worn under a kind of canvas to protect them from the snow. The ice was chaotic, the terrain was very dangerous, and the results disappointing. After reaching latitude 86°10′ N, the northernmost point ever reached by man, Nansen gave up his bid to reach the Pole. On April 8, 1895, he turned back. On August 24, he was greeted as a national hero at the port of Hammerfest in Norway.

By the beginning of the twentieth century, the dream of reaching the North Pole, latitude 90° N, had become a worldwide obsession. After seven failures, Robert Edwin Peary, a United States Navy engineer, determined to "achieve the same glory as

Christopher Columbus" and set out on his eighth attempt. He set up a base camp at Cape Columbia on Ellesmere Land, then prepared his final assault, which began March 1, 1909. After reaching latitude 87°47′ N, he decided to cover the final 124 miles to the Pole with only his black servant, Matthew Henson, and four Eskimo escorts. On April 6, 1909, at 10:00 AM, Peary declared victory, having first (as he later wrote) "nailed the star spangled banner to the North Pole."

Peary's triumph was short-lived. Immediately on his return to Cape Columbia he learned that another American, his former friend Dr. Frederick Cook, was claiming to have reached the North Pole on April 21, 1908, almost a year earlier. A violent dispute ensued, faithfully reported by the press; neither man could actually provide any tangible proof of his exploits. Eventually a committee of experts nominated by the National Geographic Society in Washington, D.C., settled the matter in favor of Peary, who was pronounced "deserving of the greatest honors." But a century later, his triumph remains controversial; new studies, relying on data from precise measuring instruments, would appear to prove it was physically impossible for Peary to have carried out his trek to the Pole and back in the time he claimed.

Since then, the Pole has been reached in a number of different ways: In 1926, the Americans Richard Byrd and Floyd Bennett flew over it in an airplane; in 1958, the USS *Nautilus*, a nuclear-powered American submarine, passed beneath the Arctic ice; in 1968, American Ralph Plaisted and Canadian Jean-Luc Bombardier arrived on snowmobiles. In 1978, the Japanese explorer Naomi Uemura became the first man to reach the North Pole alone, with a dogsled. French adventurer Jean-Louis Etienne made the journey on skis in 1986, also alone.

The lure of the Pole has not diminished.

△ American explorer Robert Peary claimed the title of first man to conquer the North Pole after reaching the mythical latitude 90° N on April 6, 1909.

▷ Ice castles floating with the sea current in a stretch of open water off Spitzbergen.

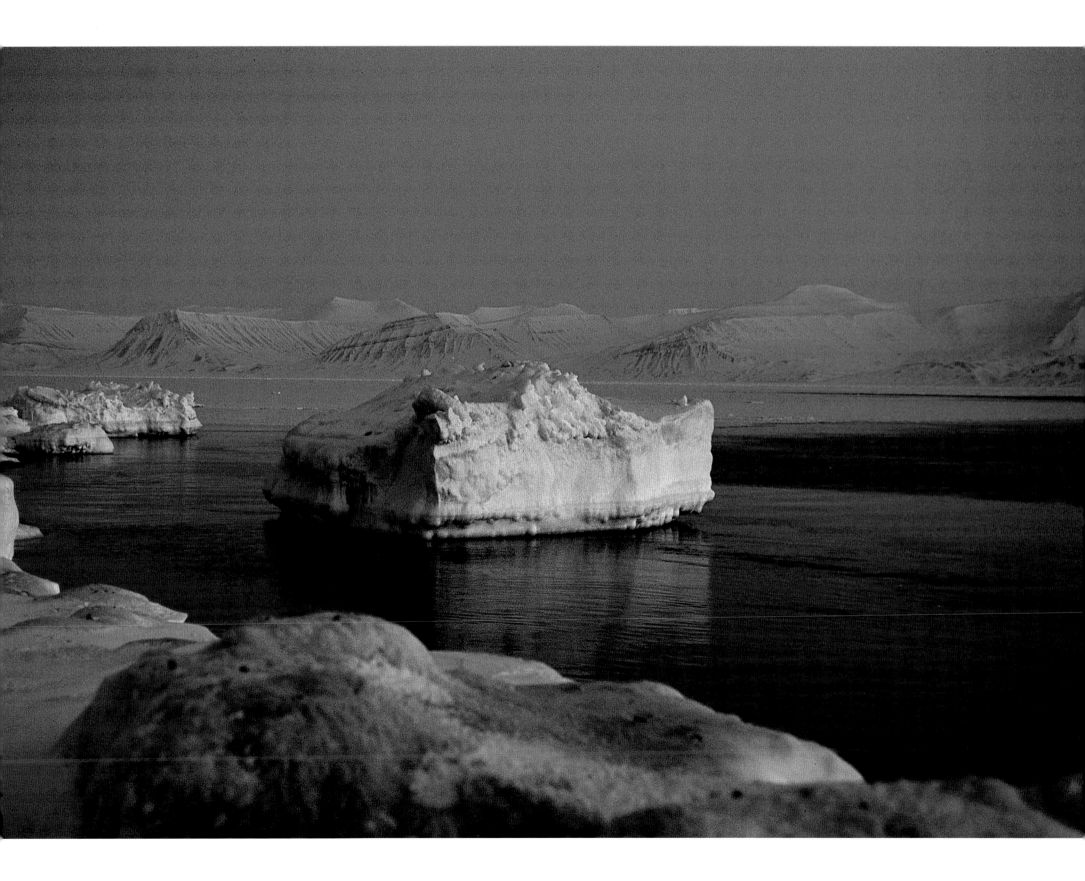

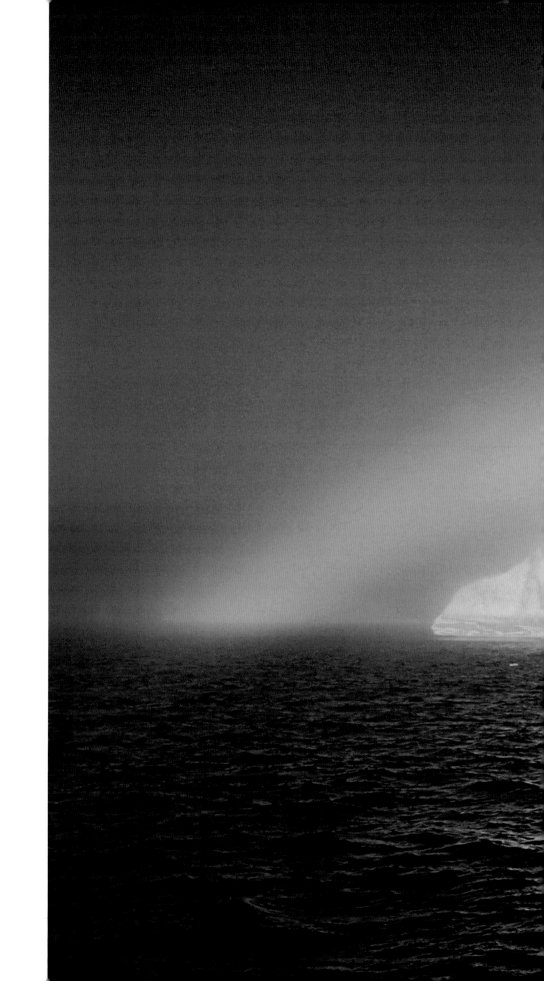

▷ Rainbowlike ice haloes, caused by particles of ice suspended in the atmosphere, are a phenomenon of the northern regions.

▷▷ Vast ice fields randomly shift and collide around the geographic North Pole, creating stretches of open water filled with giant drifting fragments.

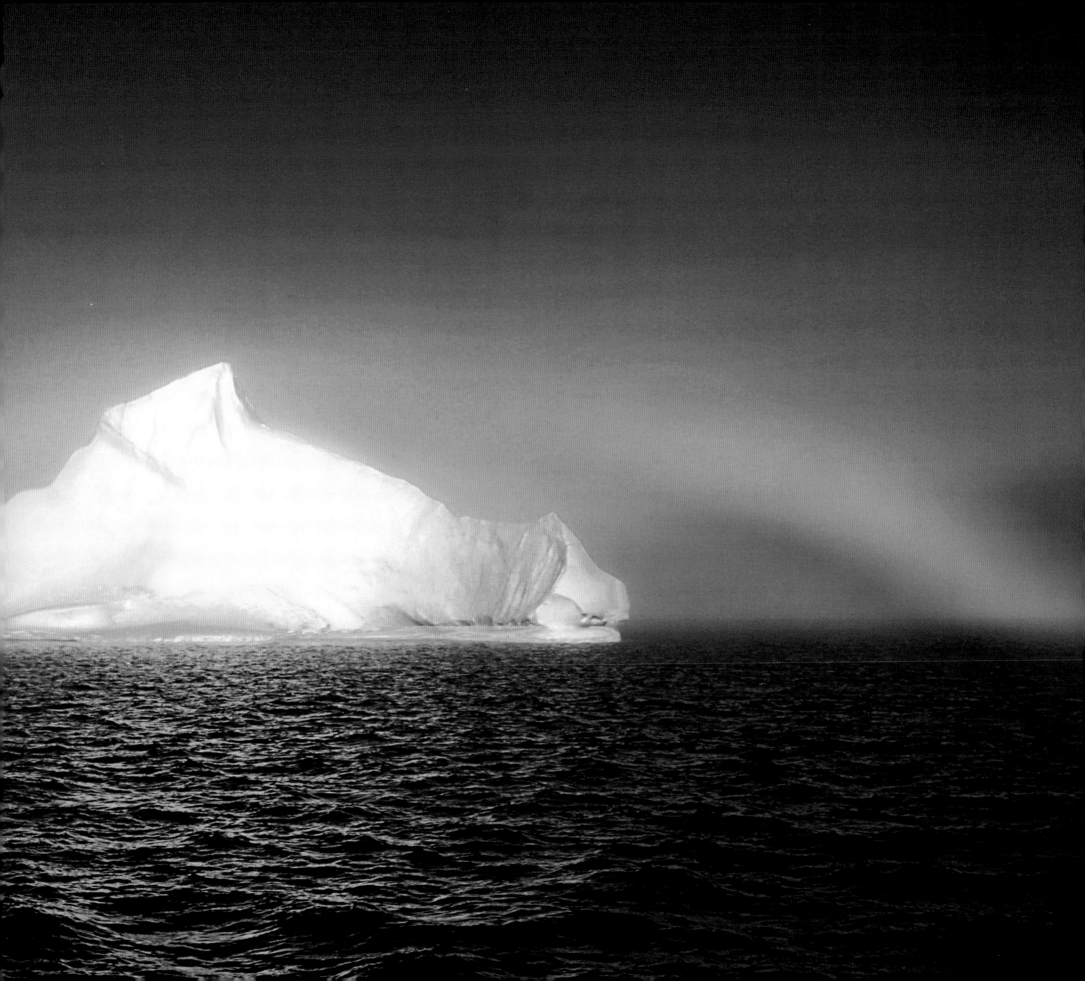

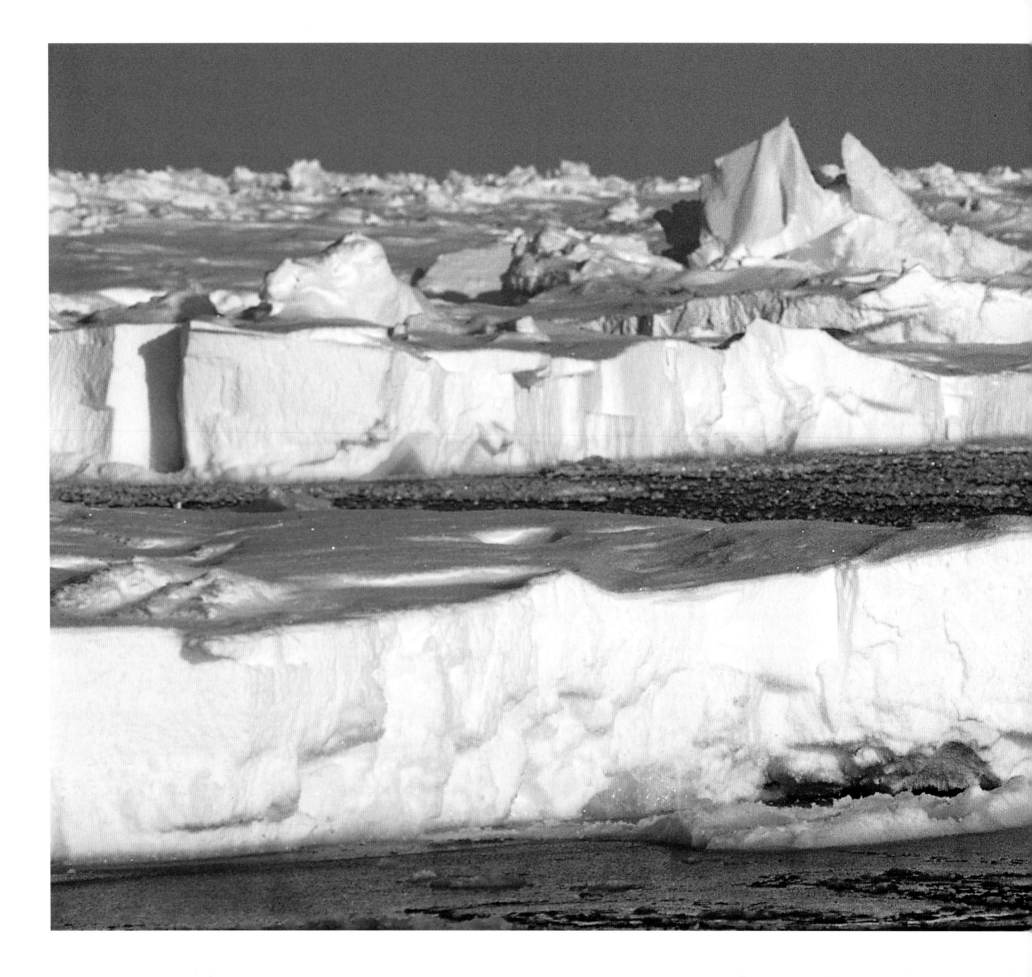

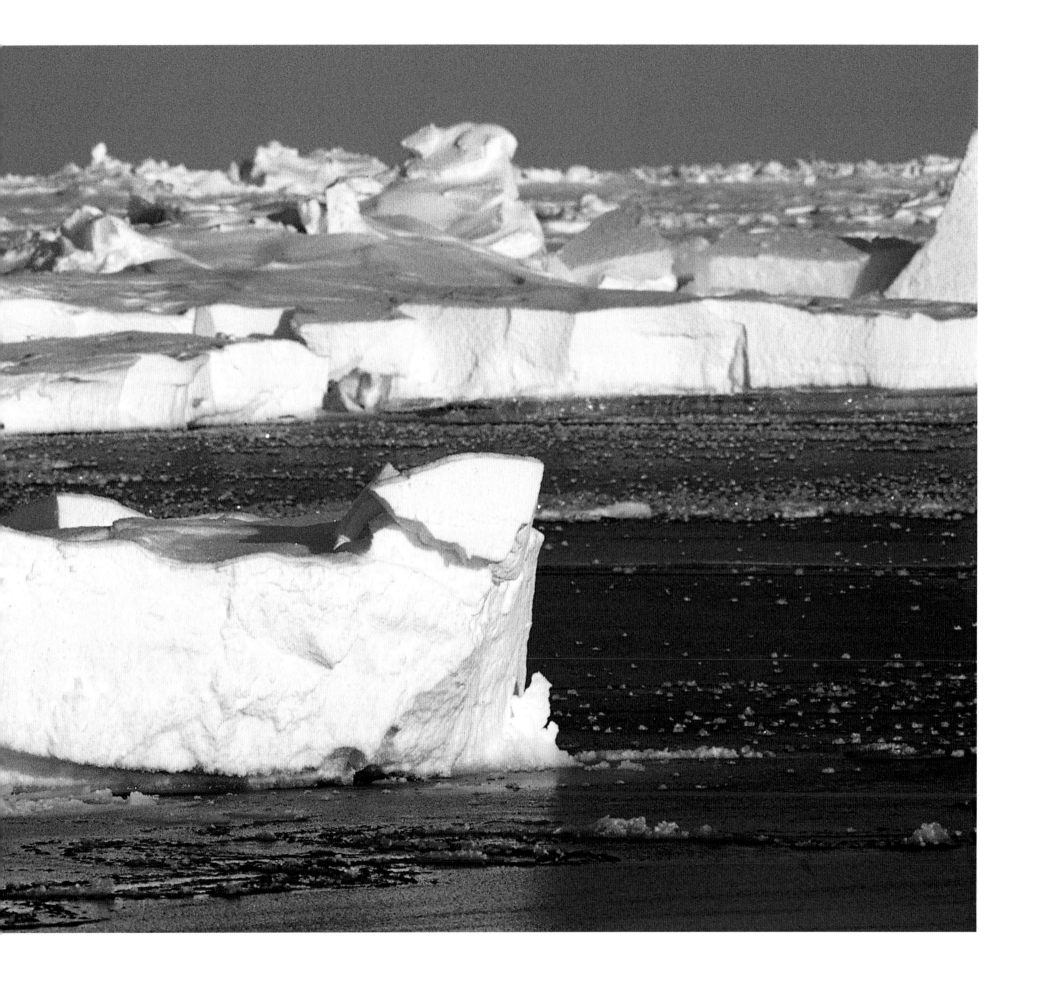

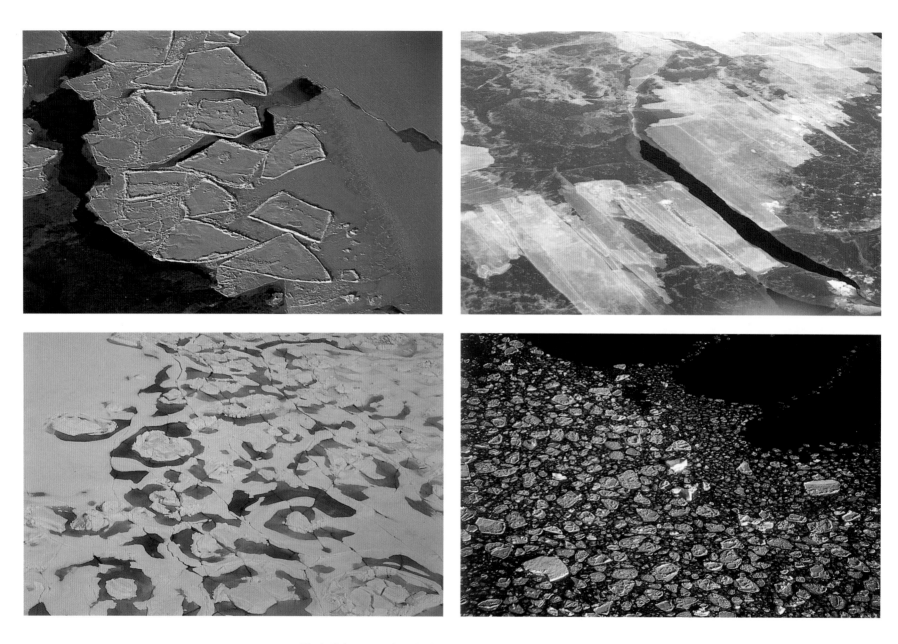

The Arctic ice as seen from the sky: Its beautiful patterns are created by the
incessant flow of sea currents across the region.

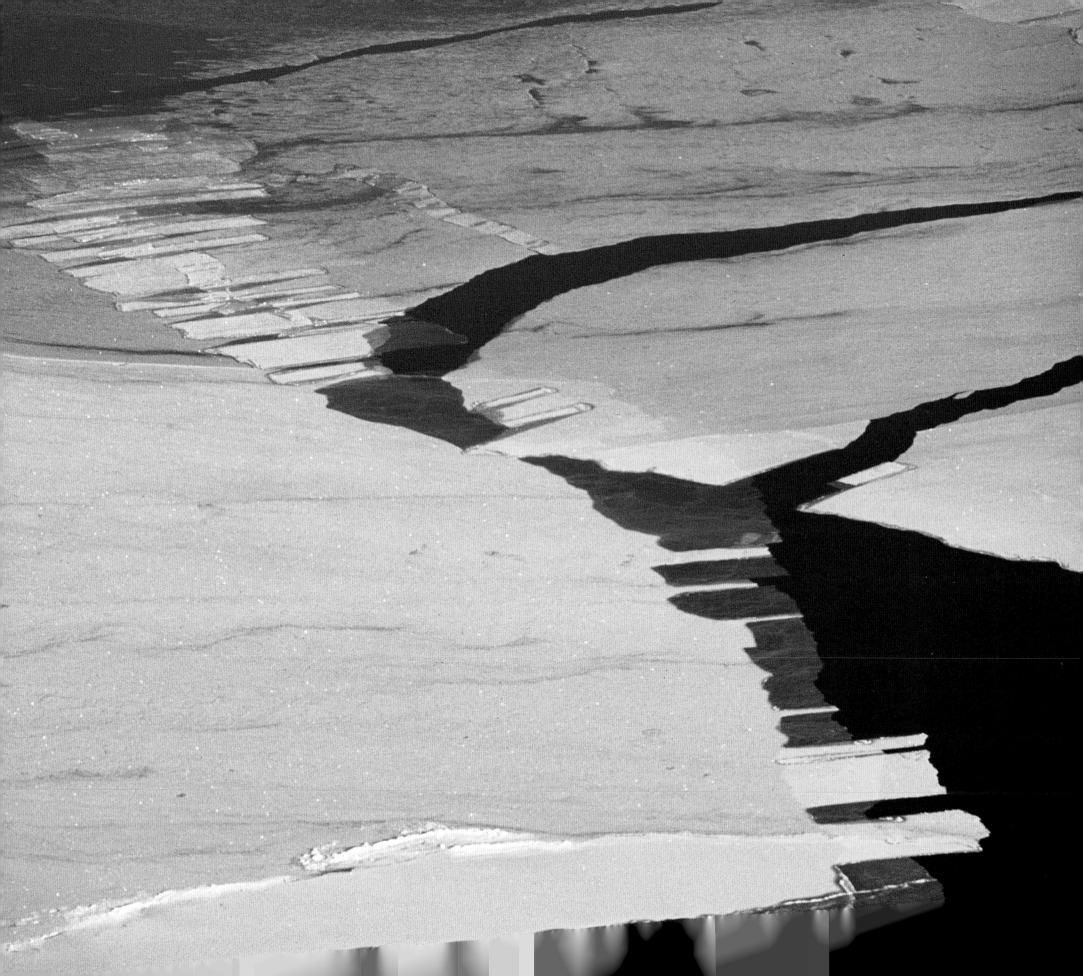

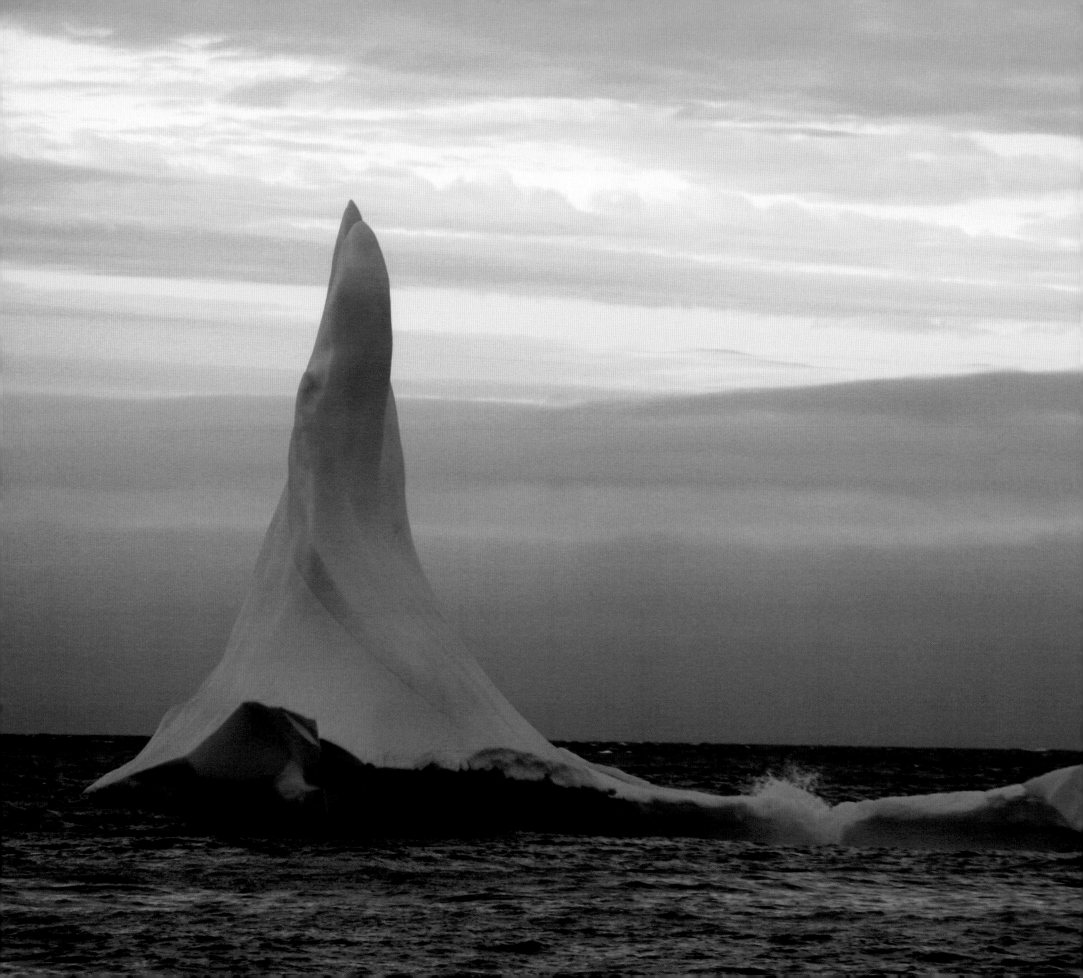

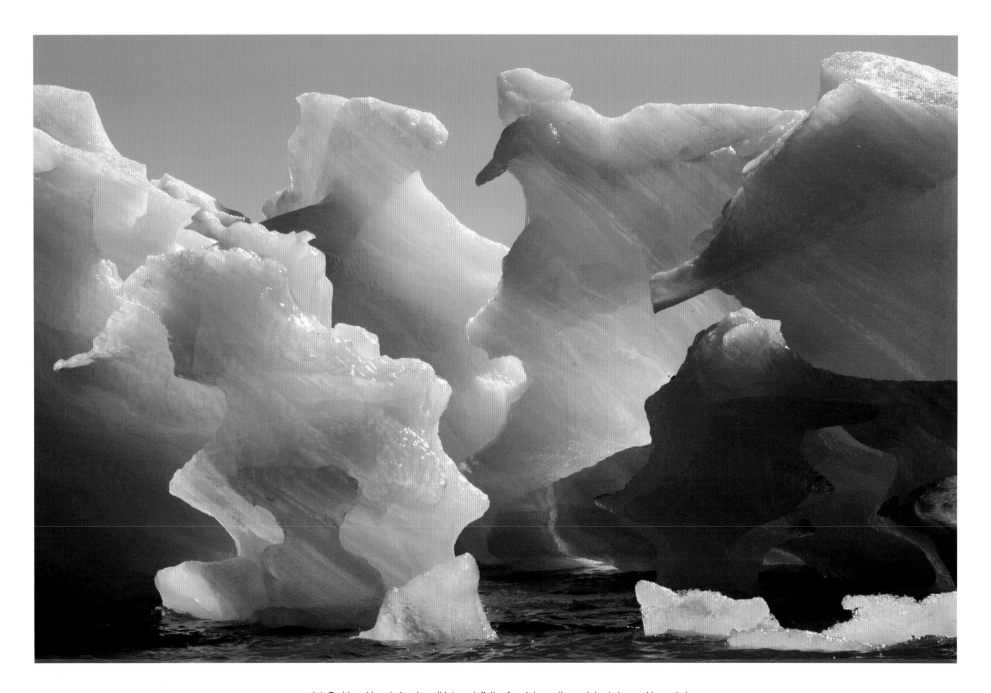

◁ △ Fashioned by wind and swell into an infinity of sculptures, the pack ice is inexorably carried
to warmer waters where it melts and vanishes.

▷▷ As the long polar night draws to an end, the first pale rays of sunlight thaw the ice into
turquoise pools on the white surface of the shelf.

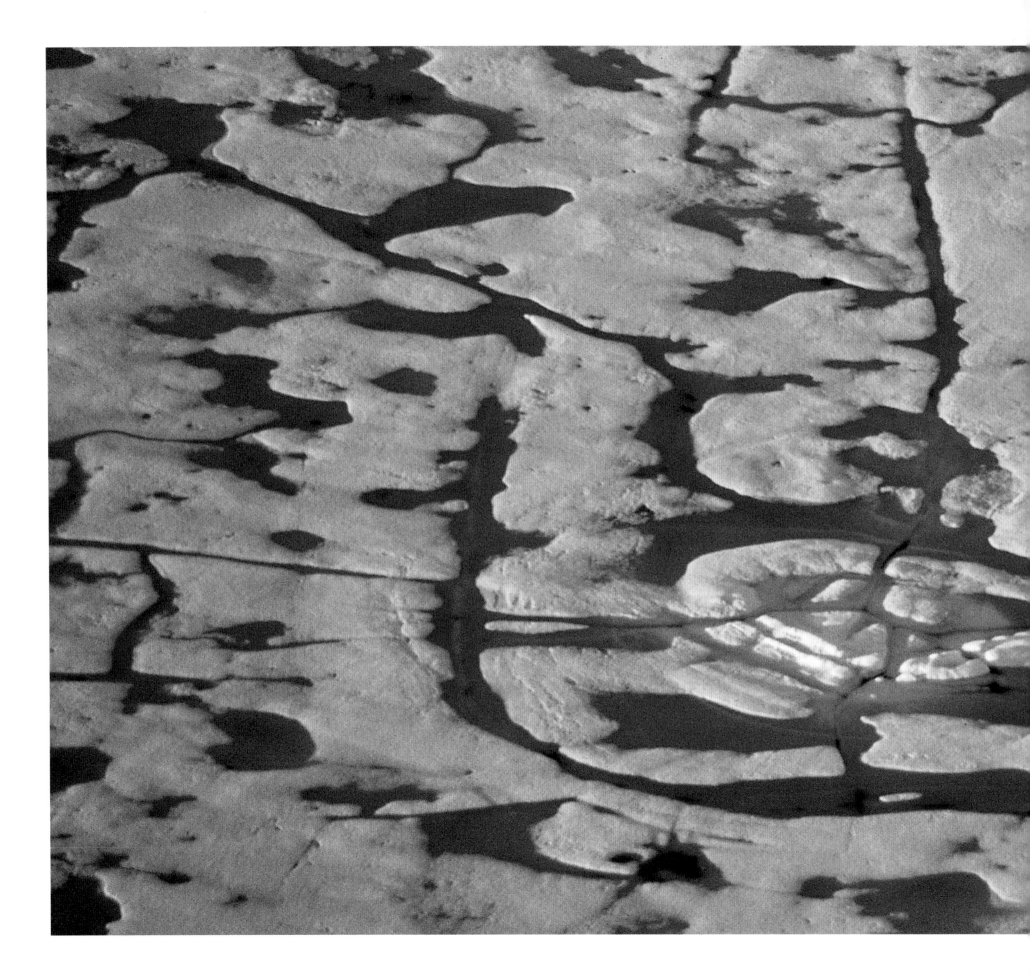

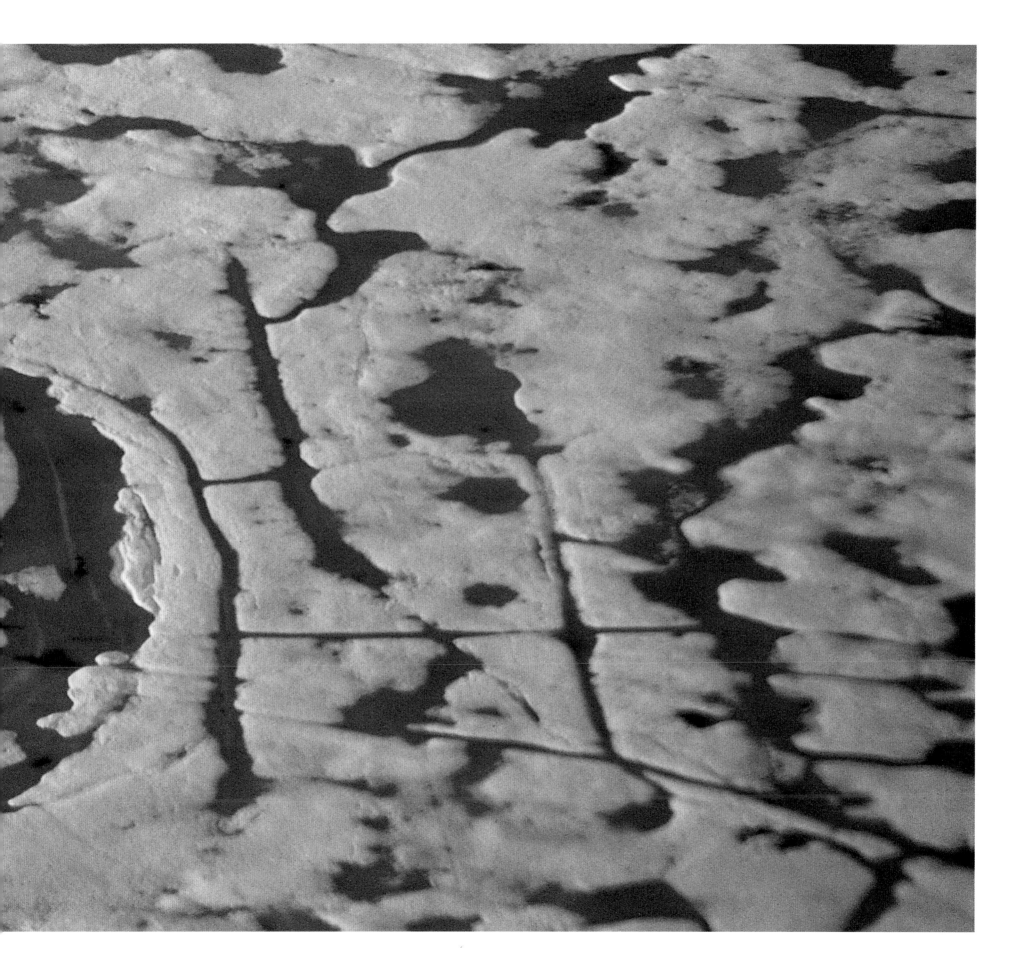

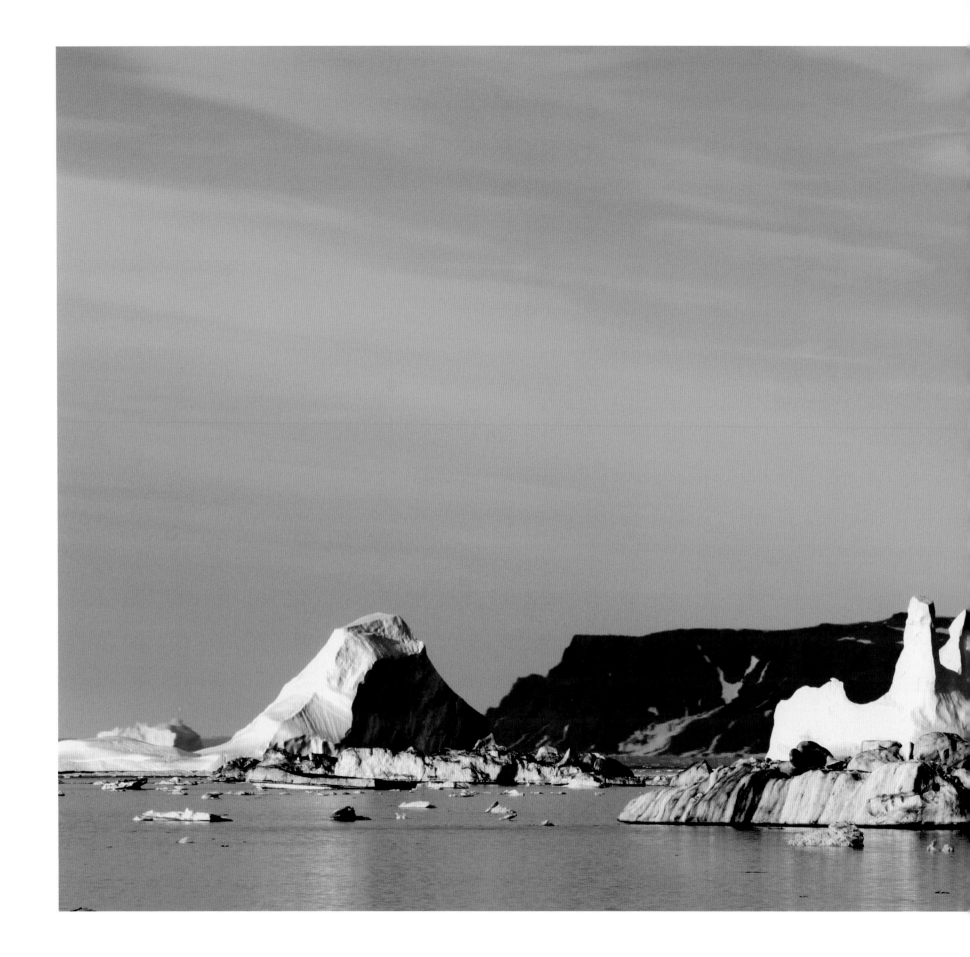

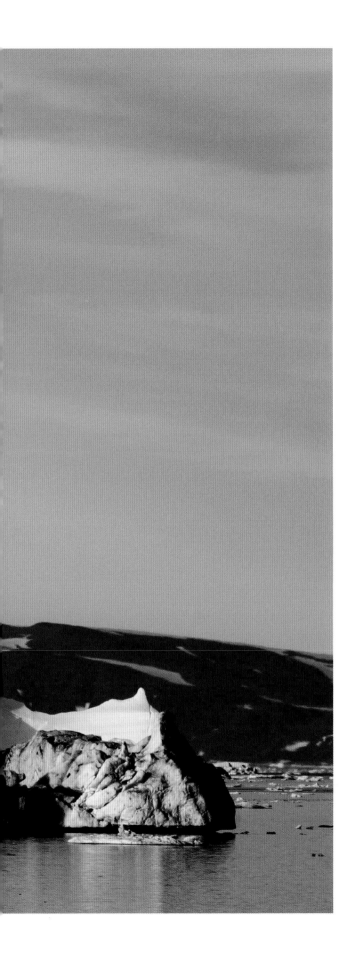

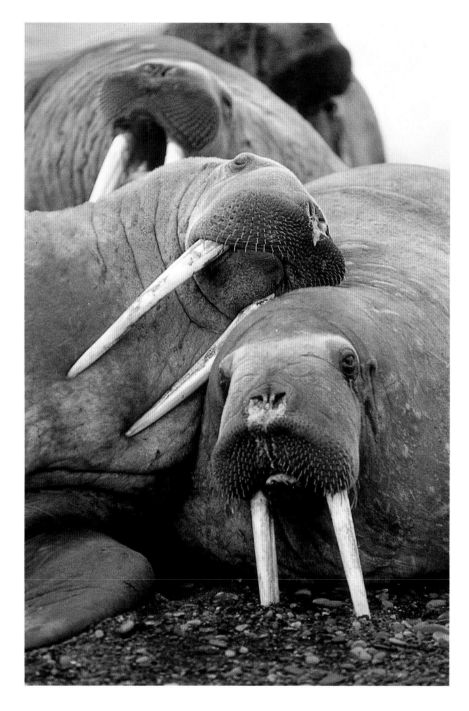

△ Walruses have flippers like sea lions and seals; they feed on crustaceans and shellfish, which they dig from the sea floor with their tusks. Afterward they bask in groups on Arctic beaches.

◁ The glaciers of Greenland's east coast—some of which flow at speeds exceeding sixty-five feet per twenty-four hours—deposit innumerable blocks of ice in the great fjord of Scoresby Sound.

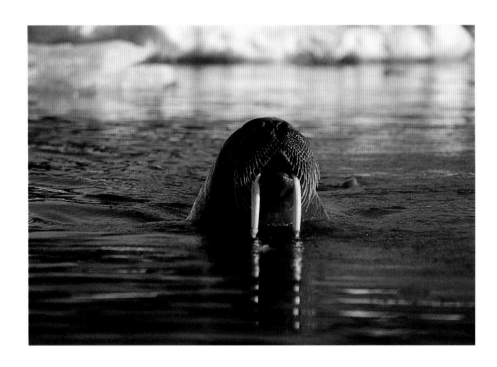

△ Walruses are perfectly adapted to the rigors of the Arctic climate, with a thick layer of blubber and a specific system of blood circulation. They can look for food underwater for upward of twenty minutes without surfacing.

▷ This gigantic iceberg, whose visible portion represents no more than a tenth of its total mass, could supply one day's fresh water for a country the size of France.

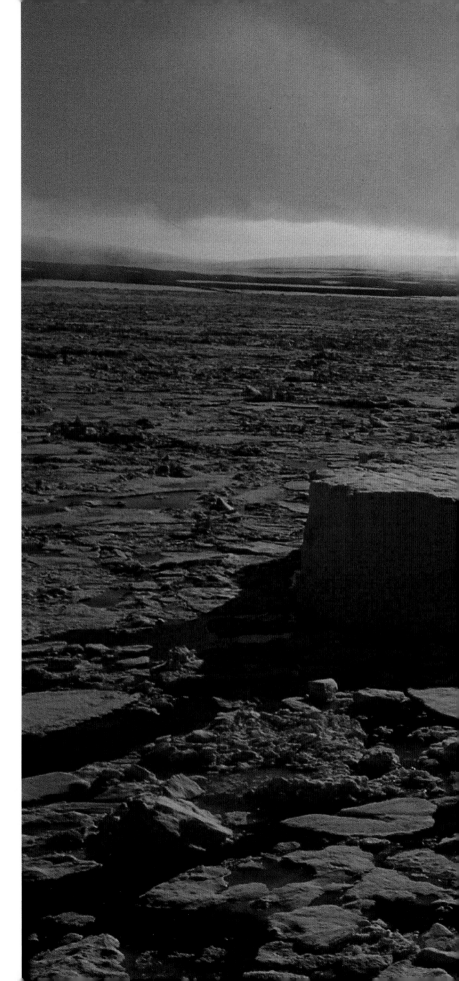

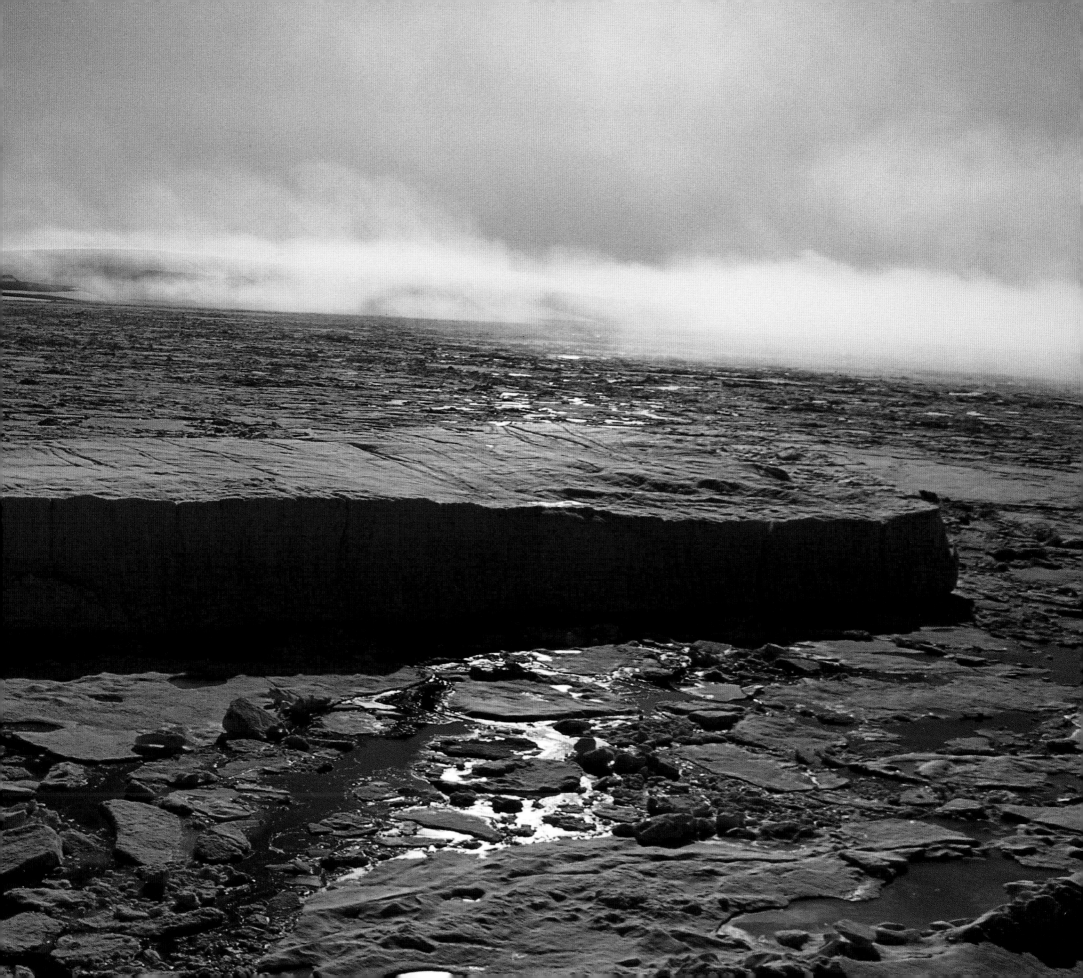

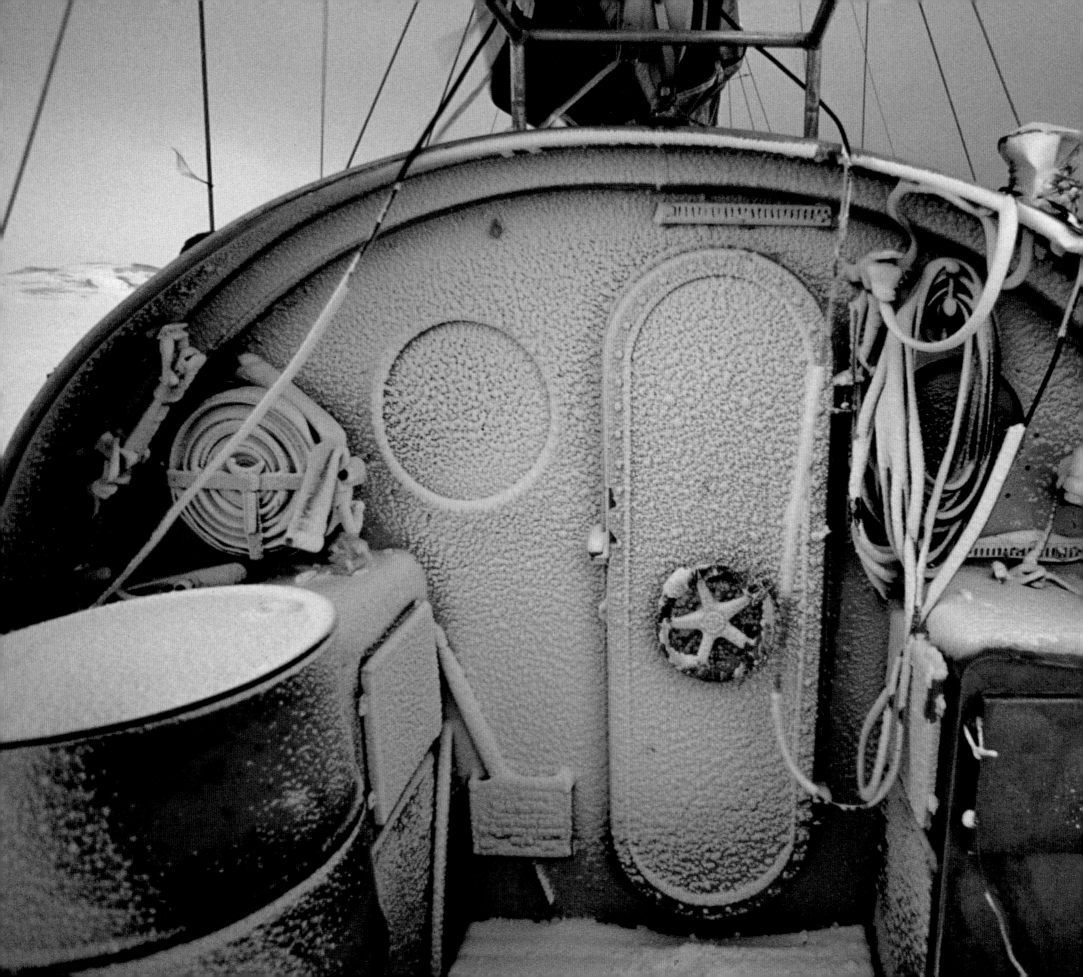

◁ △ Dr. Jean-Louis Etienne's schooner imprisoned by the cold, with frost invading every crevice
and a coat of ice enveloping the boat's upper works.

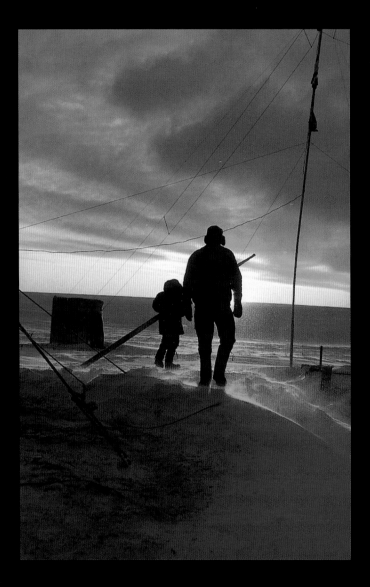

△ In the Arctic autumn of Siberia's far north, the Mammuthus expedition's campsite awakens to a sun that stays low on the horizon.

▷ During the long polar night, a full moon illumines *Antarctica*'s masts and deck.

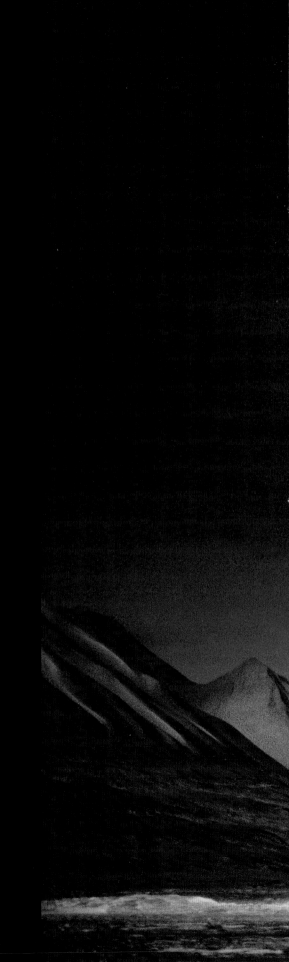

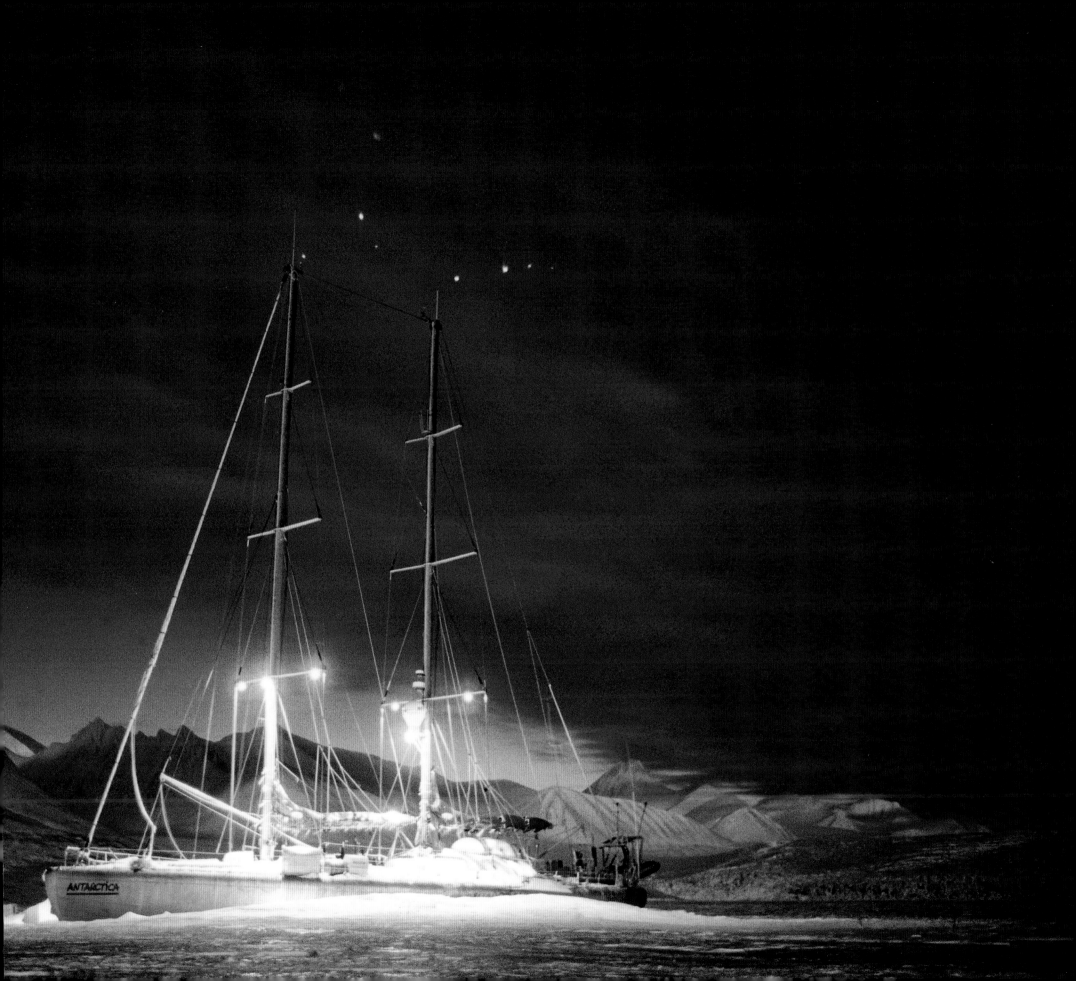

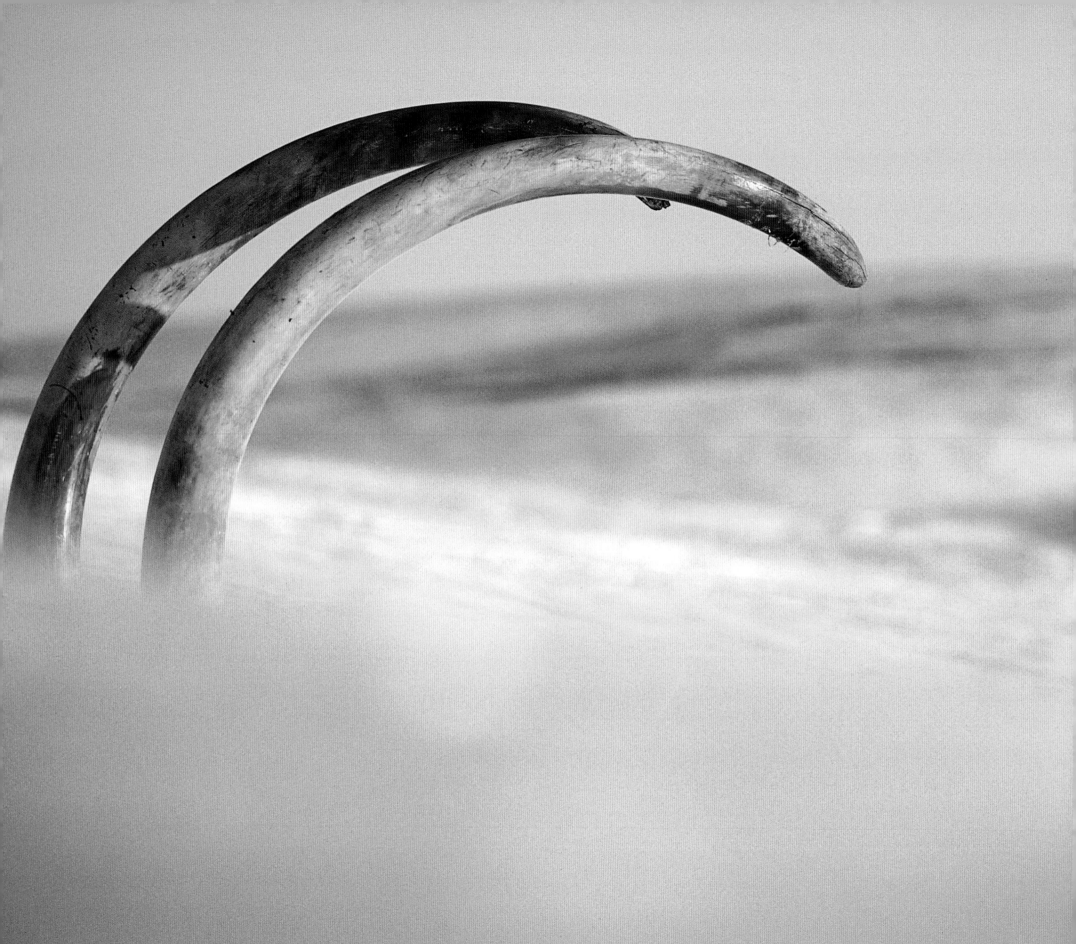

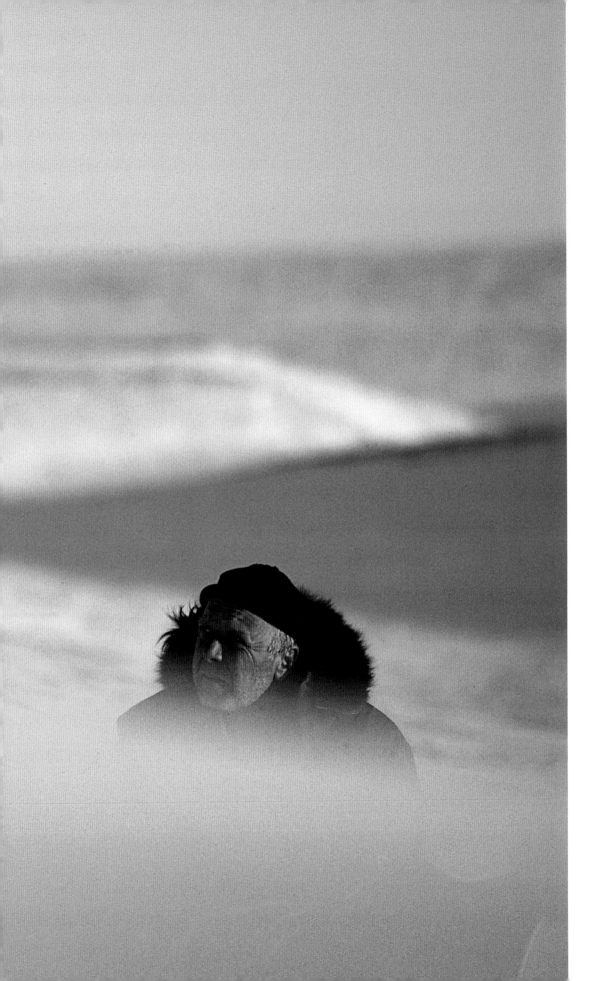

LISTENING TO THE ICE: RESEARCH IN
High Latitudes

A N INTACT RECORD OF THE EARTH'S CLIMATE, imprisoned in the ice; the adaptation of animal and human life to extreme conditions; the story of meteorological phenomena such as katabatic storm winds and the aurora borealis; the totally enthralling discovery of wooly mammoths preserved for twenty thousand years in the deep-freeze of permafrost. All of these demonstrate that science (which is also highly active in the Antarctic) does not lack for fields of research in the regions around the North Pole. Physicists, glaciologists, oceanographers, ecologists, medical doctors, university professors, and other specialists have gathered around the North Pole, all deeply concerned about the evidence of global warming, which has given their work a sense of desperate urgency, while perpetuating the tradition of the great polar expeditions.

Commandant Jean-Baptiste Charcot, who became famous as the "polar gentleman," led a number of expeditions to both the Arctic and the Antarctic in the last century. He began opening the North to science in 1908. After serving as a training ship, his celebrated vessel the *Pouquoi Pas?* (the name later became something of a mascot, being adopted by a series of successors) undertook many expeditions to the Arctic, charting twelve hundred miles of coastline, collecting fossils and steadily compiling inventories of local fauna and flora. In July 1934, Charcot brought a twenty-seven-year-old explorer and ethnographer, Paul-Émile Victor, to the east coast of Greenland. Victor's plan was to spend a full year among the Esquimau of Ammassalik, a group of nomadic hunters about whom almost nothing was known at the time. Two years later, on the night of September 15–16, 1936, the *Pourquoi Pas?* and her crew foundered off Iceland. As for Paul-Émile Victor, he continued to travel around the ice cap, revealing to the world the extraordinary Inuit culture, eventually assembling a collection of

In 1998, French explorer Bernard Buigues discovered two magnificent tusks of a mammoth that had lain frozen for thousands of years in the permafrost of Siberia's Taimyr peninsula.

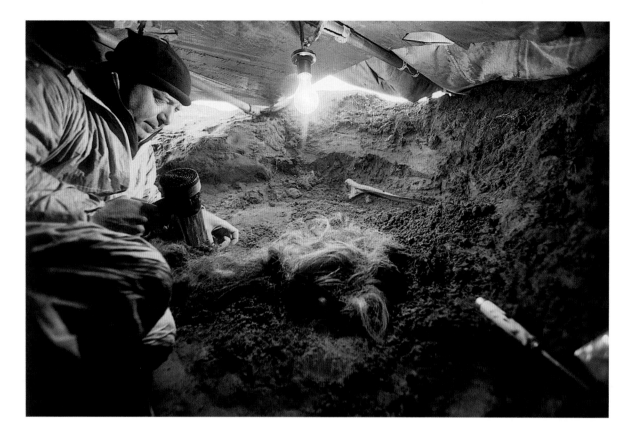

Bernard Buigues uses a hair dryer to melt the frozen sand on the back of the mammoth Jarkov, whose carcass has been in pristine condition for more than twenty thousand years. Even the mammoth's smell is intact, permeating the long hairs formerly imprisoned by the frost.

some four thousand everyday objects, which he bequeathed to the Musée de l'Homme in Paris. In 1947, Victor founded the celebrated *Expéditions Polaires Françaises.*

In the meantime, Russian Ivan Dmitrievitch Papanine and three companions had arrived on the ice floe by airplane on May 21, 1937, to establish the world's first ice-borne scientific research station. They remained in place for 274 days, keeping the world on tenterhooks with news of their exploits, broadcast daily over the wireless. Today, nearly seventy years later, the Ecopolaris scientific campaigns have revived the spirit of these pioneers. Since 1998 their missions—piloted by the *Groupe de recherches en écologie arctique* (GREA) under the aegis of Oliver Gilg, a researcher at the University of Helsinki, in Finland—have been assessing the impact of climate change on the animal and vegetable species of the Far North with expedition after expedition. Between June and September 2004, *Ecopolaris Tara-5* mobilized a multi-disciplinary group of twelve European naturalists and researchers who embarked on the polar sailboat *Tara*, a 110-foot drop-keel vessel built of aluminum—she was formerly known as the *Antarctica* when she was commanded by the explorer and physician Jean-Louis Etienne. The *Tara*'s mission was to collect samples of plants, observe seabirds while conducting a census of their colonies, and carry out a survey of metallic pollutants and their impact on bird reproduction. This research was directed by the French eco-toxicologist Renaud Scheifler of the Department of Environmental

Biology at the University of Franche-Comté. His task was to gather large quantities of seabird feathers and eggshells for later laboratory analysis, to make systematic notes of the numbers of eggs incubated in each nest, and to take blood samples from chicks.

The work of the naturalists of GREA showed beyond doubt that climate change was already affecting the Arctic, insofar as it demonstrated that animal and vegetable species previously unknown in the region were not only on the increase but also reproducing. For example, the common gull, whose range-limit was formerly well to the south of Greenland, is now regularly nesting there. The golden plover, the wild swan, and the gray goose will shortly be doing the same. Likewise, *Borytris lunarea,* a primitive fern, is now found growing some sixty-two miles north of its known territory, along with other previously unknown plants. The shrinking of the ice cap has become palpable. While the melting of the sea ice could open up new seaways between the Atlantic and the Pacific, drastically shortening the historic itinerary to the Far East, it is bound to condemn all species living on the ice cap—most notably the polar bear—to certain extinction. Furthermore, if the ice of the Arctic sea were to disappear altogether in the summer, the level of the world's oceans would rise by more than three feet on average; if the Greenland ice cap were also entirely to melt, the waters would rise by twenty-one feet, literally submerging many countries of the world.

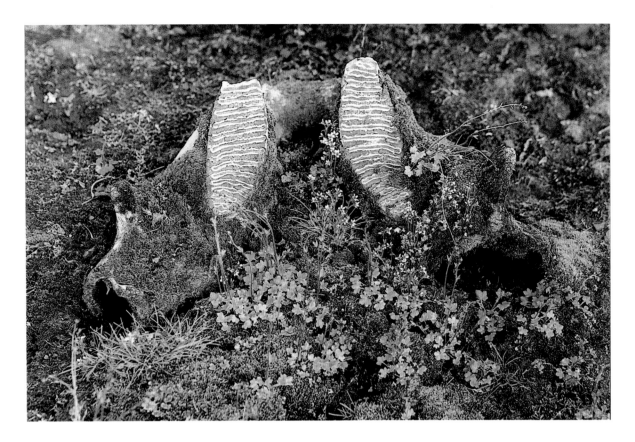

In the brief summer of Northern Siberia, the prehistoric bones, teeth, and flesh of mammoths litter the tundra among the burgeoning plants and flowers.

Other scientists worry about the approaching thaw of the permafrost, which will lead to the total loss of the treasures that have lain frozen beneath its surface for millennia, such as the carcasses of woolly mammoths, like those that have already turned up in Siberia and Yakutsk. These finds are among the most astounding yet made by scientific researchers in the polar regions.

In December 1997, on the Taimyr peninsula in Russia, Bernard Buignes—the leader of a French expedition—stumbled on a fragment of a skeleton poking out of the frozen tundra. This proved to be the first piece in a gigantic puzzle, for the bone came from a mammoth. A few months later, a family of Dolgan hunters guided the researcher to a site where he discovered a pair of nine-foot-long ivory tusks.

In September 1999, the Mammuthus expedition, a project that included the French evolution specialist Yves Coppens, set up a base camp in the middle of the tundra, 174 miles from Khatanga, the regional capital of Taimyr. Over a period of five weeks, the team broke through the frozen soil with jackhammers and struggled with bitter winds and temperatures of −40°F. Finally, on October 17, 1999, in the pale light of the polar autumn, "Jarkov" was extracted from his ancient tomb by an MI-26 Russian helicopter, the largest civil aircraft of its type in existence. The mammoth itself, weighing three tons, lay in an ice casing that weighed twenty tons. Carbon-14 dating showed it to have been a healthy forty-seven-year-old male that died 20,380 years ago. Jarkov was transported by helicopter to Khatanga where he has been stored ever since in a laboratory cellar maintained at a temperature of 5°F. His carcass, left to science, should cast light on exactly what caused the extinction of the woolly mammoth.

Before the exhumation of Jarkov, the remains of others of his species had come to light in the Siberian tundra; for example, the Berezovka mammoth was found in the Russian Northeast in 1901, and further discoveries followed in 1947 and 1978. But Jarkov was the first to emerge in near-pristine condition. A second carcass, Hook, was found in 2001, making the Taimyr the world's most prodigious graveyard for the woolly mammoth, and these treasures are beginning to reveal their secrets to science. Contrary to the accepted wisdom, Jarkov seems to have lived in a steppe environment that in no way resembled the present tundra. His death, like that of his forebears, was attributable to climate change. The first results would appear to prove this, although the experts are taking their time before publishing definitive conclusions.

Perhaps, like La Fontaine, we should now look more seriously for a moral to the story of our planet. We must conclude that if the North Pole is warming, *it is entirely because we as a species have lost our bearings.*

In 2000, a team directed by the Dutch paleontologist Dick Moll found the
remains of prehistoric grass seeds, pollens, insects, and other evidence of
a vanished era in Jarkov's woolly pelt.

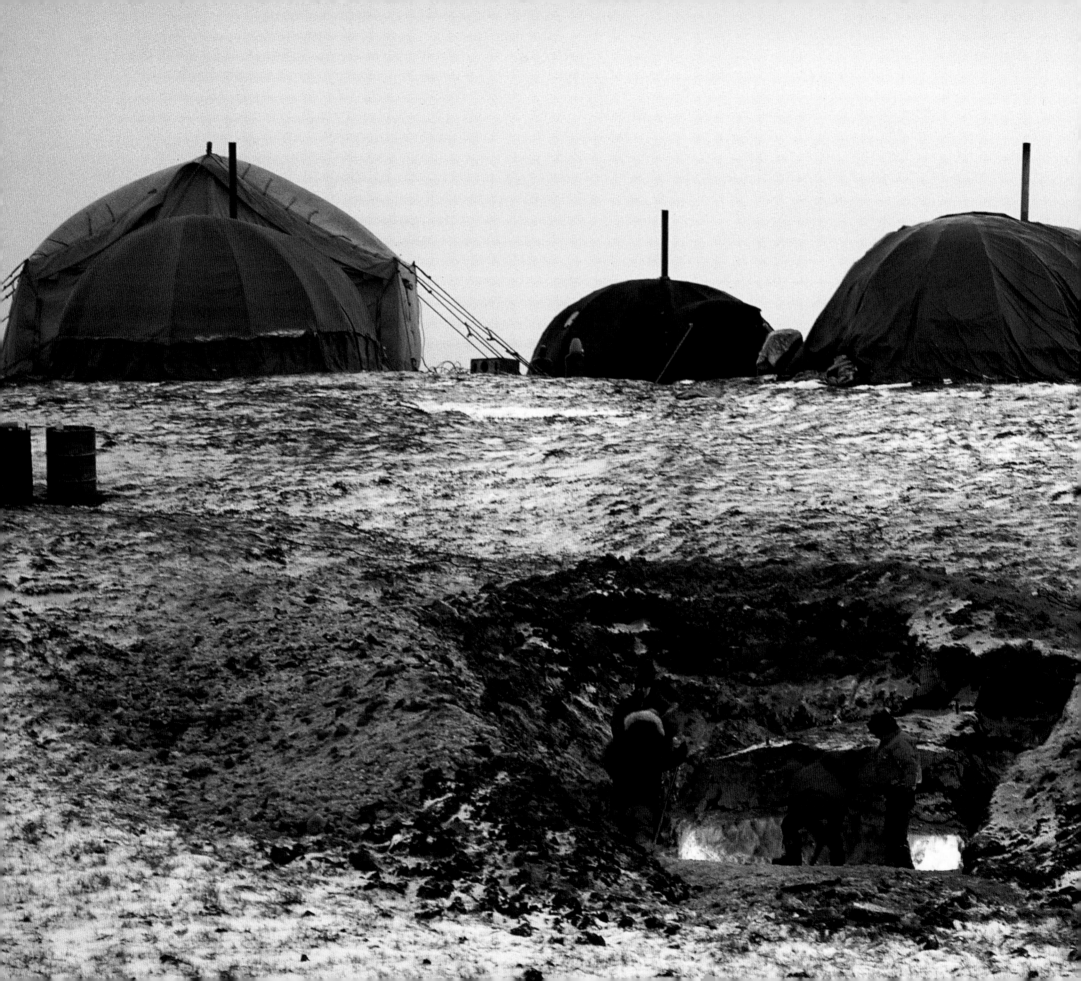

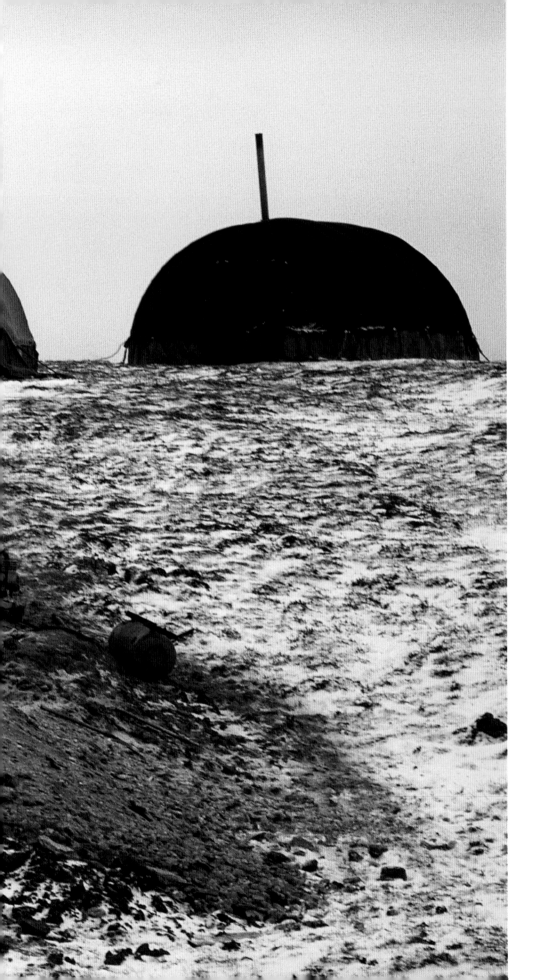

The mammoth Jarkov was unearthed at Bolshaya Balarnaya in
Northern Siberia, after a 20,380-year sleep in a shroud of ice.

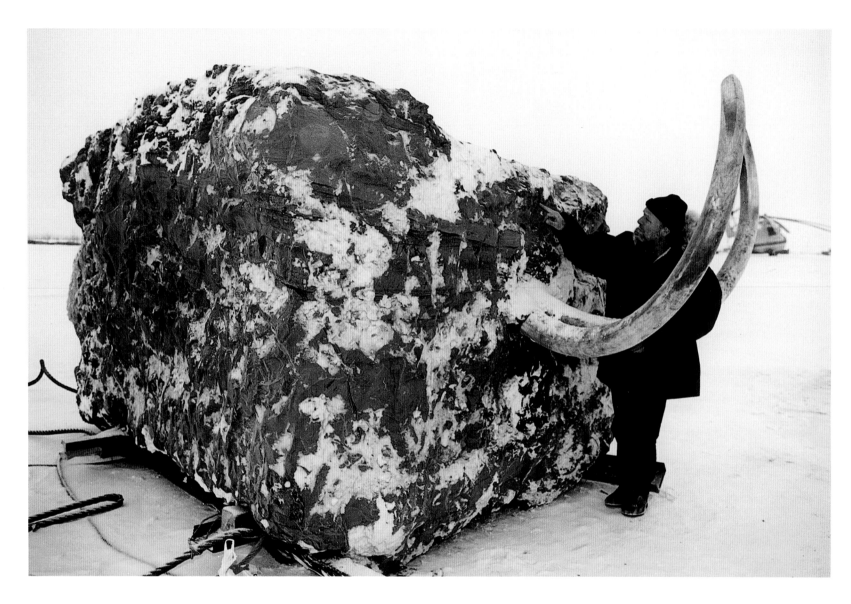

French explorer Bernard Buigues examines the frozen
block of soil containing the remains of Jarkov.

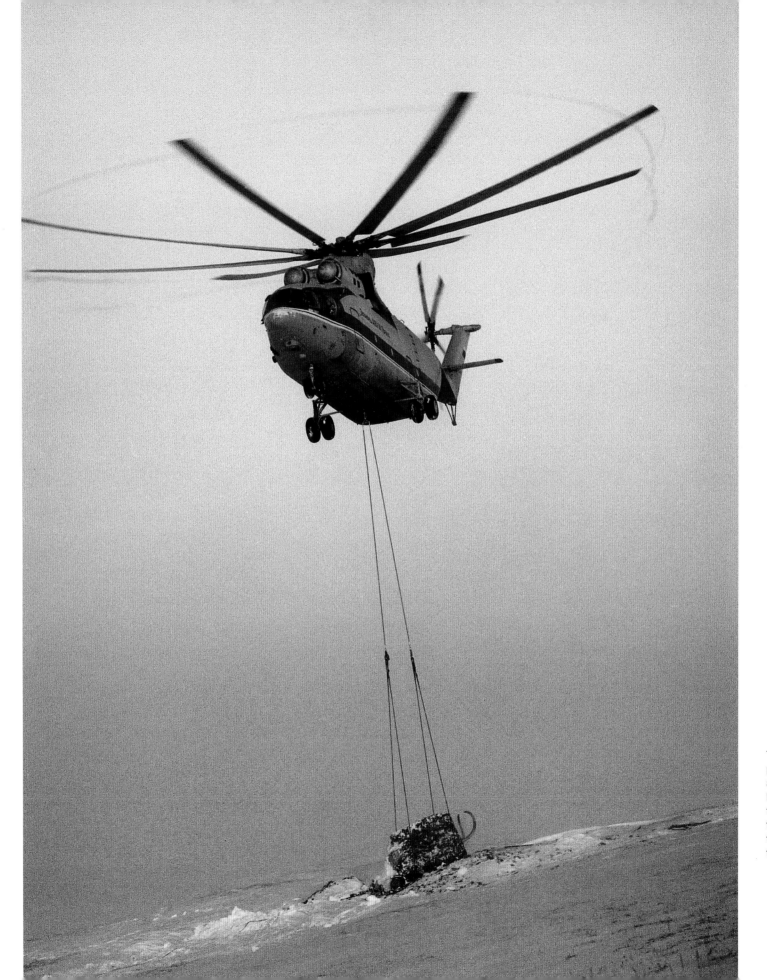

The world's most powerful helicopter, a Russian MI-26, hoists Jarkov's twenty-ton coffin of frozen earth from the surface of the tundra.

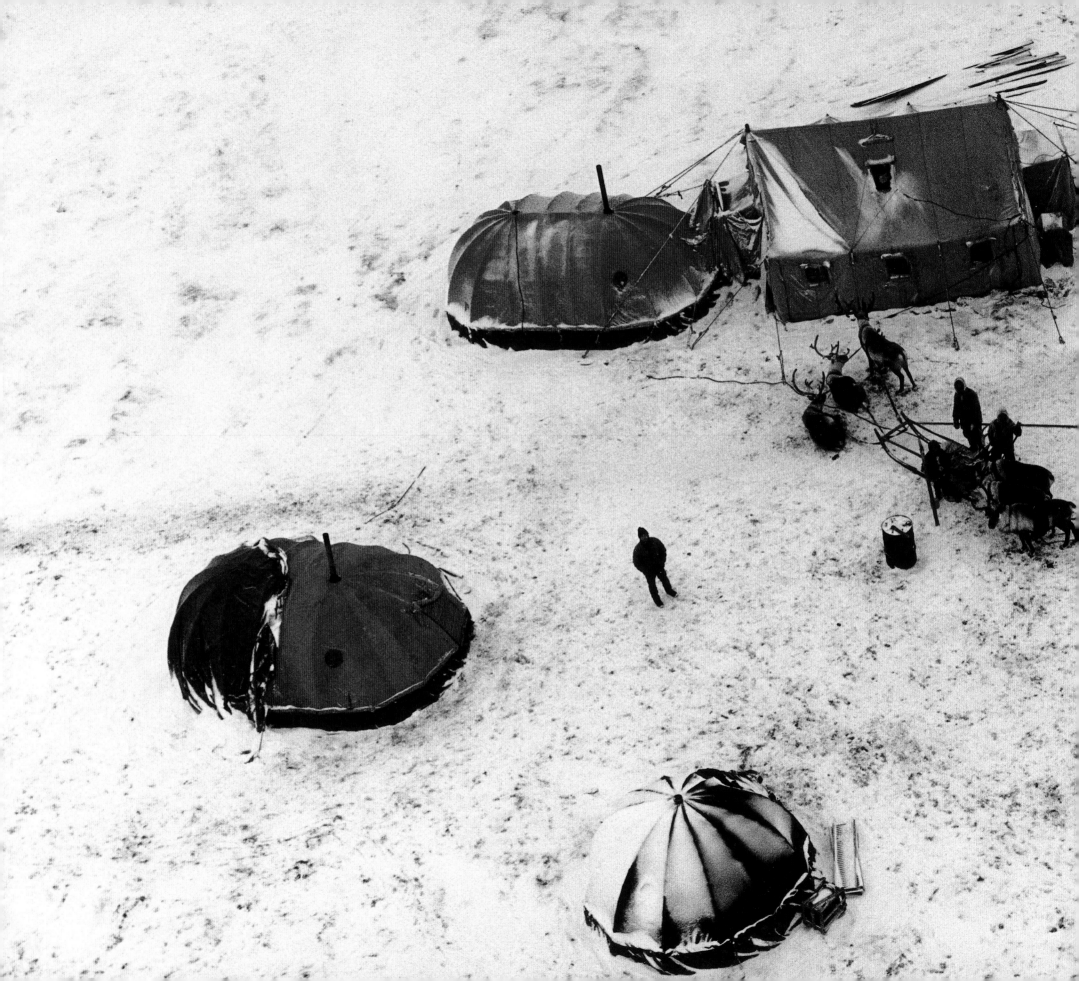

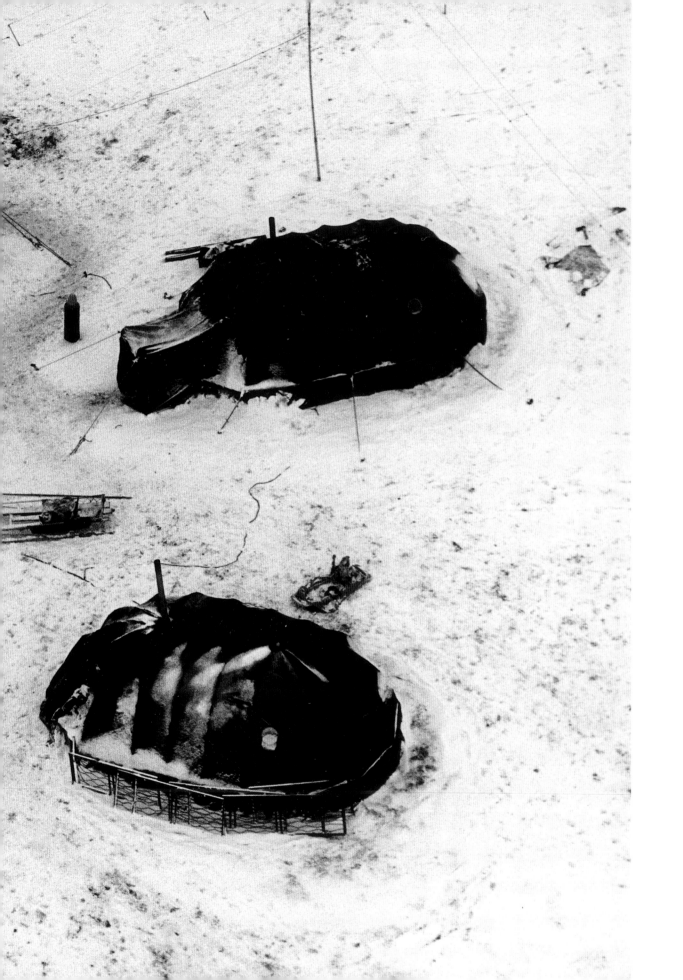

◁ An aerial view of the Bolshaya Balarnaya encampment where the Mammuthus expedition was based for several months between 1998 and 1999.

▷▷ At the Khatanga airport, expedition members drag the ice-block containing Jarkov's prehistoric carcass to its frozen-earth cellar.

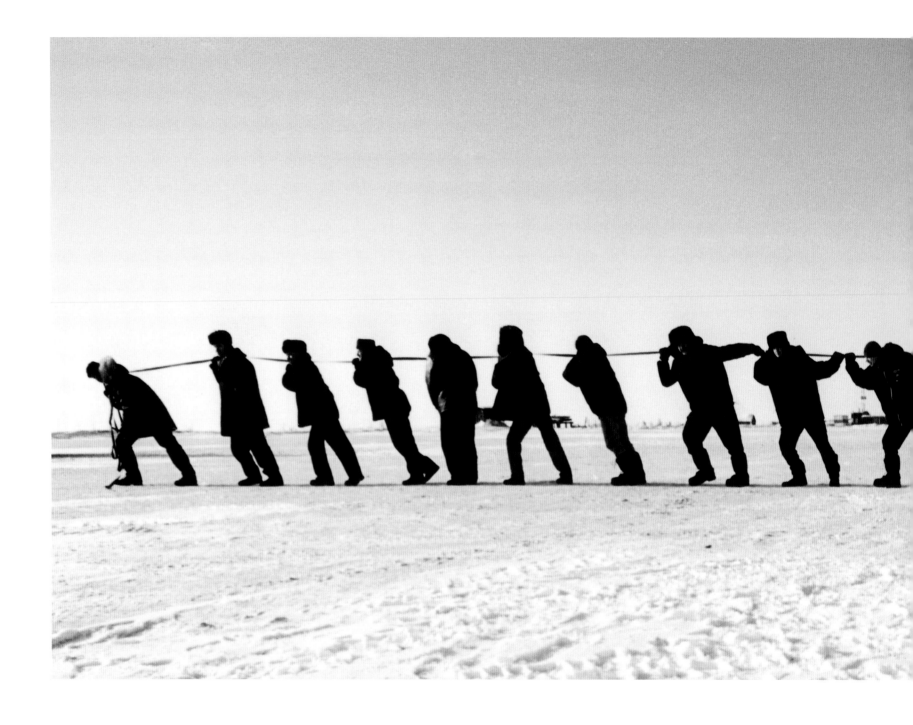

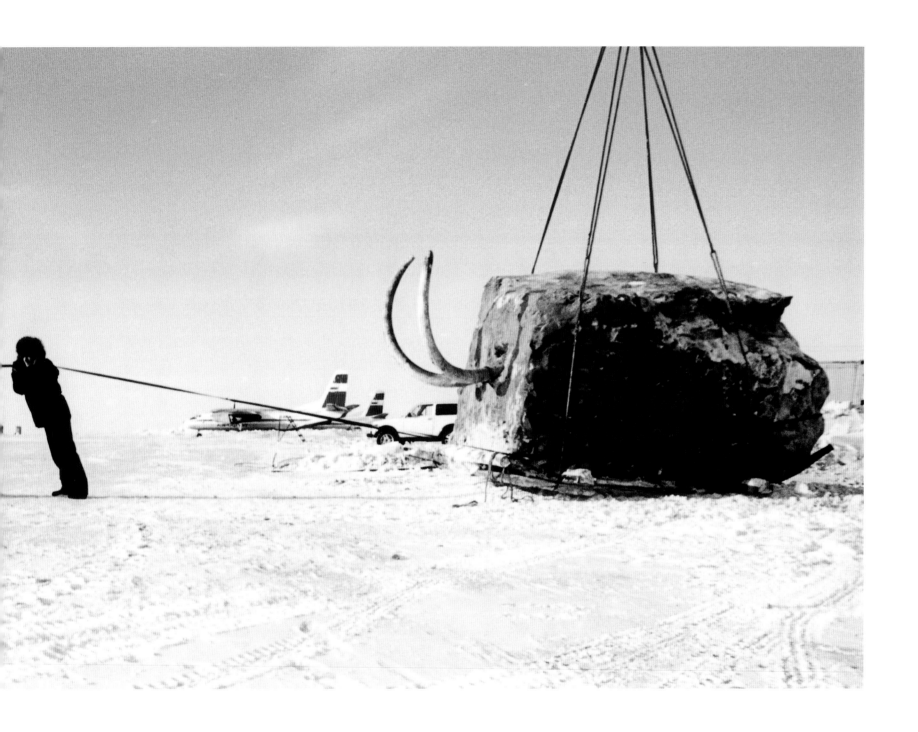

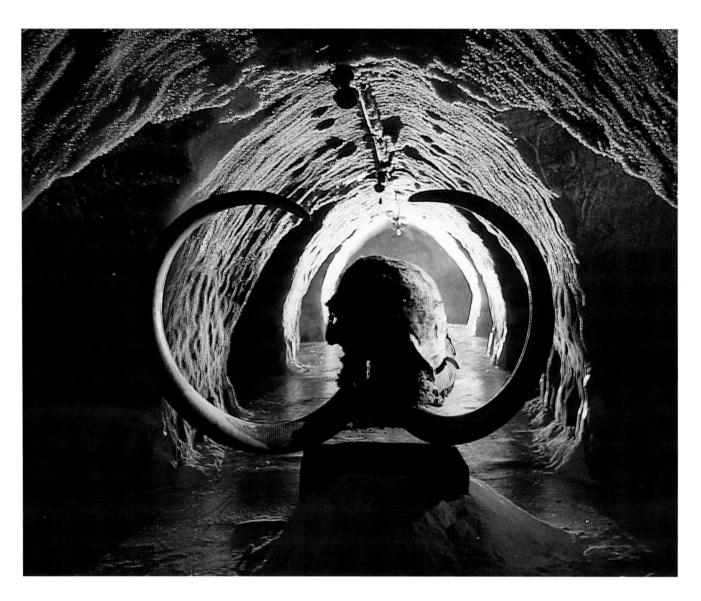

△ ▷ So as not to disturb temperature consistency,
the head of the mammoth Yukagir is stored in a
cellar-laboratory of frozen earth in Yakutsk for
use of the international scientific community.

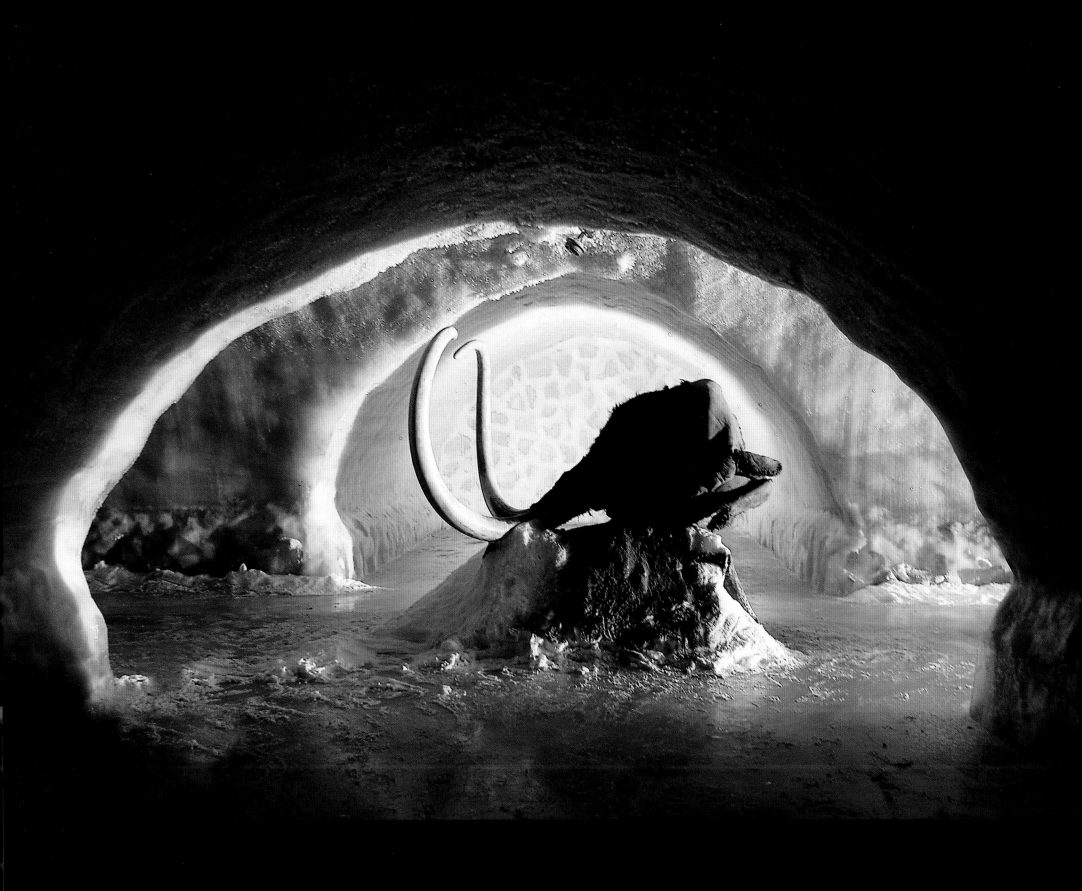

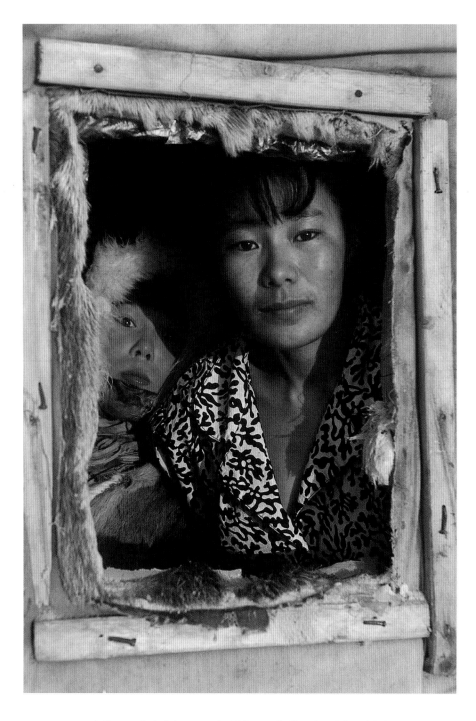

△ Olga, an ethnic Dolgan nomad, with her son Kostia at the window of their *balok,* a small mobile home mounted on a sled.

▷ In the Taimyr peninsula of northern Siberia, the Dolgan nomads migrate with their livestock and homes in search of fresh pastures. Their *baloks* are hauled over the snowfields by teams of reindeer.

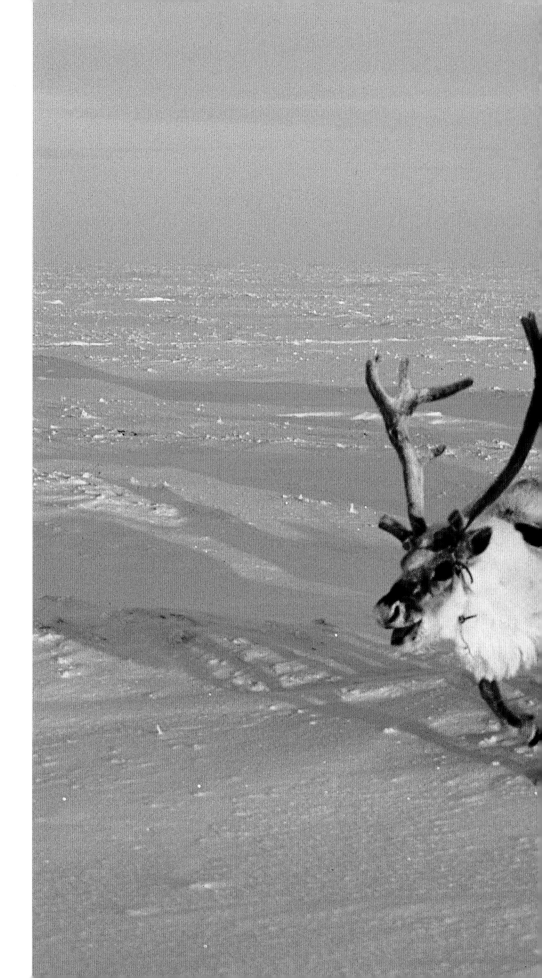

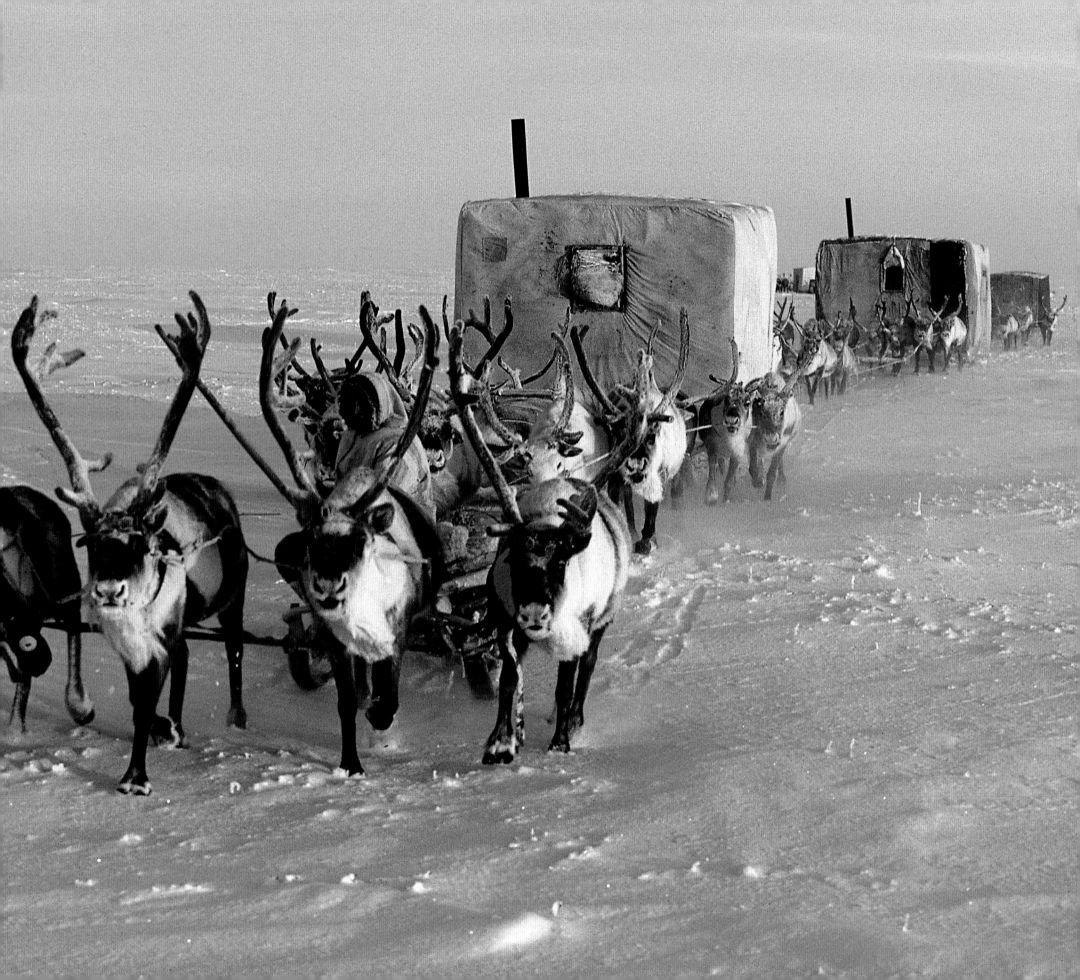

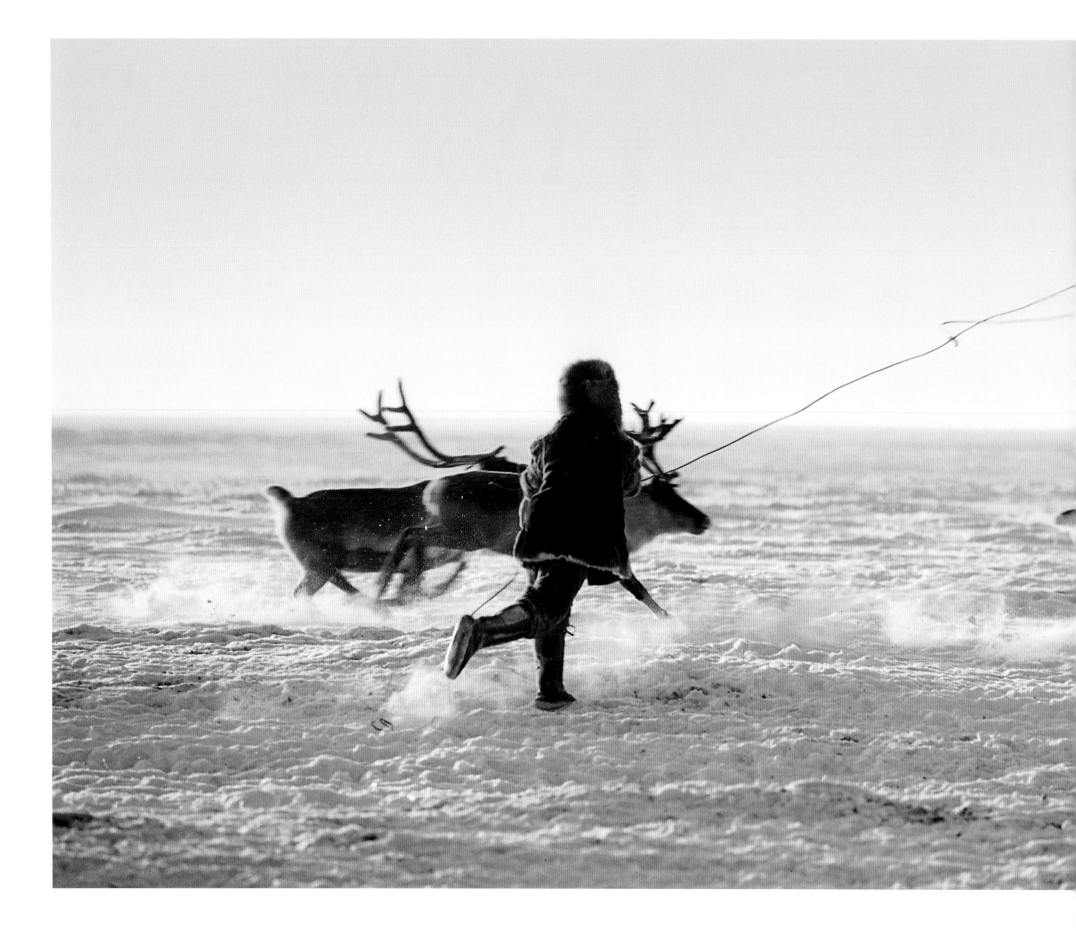

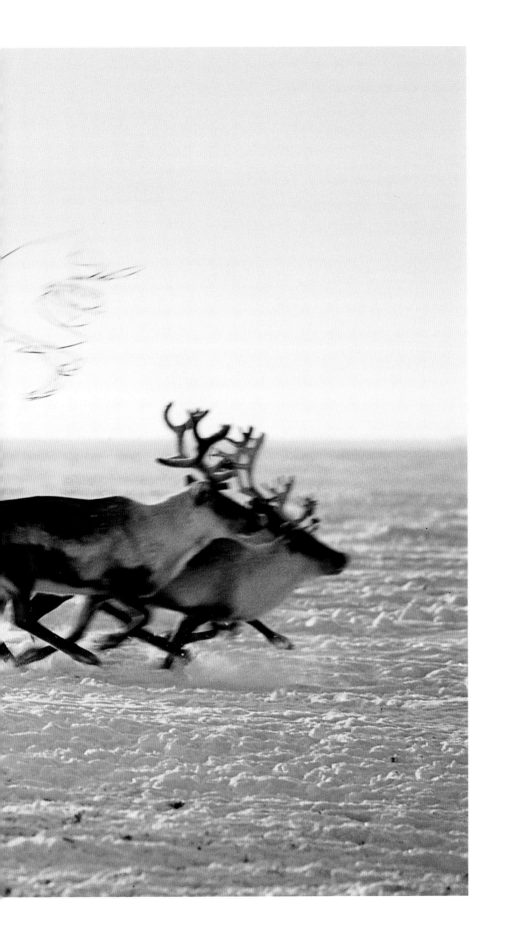
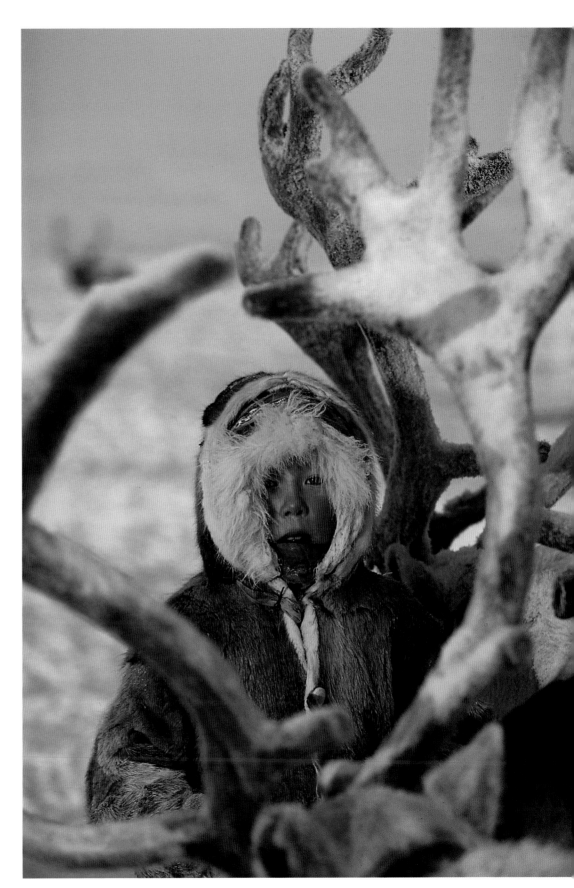

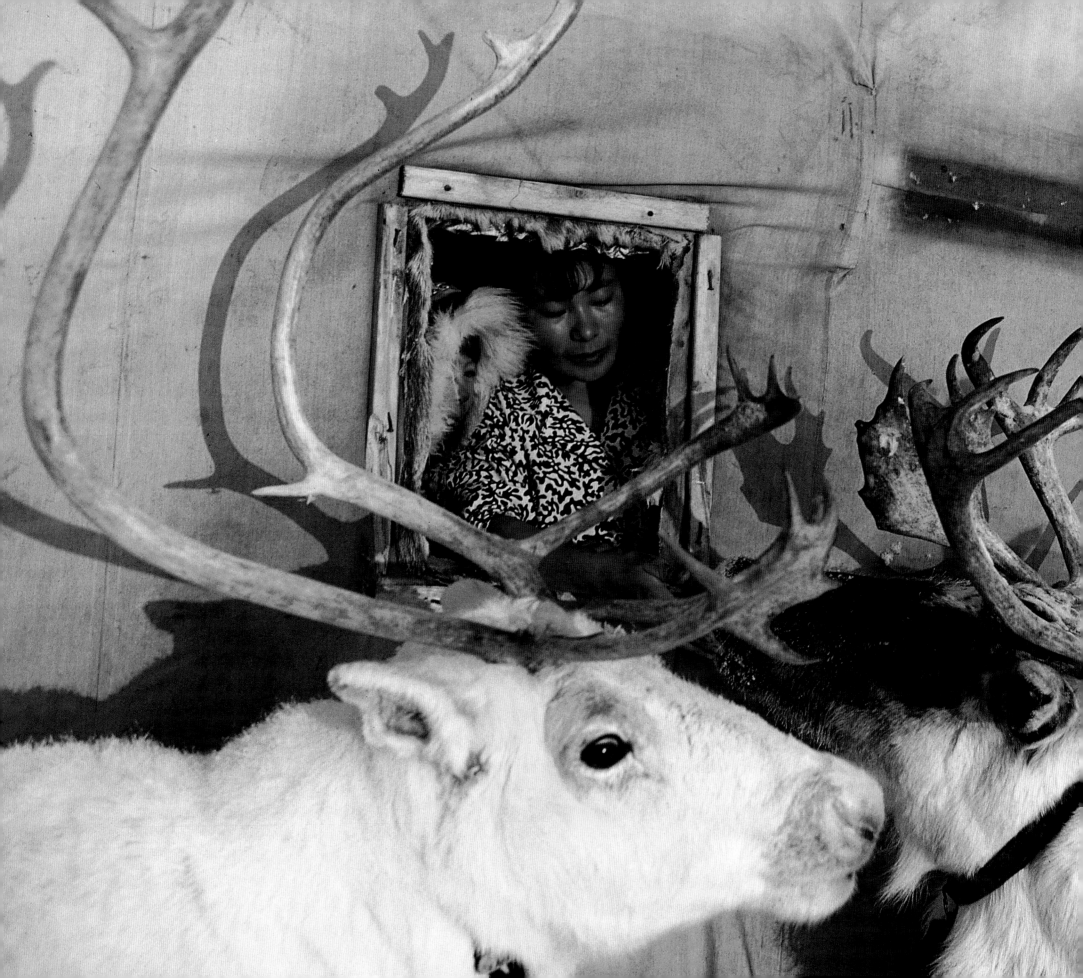

◁◁ Kostia, a little Dolgan boy, lassoes a reindeer, which will later be hitched to the caravan for the journey of migration.

◁ Olga at her window.

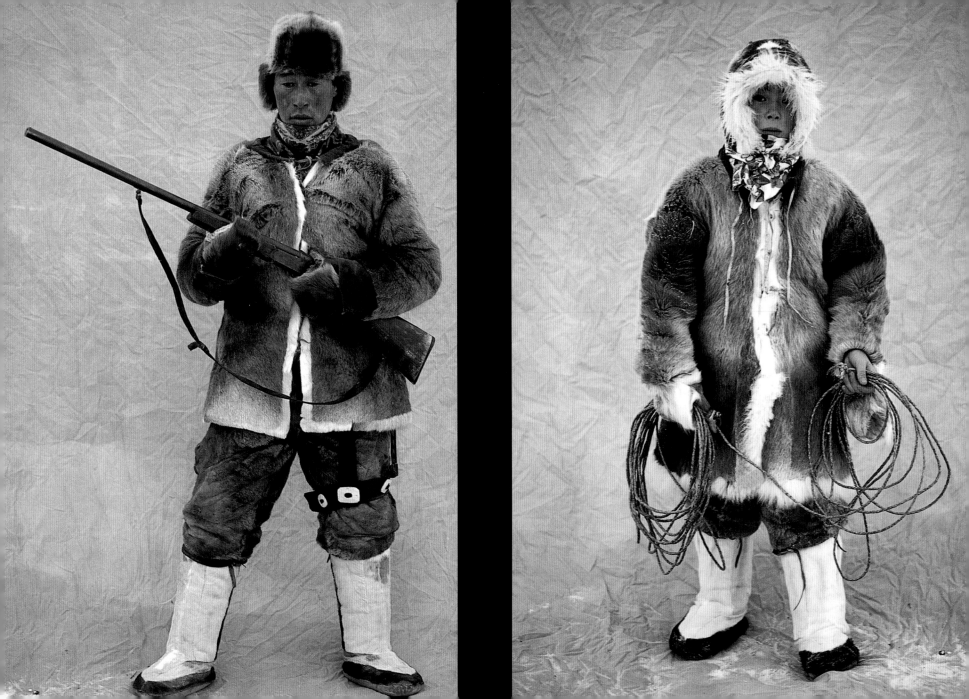

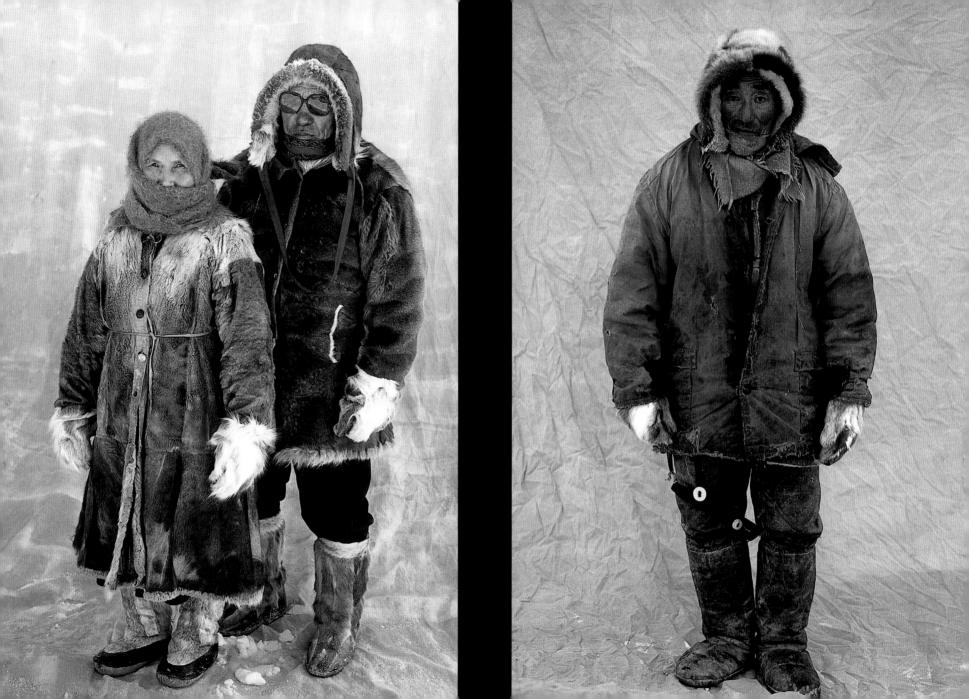

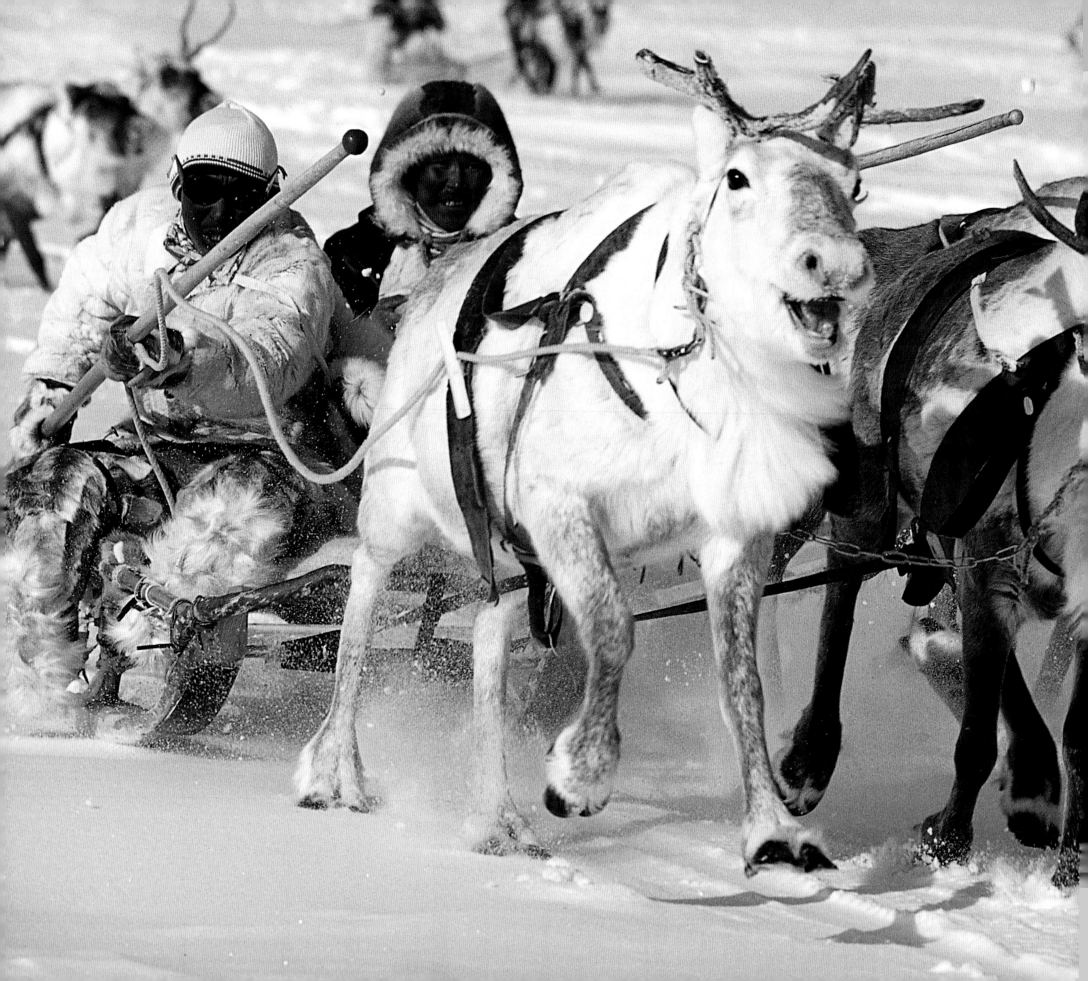

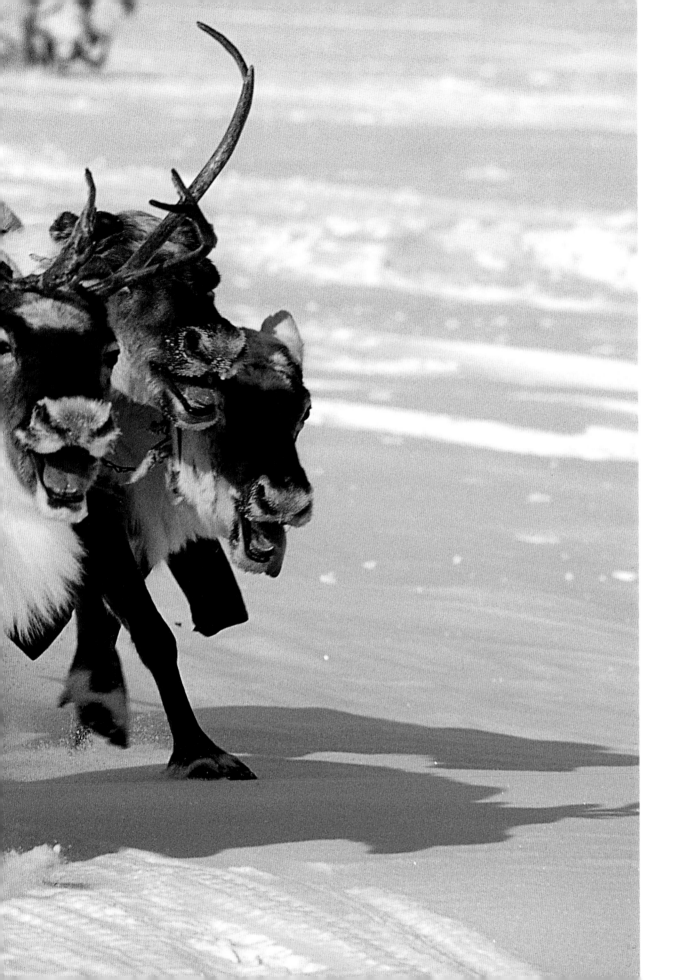

◁◁ Portraits of Dolgan nomads in their everyday reindeer-skin clothing.

◁ Dolgan Alexandre Simarov places first in the Popigay race, an extraordinary event at which all the best reindeer teams in the Taimyr compete.

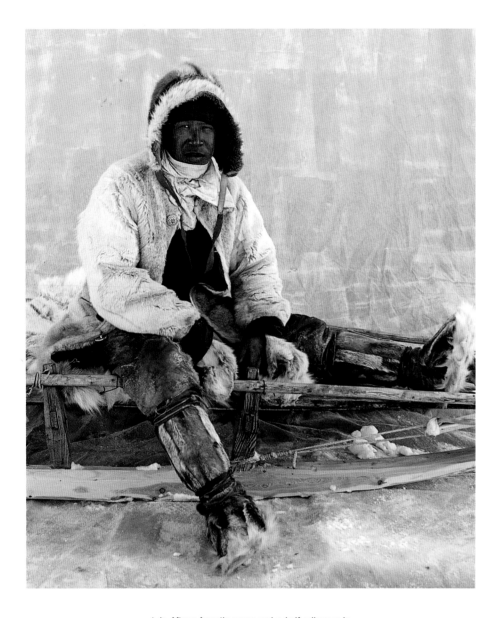

△ ▷ After a frenetic seven-and-a-half-mile race in temperatures of −26°F, men and reindeer need to catch their breath and recover their strength.

▷▷ During the migration season, the Dolgan people move their livestock—between three and five hundred head of reindeer per family—every ten or fifteen days. They are constantly in search of new pastures.

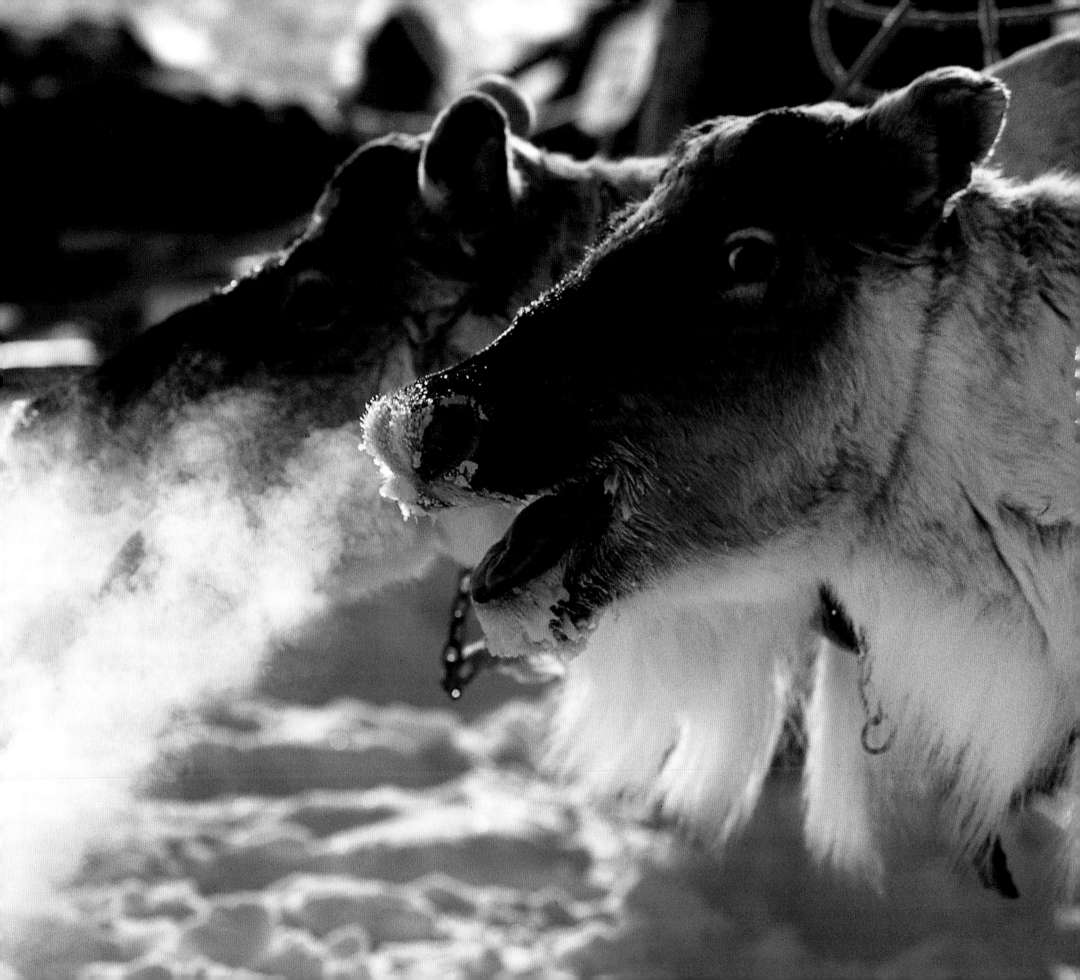

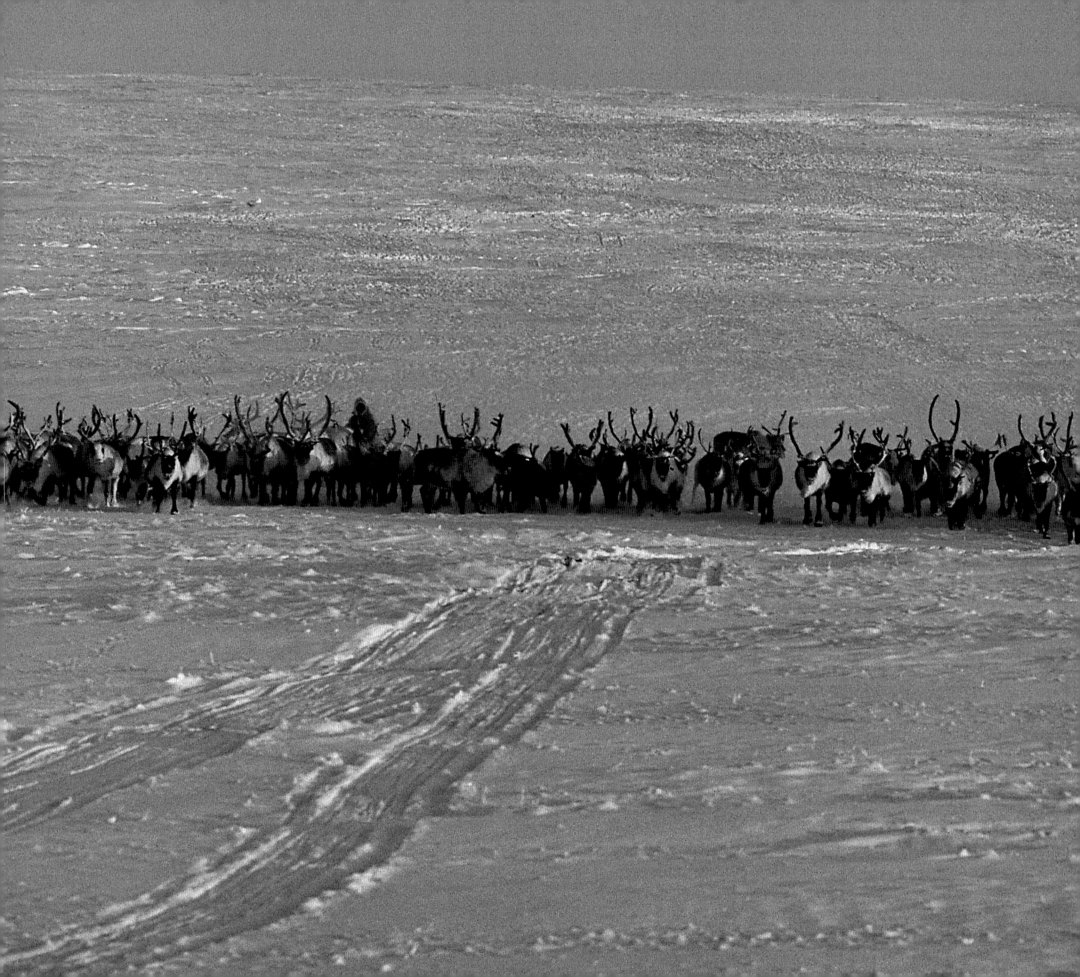

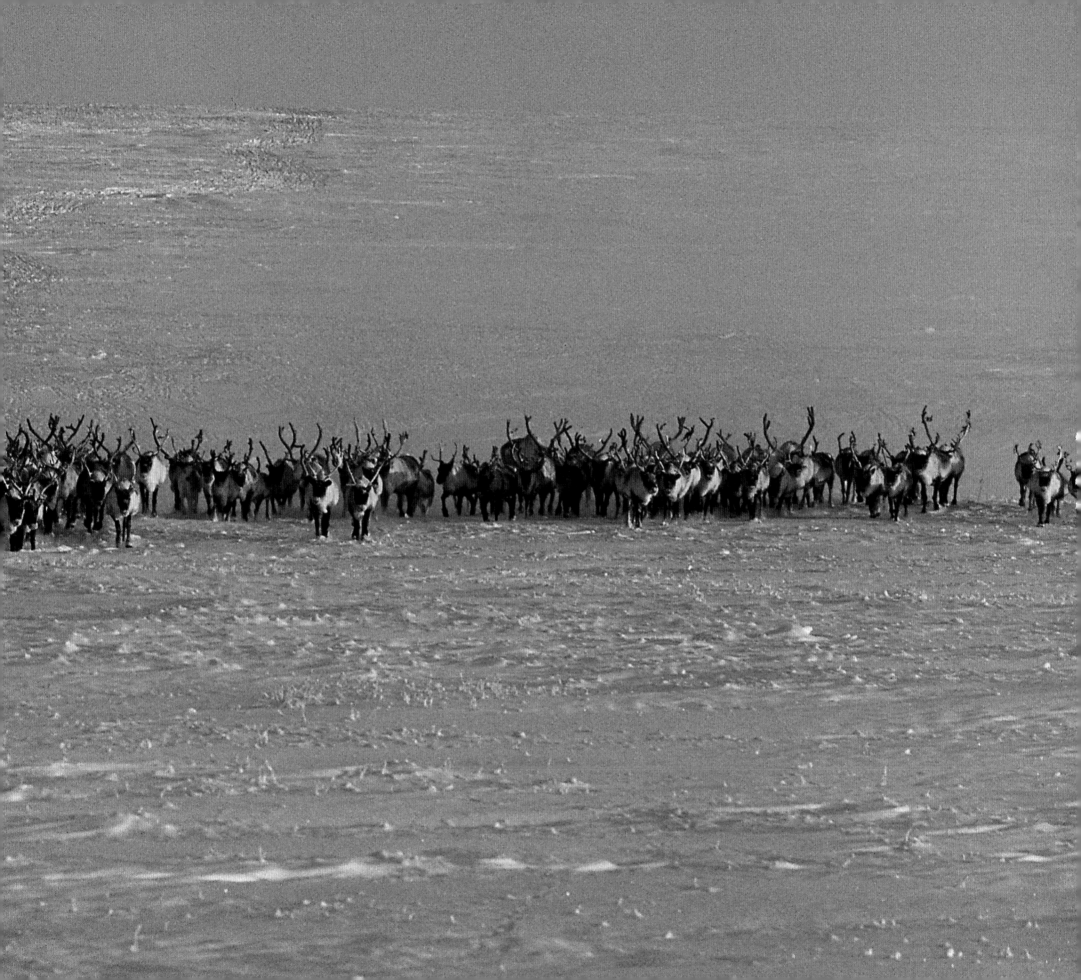

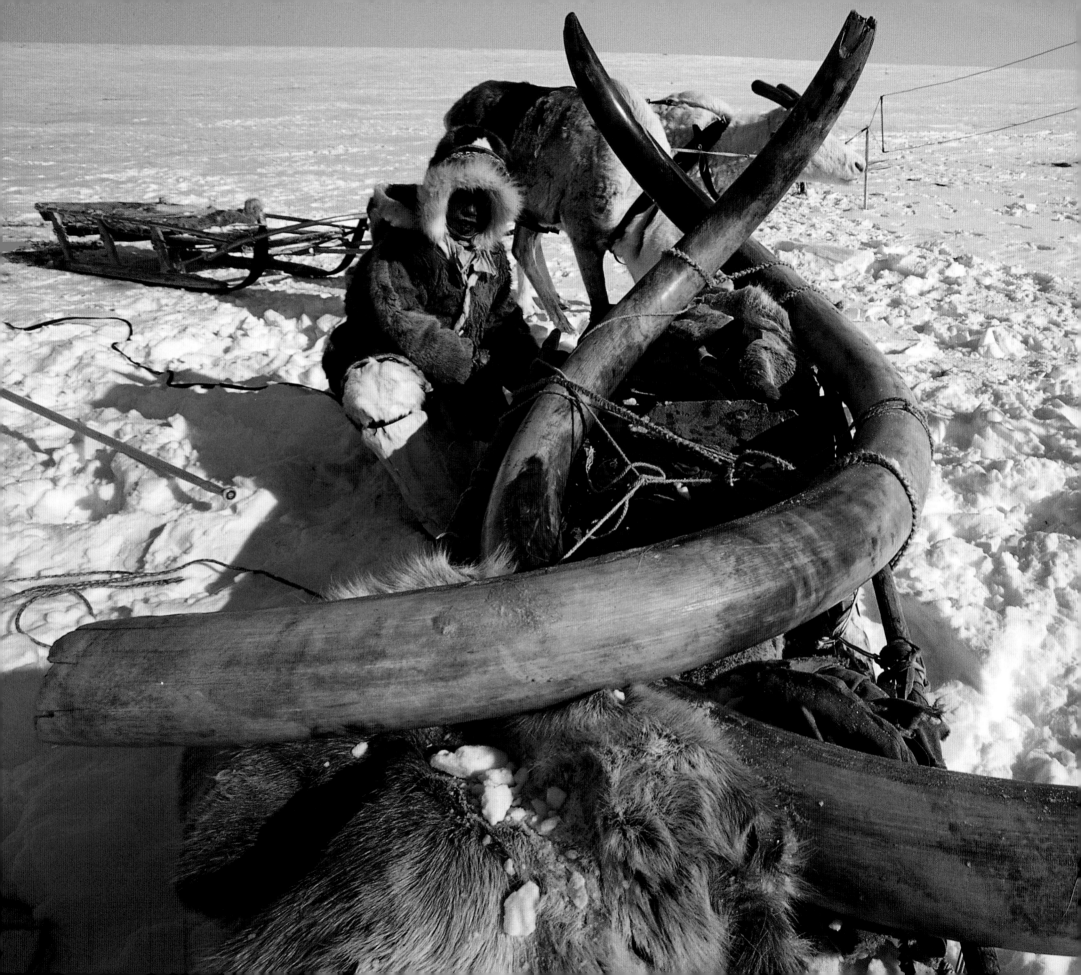

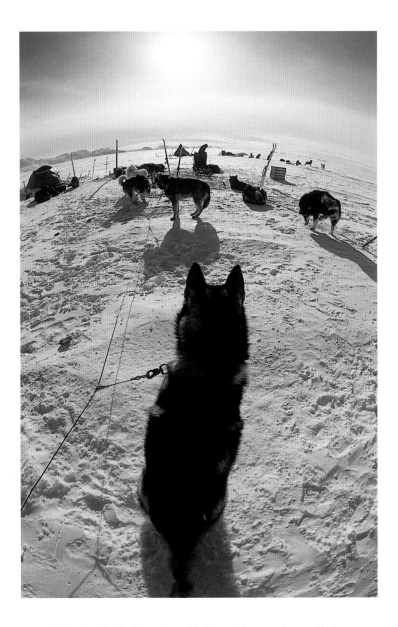

△ Throughout the Arctic, man's most indispensable companions are his dogs, which pull his sled and alert him to the presence of wolves and bears.

◁ Kostia, a Dolgan boy, in 1998, very proud of the twenty thousand-year-old tusks from the mammoth found by his parents. The mammoth will later be known to science by their family name: Jarkov.

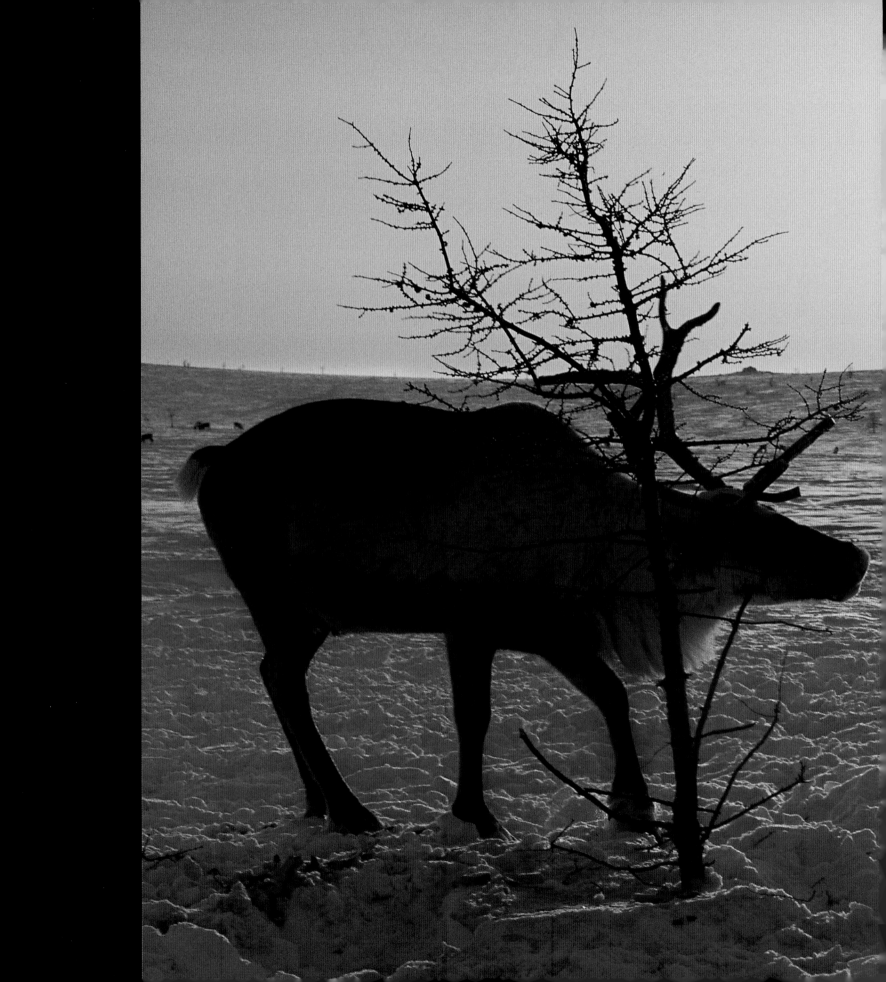

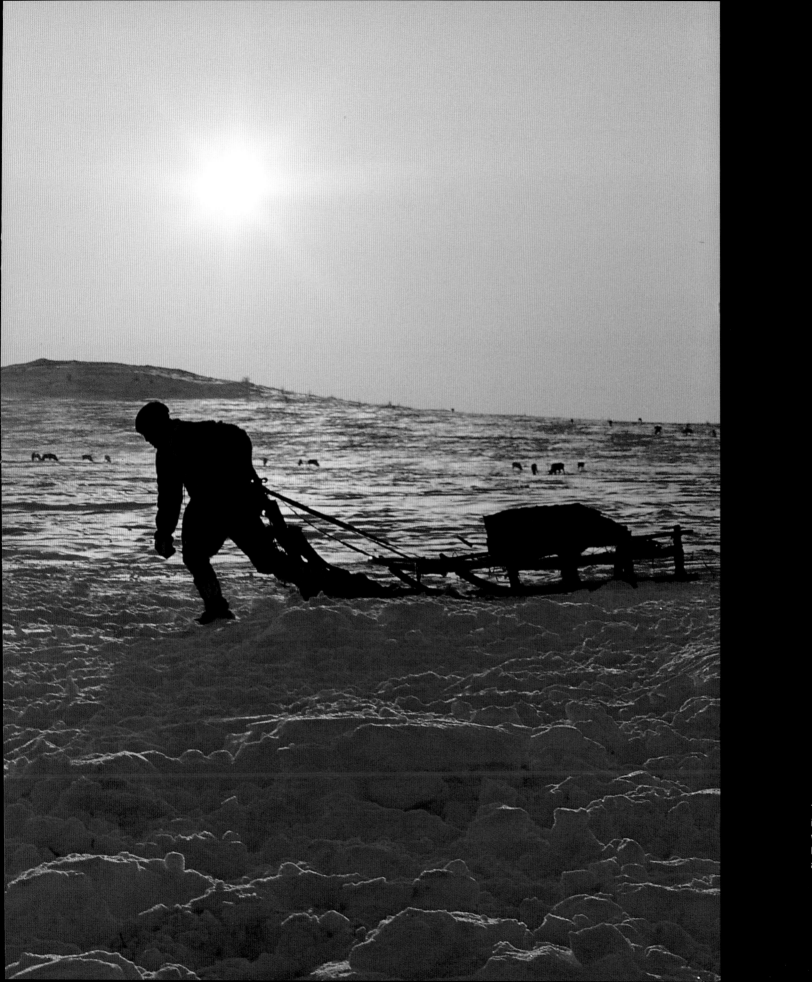

This small pine is the only tree that can survive in the northern tundra. The small amount of vegetation found there grows very slowly; lichen, which is the staple diet of reindeer, advances only one centimeter every ten years.

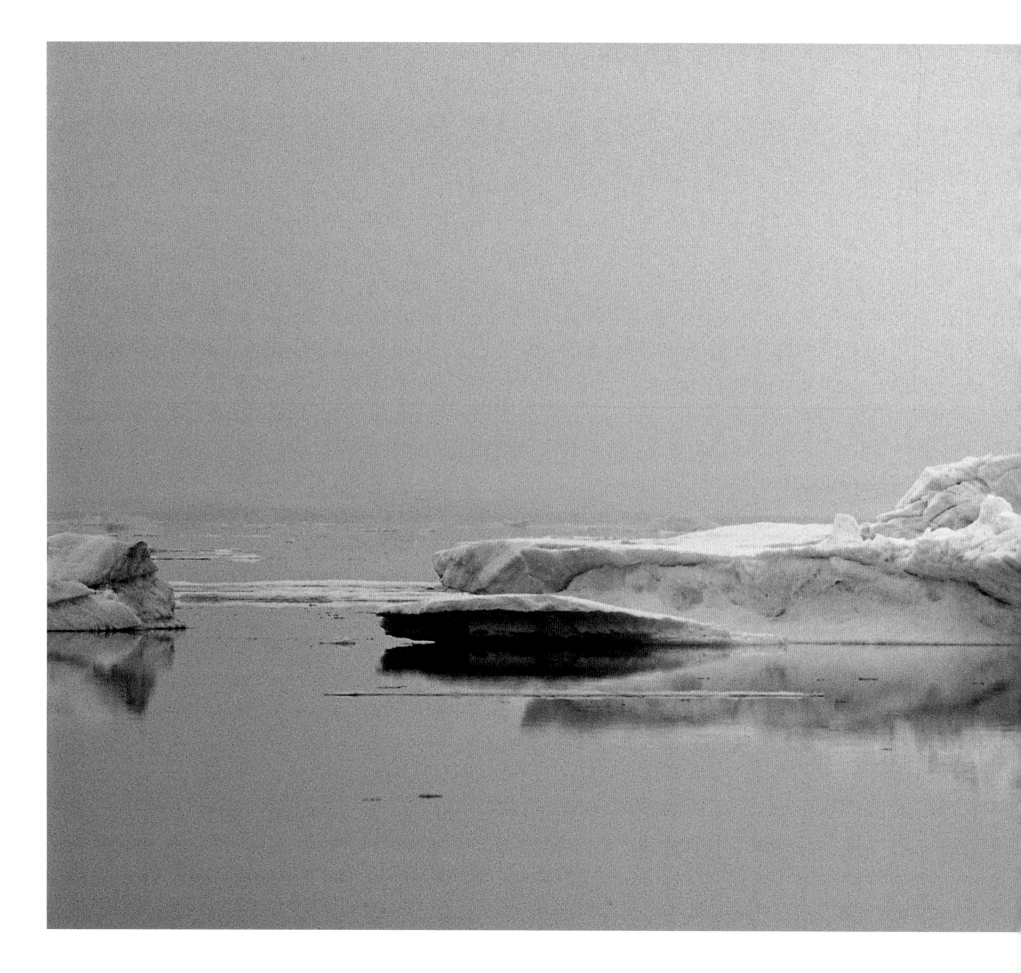

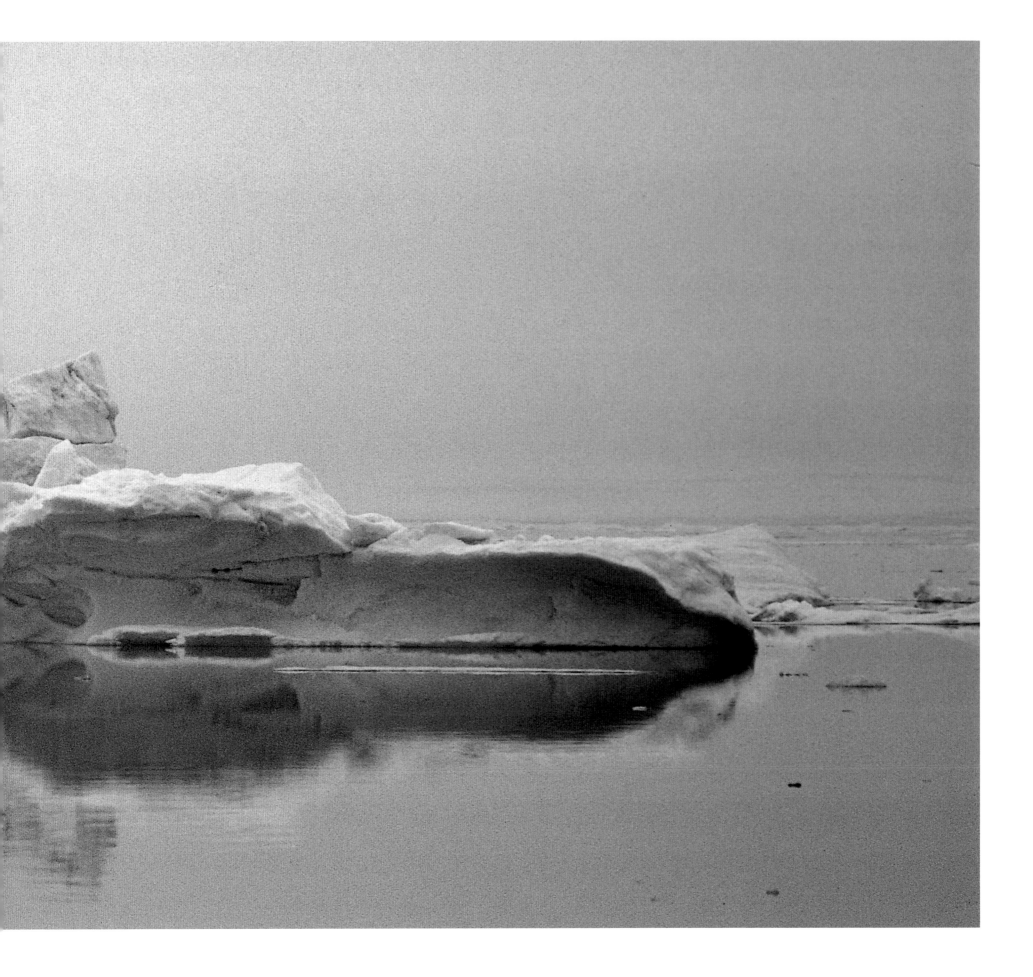

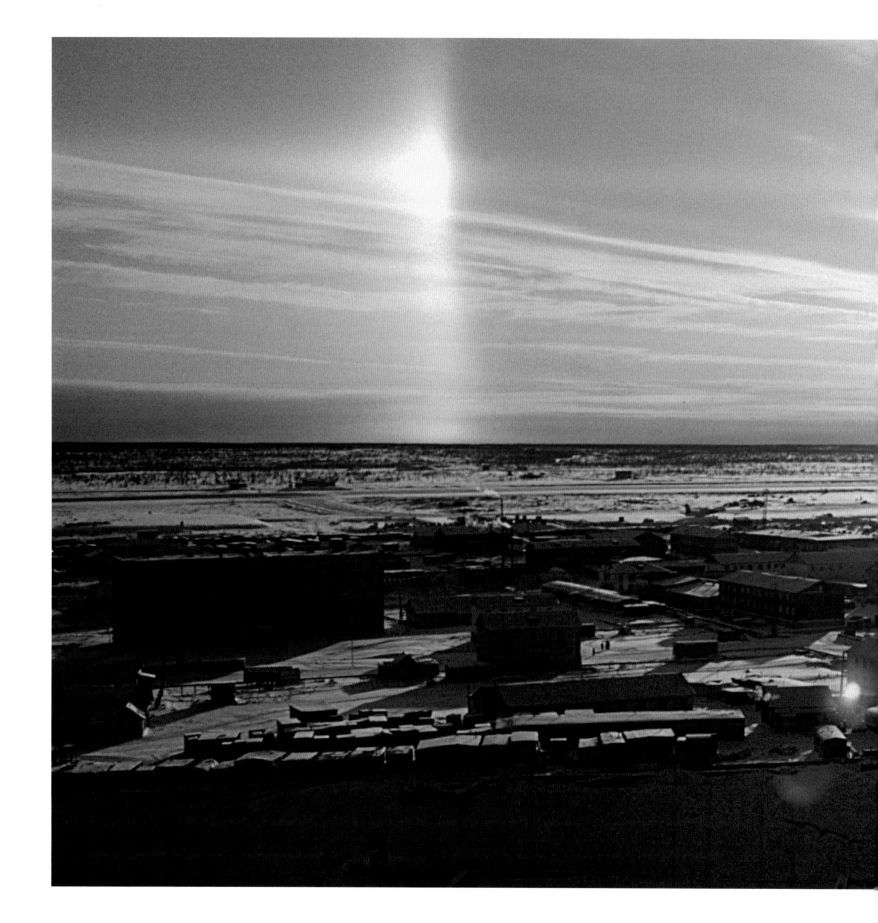

◁◁ In the calm, misty Arctic summer, an ice floe drifts gently through a lead of open water.

▷ Khatanga in Northern Siberia, illuminated by "mock suns" or parhelia. These immense light phenomena are invariably vertical and give the bizarre impression that there are many suns. Thus, one may have the illusion of witnessing several sunsets simultaneously.

▷▷ In Scoresby Sound, a fjord east of Greenland, wind and waves work the icebergs into strange shapes.

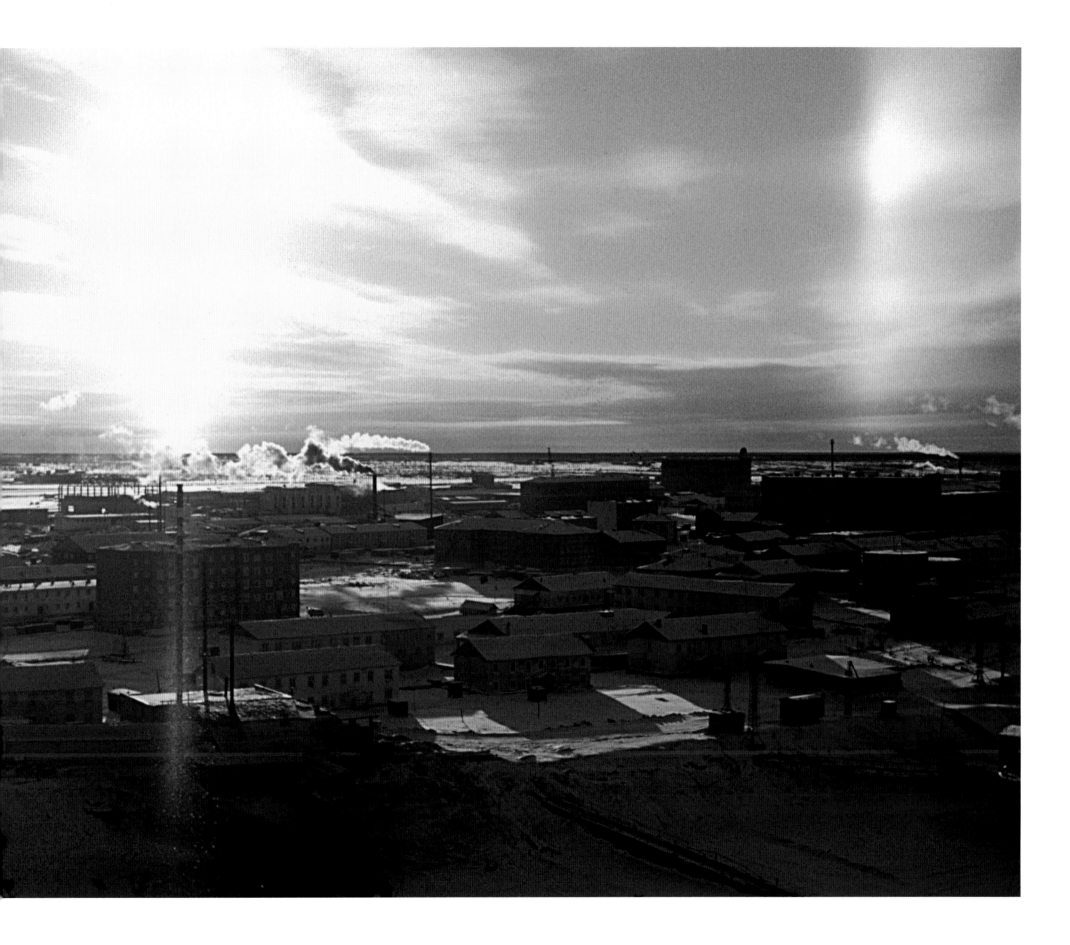

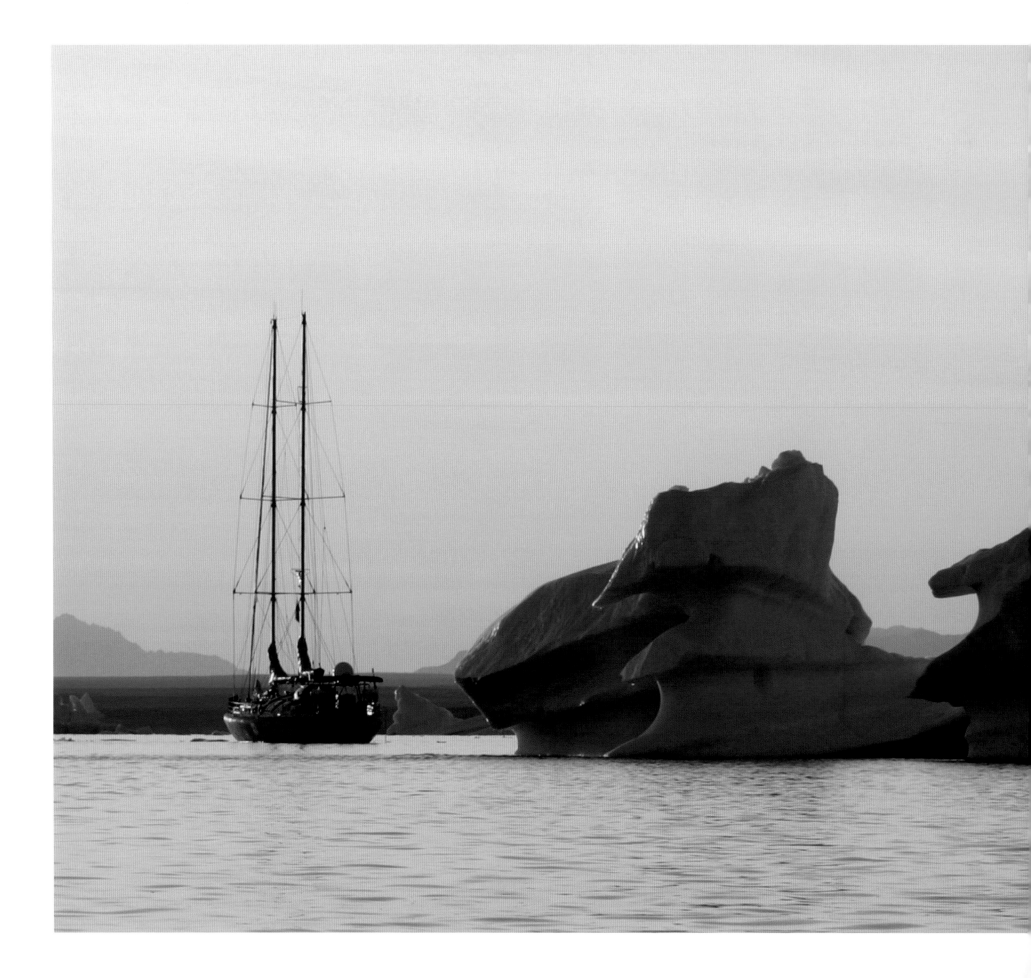

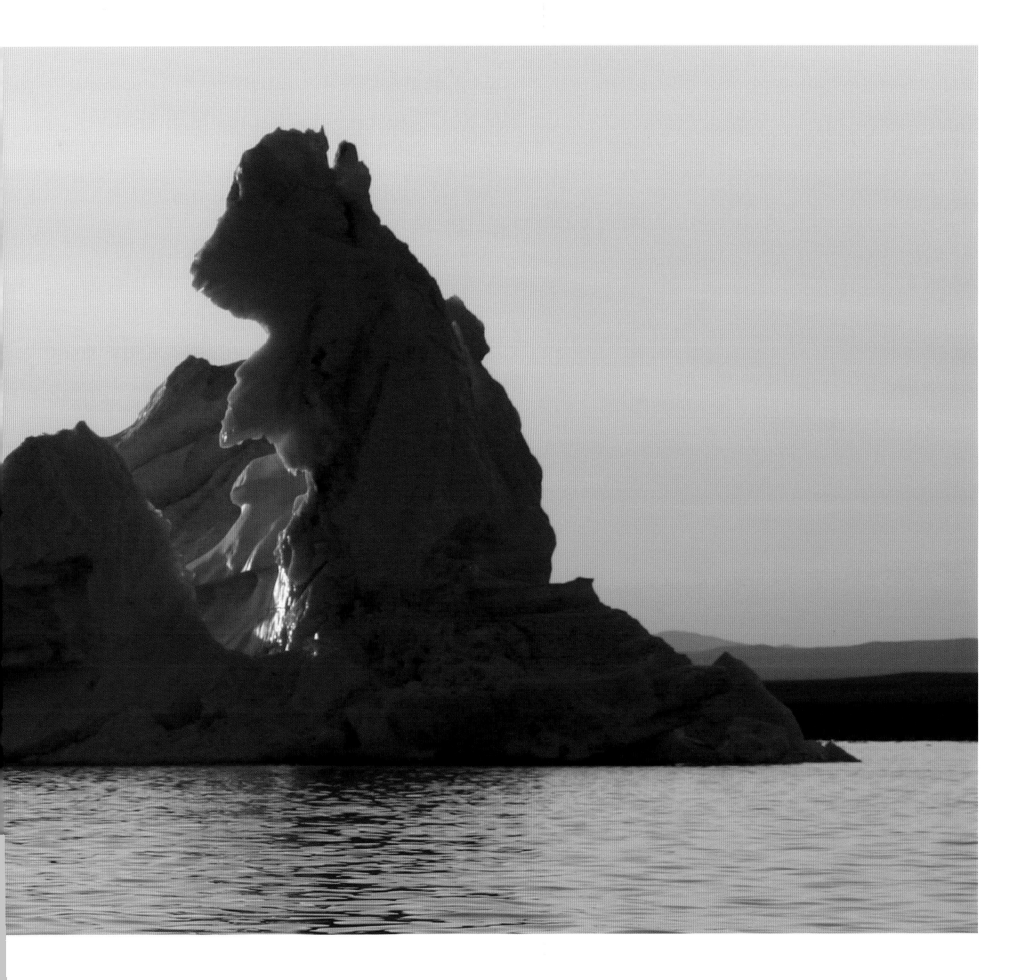

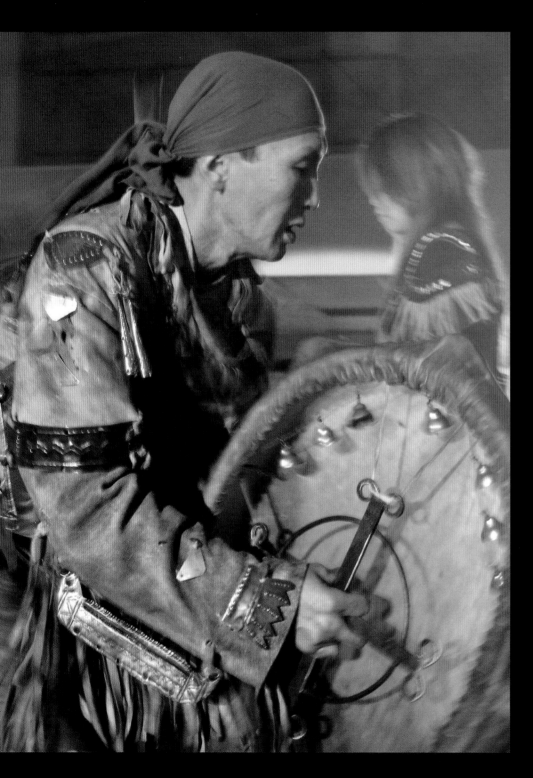

△ In Yakutsk, the shaman still features strongly in the lives of indigenous people. The shaman's drum is an important tool, giving rhythm to the dances and incantations with which he summons the protective spirits of the tundra.

▷ The aurora borealis is the most spectacular light phenomenon observed in the polar regions. On particularly bitter nights, its spiraling colors blaze across the firmament in a planetary fireworks display.

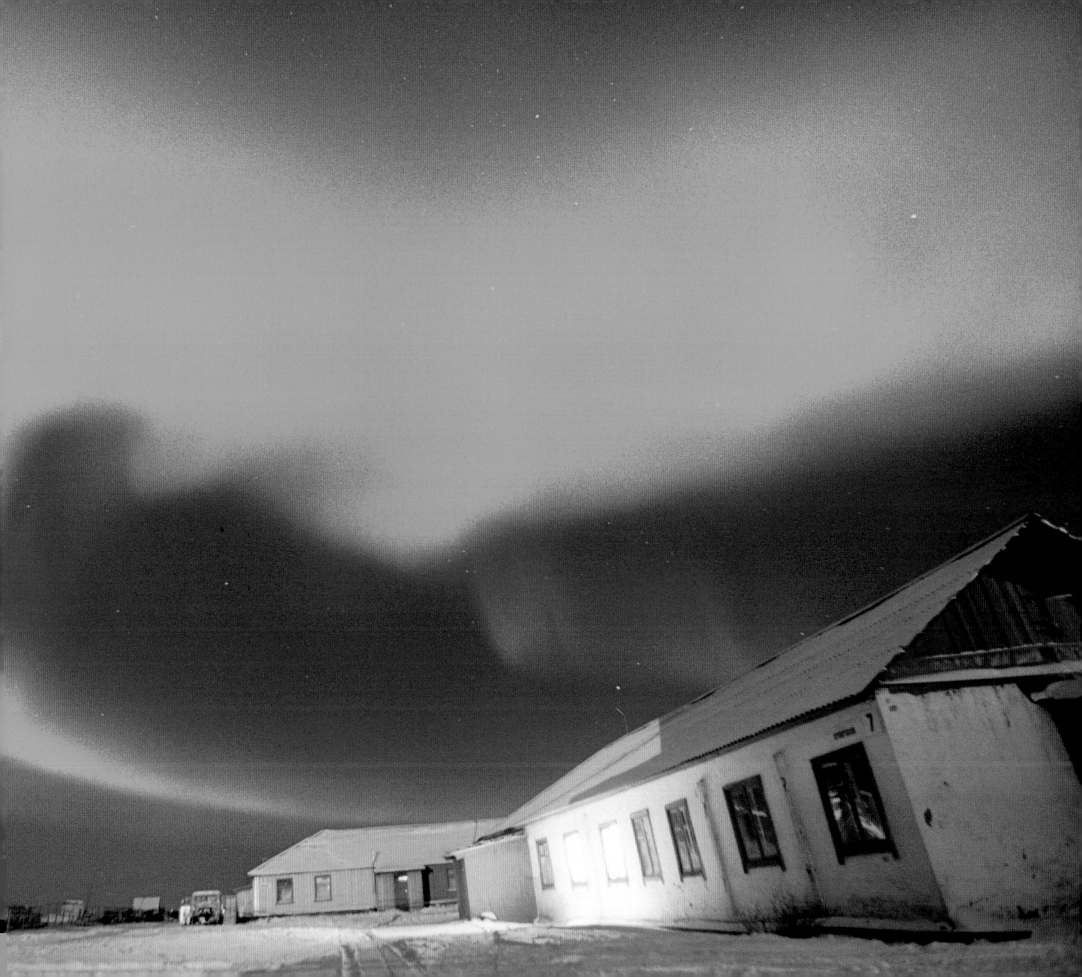

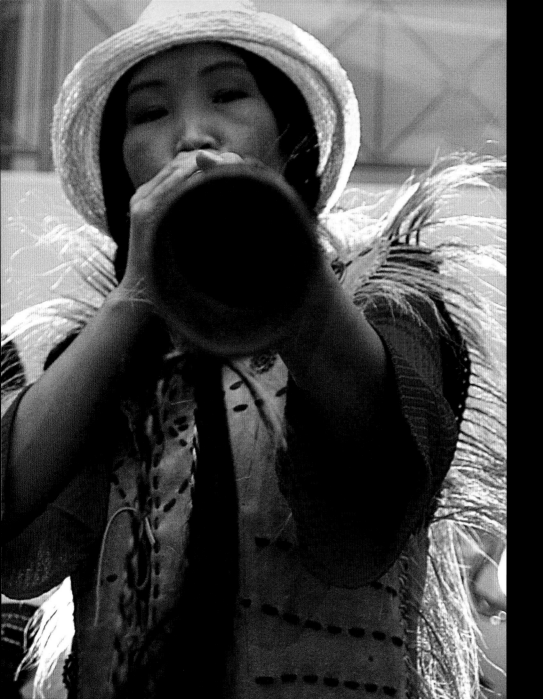

◁ ▷▷ Every expedition to the inhospitable regions of Siberia must be preceded by a shamanic ceremony to appease the spirits that inhabit the tundra. Music, dances, incantations, and offerings are indispensable accompaniments to the process.

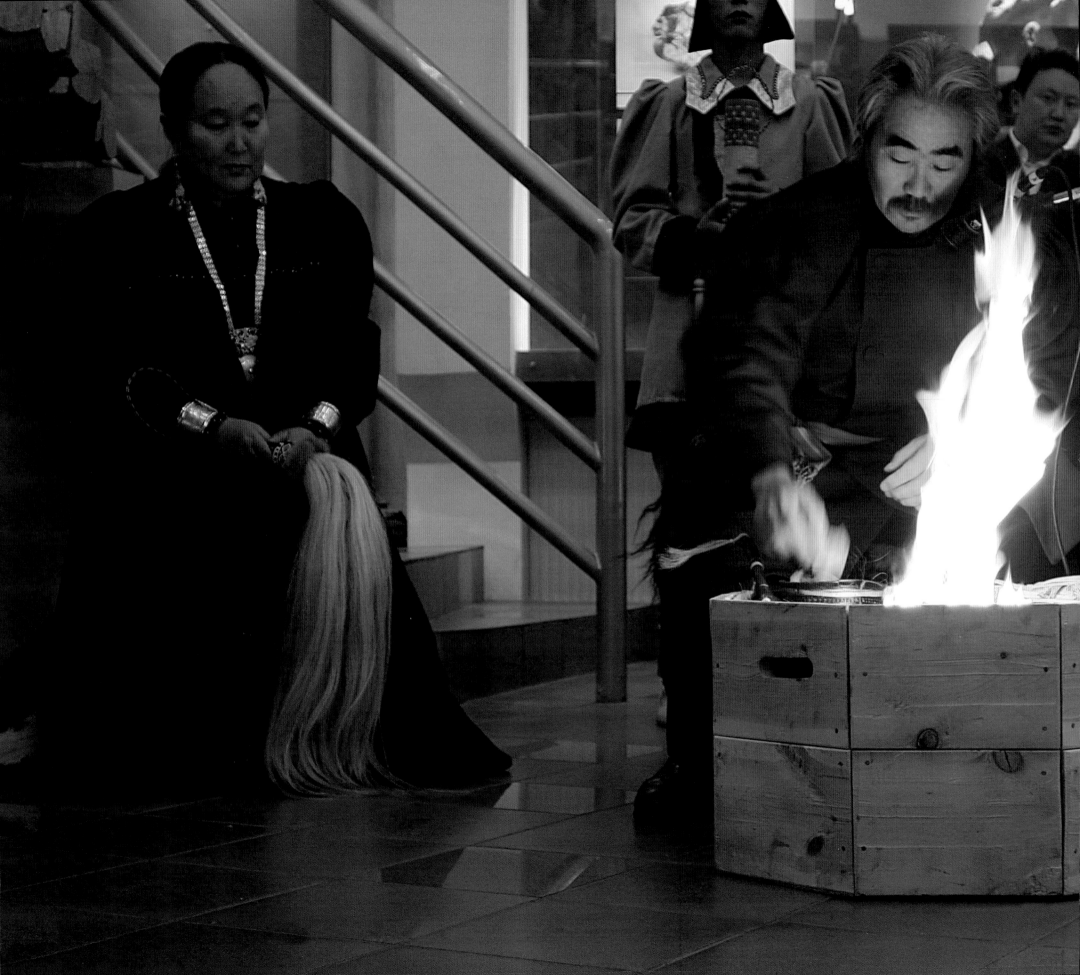

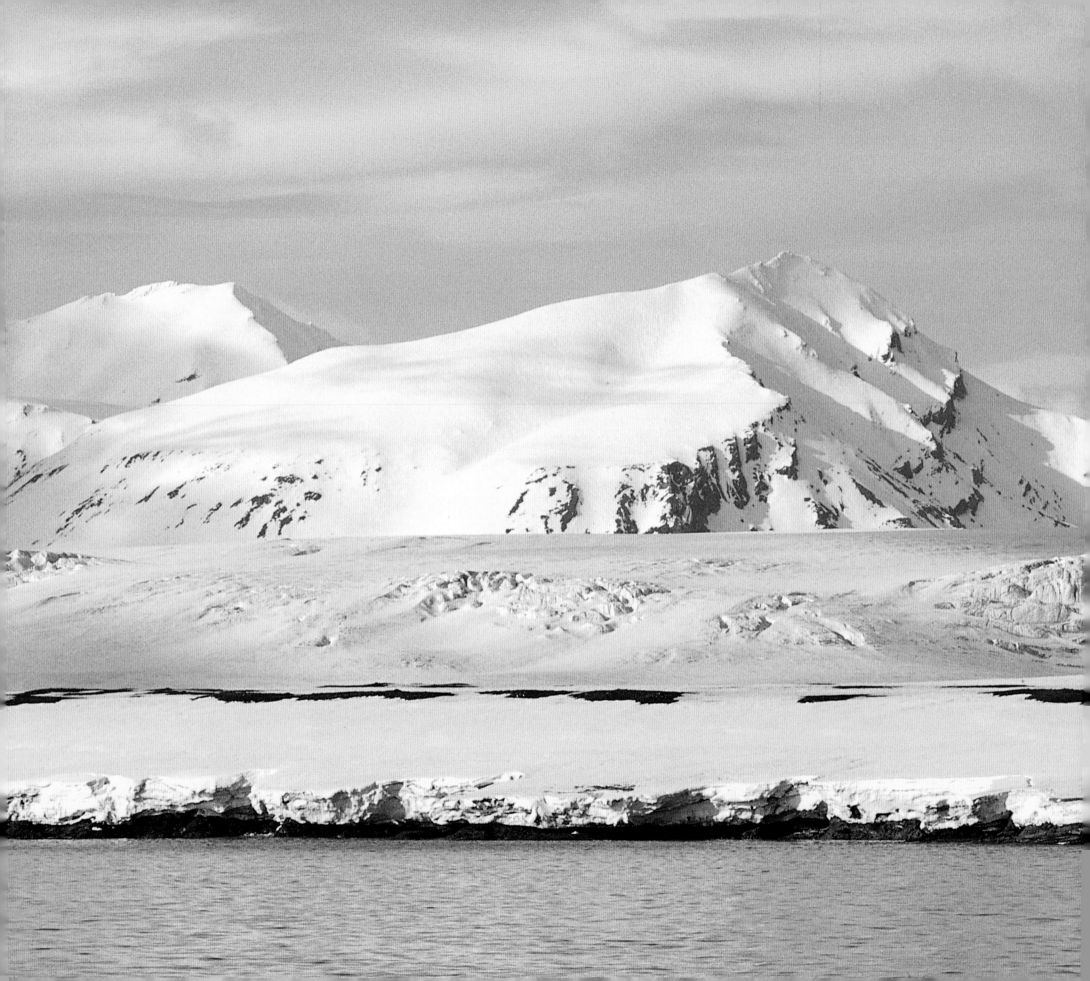

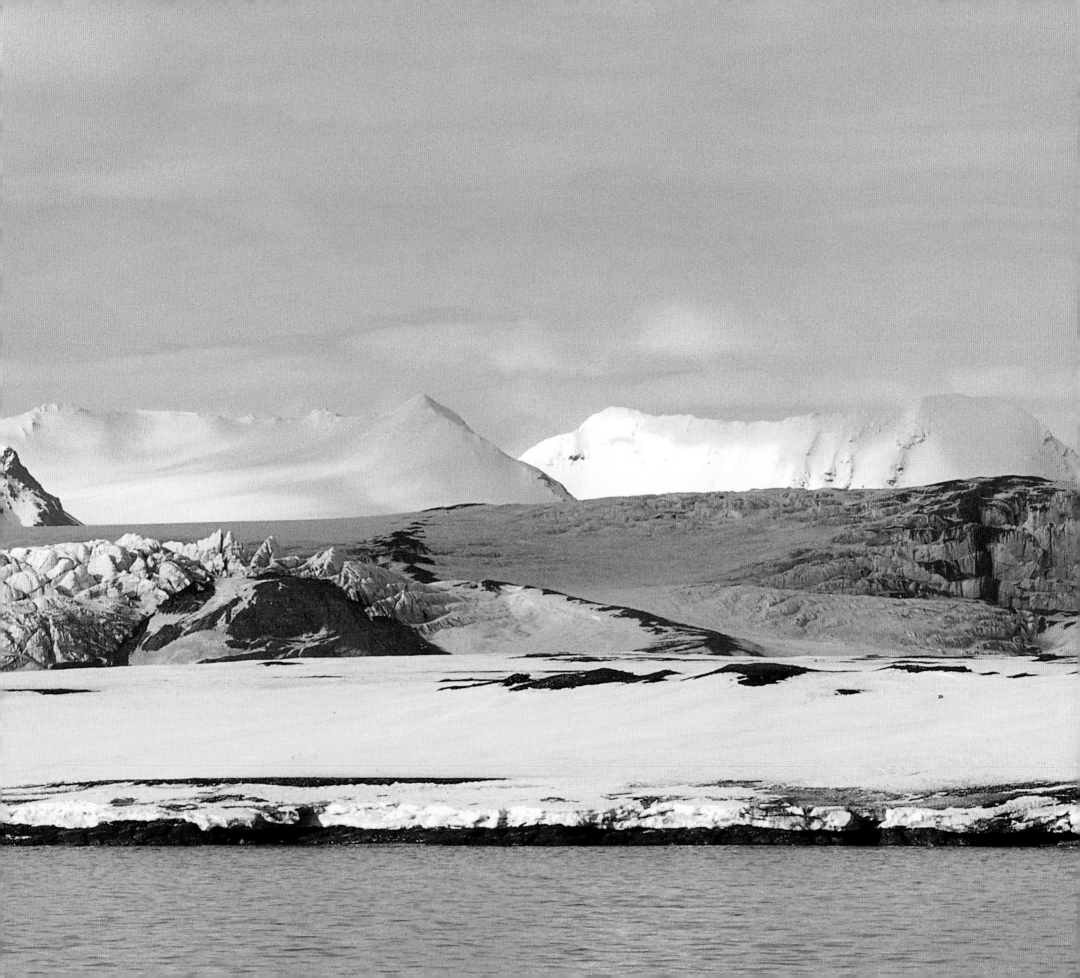

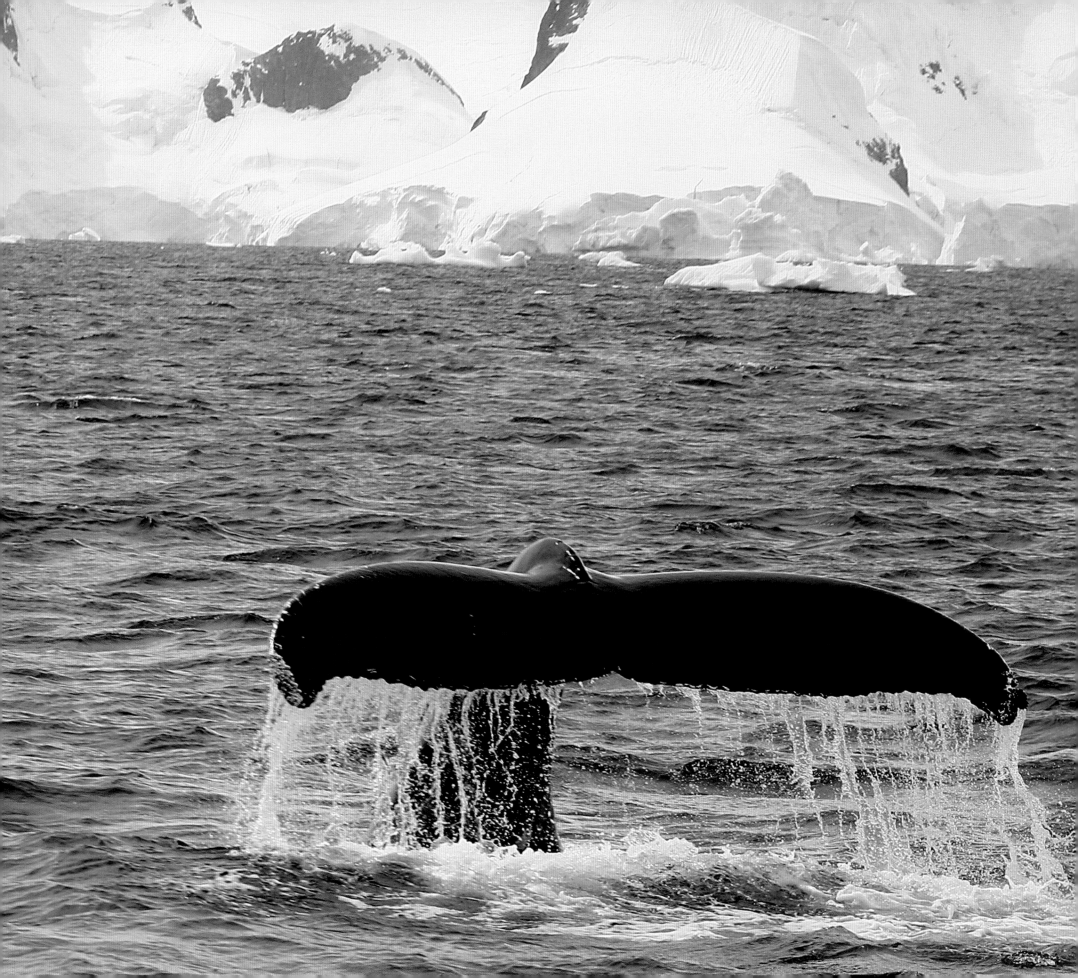

◁◁ A glacier is a frozen river moving slowly in the direction of the sea. In Greenland certain glaciers flow at a speed of sixty-six feet per day, depositing vast icebergs at their estuaries.

◁ Humpback whales inhabit cold-water zones, where they can find plenty of food. From the north to the south of Greenland they are a familiar sight, cruising inshore and around glacier estuaries.

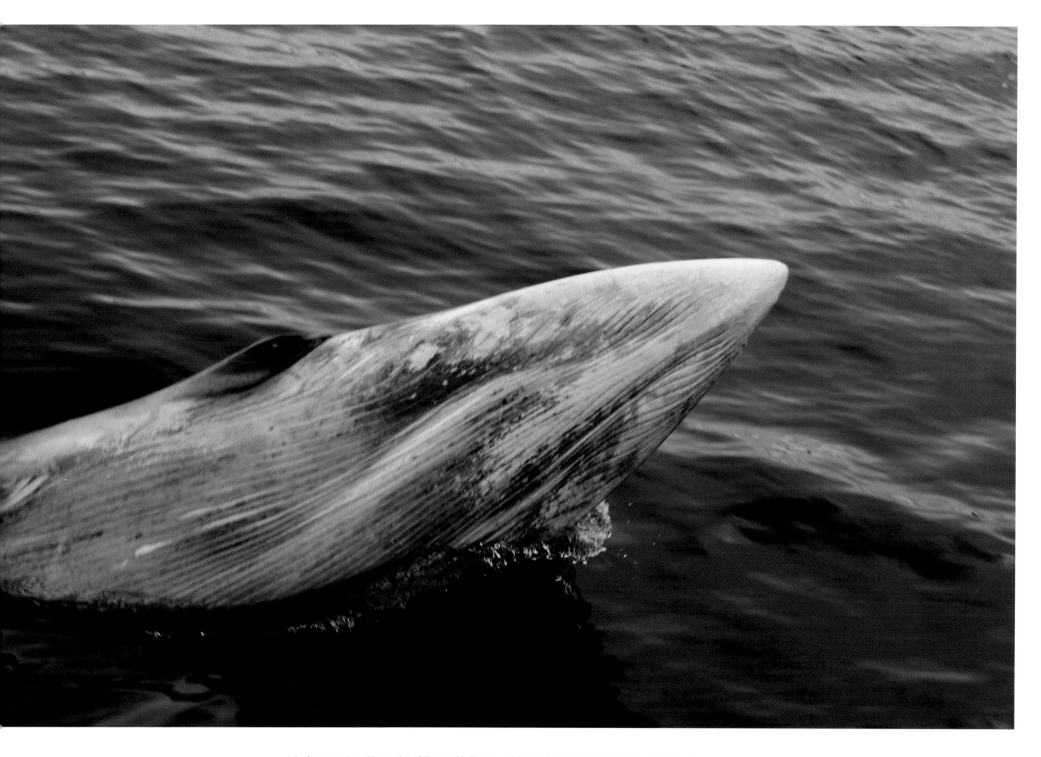

△ ▷ An encounter with a native of these cold climes, a minke whale (lesser rorqual) twenty to thirty meters long and about eight tons. The rorqual feeds on krill, a kind of shrimp, and small fish.

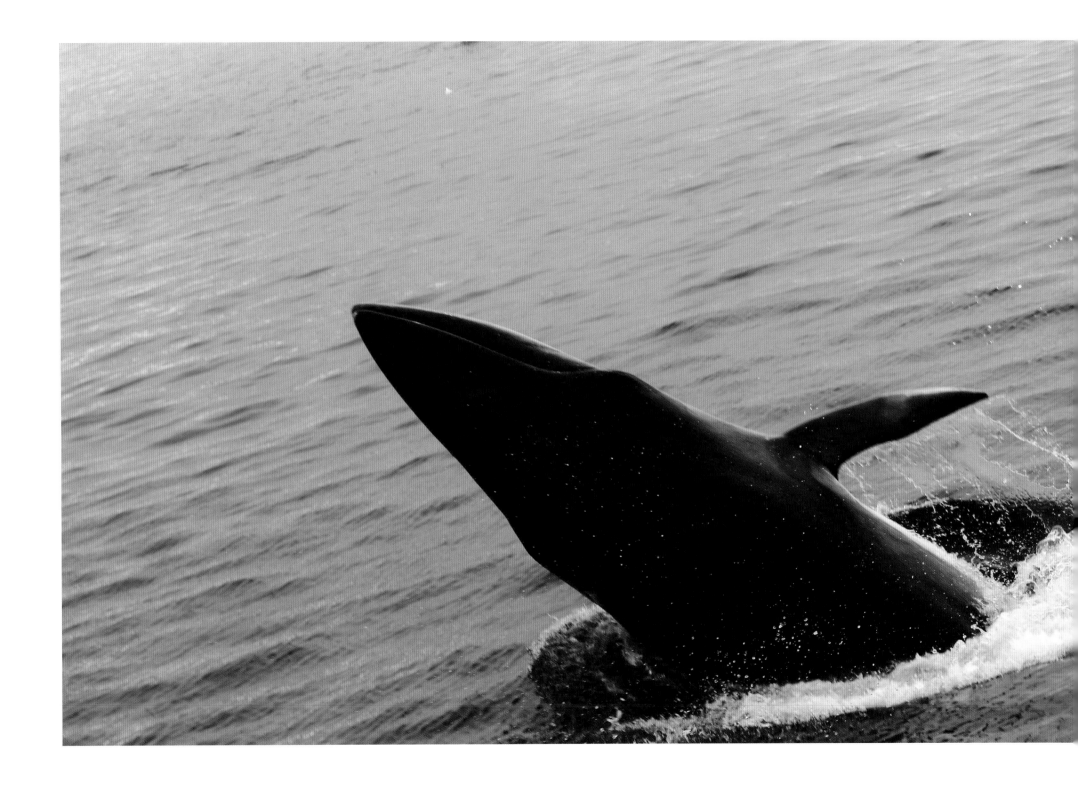

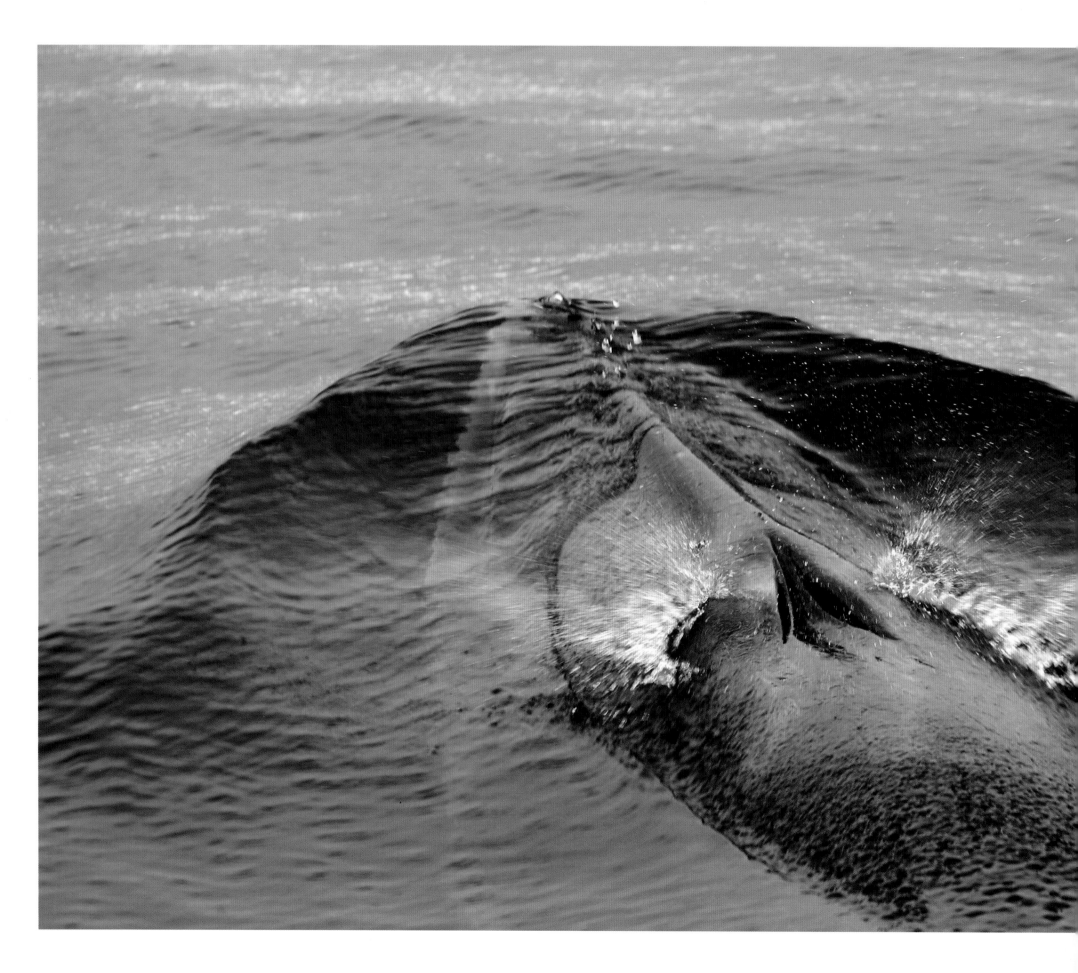

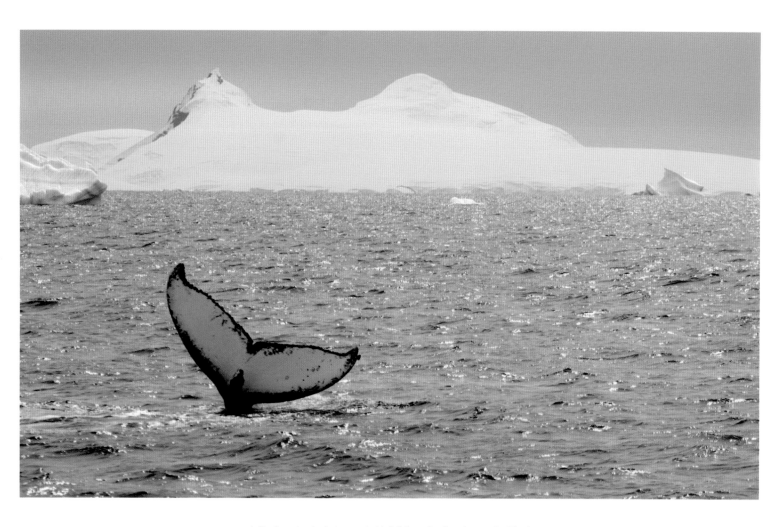

△ The humpback whale upends his tail fin as he dives in search of food.
He can remain beneath the surface for nearly two hours and is known to
swim at depths of three thousand feet.

◁ When the rorqual surfaces he raises his narrow, elongated head and
slices through the water like a submarine, blowing noisily.

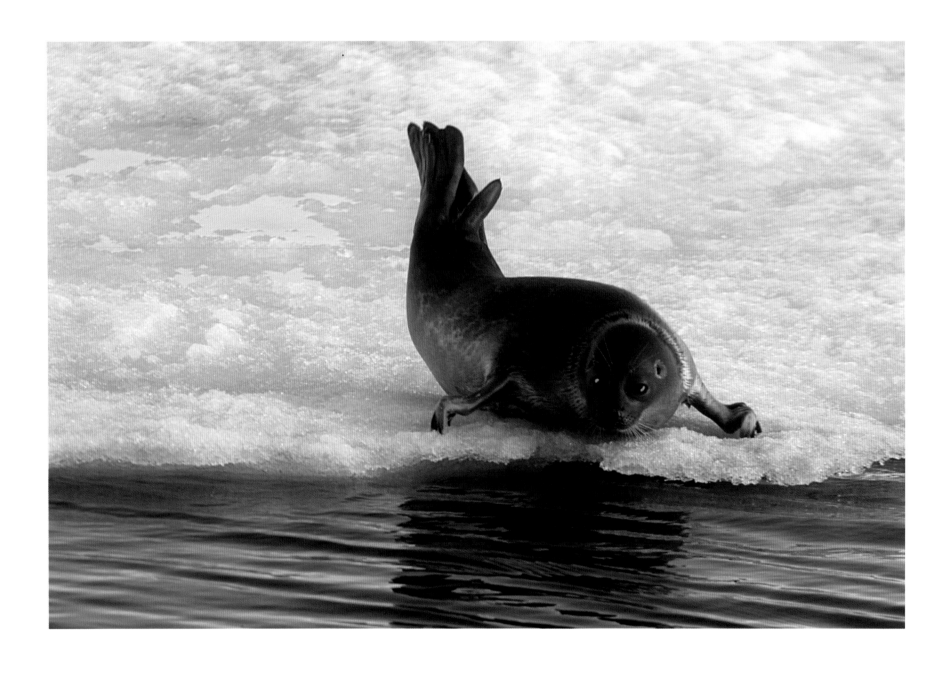

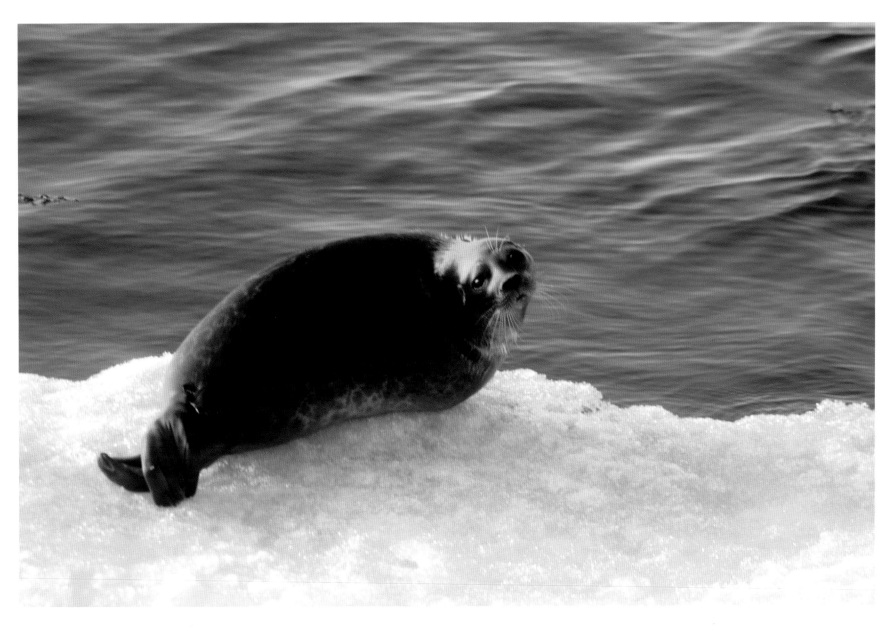

Greenland seal pups like this one, lounging on an ice floe, are the
favorite prey of the ever-present polar bear.

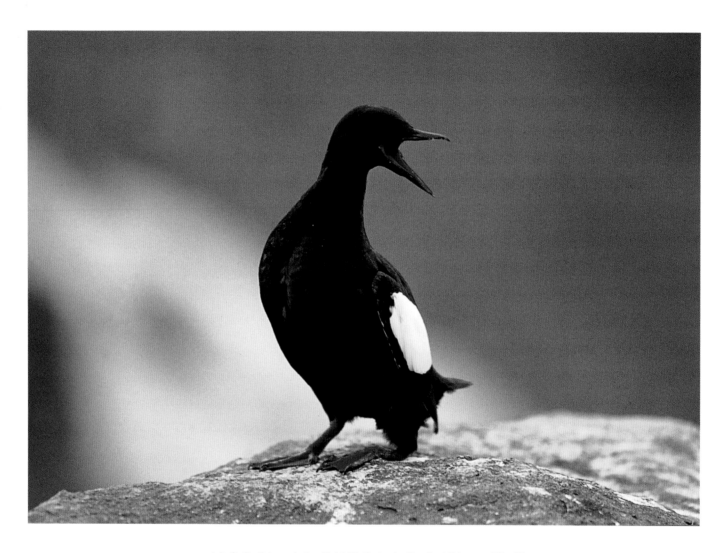

△ ▷ On Begitchev, a lost arctic islet in the Laptev Sea, the tall, inaccessible cliffs
provide abundant nesting sites for black guillemots and Brunnich's guillemots.

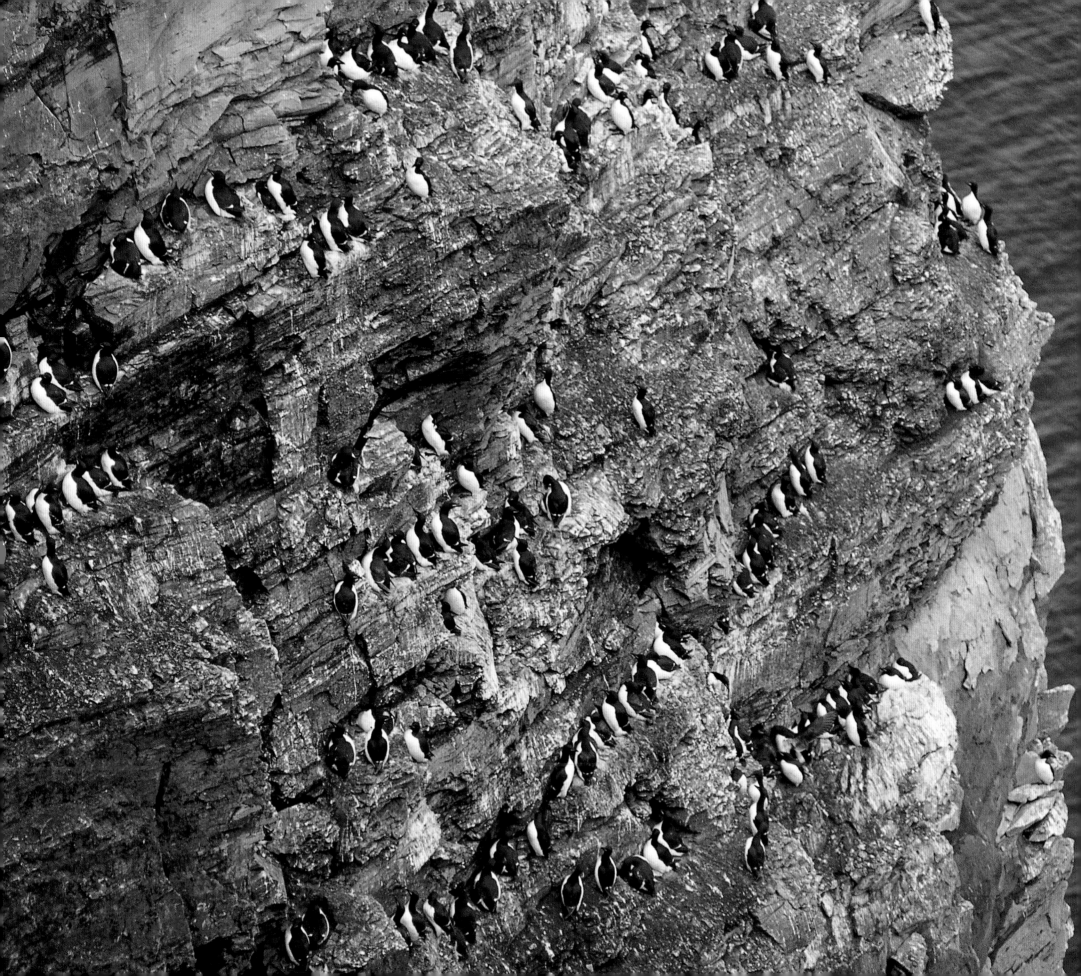

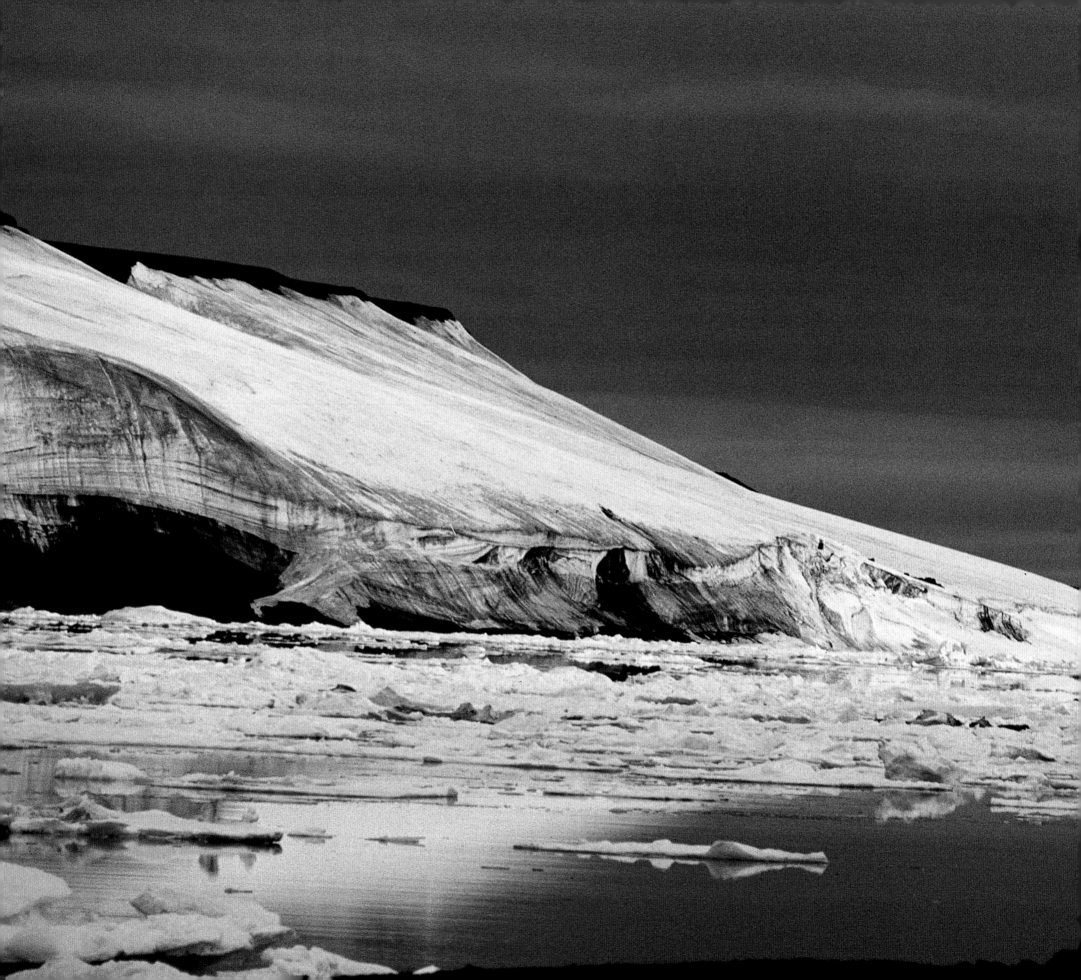

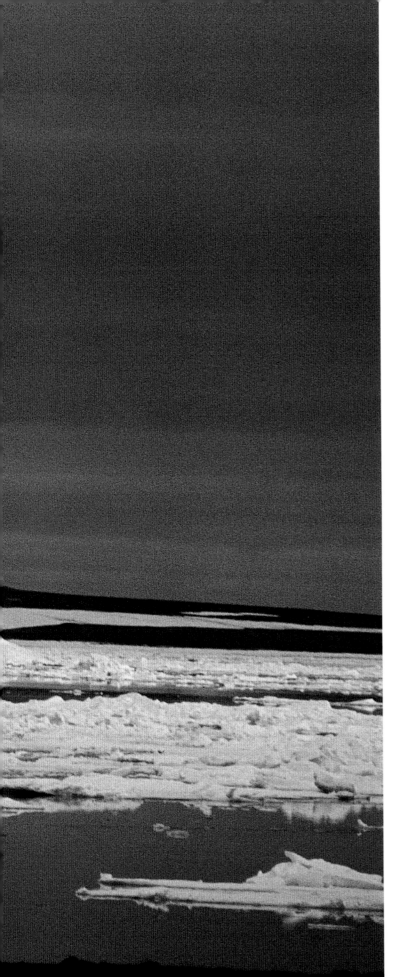

On the Franz Josef Land archipelago, north of Siberia, the ice drifts southward during the summer, where it disintegrates and melts.

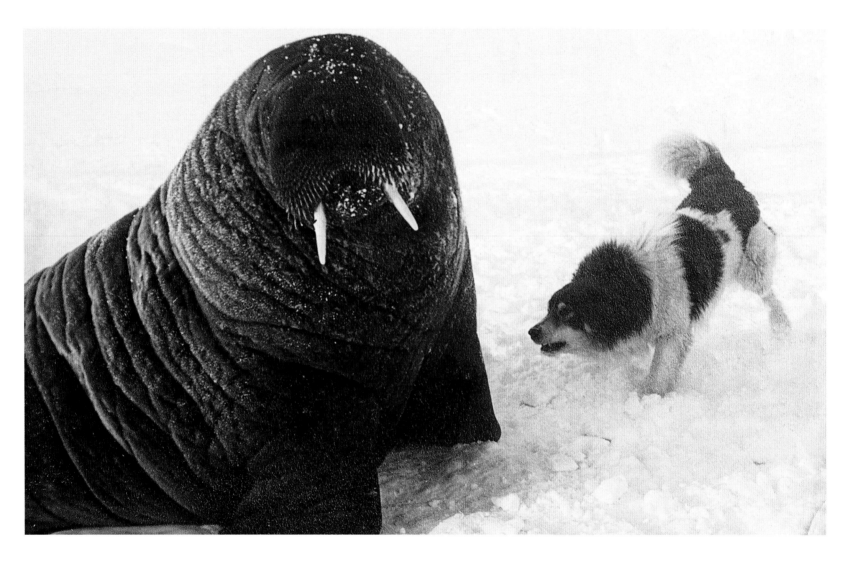

The indigenous peoples of the Far North have long hunted walruses, seals, and whales. Today, they are exempt from restrictions and continue to hunt and fish for sustenance.

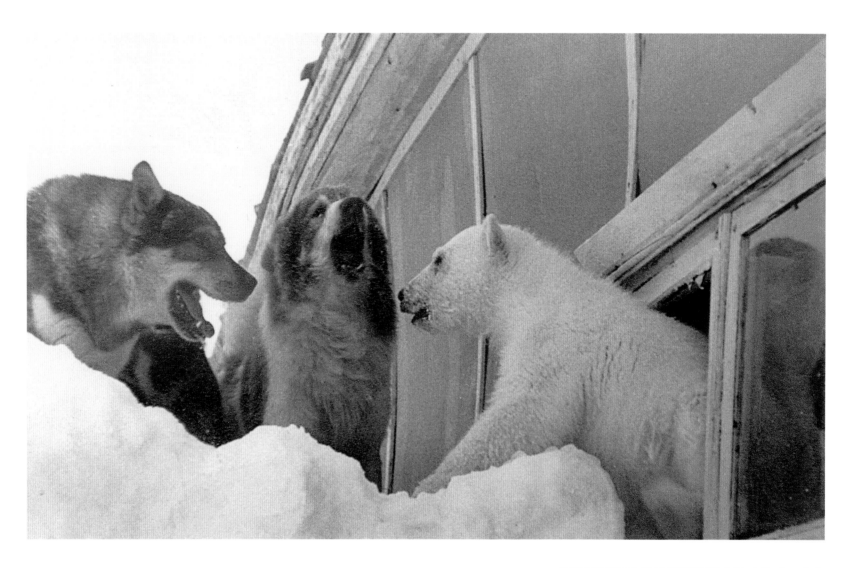

In the polar regions, man's indispensable partner is the dog, who is constantly on guard against wild intruders.

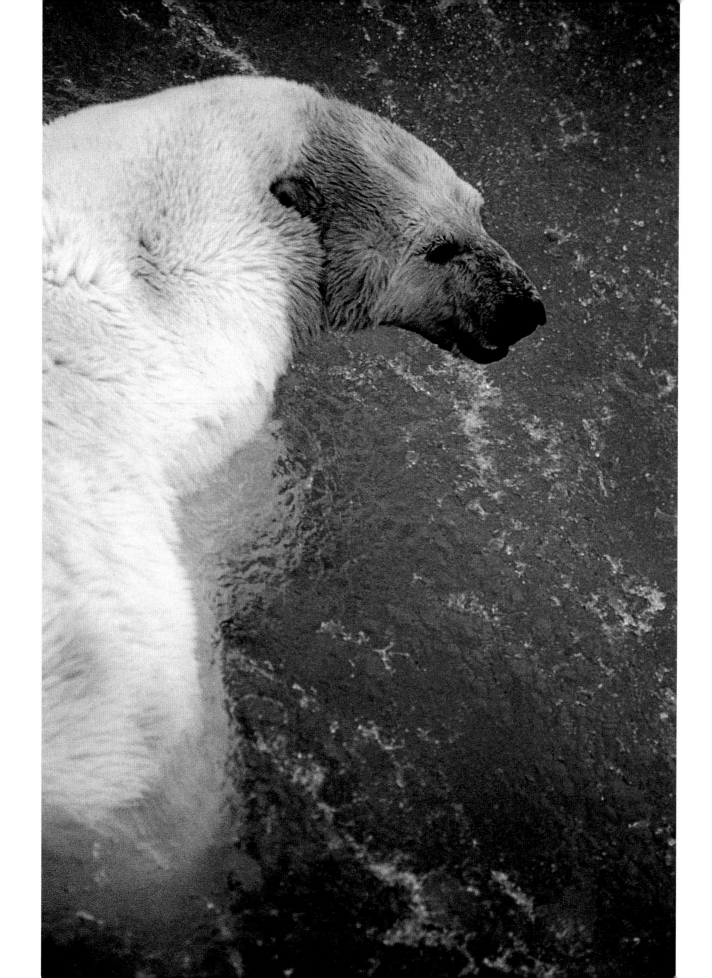

The polar bear is the largest carnivorous mammal on the planet. His habitat is the ice shelf and the drifting floes of the Arctic Ocean. The main component of his diet is seal meat; the polar bear weighs between 660 and 1,700 pounds and can roam more than three thousand miles throughout a year. Polar bears are also excellent swimmers.

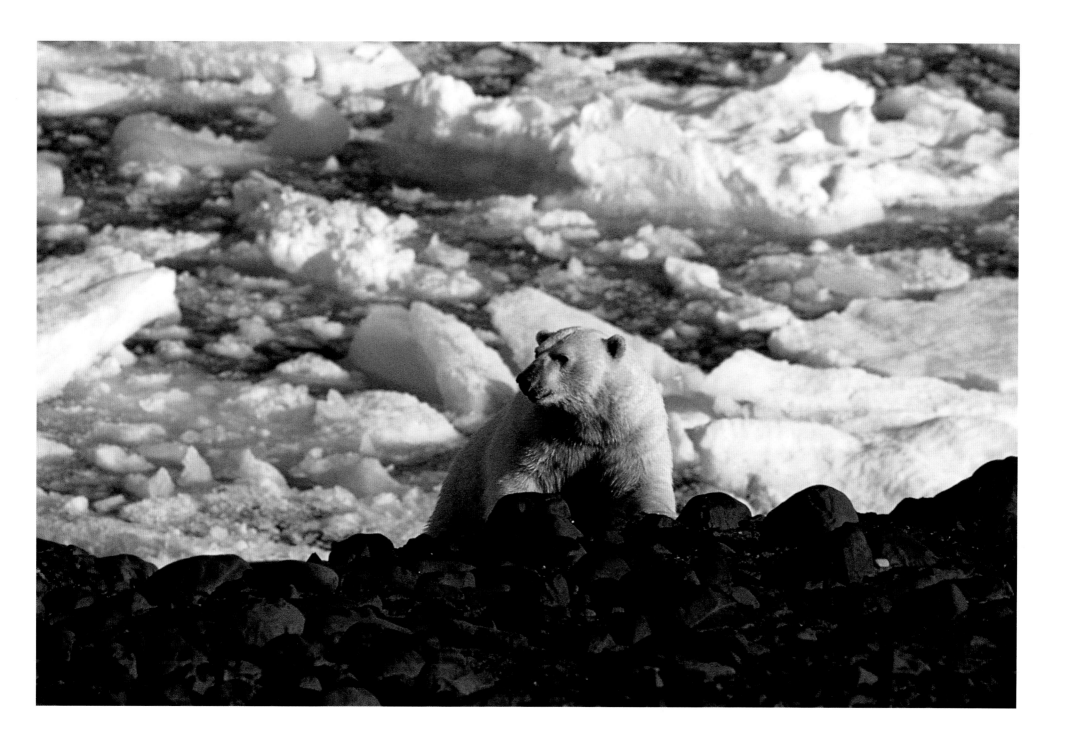

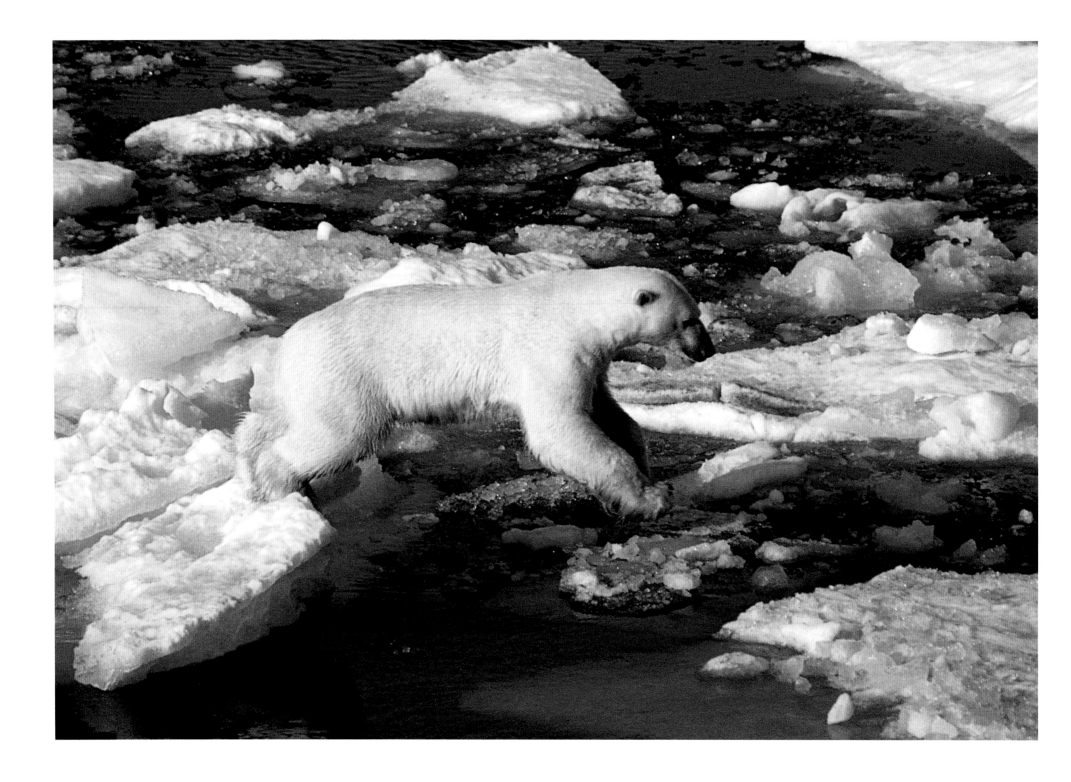

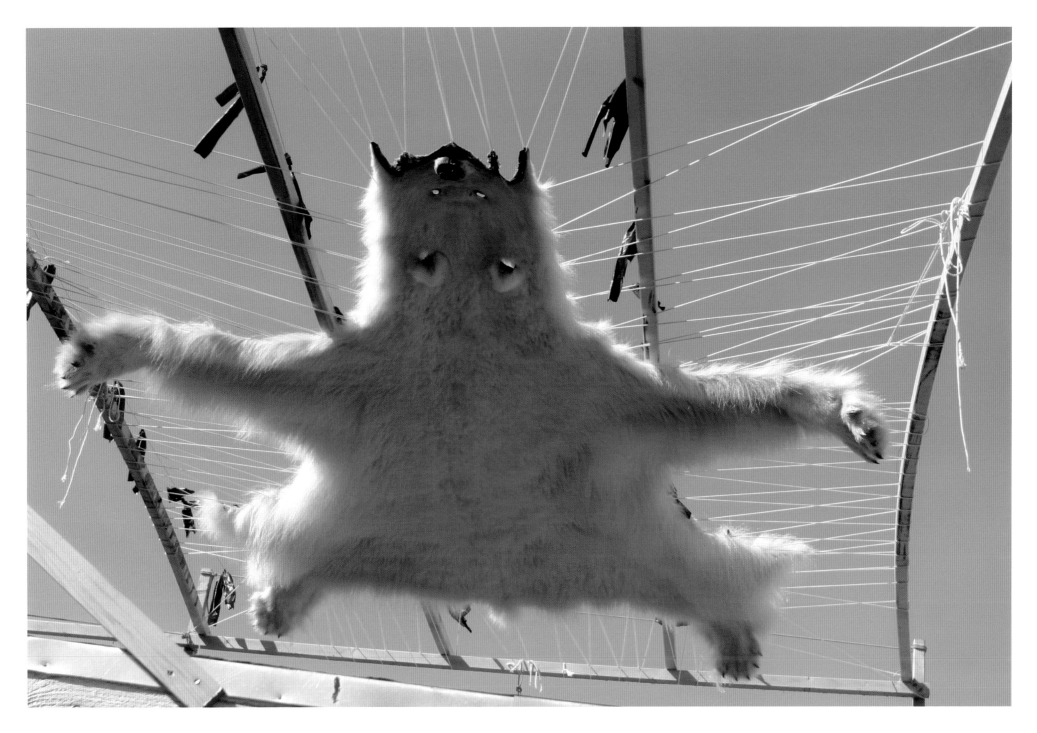

The hunting of polar bears—a threatened species—is severely restricted;
only the Inuits continue to kill the animal for its flesh and skin, which they use
to make fur breeches, boots, and slippers.

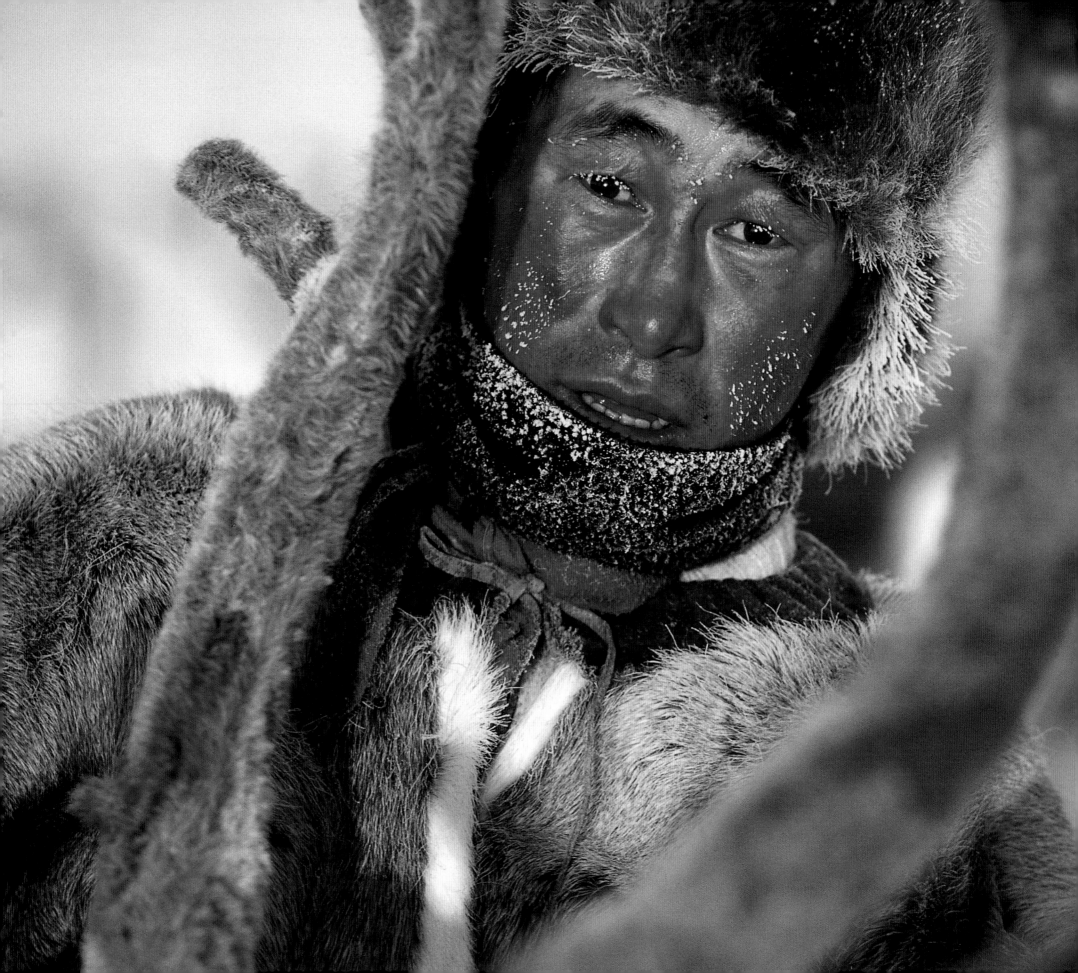

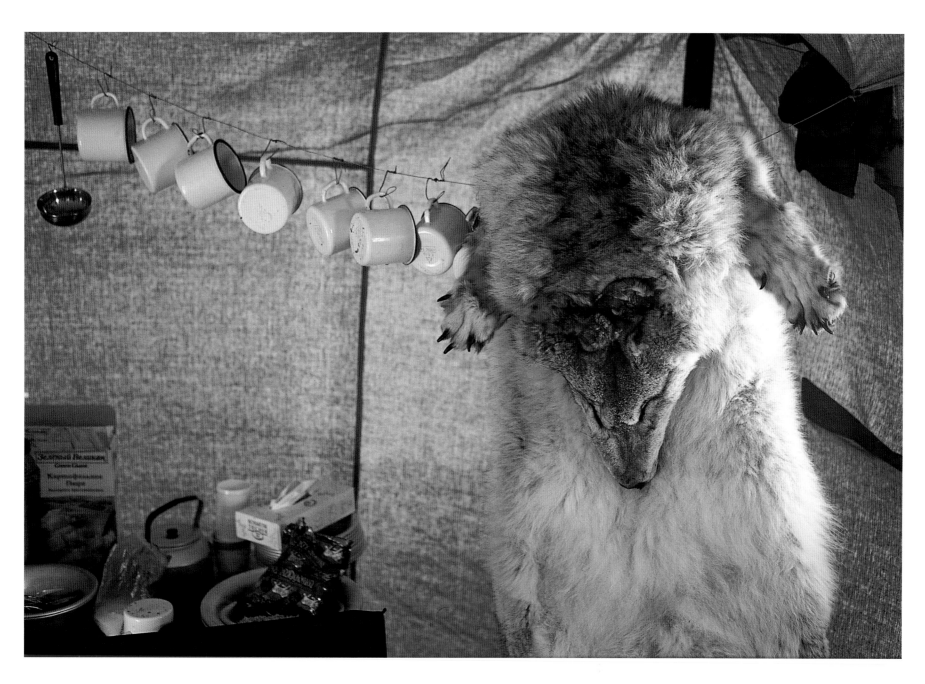

This wolf was shot by Gavril, a Dolgan trapper, because it threatened his reindeer herd. The hide will be dried in camp; later, after tanning, it will be used to make clothes and *czapka*s, a type of hat.

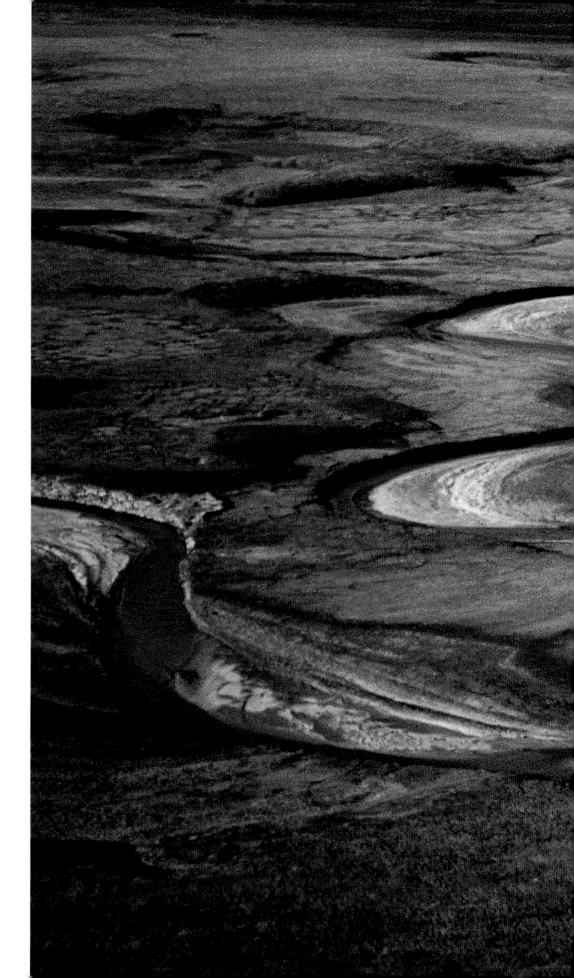

▷ An aerial view of the tundra during the polar summer. The winding river provides the only access to some of the remoter encampments.

▷▷ Siberians like to joke that their winter only lasts twelve months. The summer season is very brief, lasting only a few weeks; during this time Piotr, the old Dolgan, decides to make camp near his fishing grounds.

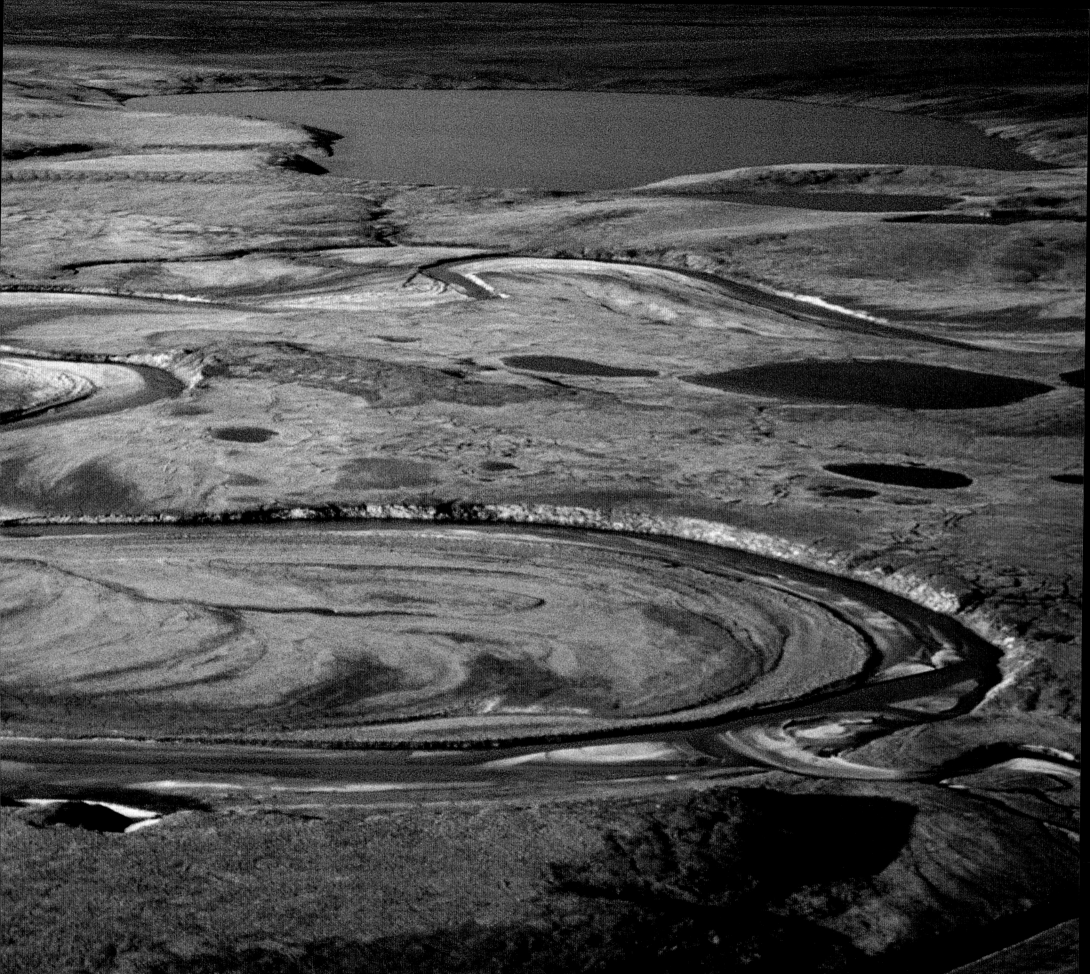

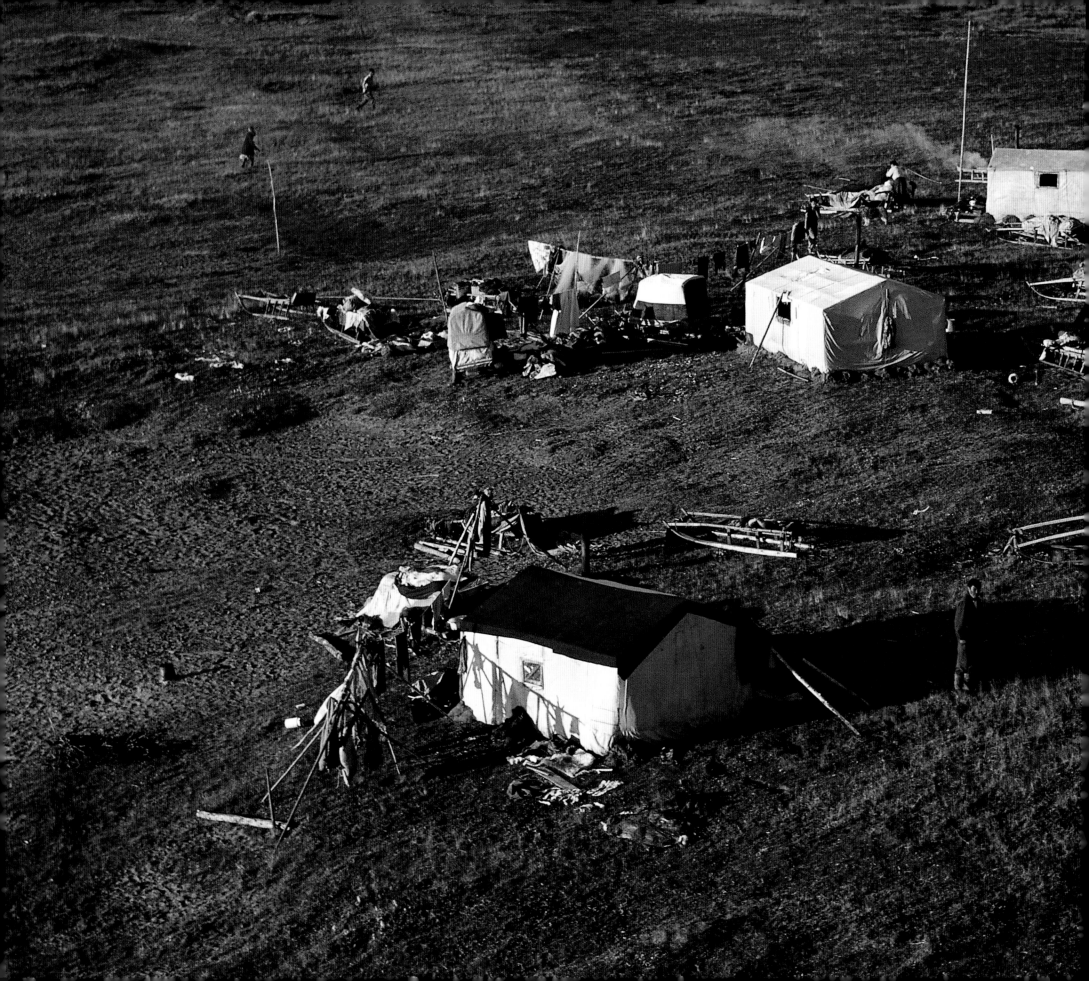

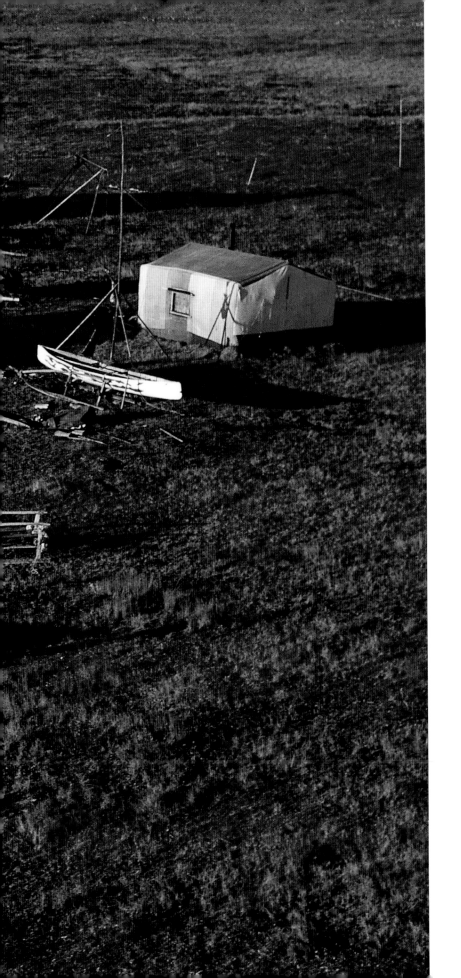
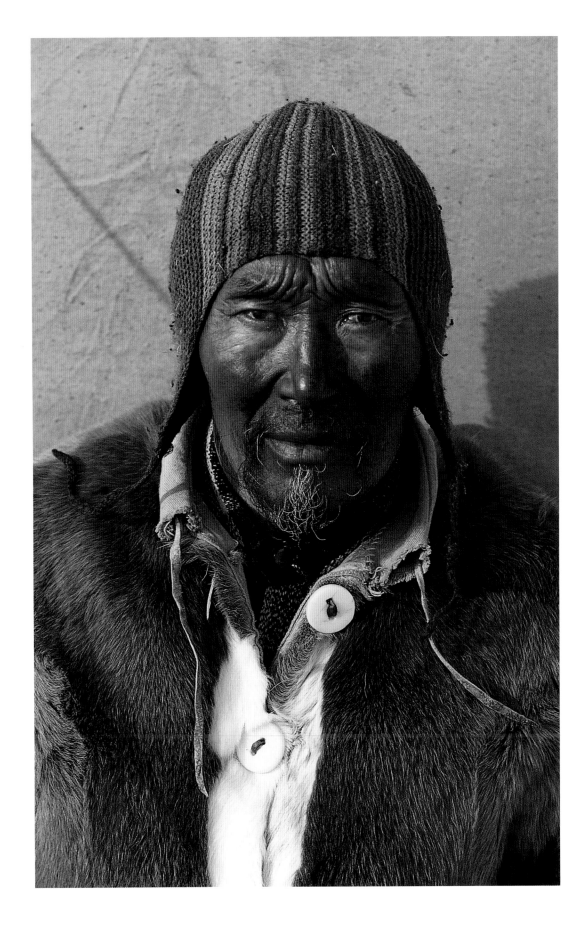

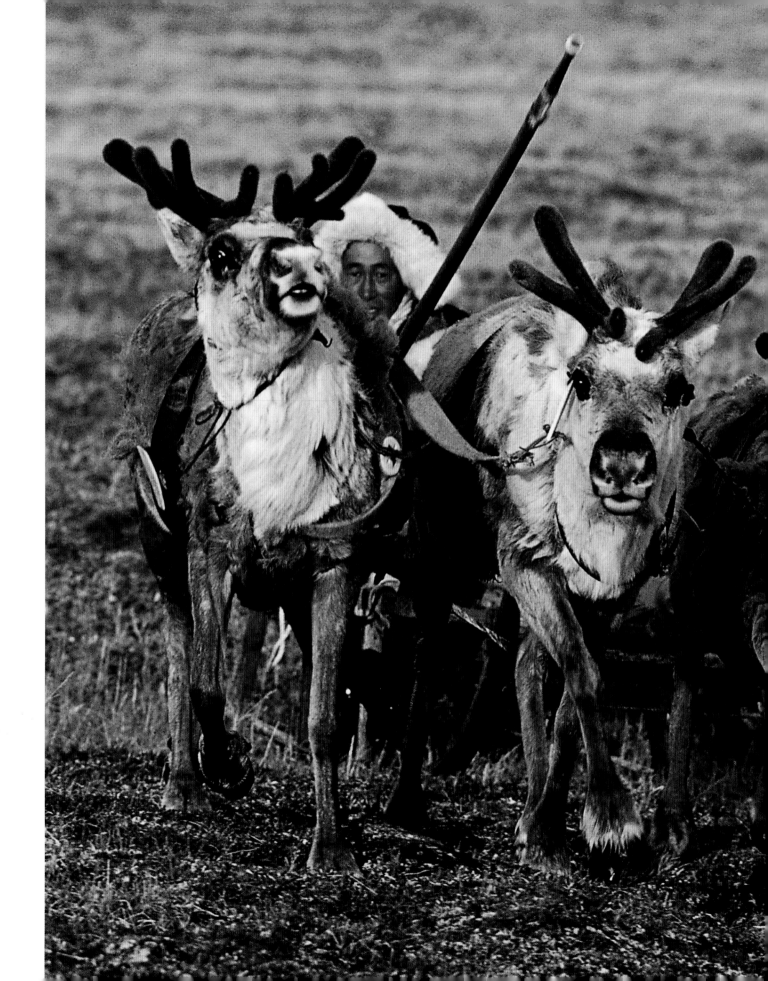

Gennady, a Taimyr nomad, uses a light sled to collect wood that was carried down the river from the distant *taiga*. This wood is the only source of fuel used by the nomads.

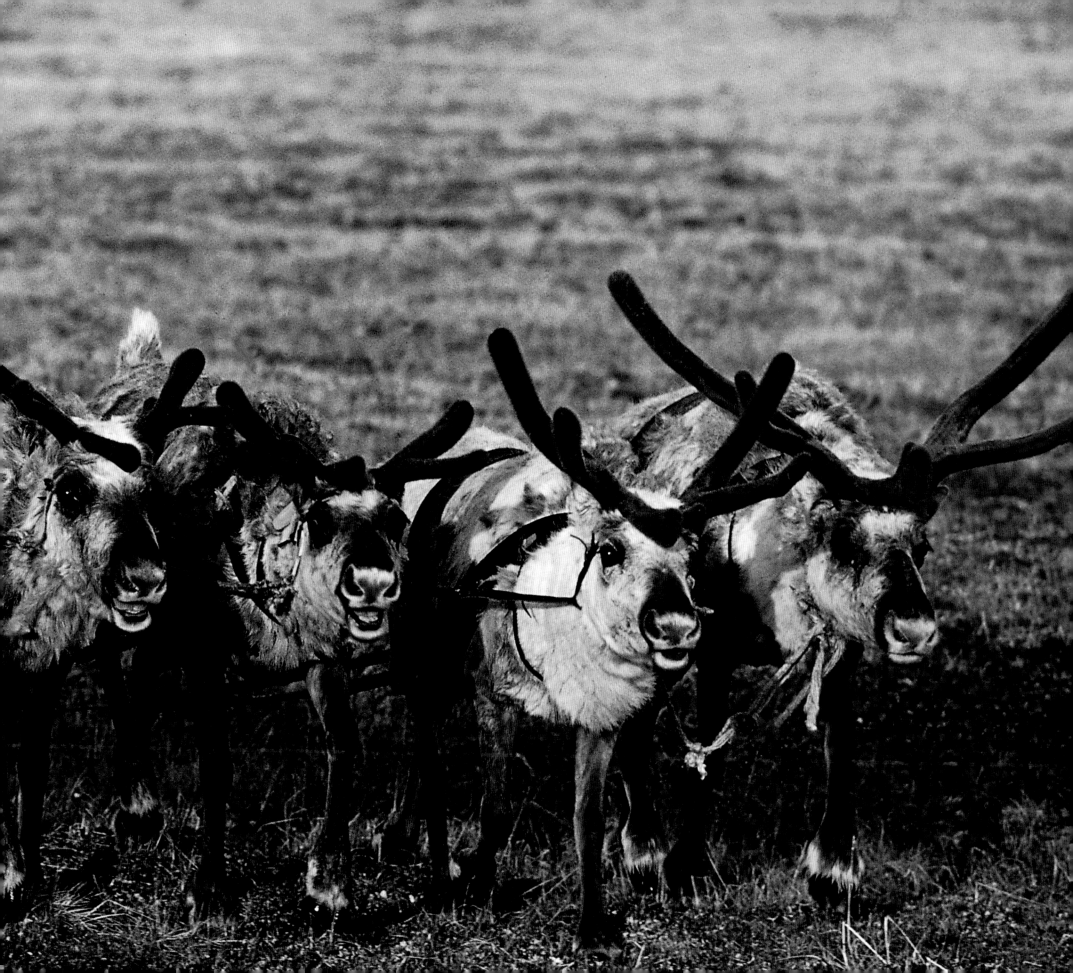

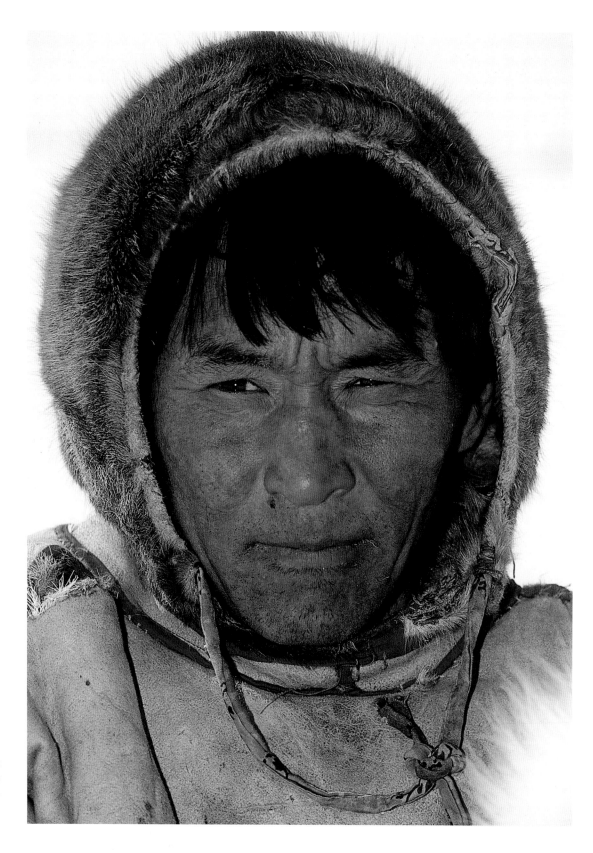

Gennady is the head of a Dolgan "brigade," meaning a family group or band of nomad companions.

Peoples OF THE Far North

FOR TIME OUT OF MIND, THE PEOPLES OF THE ARCTIC have perfected the art of survival in desolate, largely frozen wastelands, where there are no trees, vegetation of any kind is rare, and the polar night blankets everything for much of the year. Hunters, fishermen, herders, and nomads—and most notably the Inuits of Greenland, the Far North of Canada, and Alaska—have evolved a "seal-based civilization," as the French explorer and writer Paul-Émile Victor termed it. Others, like the Lapps and Samis of Scandinavia and the tribes of Siberia, have been more dependent on reindeer for sustenance. For a long time these peoples were cut off from the rest of the world's development, but today they are becoming more sedentary and urbanized. There is an exception: the Dolgans of Russia's Taimyr National Territory, who today are among the last authentic nomads of the polar North.

And yet the indigenous populations of the Arctic Circle have a long tradition of nomadic life. For example, ever since the English pirate and adventurer Martin Frobisher discovered the Eskimos in Greenland in 1576, their presence on the world's largest island has been a source of deep interest and curiosity. It has been explained as the result of an epic migration, carried out by small groups of between twenty and thirty people originating in Mongolia; they probably started their odyssey in Northeastern Siberia, though ethnologists have no real idea when or how they did so. They crossed the Bering Strait to settle in Alaska, where archeological sites confirm their presence in around 10,000 BC. Harassed thereafter by the northernmost Red Indian tribes, they journeyed on to the Canadian Arctic, hunting the whale around Baffin and Somerset Islands. Some continued on their eastward course, subsisting on seal meat, game, and fish, and they seem to have reached Greenland between 2050 and 1700 BC by way of the northwest coast of the island. They were followed by successive waves of migration. Adapted as they were to existence in the Arctic, the Inuits were able to withstand an abrupt cooling of the climate, which brought about a miniature ice age in about 1500 BC. Throughout centuries of self-sufficiency, the Inuits learned to travel on land, with sleds pulled by teams of dogs, and on the sea, in kayaks, during the brief Arctic summer. They hunted seal, walrus, whales, and polar bears to supply their basic needs: oil for their lamps, fur, leather, and meat. Today, all this has changed: Greenland, granted autonomous status by the kingdom of Denmark, has seen its indigenous population of about fifty-five thousand forcibly relocated to its coastal towns, just as the Canadian Inuits have occupied the fur-trading outposts of the white man. In 1999, the Inuits created the Nunavut Territory ("nunavut" means "our land" in their dialect), which covers some 772,000 square miles of one of the world's least populated regions. The last few years have seen twenty-eight communities of Inuits, comprising 21,250 people and 85 percent of the entire Inuit population of Canada, begin the task of reviving their former traditions in this territory.

By contrast, the last Dolgan nomads have consistently fought to keep their traditions intact. From their distant beginnings, these hunters and reindeer herders have passed down a legend whereby their race emerged in the Taimyr tundra, out of clods of earth that rolled off the mountain into the sands below. The earth gave life to a boy and a girl who fed themselves on wild plants. When the boy and the girl were grown, they met with two reindeer, which they tied with halters made of grass. Then the girl had two children, and the reindeer had two calves… and so life continued until two of the reindeer broke their halters and ran away to form a herd of caribou.

The Dolgans of today number about seven thousand. Together with the Nganasans they are the only indigenous people of the Taimyr, a vast territory of 332,859 square miles, which is the northernmost region of Siberia. They are one of twenty-six distinct ethnic groups singled out in the European and Asian areas of the former USSR and assembled in 1925 under the umbrella definition of "indigenous peoples of the North." Many of the Dolgans, whom the Soviets forcibly relocated to their Dolgan-Nenet territory, have remained in the towns, where they all too often fall victim to poverty and alcoholism. Their life expectancy is less than fifty years. But the tundra still shelters a handful of diehards, about 250 individuals who perpetuate—despite the snows and extreme temperatures (as cold as –76°F)—a nomadic existence in symbiosis with their bitter surroundings.

The Dolgans' ancestors, who intermarried with Evenk clansmen and Russian colonists who arrived in the region in the eighteenth century, knew the North very well and were fully acclimatized to it. They founded small settlements, which often con-

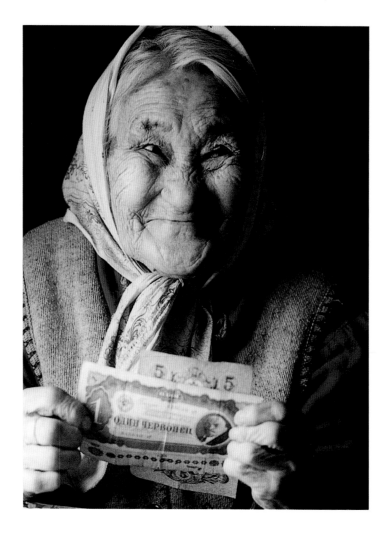

Anna Antonova is the oldest Dolgan. She remembers Lenin's reign and has kept a banknote bearing the Bolshevik leader's effigy.

sisted of a single house (called an *isba*) shared by several different families. Little by little these *isba*s gave way to conical log constructions, covered with lumps of earth: these *golamo*s, as they were called, were used in winter and replaced in summer by *choum*s, houses made of reindeer skins. The Dolgans began as trappers, specializing in fur-bearing animals, but over time they began to concentrate entirely on wild reindeer, or caribou. They explored new territories, studied the winter migration routes of their quarry, and exploited the most productive areas. Their reindeer culture obliged them to live the seasonal lives of nomads, for which they invented the *balok*, a small house that could be moved by sled. They broadened their territory rapidly until the beginning of the twentieth century.

During the 1930s, the Soviets created *kolkhoze*s (collective farms) in the tundra, based on the collective ownership of the reindeer herds and of hunting and fishing equipment. Decades of acculturation followed, which wrought irreversible damage on the tradi-tional Dolgan way of life. Furthermore, the industrialization of the region seriously disturbed the ecosystem on which the local fauna depended. Although the Taimyr today contains the largest herd of caribou on the planet (about a million head), the incredible pollution spewed by the nickel, copper, and cobalt factories around the Noril'sk complex has forced these creatures to shift their migratory route in the direction of Khatanga, a town farther north on the peninsula. The new routes taken by their wild brethren have in turn upset the balance among local domestic reindeer, with females escaping to follow dominant wild males on their yearly passage. In addition to this, caribou and domestic reindeer must now compete for lichen, a source of food on which both depend. For survival, many Dolgans, who until recently were reindeer herdsmen, have turned to hunting, a much more precarious way of survival, as it is entirely seasonal.

The economic difficulties faced by the Dolgans since perestroika in 1985, and the collapse of the Soviet welfare state, have been made worse by rising prices, especially

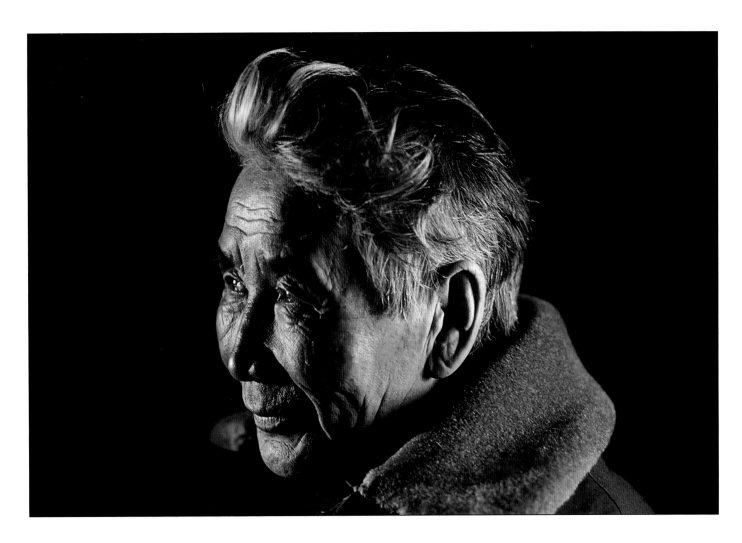

Atsukin, the leader of the region, is deeply concerned for the future of the peoples of the Taimyr peninsula.

the price of transportation, which the reindeer herders themselves must pay. As a result, the price of reindeer meat has become exorbitant, and sales have plummeted. At the same time the Dolgans, who are viewed as the guardians of mammoth ivory (the remains of mammoth being abundant locally) must confront the greed of unscrupulous dealers. Since the banning of the trade in elephant ivory, mammoth ivory prices have skyrocketed, and the rich repository of prehistoric remains in the frozen tundra have been scattered. The last Dolgan nomads strongly disapprove of the harvesting of mammoth ivory: they are afraid, rightly, that the resources of their land are being exhausted. They know from their ancestral shamanistic laws that it is vital for man to live in harmony with the earth and to respect what it gives to him. Frozen mammoth carcasses have sometimes saved their lives. For example, many times snowstorms have stranded the Dolgans for days and nights on end—all their supplies gone. The marrow inside those mammoth bones has yielded edible fatty matter that has saved their lives.

Ever since the collapse of the Soviet Empire, the Dolgans have striven to resurrect their ancient traditions, among them the Feast of Popigay, which celebrates the return of the sun to the earth, in the final days of April. During this time the entire community gathers to burn the effigy of the long and gloomy polar night. The temperature rises, nature bestirs herself, the reindeer give birth to their calves, and the migrant birds return.

For every group that inhabits the high latitudes—Inuits, Lapps, the peoples of Siberia—the ending of the polar night is a time of rejoicing. Their feasts date back to the very origins of nomad existence. Even so, the peoples of the Arctic are deeply concerned about the relatively new phenomenon of global warming, which will probably lead to their utter ruin.

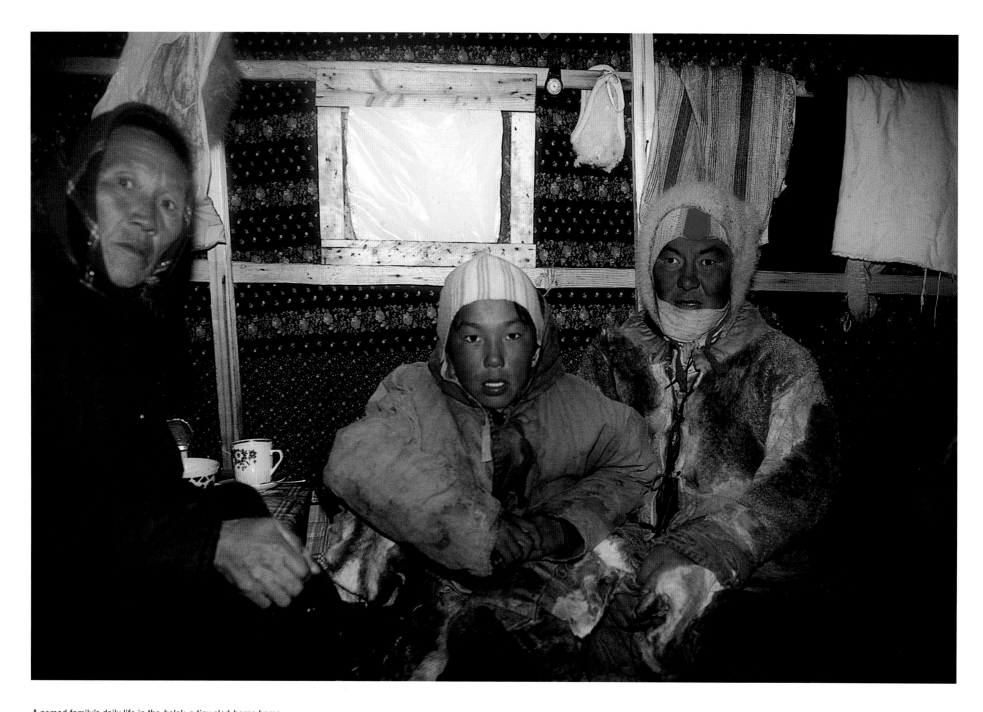

A nomad family's daily life in the *balok,* a tiny sled-borne home
ten feet long by six and a half feet wide, covered in reindeer skins.

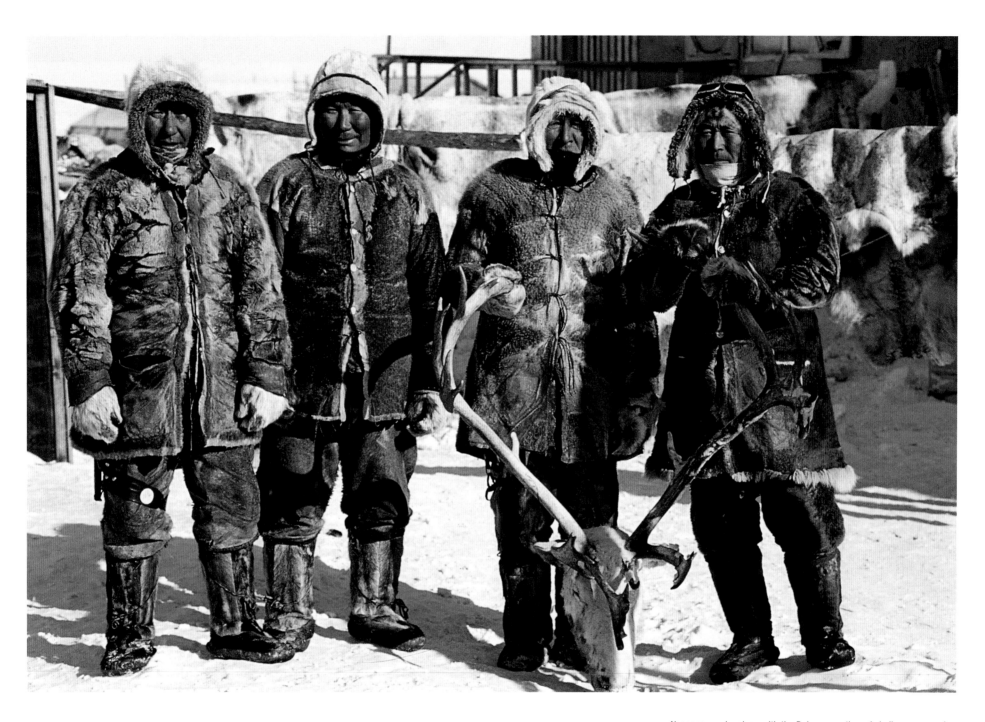

Nganasans, who along with the Dolgans are the only indigenous peoples
of the Taimyr, pose with the skull and antlers of a wild caribou.

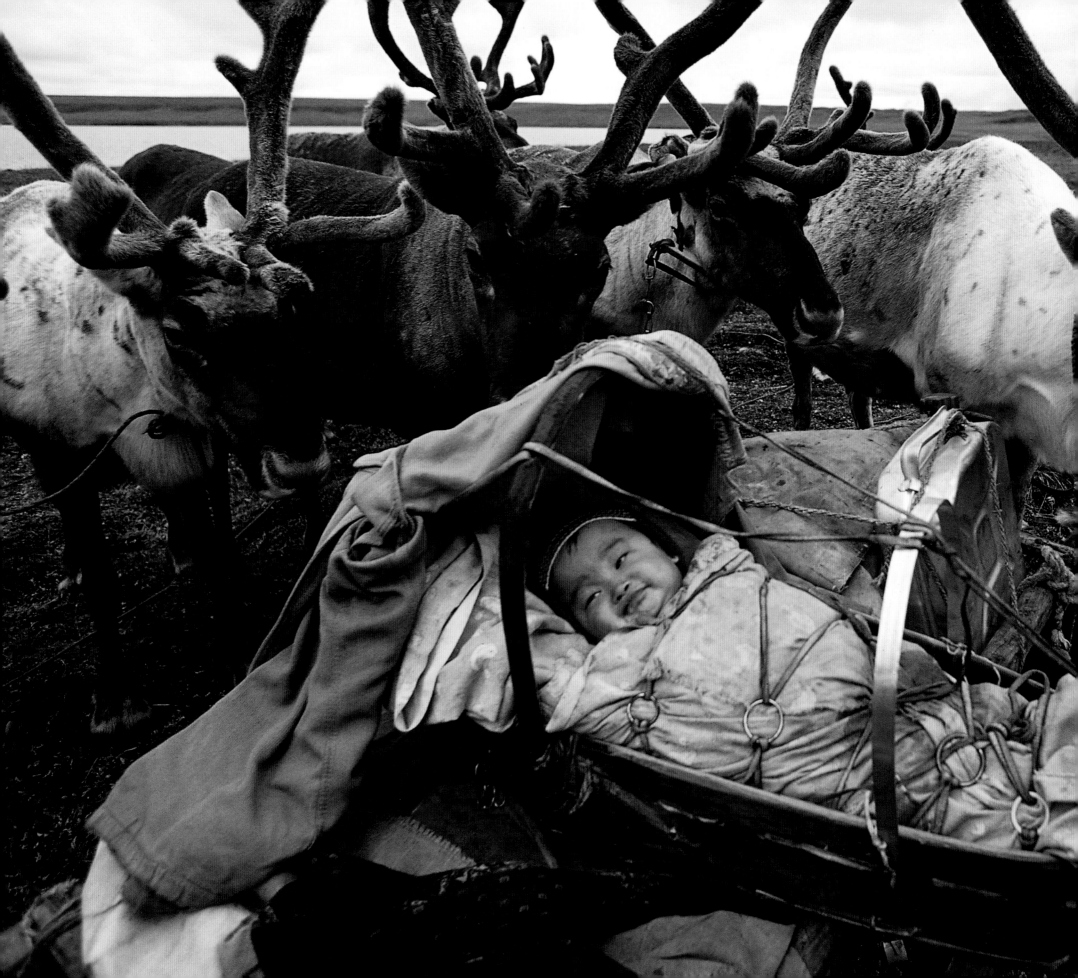

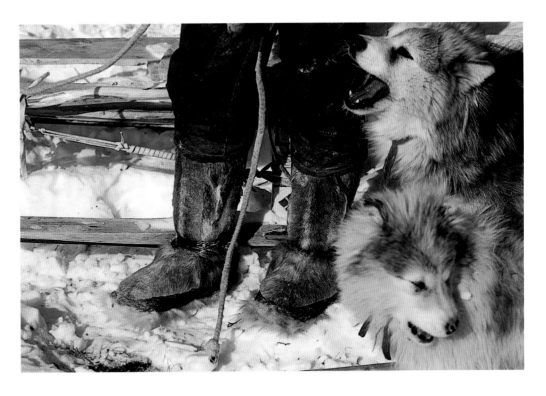

From the earliest months of a Dolgan baby's life, he travels on his parents' sled;
reindeer, perpetually moving, follow along.

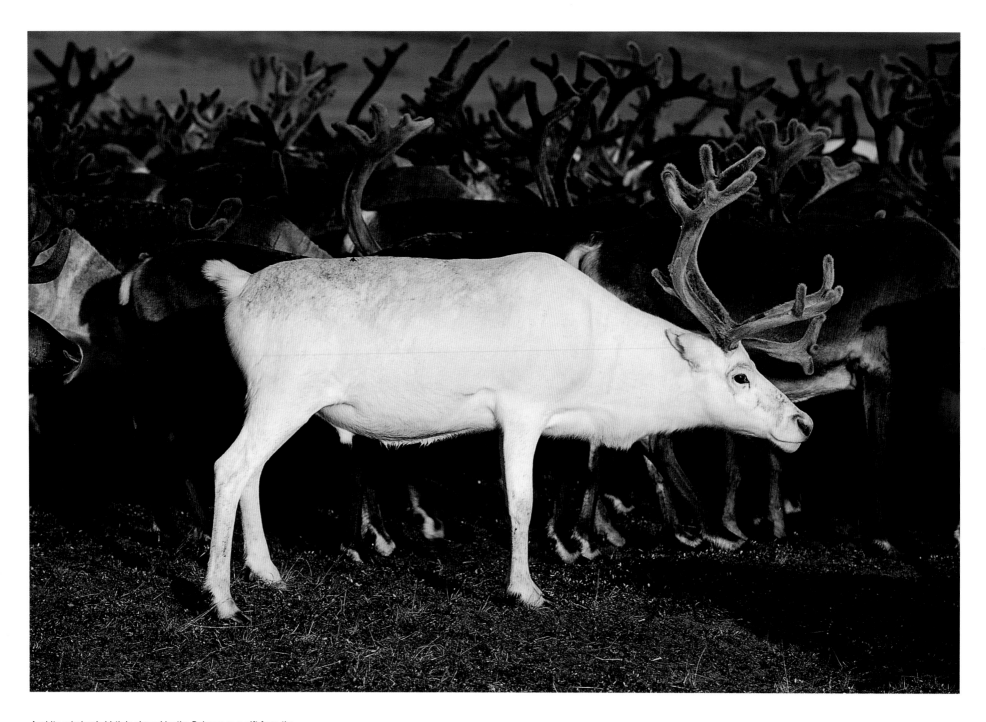

A white reindeer's birth is viewed by the Dolgans as a gift from the benevolent spirits of the tundra. Later, the animal will be sacrificed at one of the sacred sites to ensure the species' continued protection.

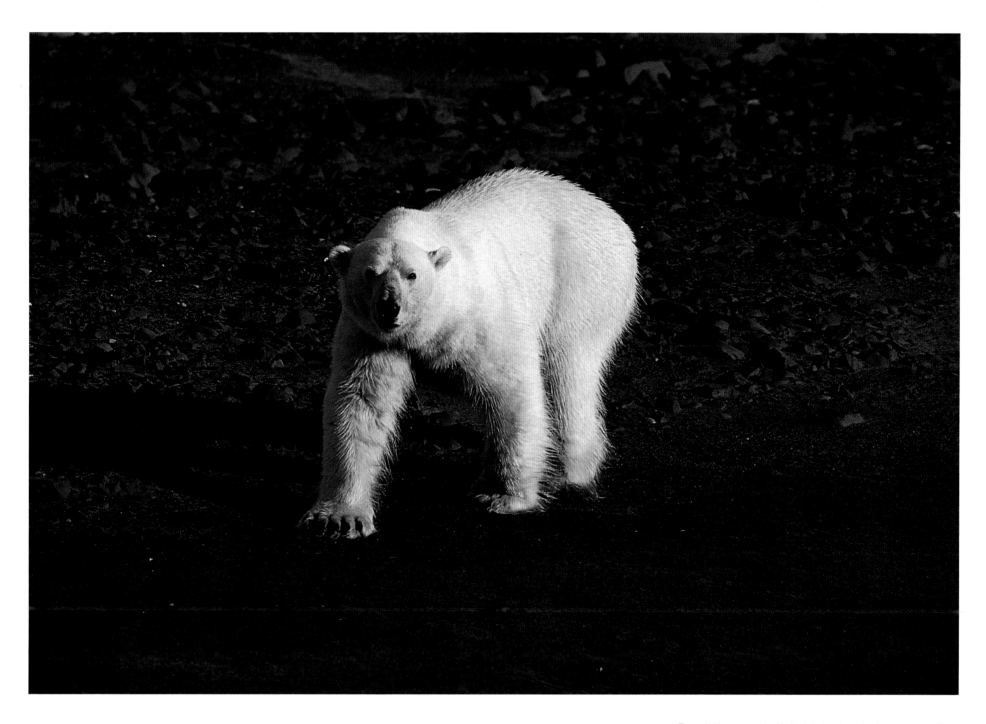

The polar bear searches for food during the short Arctic summer. Since the ice is gone, he is forced to prey on small land-based creatures like lemmings or nesting birds.

Bathed in red autumn sunshine, nomads in their encampment prepare for the coming polar night. They will be cut off from the world for the next four months.

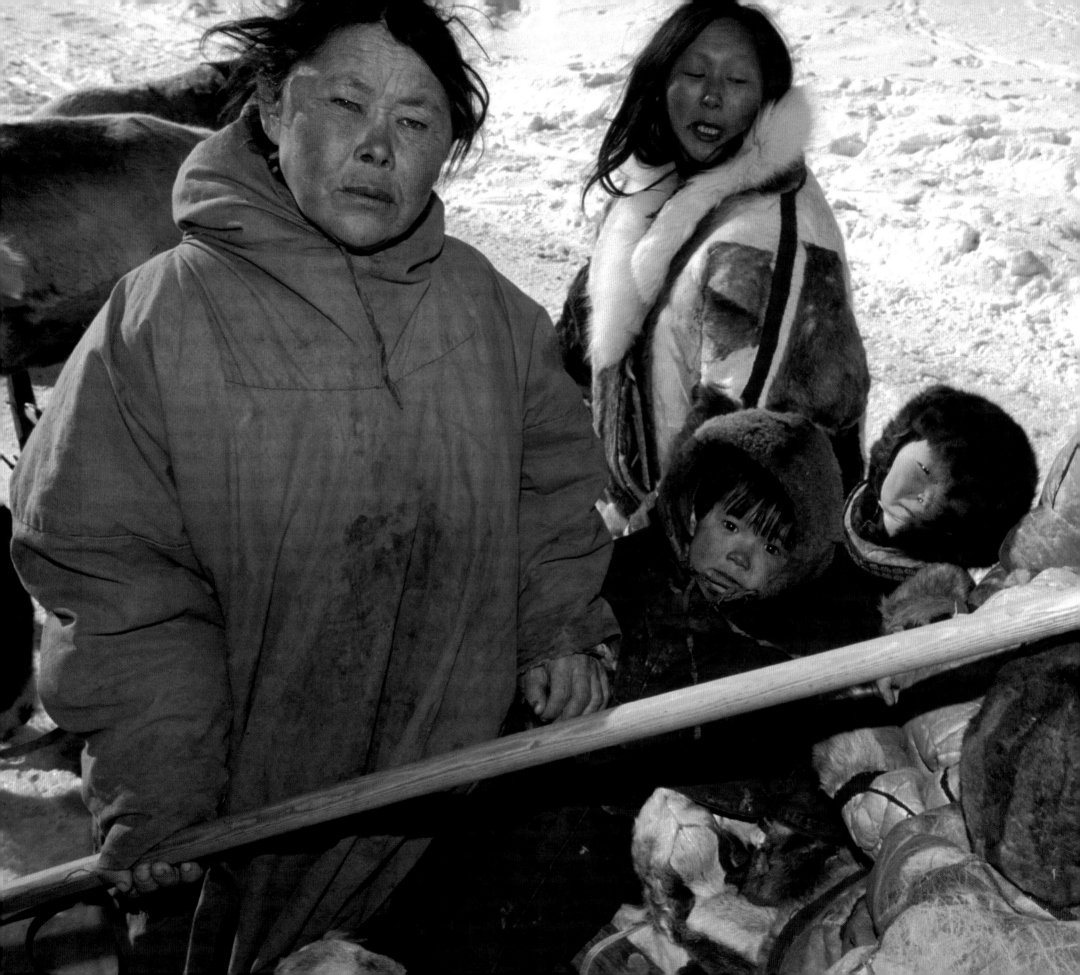

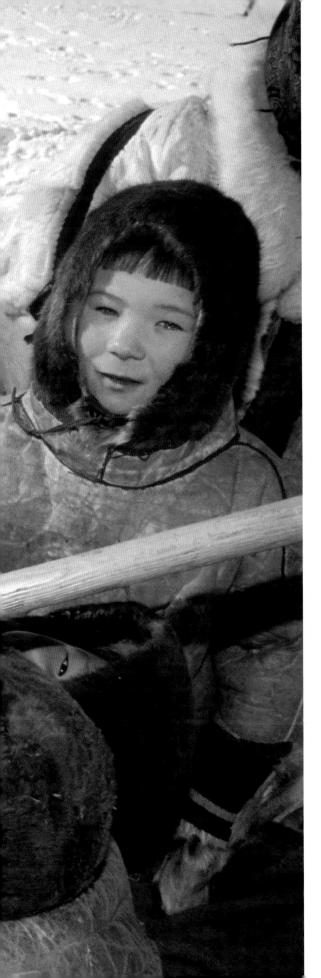

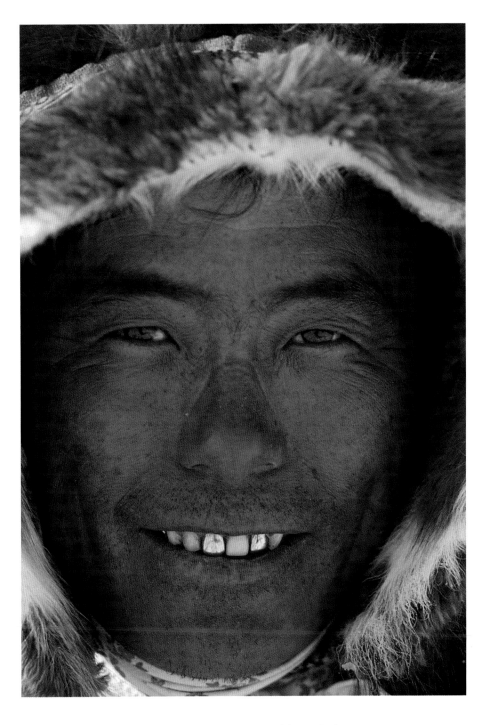

The Nganasan community is one of the twenty-six
"little peoples" of Siberia, as Stalin called them.

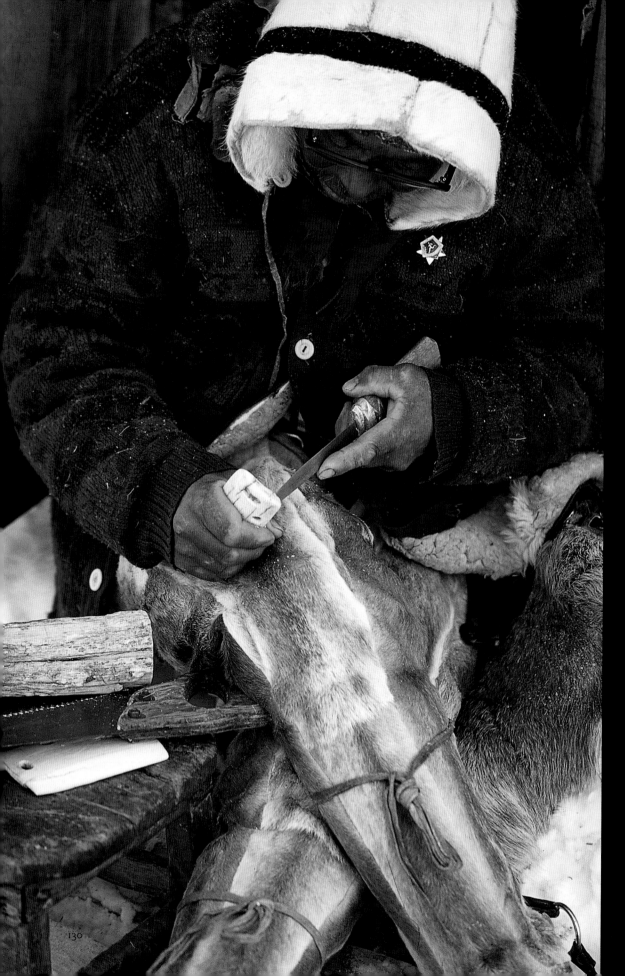

Viktor, an elderly Dolgan, carves and engraves objects and utensils out of mammoth ivory, one of the few workable materials found in the tundra.

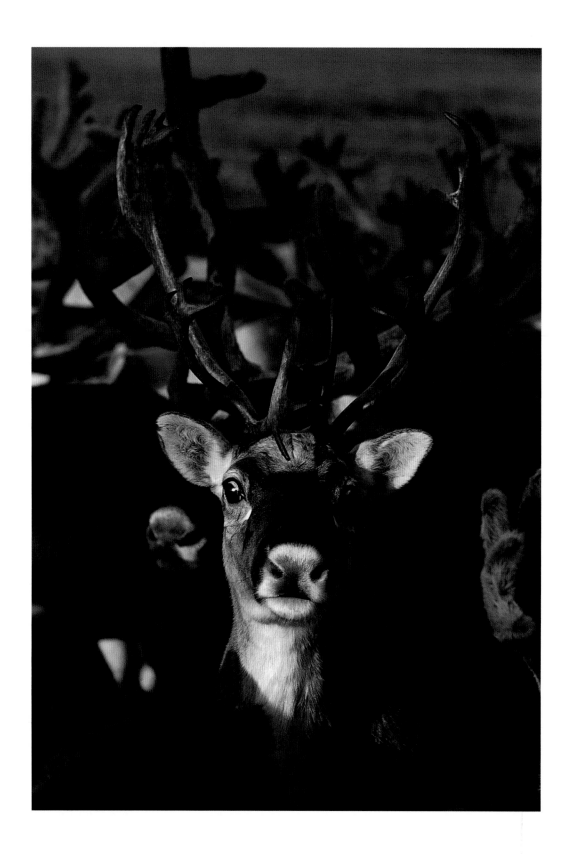

◁ As winter sets in, the antlers of the reindeer become bloody before falling off. They regrow very quickly in the spring.

▷ Around the encampment, tame reindeer—usually orphaned at an early age and raised with milk from a bottle—often come to beg for food from their adoptive human family.

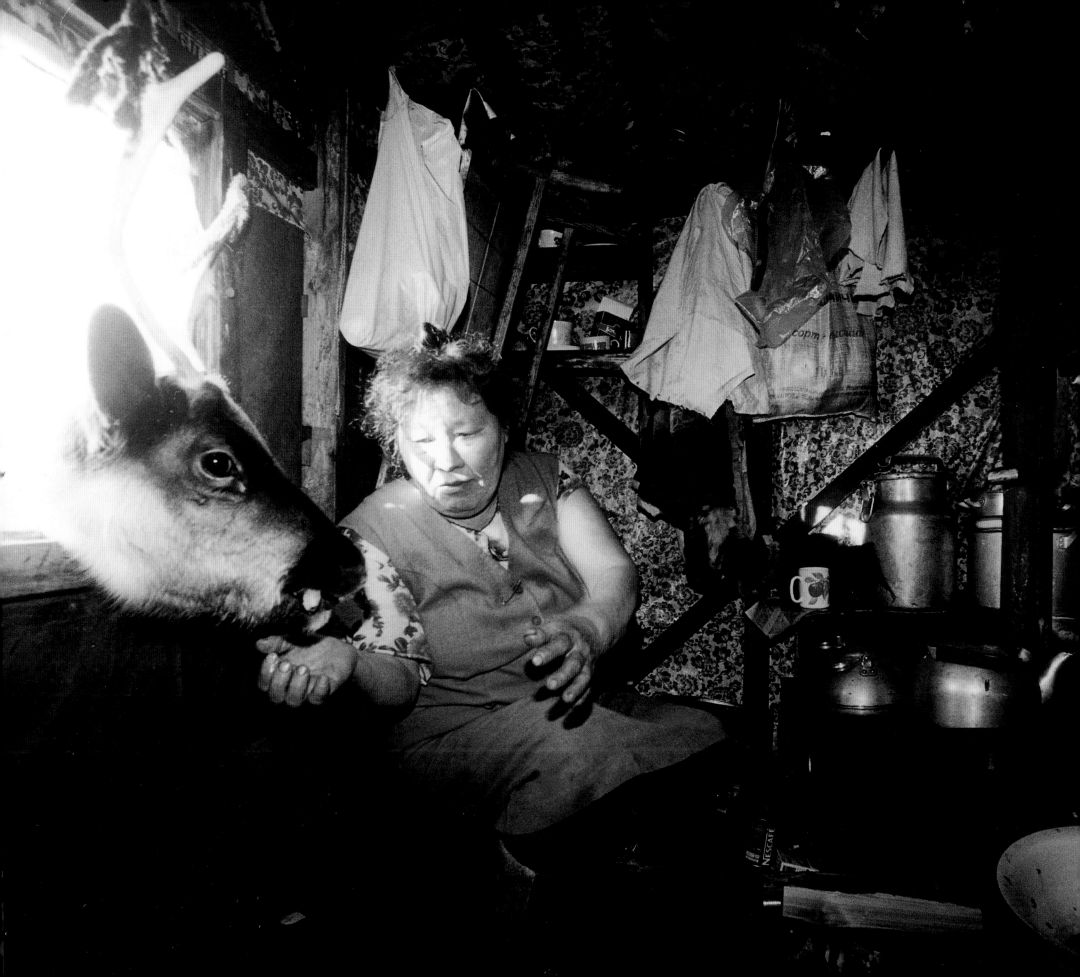

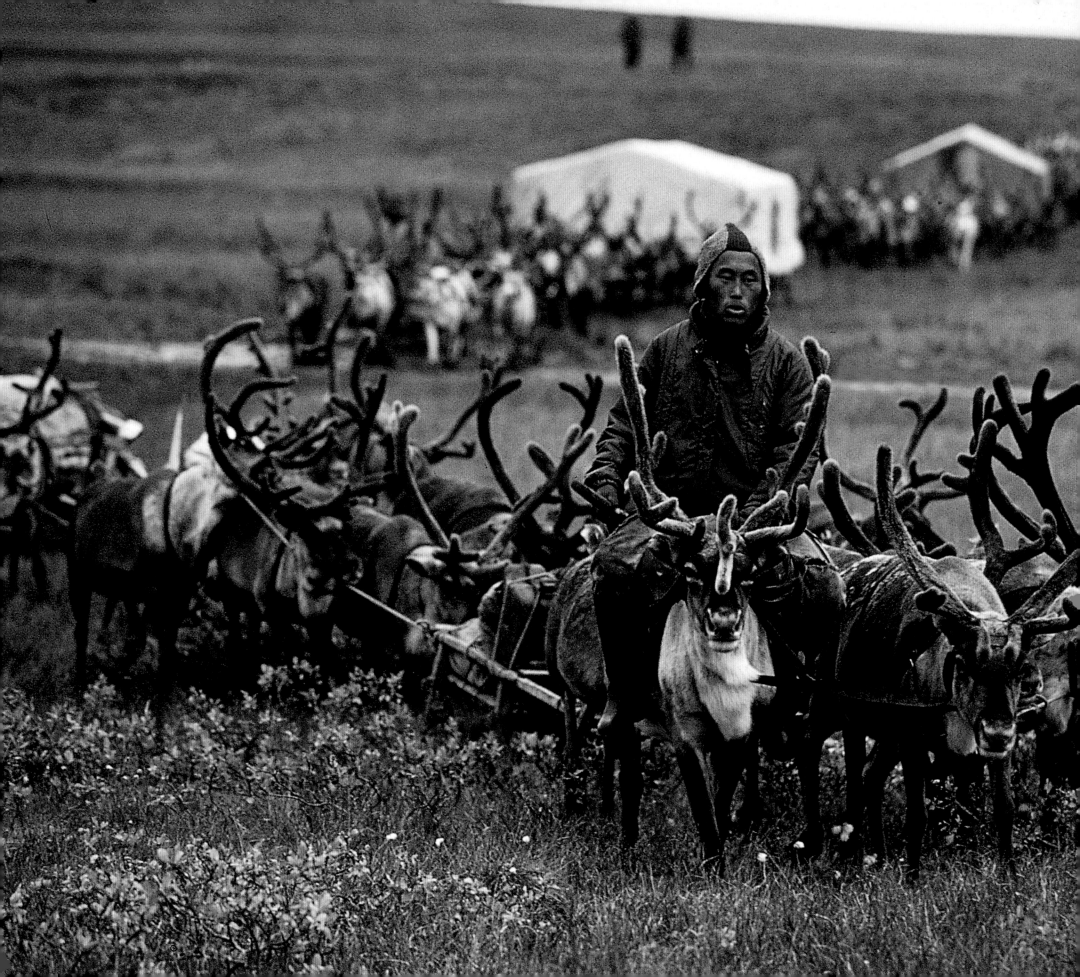

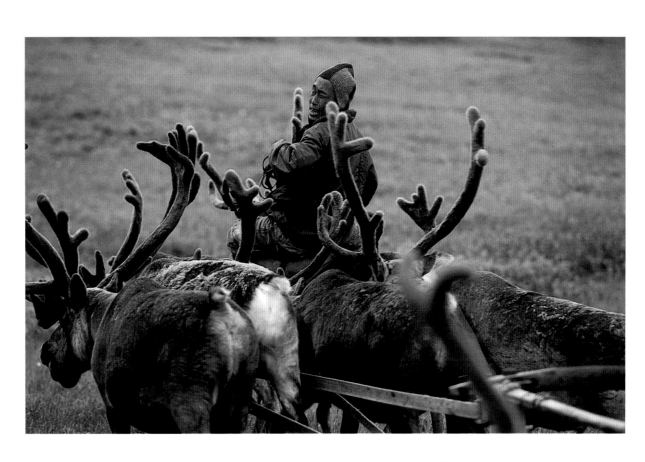

During the summer migration, the Dolgans move their lightweight
homes to fishing grounds by the river.

Helicopters are the only rapid means of transport in
the Arctic regions of Siberia. They ferry provisions to
the people of the tundra in all types of weather.

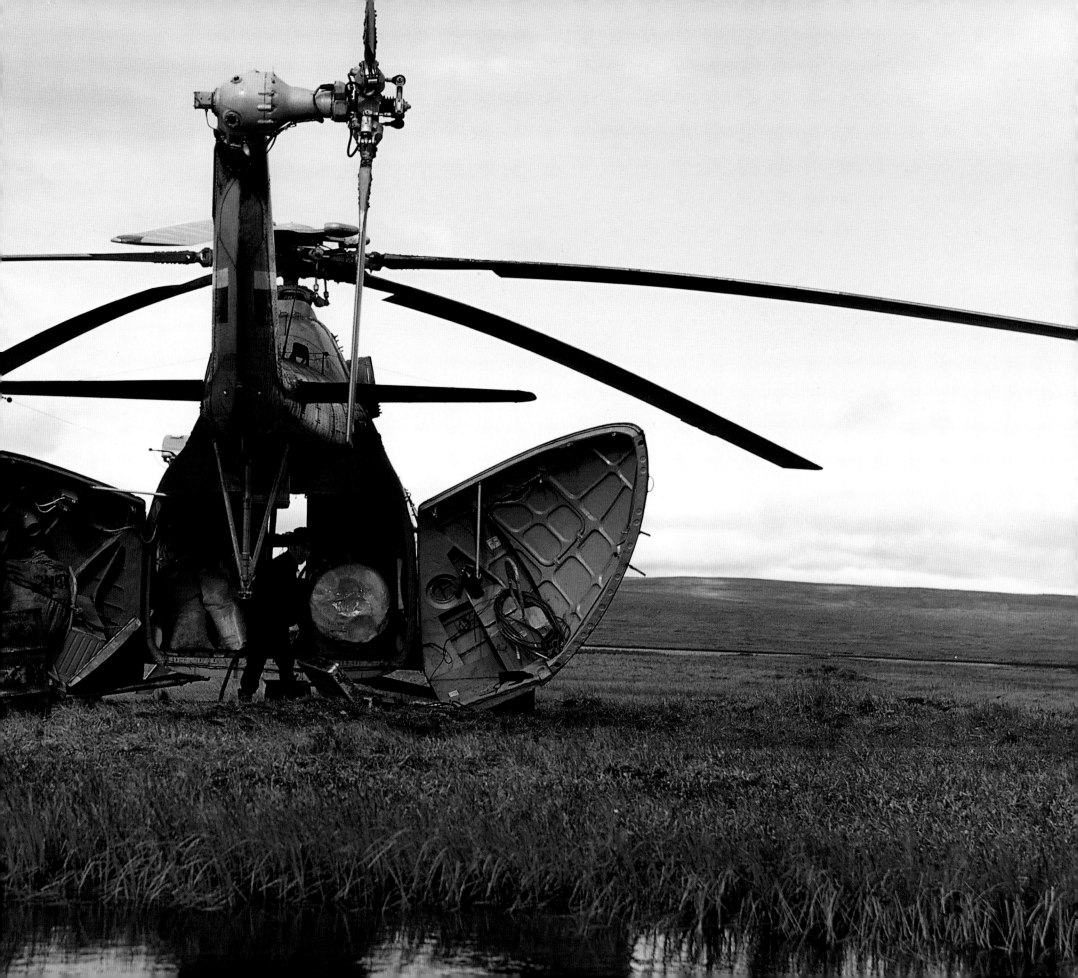

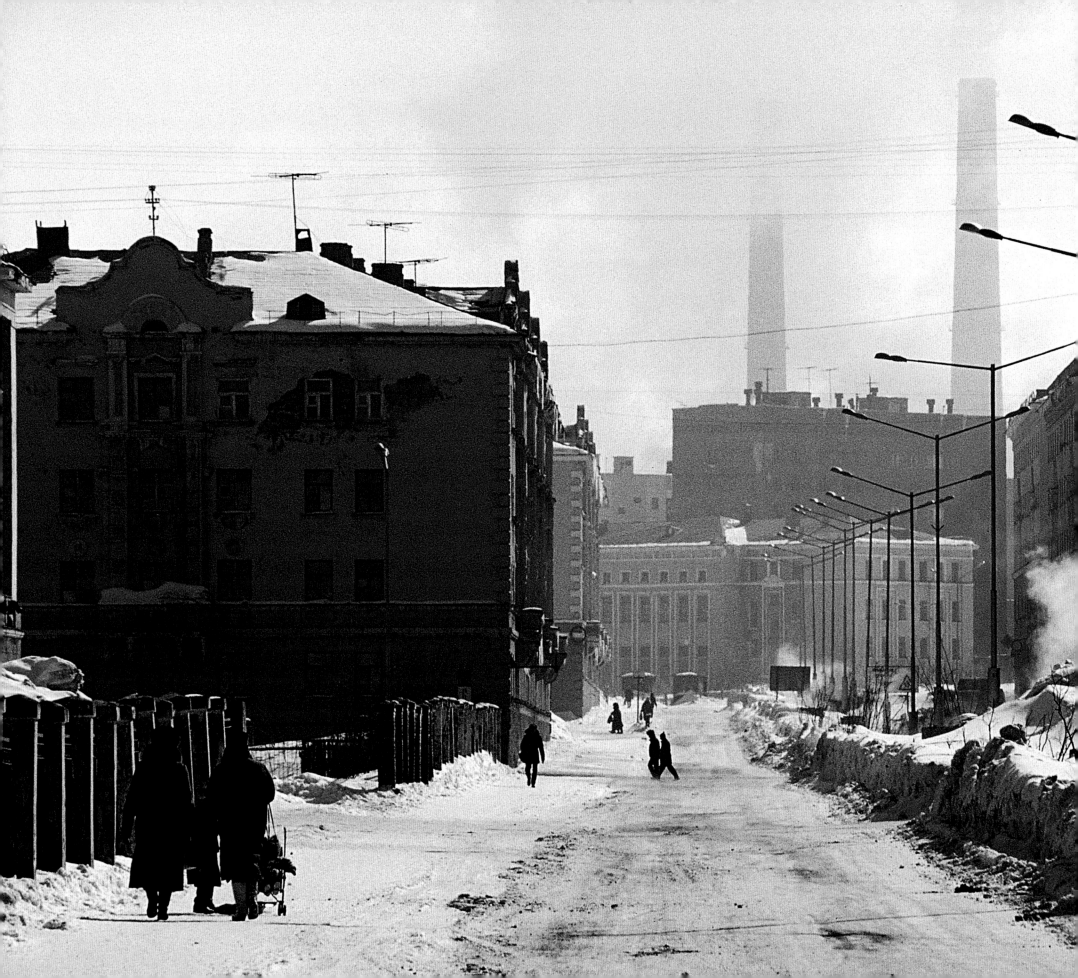

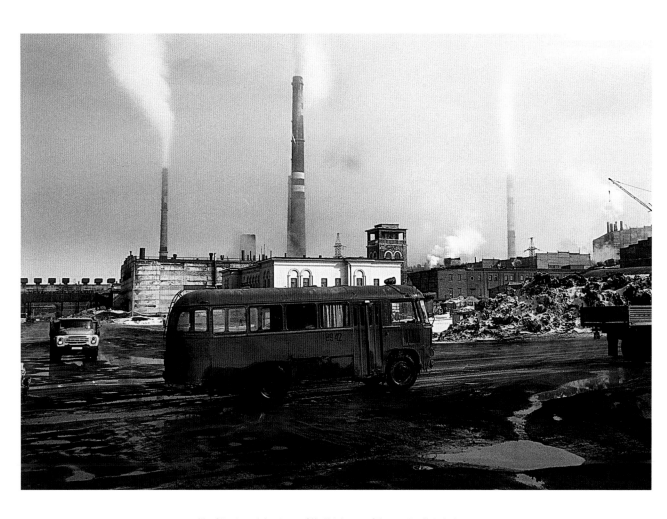

The Siberian mining town of Norilsk is one of the most polluted places
in the Northern Hemisphere, with a population of 133,000 living in
extraordinarily harsh climatic conditions.

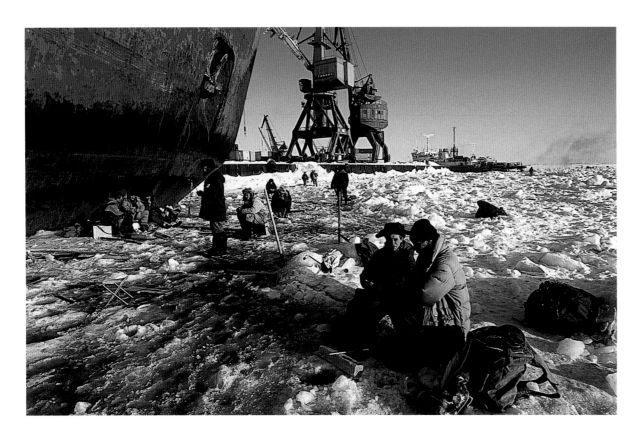

△ ▷ The port of Dudinka, on the Yenisei River in Siberia, is iced over.
Fishermen crouch in the shadow of an imprisoned cargo ship, hoping to
pull a fish from under the ice. In these extreme temperatures, the fish will
be frozen solid as soon as it leaves the water.

▷▷ A perpetual pall of smog hangs over the Norilsk basin. The city pours out
toxic fumes that poison the lichen and vegetation for hundreds of miles around,
pushing reindeer herds and wild fauna farther and farther afield for sustenance.

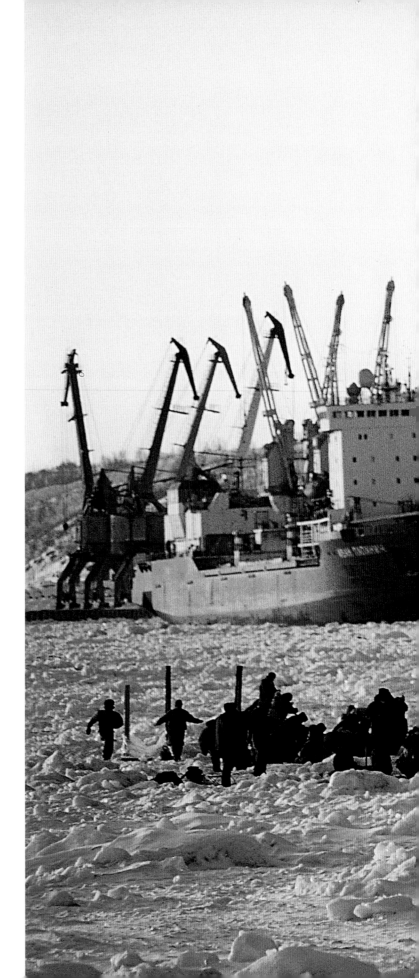

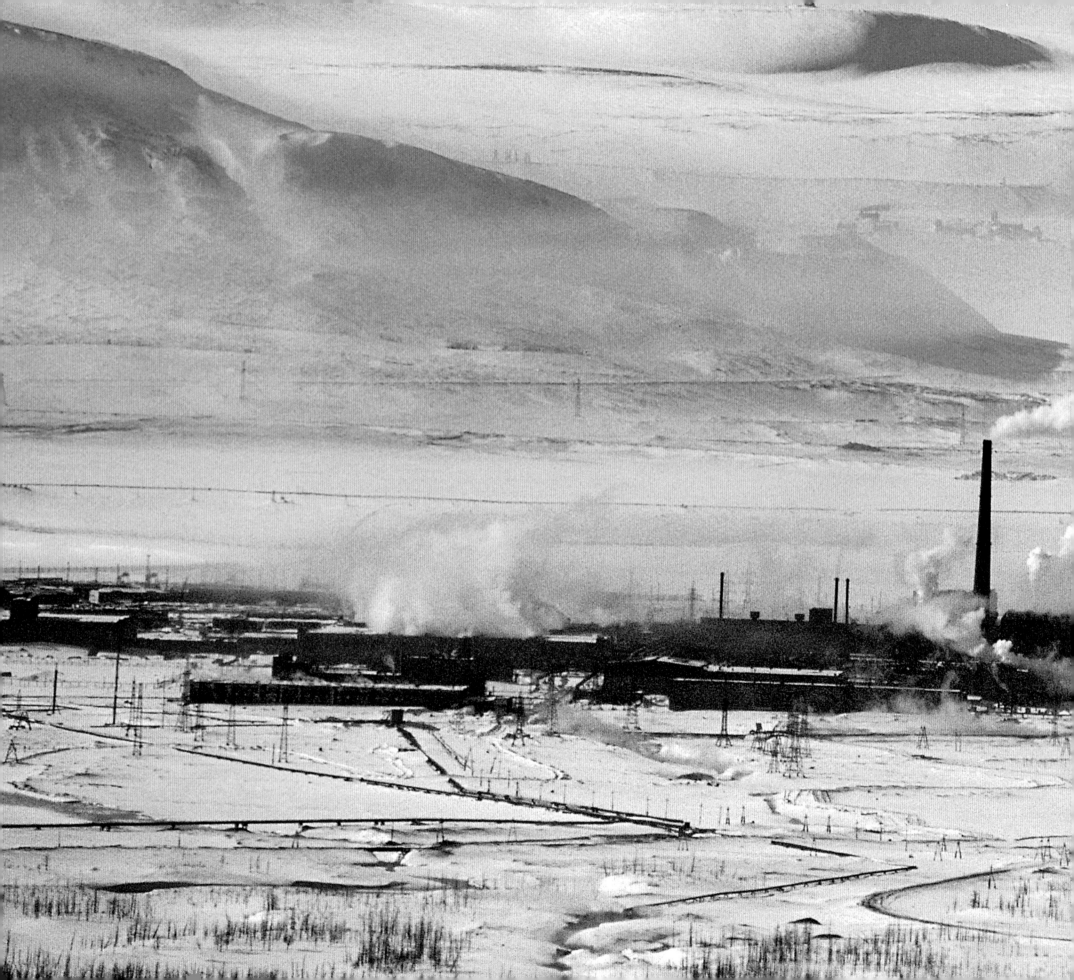

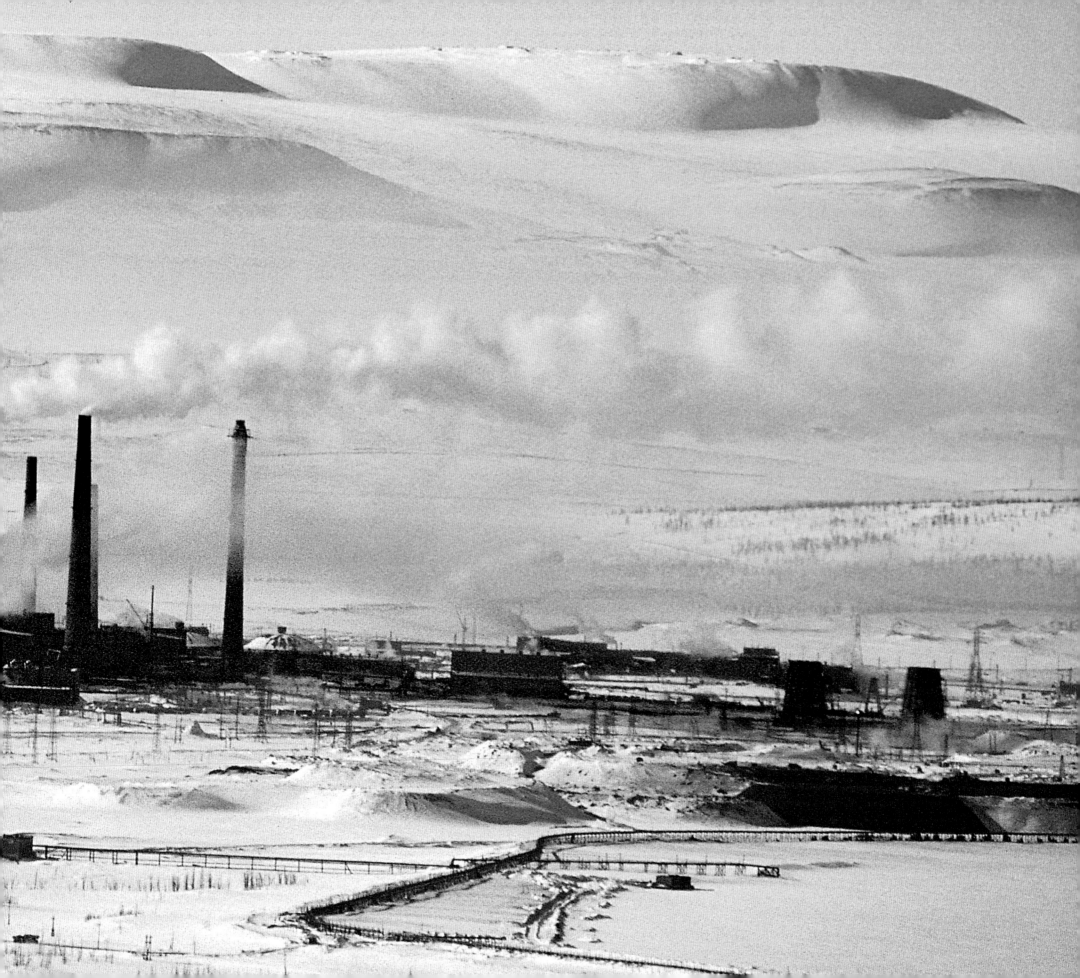

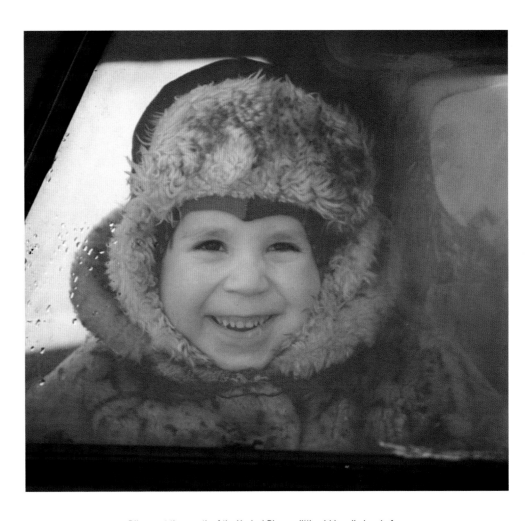

Dikson, at the mouth of the Yenisei River: a little girl bundled up in furs gazes through a frosty windowpane. The old house still has its pre-Stalin colors and embellishments.

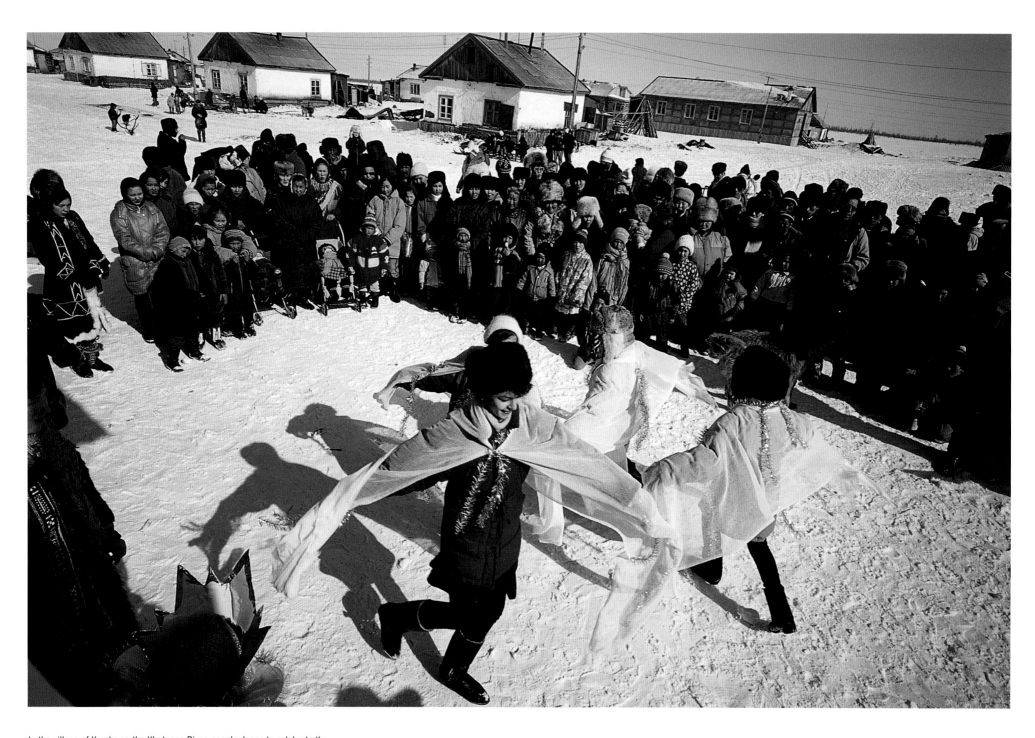

In the village of Kresty, on the Khatanga River, people dance to celebrate the
end of the polar winter—and spring's arrival.

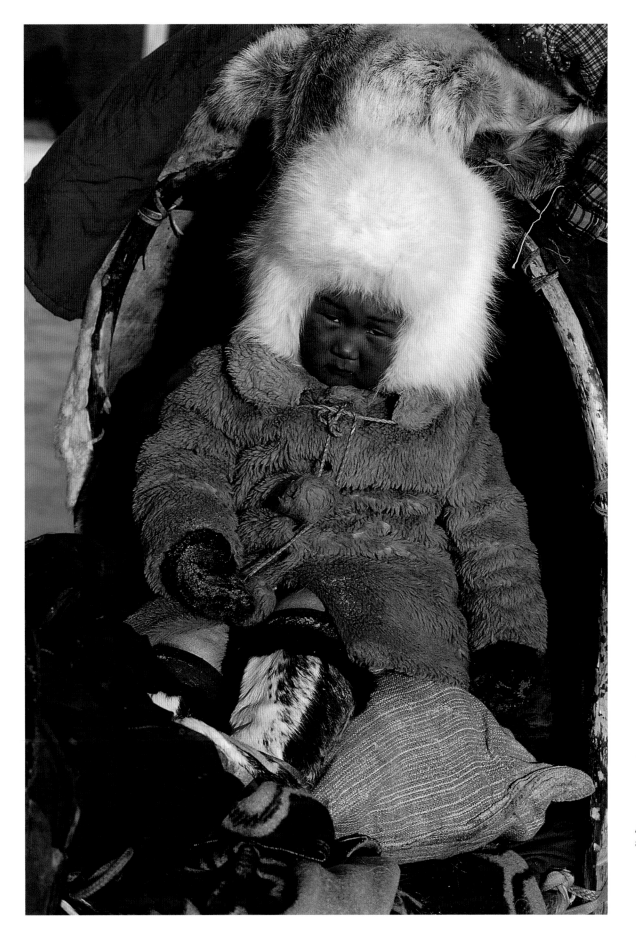

A little girl in her *chapka* made of arctic fox fur.

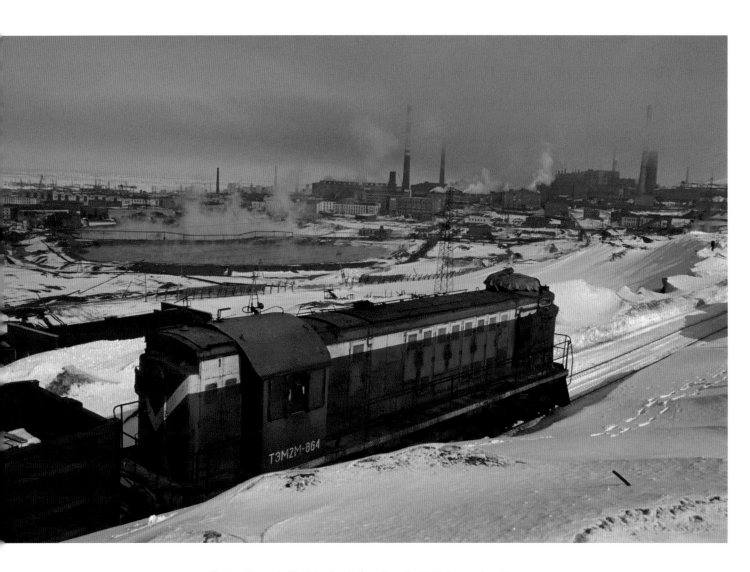

Spring at the port of Dudinka, beside the railway line that brings ore from the
nickel mines of Norilsk. At this time of year, the gigantic loading cranes are
moved from the docks to a place higher up in the town in the expectation that
melting snow will raise the river level by more than seventy-five feet.

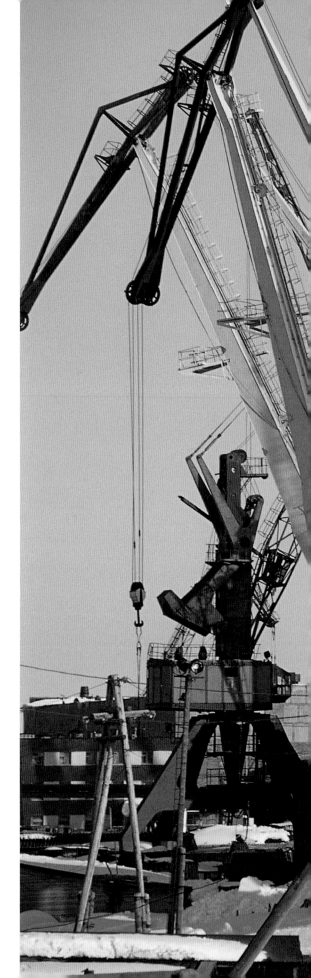

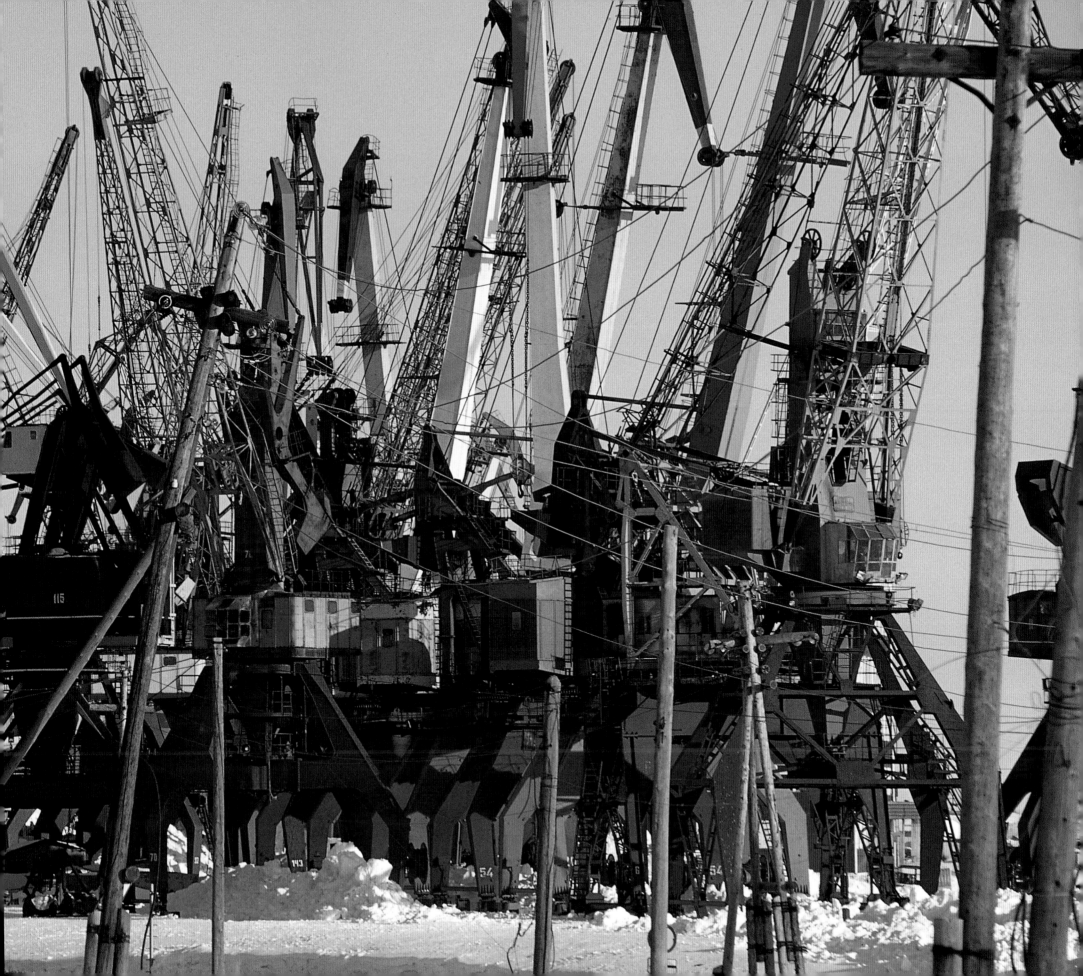

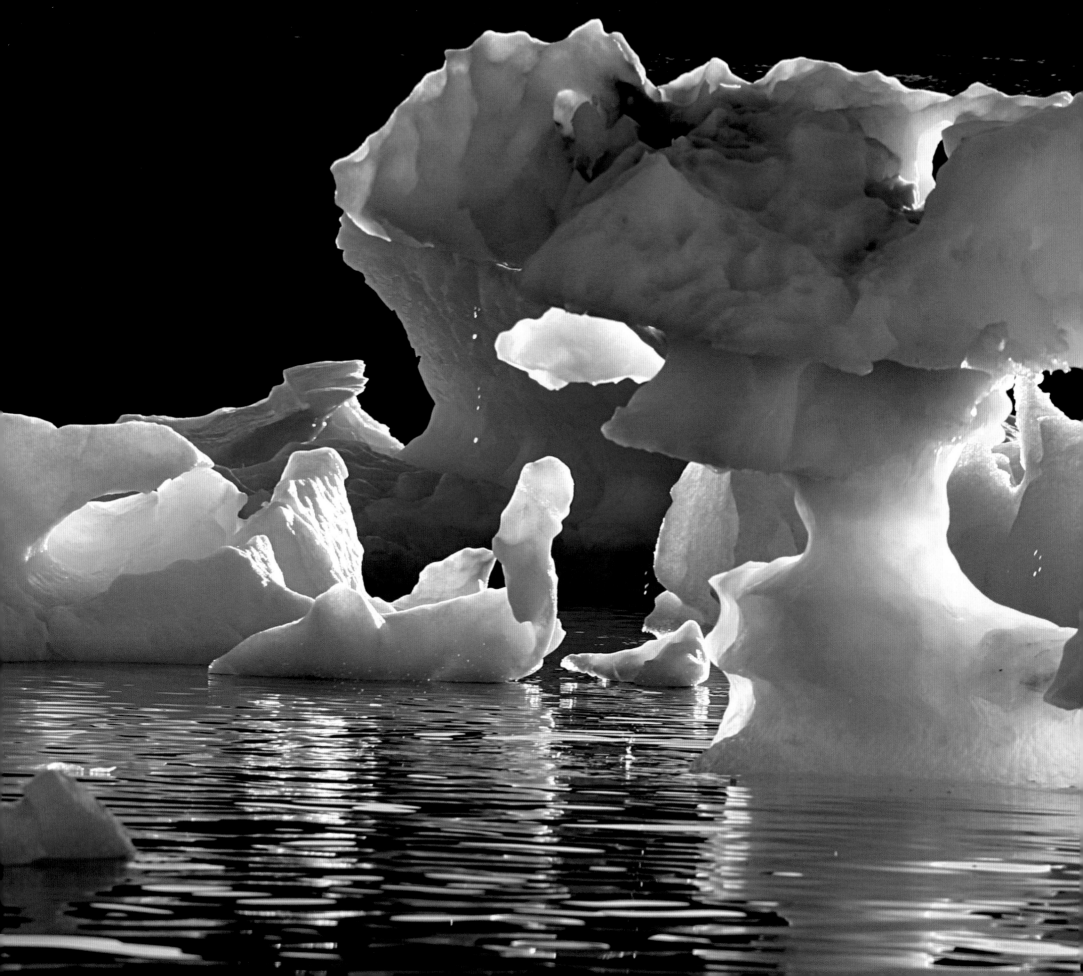

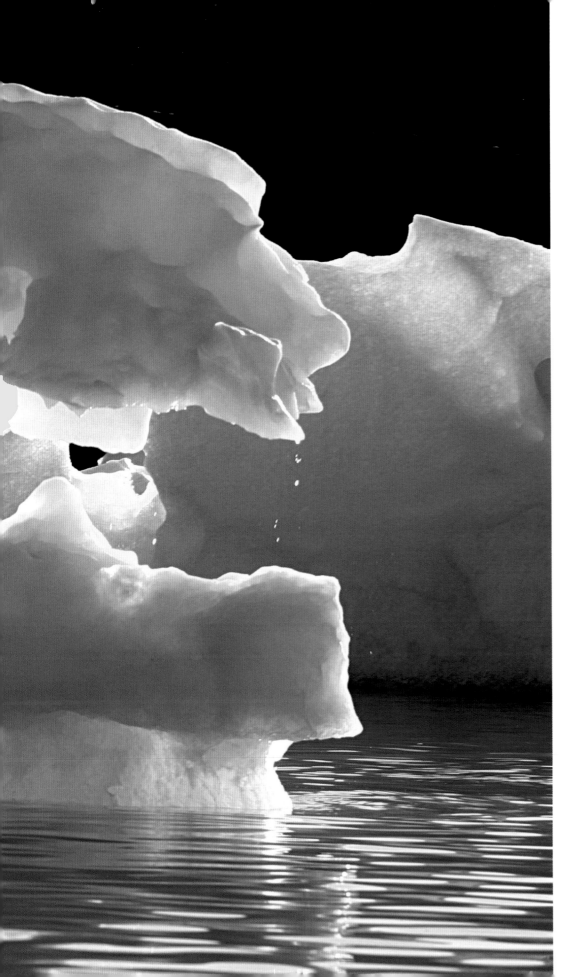

Heat Wave
IN THE ARCTIC

THE CIRCUMPOLAR REGIONS HAVE BEEN the first casualties of global warming and of its unbelievably swift consequences. According to a study published in October 2004 by Arctic Climate Impact Assessment (ACIA), the Arctic is warming twice as fast as the rest of the planet. It is predicted that greenhouse gases in the atmosphere will increase the mean temperature at the North Pole 4–7°C by the end of the twenty-first century. Even now, the ice floe (or ice sea) has lost more than 8 percent of its surface area and 40 percent of its thickness in the course of the last three decades. At this rate, the *inlandsis*, or Greenland ice cap (comprising an area of 656,374 square miles and 90 percent of the Northern Hemisphere's reserve of fresh water) has begun to melt away—literally. Everywhere in these regions the effects of global warming have become perceptible, threatening the entire population of some 3.5 million people (half a million of whom are indigenous) and smashing the fragile equilibrium of their ecosystems.

In the last fifty years, the temperature has increased by 20 percent in Alaska and Siberia to an average of 5.5°F. In the Canadian Northwest, the winters have become warmer by about 5°F, with an average of 7.2°F. The great glaciers of Greenland are retreating. The seafront of the Sermeq Kujalleq glacier, which delivers immense icebergs into the Kangia fjord at Ilulisat on the west coast, has fallen back seven miles since the 1960s; the mighty Kangerdlugssuaq on the east coast has become one of the world's fastest-moving glaciers at a speed of nine miles per year, compared with the three miles per year at which it was traveling in 1988. The immense Ward Hunt Ice Shelf (171 square miles), which formed more than three thousand years ago north of Nunavut in Canada, began breaking up in 2003. Freshwater is pouring into the Atlantic Ocean due to the melting ice, altering its salinity and affecting the spread of algae, which constitute the first link in the food chain for fishes and marine mammals.

The permafrost is also warming. Permafrost is made up of earth, vegetable matter, and ice and is up to fifteen hundred feet deep. This frozen mix covers some four million square miles in Siberia, Canada, and Alaska. Its surface,

Icebergs from the mighty glaciers of Canada and Greenland break up
and melt in the summer sun.

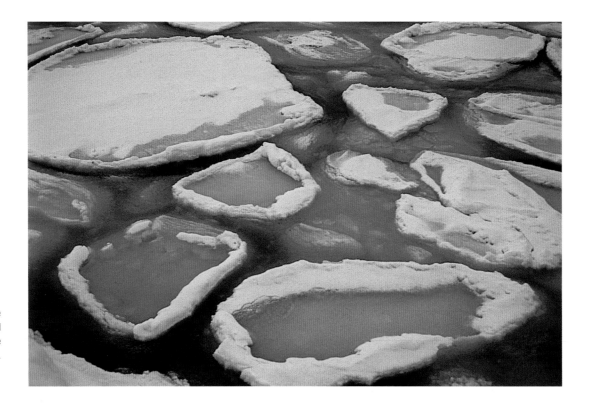

At a temperature of 28°F, the water freezes into lily-pad shapes, which then fuse together to form the ice shelf.

which varies in thickness from a few inches to twelve feet, thaws temporarily in summer and supports a fragile growth of vegetation, which vanishes as soon as the cold returns. Various scientific studies—notably that of the Russian botanist Sergei Kirpotin—show that a deep thawing of the permafrost layer has now commenced on a scale that has not been seen in the last eleven thousand years. The risk is clear: The tundra has begun to transform into a swamp, releasing incalculable quantities of methane gas presently fossilized in the ice. The astrophysician Herbert Reeves has compared this gas to a "sleeping dragon". Its contribution to the greenhouse effect will be gigantic.

Already the polar peoples are paying the price of global warming. The melting of the permafrost is destabilizing infrastructures, nudging roads, and altering landscapes. Towns, airports, and pipelines are seriously threatened in Siberia. The six hundred Inuit inhabitants of the Alaska village of Shishmaref have lost the protection of the ice jam, causing winter storms to carry away their land, the school playground, and their fish-drying installations. Since 1997, a score of houses have been moved, raised onto sleds by cranes and hauled over the ice to less vulnerable zones. The people of Shishmaref are among the first victims of a new form of migration—climatic migration. Hunters and fishermen are seeing their traditional livelihoods wither away. The ice shelf, formerly a paradise for seals, now forms much later in the year, and when it does, it is infinitely more fragile than before. The Inuits who dare to move across it run a higher risk of

drowning. Their hunting season has been significantly shortened. In northern Greenland, many are doing away with their dog teams, which no longer serve a purpose and are too expensive to feed. The milder temperatures have caused the burrows of lemmings and voles to collapse, severely disturbing reproductive cycles. As a result their natural predators, the ermine, snowy owl, and weasel, are also under unaccustomed pressure. During the summer months the heat brings forth vast swarms of mosquitoes and flies. The vegetation is also changing; northern forest is closing in on the Arctic tundra, and highly destructive insects like the typographer beetle, which ravages that forest, have proliferated.

Mosses and lichens, which represent 70 percent of the food eaten by reindeer and caribou, are also vulnerable to climate change. The Lapps or Samis, herders in northern Norway who depend on about two hundred thousand head of semi-domesticated reindeer, have noticed a steady decline in their stock. It seems that despite the reindeer's ability to detect lichen through several inches of snow, *they are no longer able to uncover it*. In the last few years the Norwegian lichen pastures have been subjected to frequent freezing and melting, which have led to the formation a hard crust of ice that the animals are unable to break with their hooves. They exhaust themselves in the attempt and perish of malnutrition. The Canadian Inuits have reported similar phenomena.

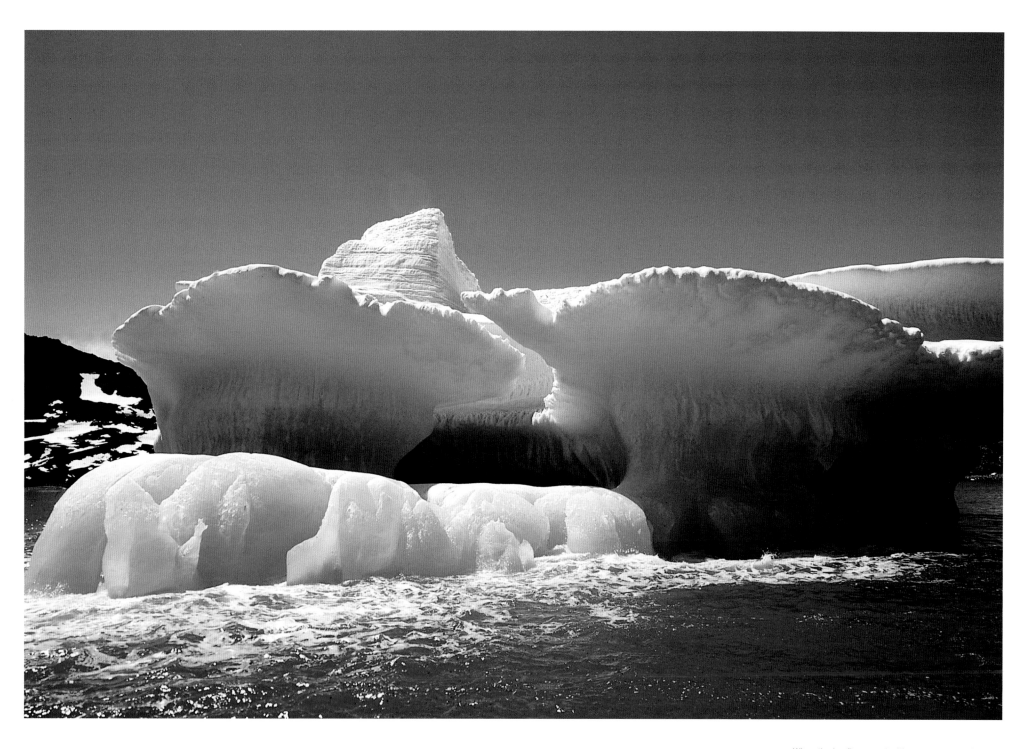

When the ice floes meet with warmer water, they are
transformed into exquisite, transparent sculptures.

For example, the number of caribou around Peary, in Ellesmere Land, has steeply declined, from twenty-six thousand in 1961 to one thousand in 1997.

But the creature most vulnerable to global warming is the polar bear, the world's largest carnivore. At present there remain only twenty-five thousand of these beasts in the Arctic. The male polar bear may weigh up to 1,700 pounds and the female 660 pounds—provided they are able to remain on the ice shelf from November to May, where they can hunt alone for seals and white whales. There they gorge themselves on fresh meat, building reserves of fat that will see them back to dry land, where the females build their dens and give birth to their cubs.

With the shrinking of the ice shelf—which spells the ruin of their playground and food store—the polar bear is suddenly fighting for survival. The twelve thousand currently living west of Hudson Bay are showing signs of fragility as a consequence of the breakup of the ice earlier in the year. According to the Canadian Wildlife Service, their birthrate has been steadily declining for the last fifteen years because undernourished females are too weak to feed their cubs through the period of hibernation. Worse, the cubs themselves—which are born in the fall and spend their first months in a den with their mothers—must now emerge the following March and learn to find their own food when the sea ice has begun to dwindle drastically. As a result, today's cubs have lost an average of 15 percent of their body weight in comparison with their predecessors.

Even more disturbingly, polar bears are now affected by persistent organic pollutants (POPS): pesticides and chemical wastes spilled into the environment—especially into the water—as a result of industrial and agricultural activities. Riding the ocean currents, these pollutants flow to cold zones. They penetrate the algae eaten by fish who are eaten by seals and then end up powerfully concentrated in polar bears at the top of the food chain through the phenomenon of bioamplification. The toxins cause a general collapse of the animals' immune systems, affecting their ability to reproduce and provoking congenital malformations.

Within a relatively short period of time, all the civilizations of the North, along with their environment and everything it contains, have become imperiled. Aware of the danger, the indigenous peoples have formed pressure groups. In May 2005, in Brussels, representatives of the Arctic Council, an intergovernmental forum created to promote circumpolar cooperation, issued an alarm, declaring that what happens in the Arctic is a barometer for the rest of the world. It remains to be seen if the rest of the world will hear that cry and take an economic path more respectful of the environment. In any case, those men of science, more and more determined to unravel the mysteries of the Arctic ice cap before it is too late, are sending out the same message.

Pale sunshine floods the lingering Resolute Bay ice shelf in the far north of Canada, heralding warmer temperatures.

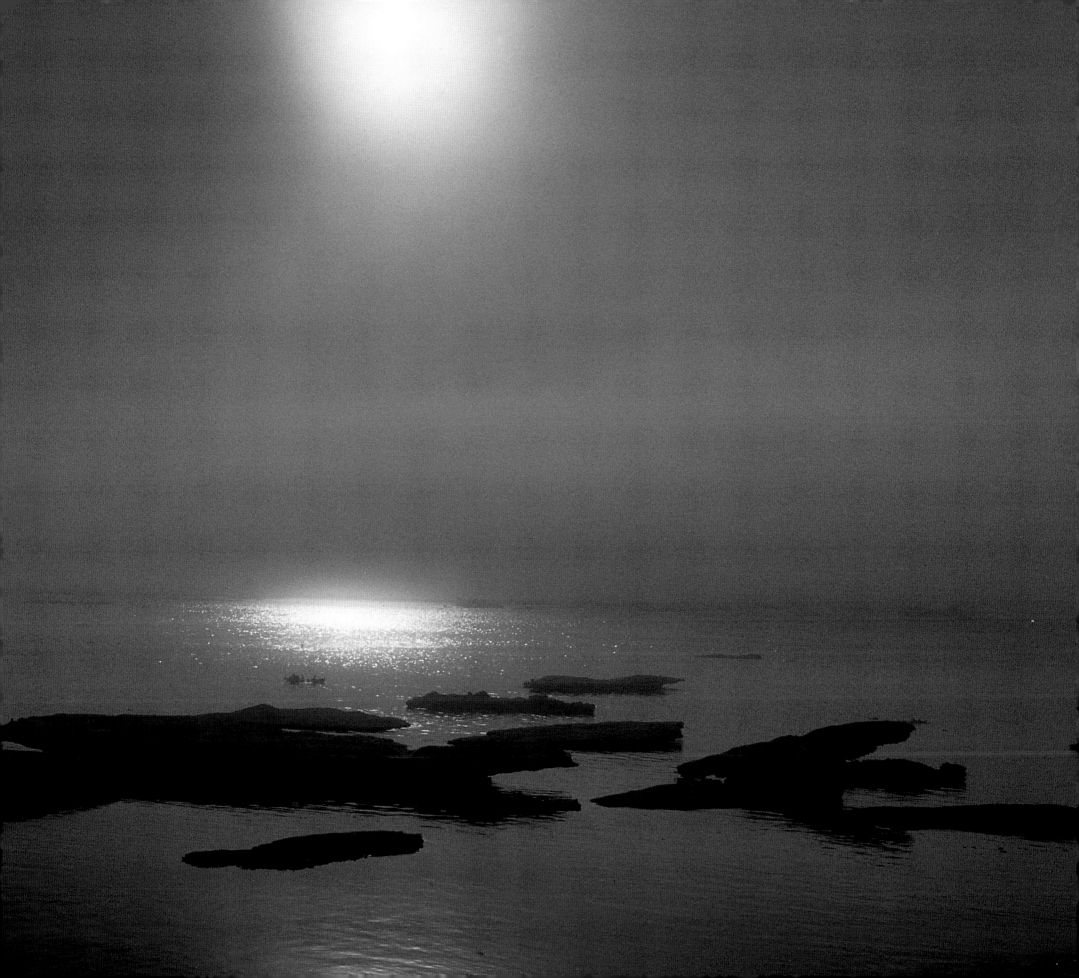

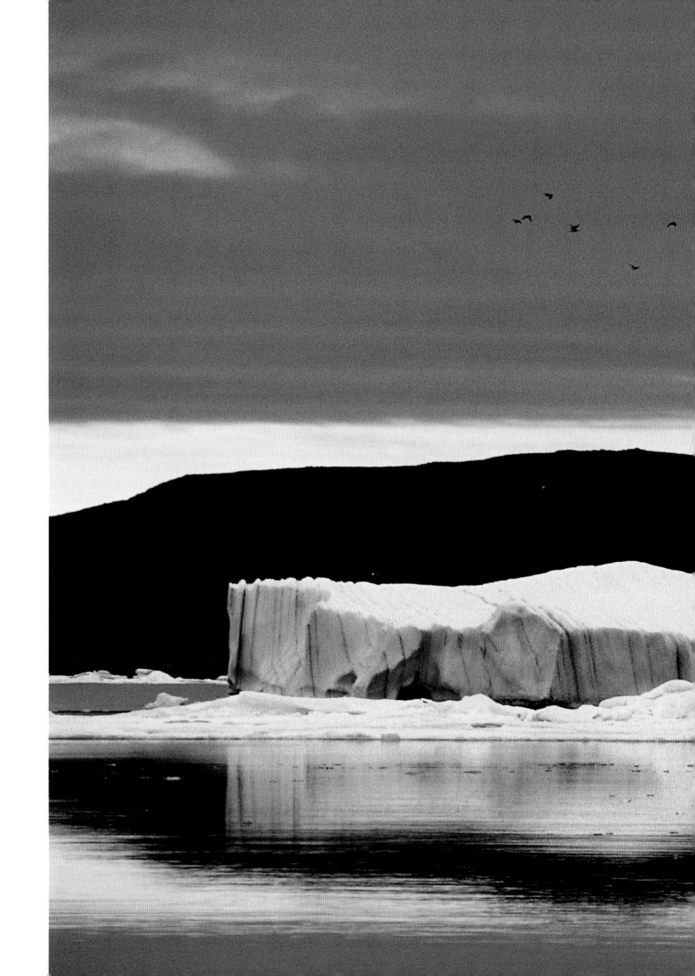

A stormy summer on the shores of Tikhaya Bay in Franz Josef Land, an archipelago lost in the immensity of the Arctic.

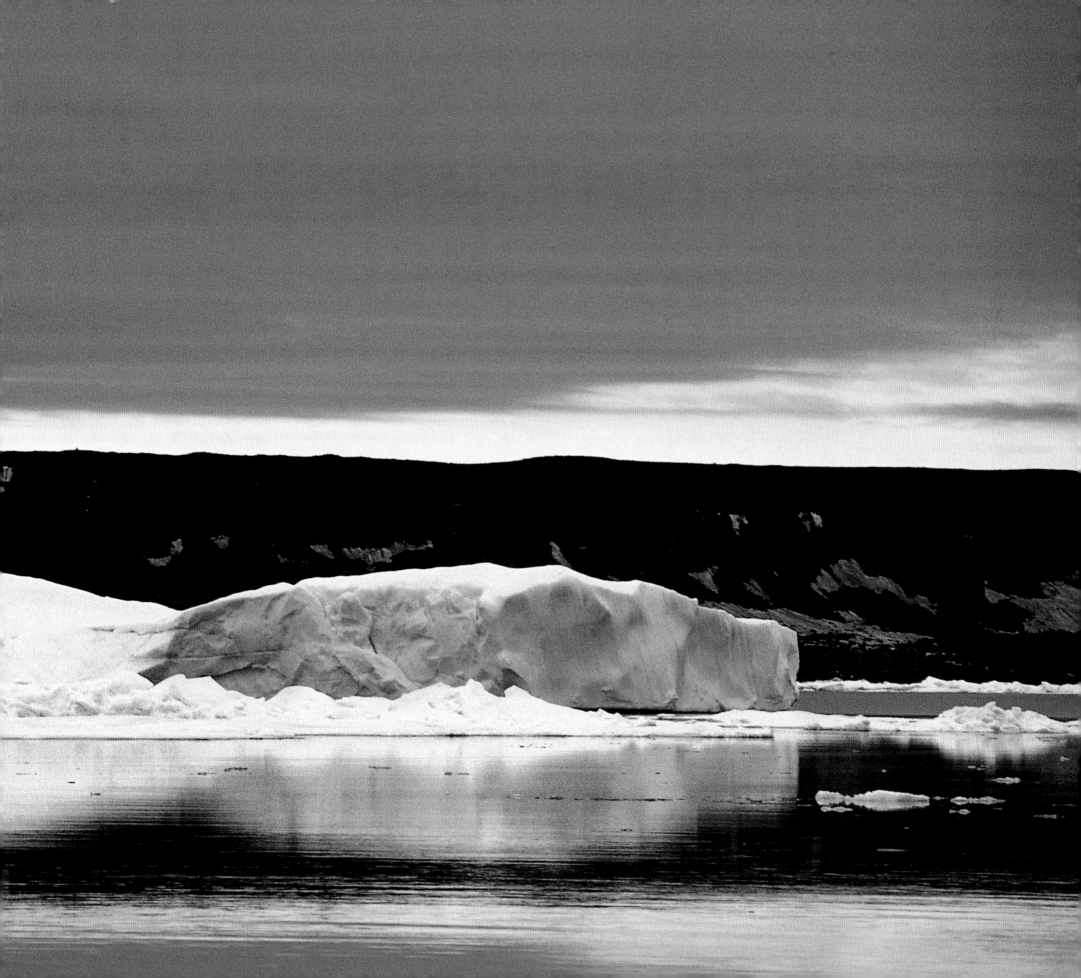

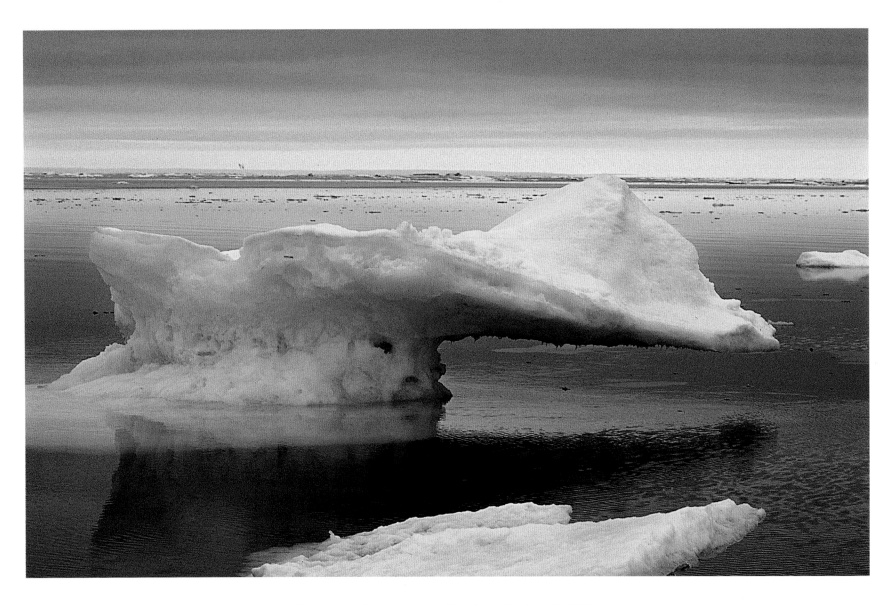

Drifting pack ice in the Nunavut region of Grise fjord, a Canadian Inuit settlement.

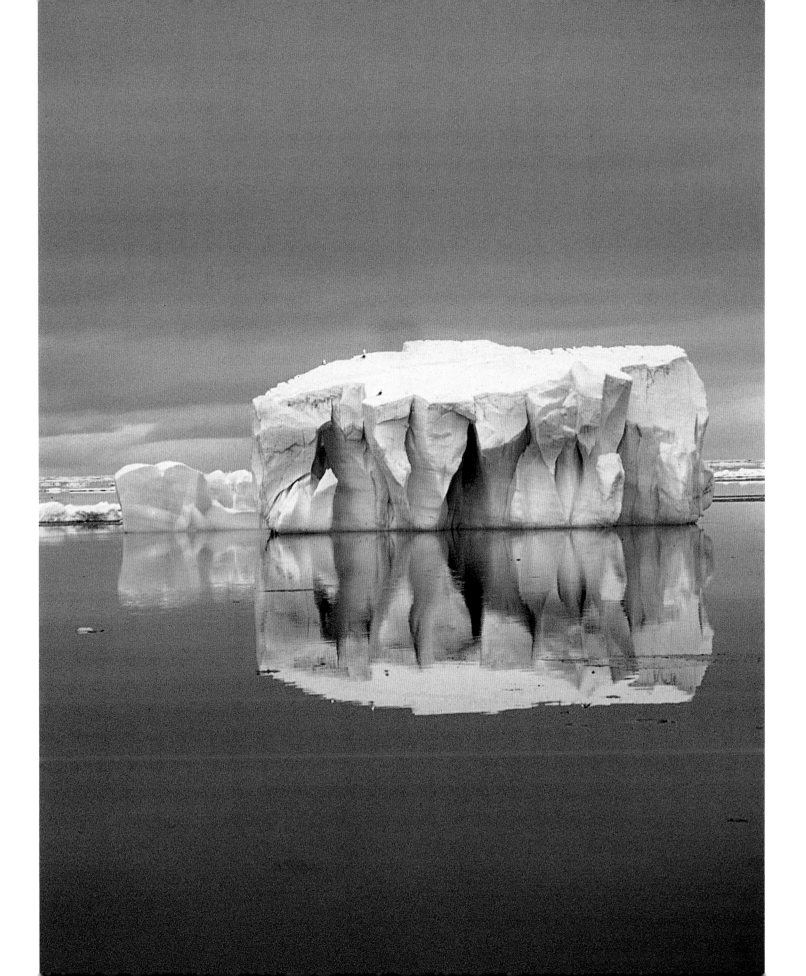

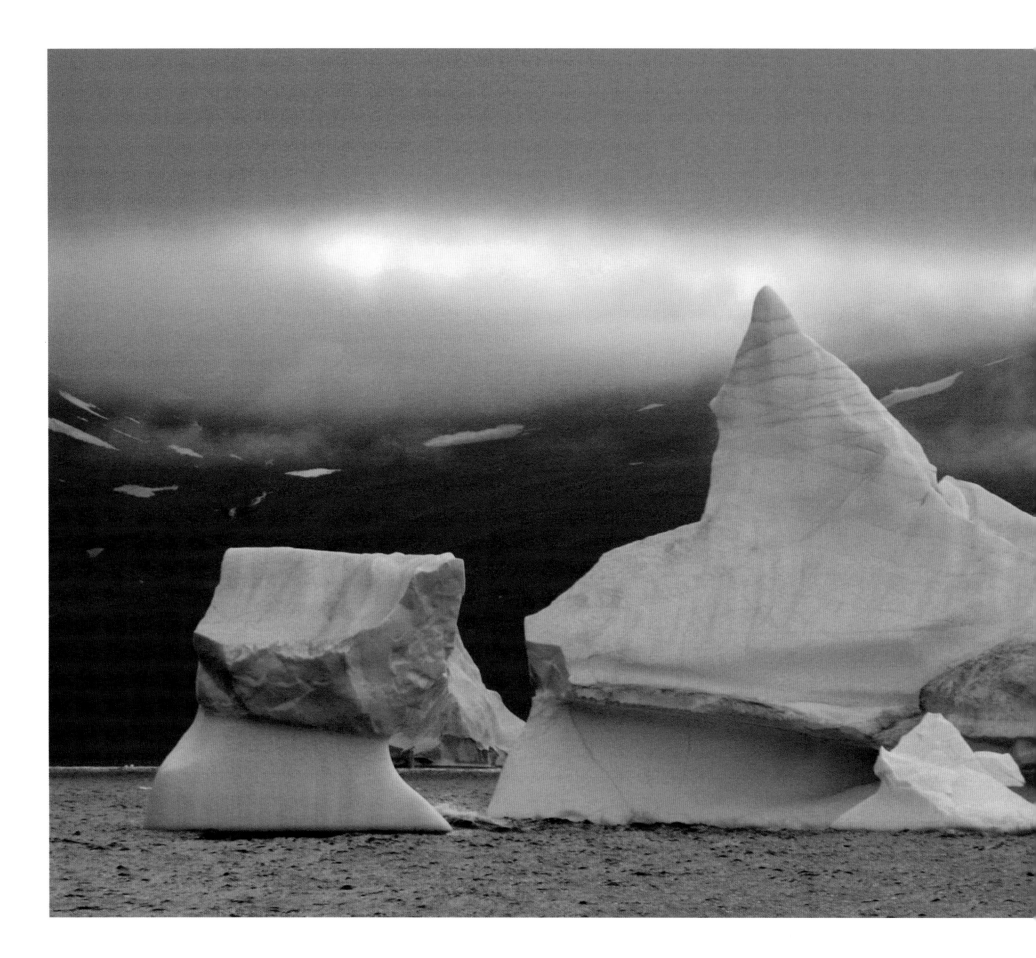

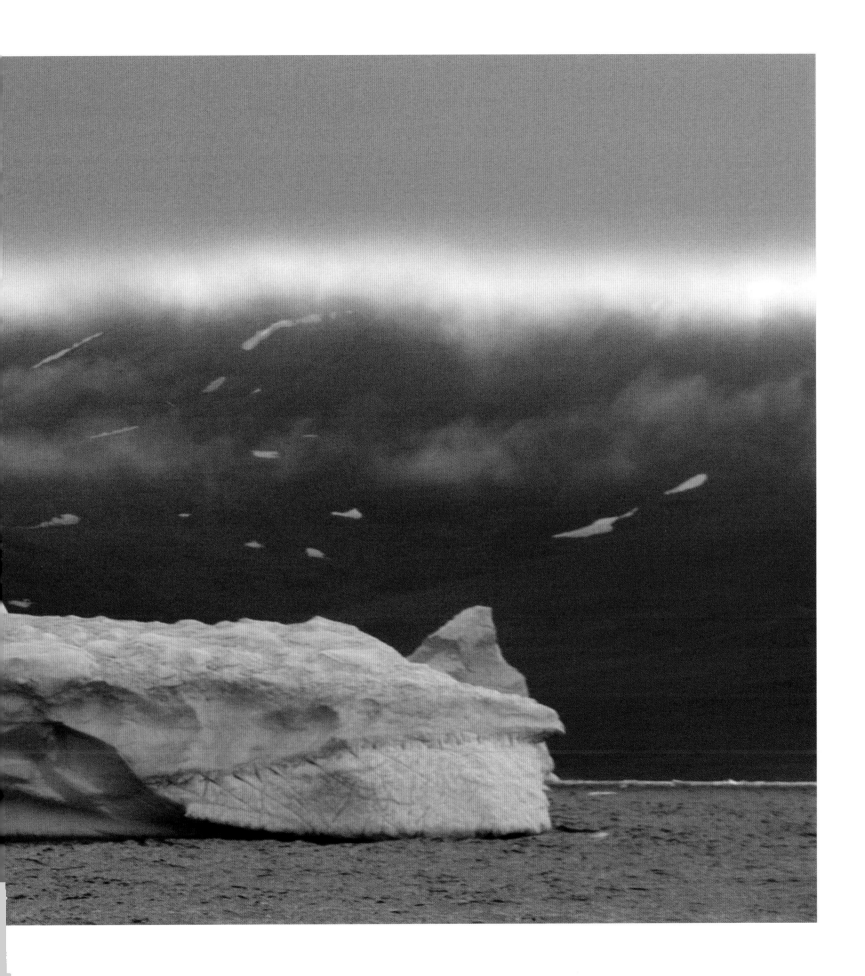

An iceberg looms in the mist along the coast of eastern Greenland, near the village of Ammassalik, made famous by Paul-Émile Victor.

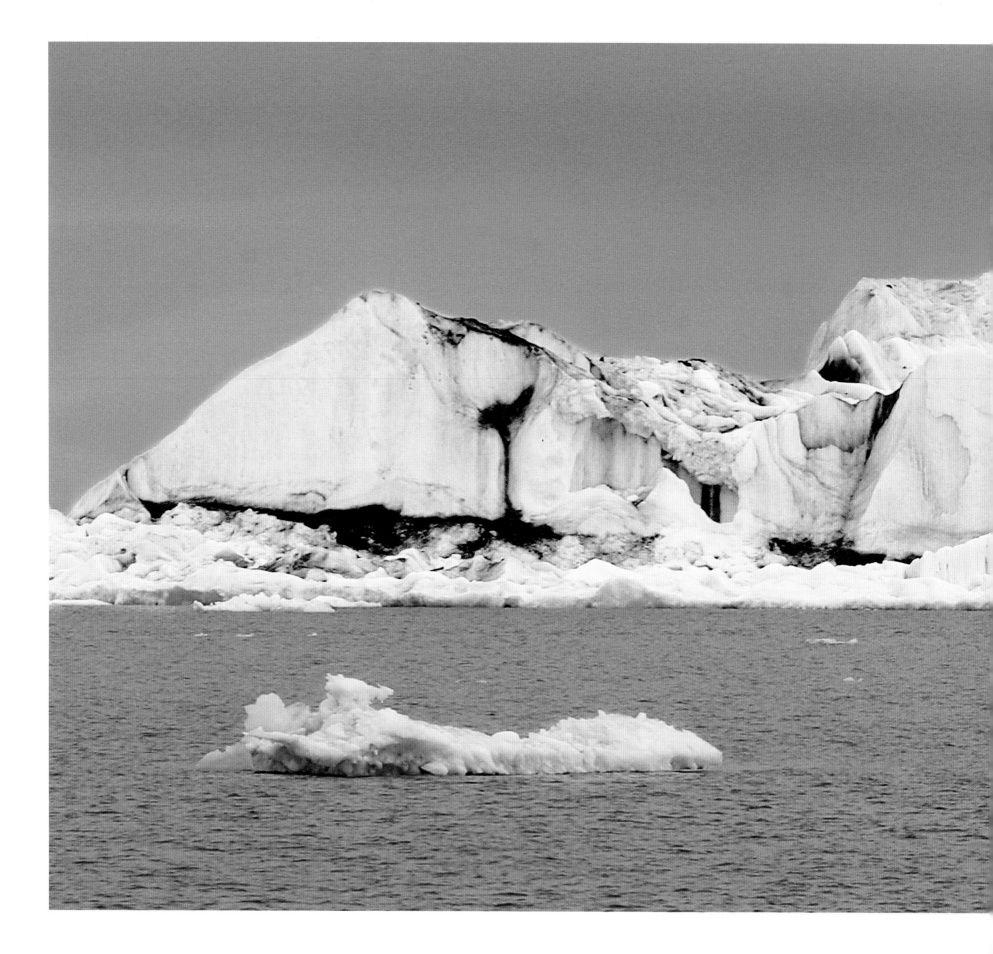

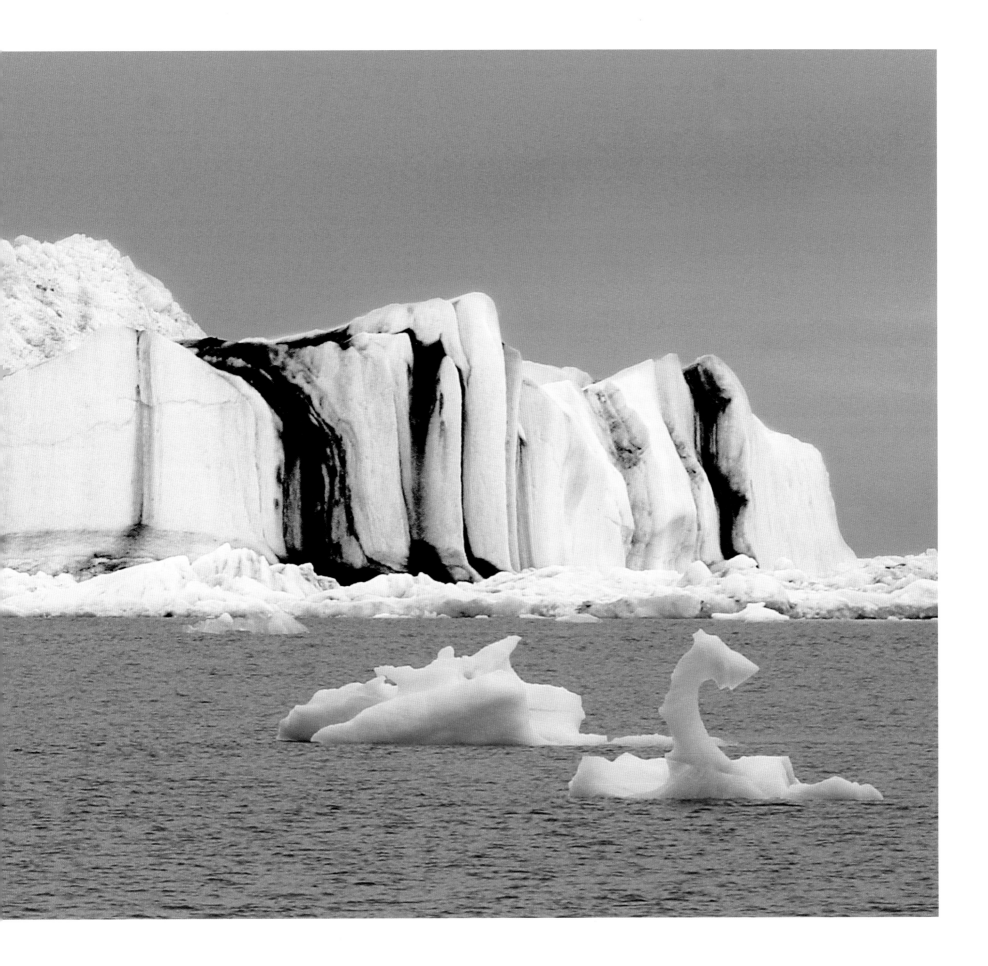

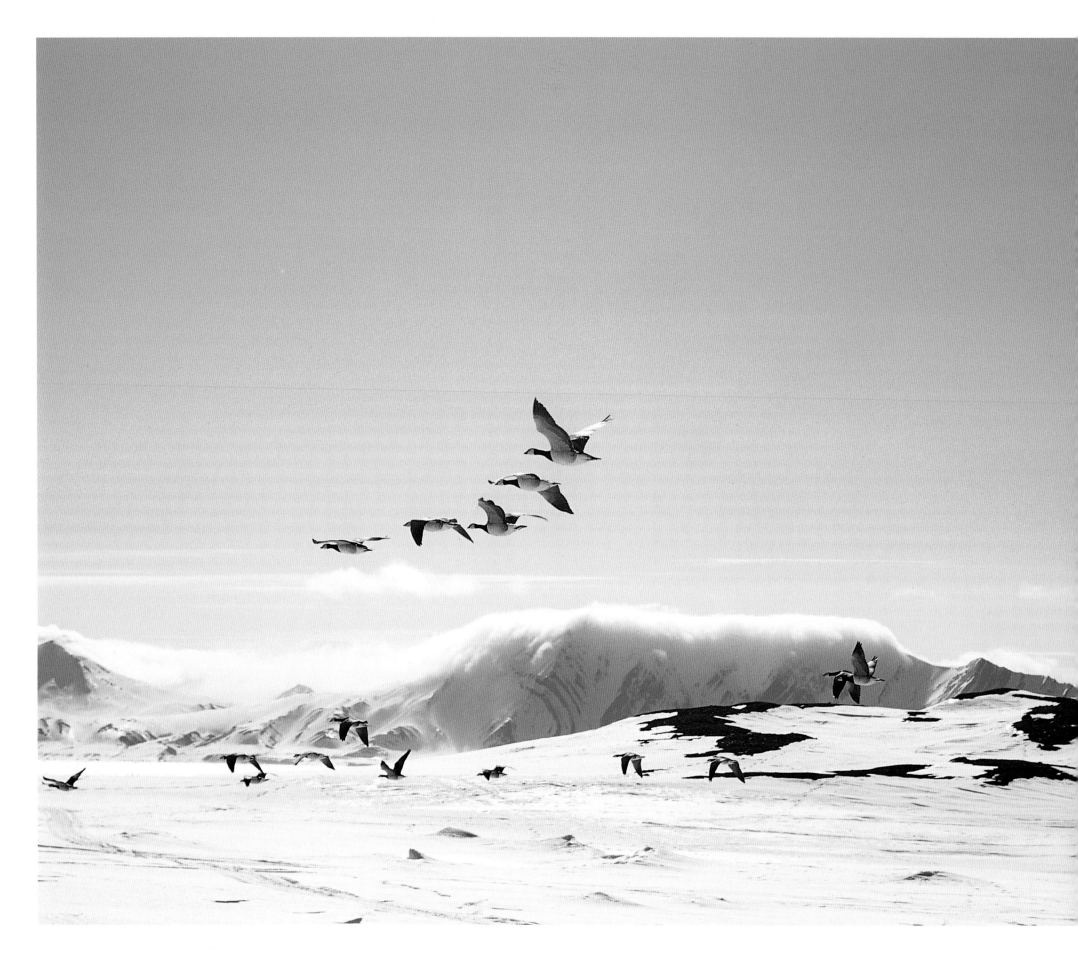

◁◁ The glaciers give birth to mighty icebergs, which are often stained with gouges from the land along their course.

◁ In Siberia, as in all the other regions of the Arctic, spring brings with it a wave of migrating birds. Barnacle geese nest here in large numbers, attracted by abundant food.

▷ A mountain in Franz Josef Land, northern Russia, reflected in the still waters of Tikhaya Bay.

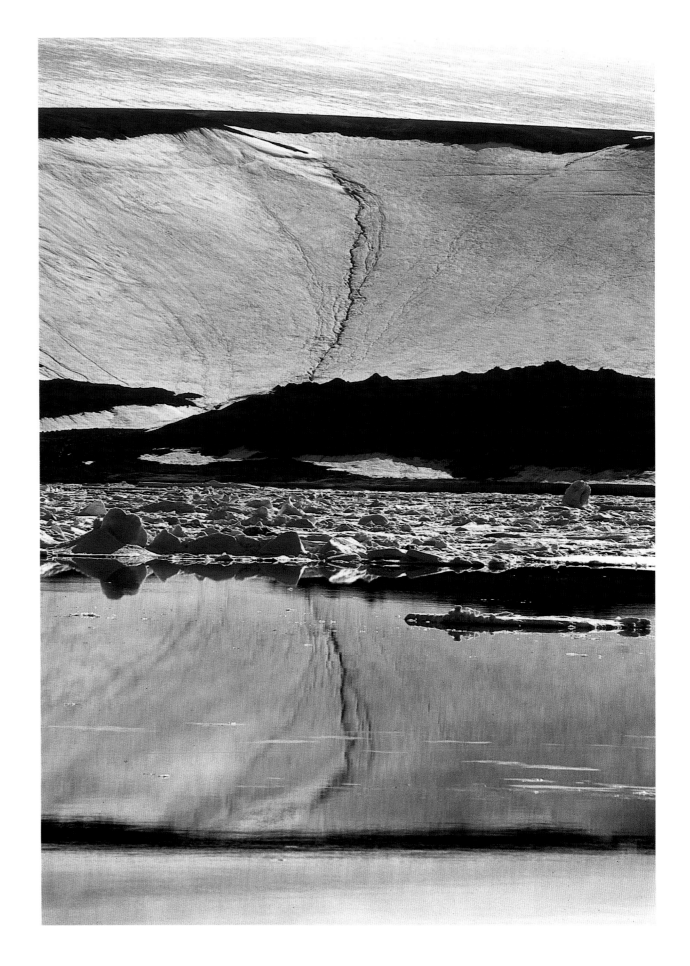

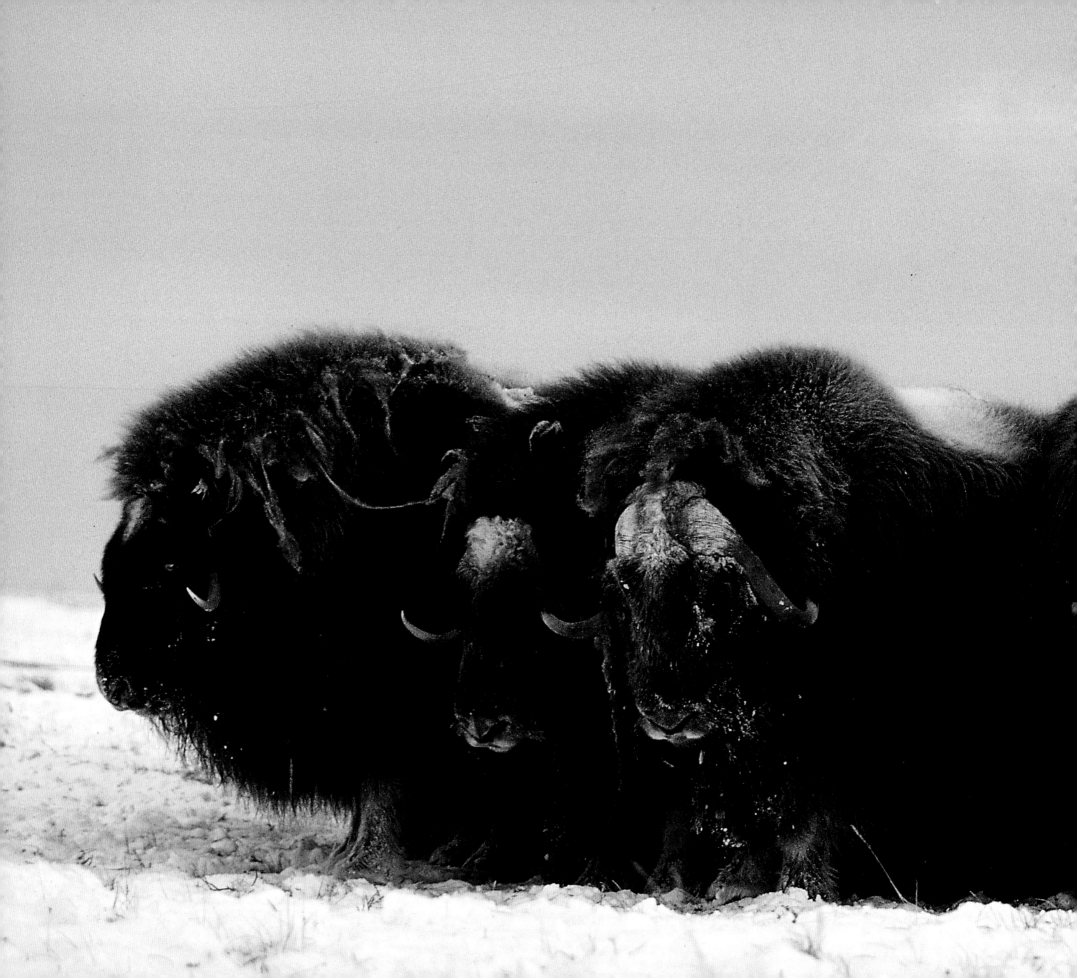

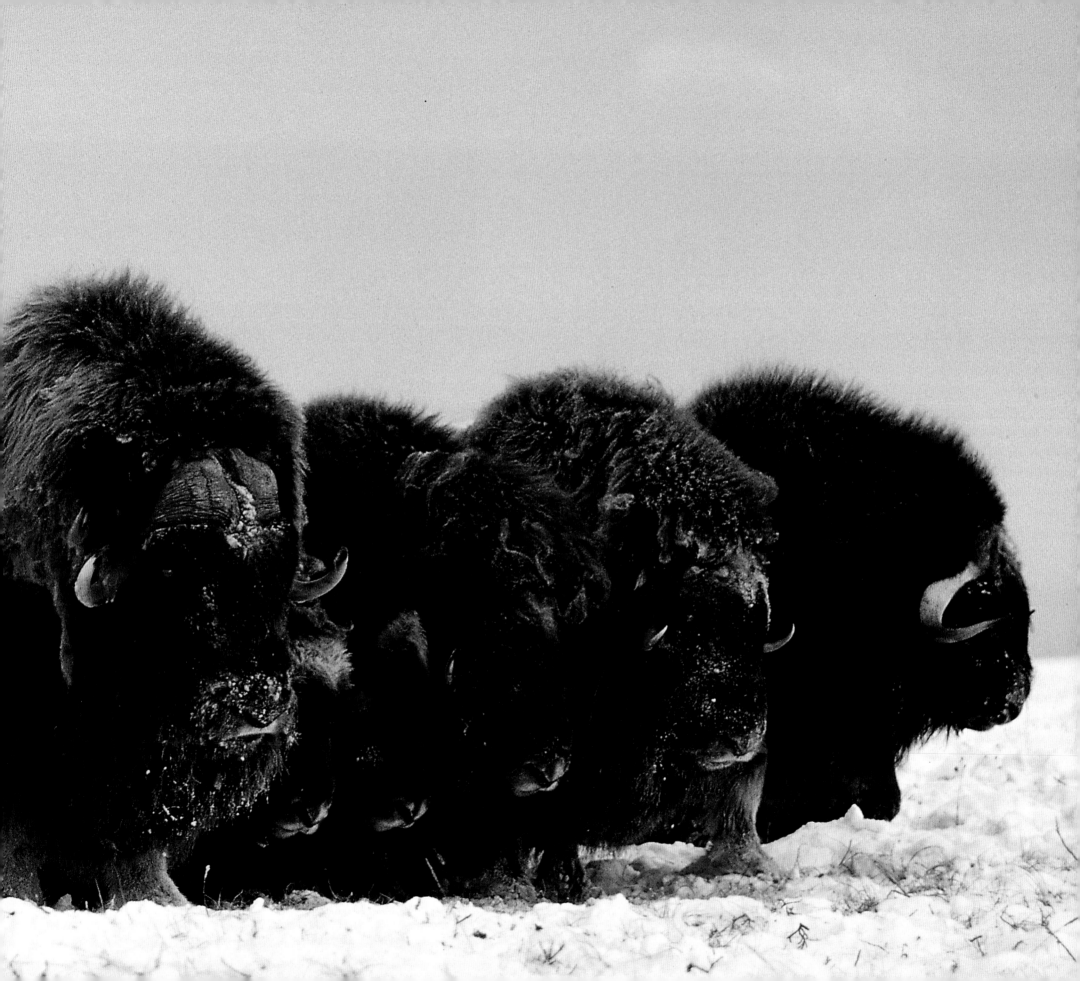

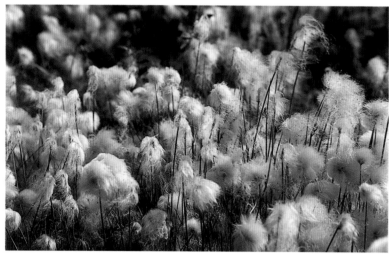

△ ▷ Vegetation proliferates in the brief summer, with arctic poppies, mushrooms, cotton grass, and lichen appearing in a matter of days.

◁◁ Musk oxen, herbivorous creatures of a similar antiquity to the mammoth, are found throughout the tundras of Canada and Greenland. When danger from attack threatens, the big bulls rally to protect the cows and their calves.

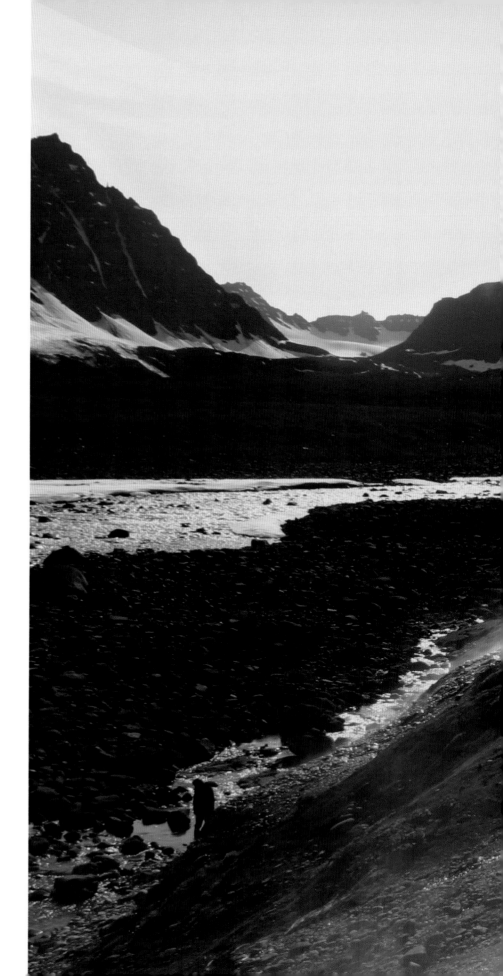

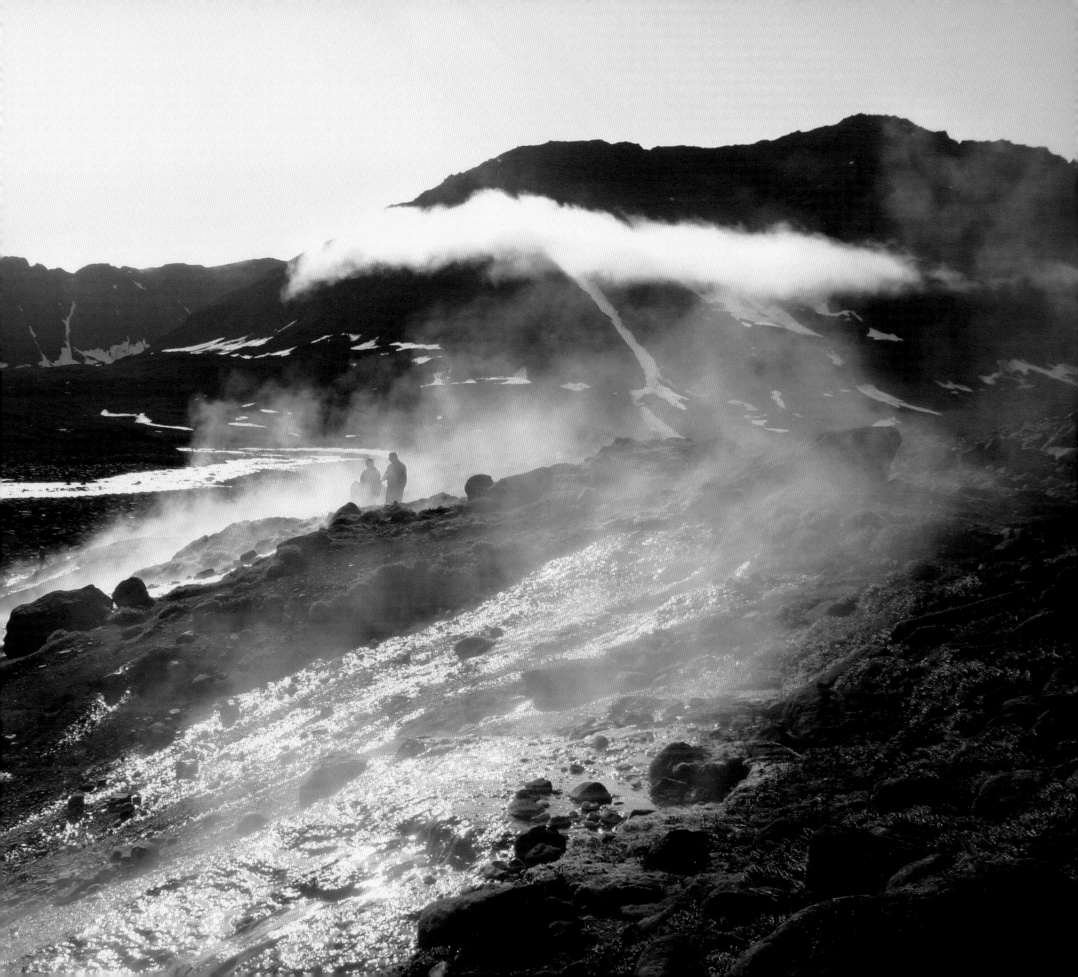

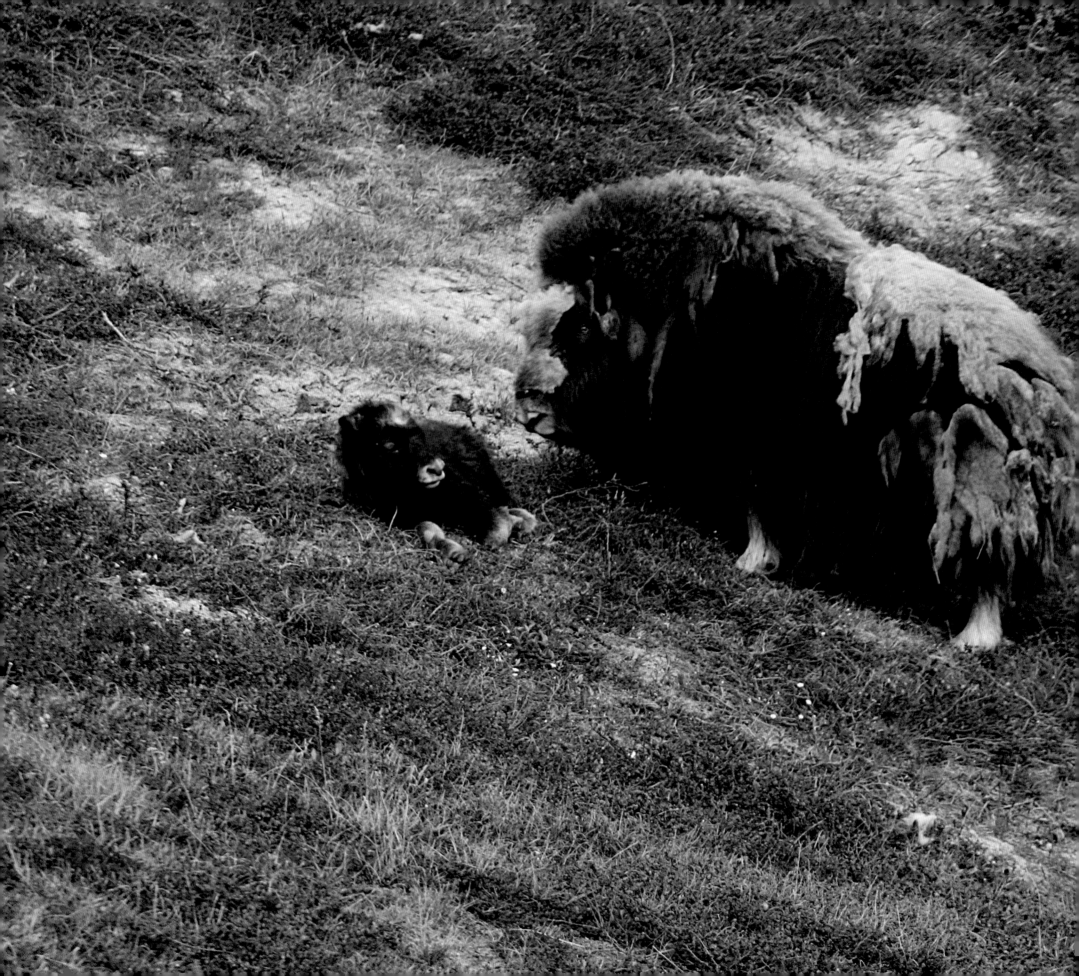

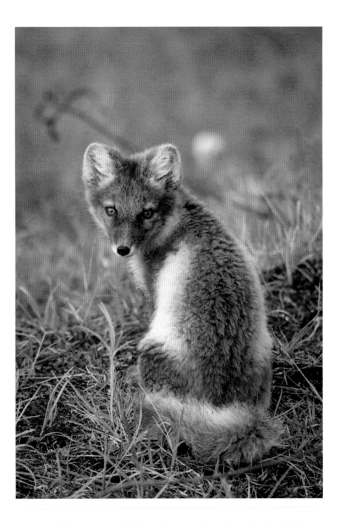

△ A Siberian fox stalking lemmings—its favorite food—in a field of cotton grass.

◁ A musk ox protecting her young. In the summer, the animal sheds its thick pelt.

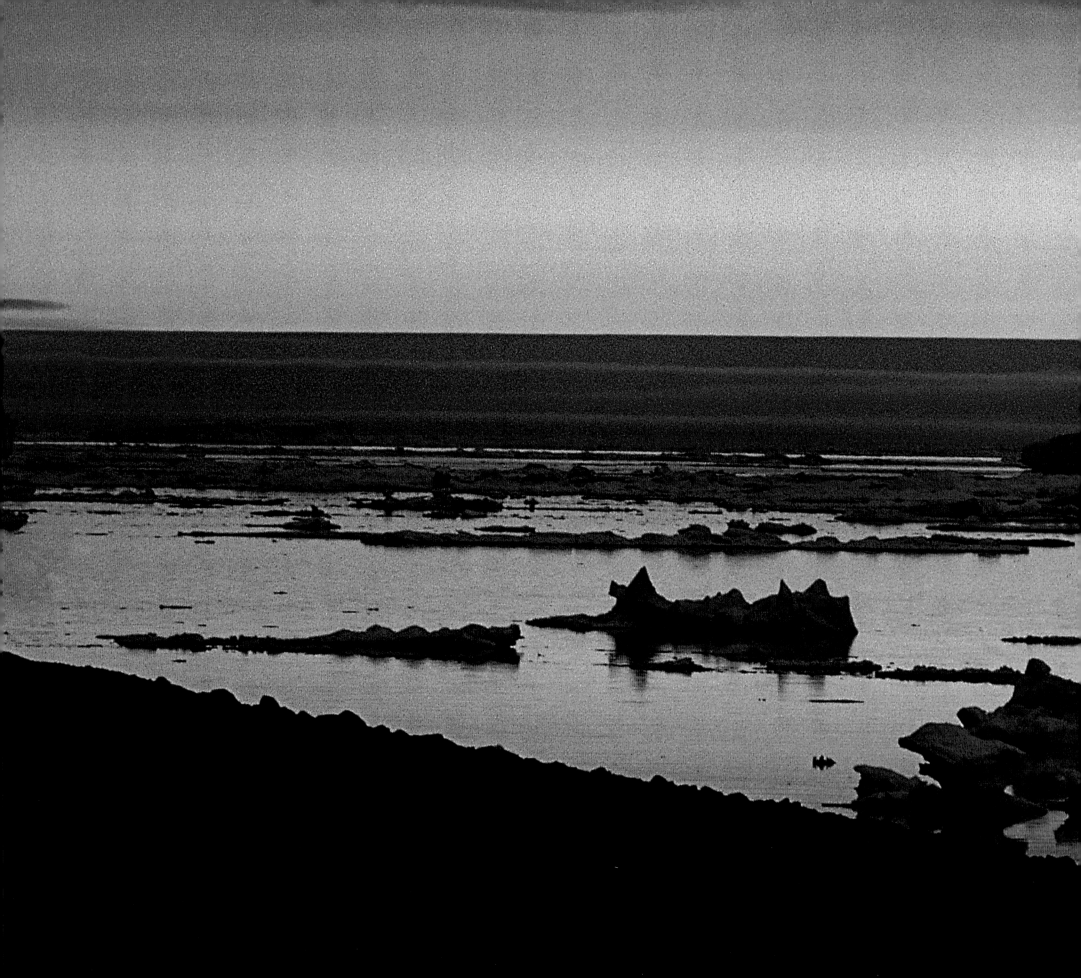

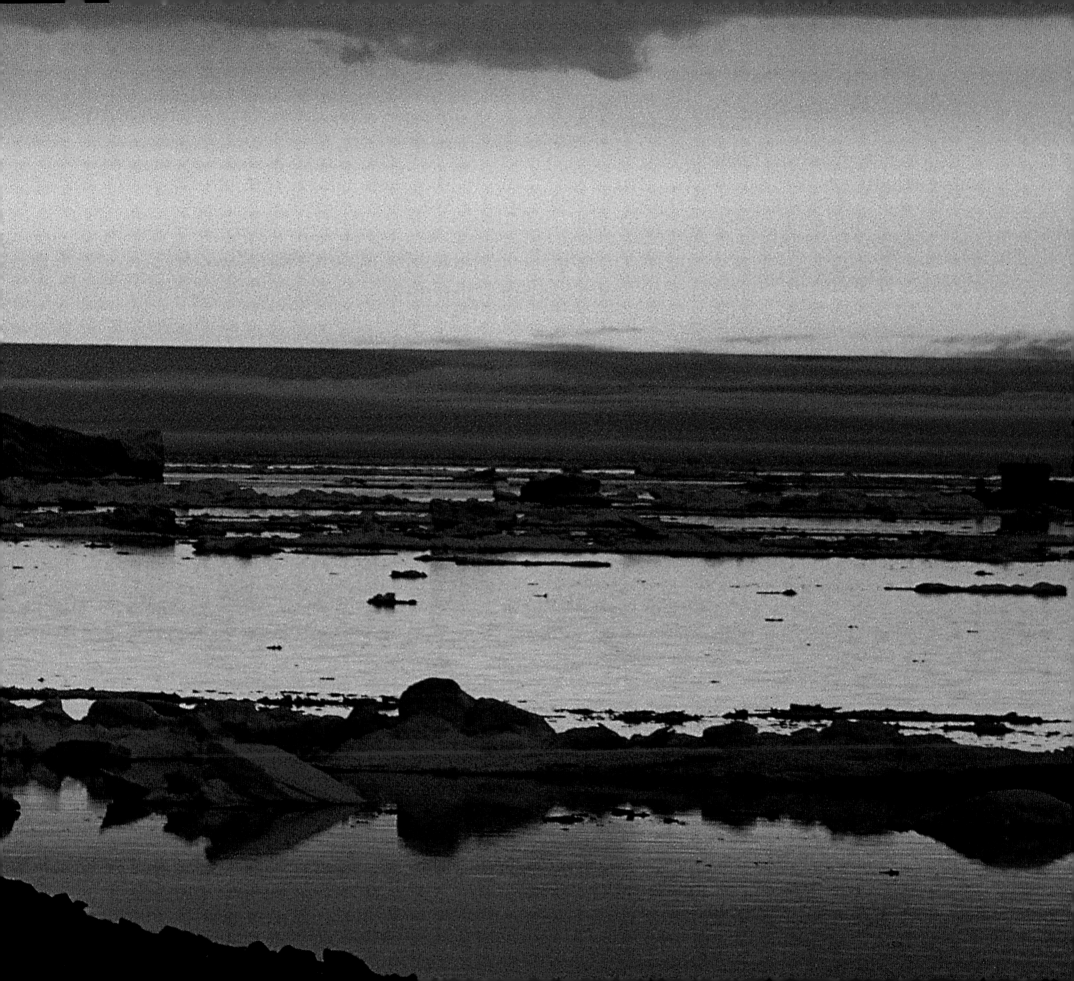

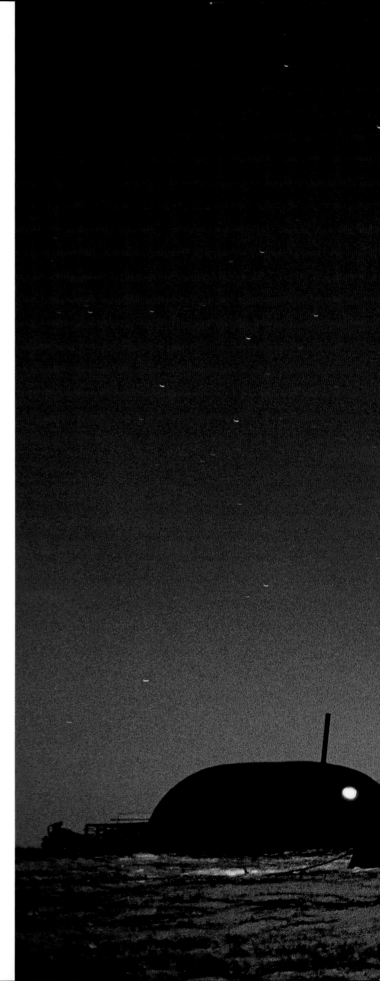

◁◁ Spring on Agarbukta Bay, east of Spitzbergen: The ice fields begin to thaw
in the summer sunshine.

▷ The Mammuthus expedition's encampment illuminated by the aurora borealis
in the bitterly cold polar night.

▽ Dolgan women while away the long winter nights embroidering reindeer skins.

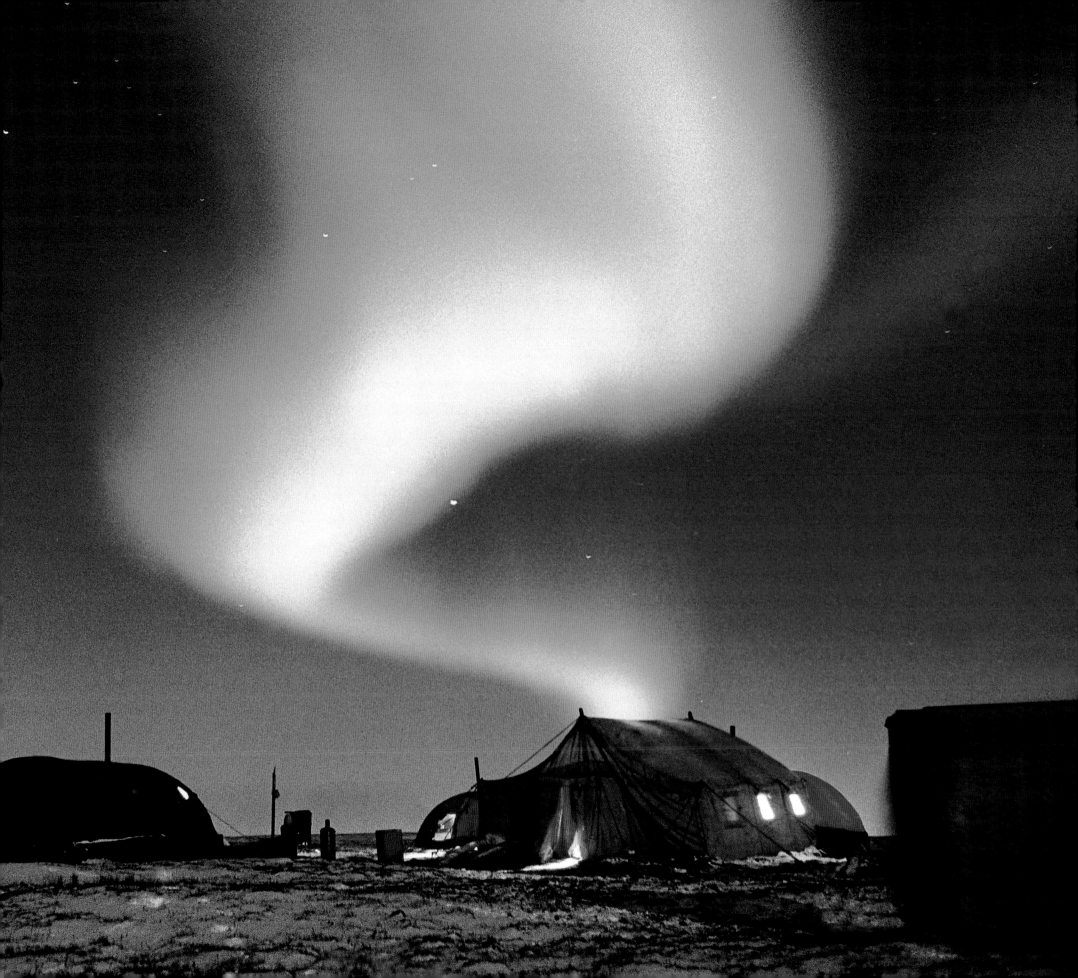

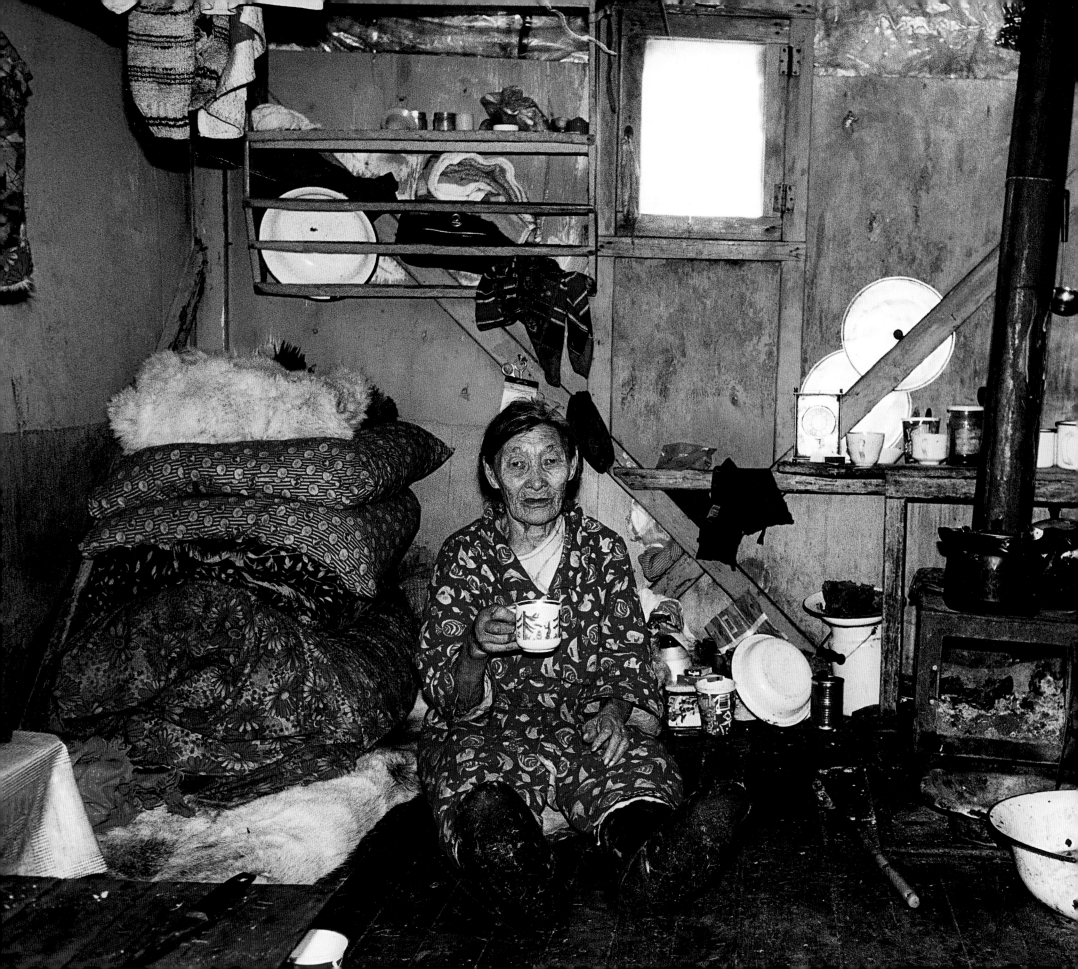

An elderly Dolgan woman watches the *balok* fire. The stove and a few kitchen utensils are all she possesses.

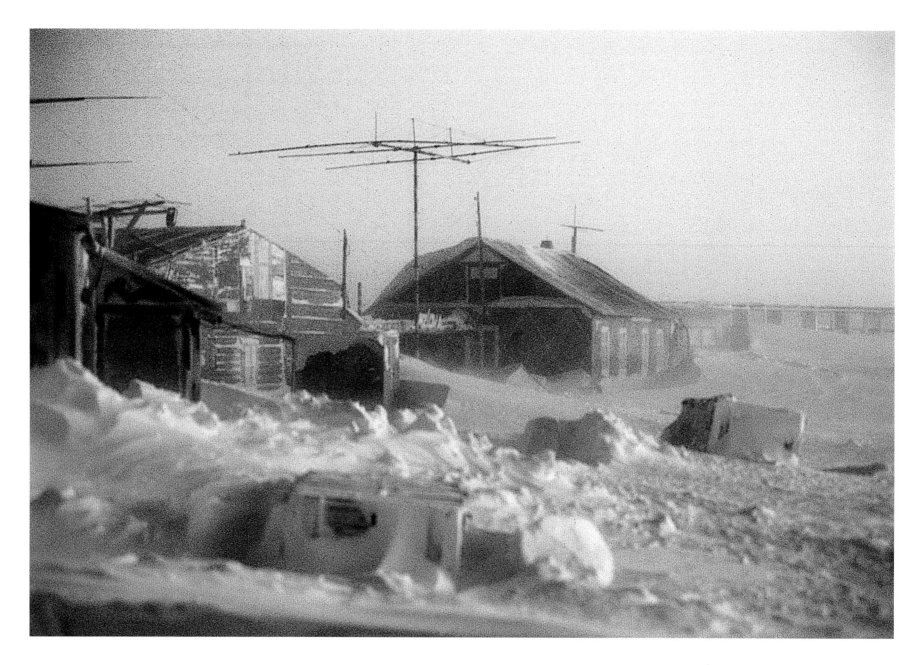

△ Blizzard at the Krenkel weather station in Franz Josef Land.

▷ Captive of the ice: A ship in the port of Dikson awaits the spring thaw.

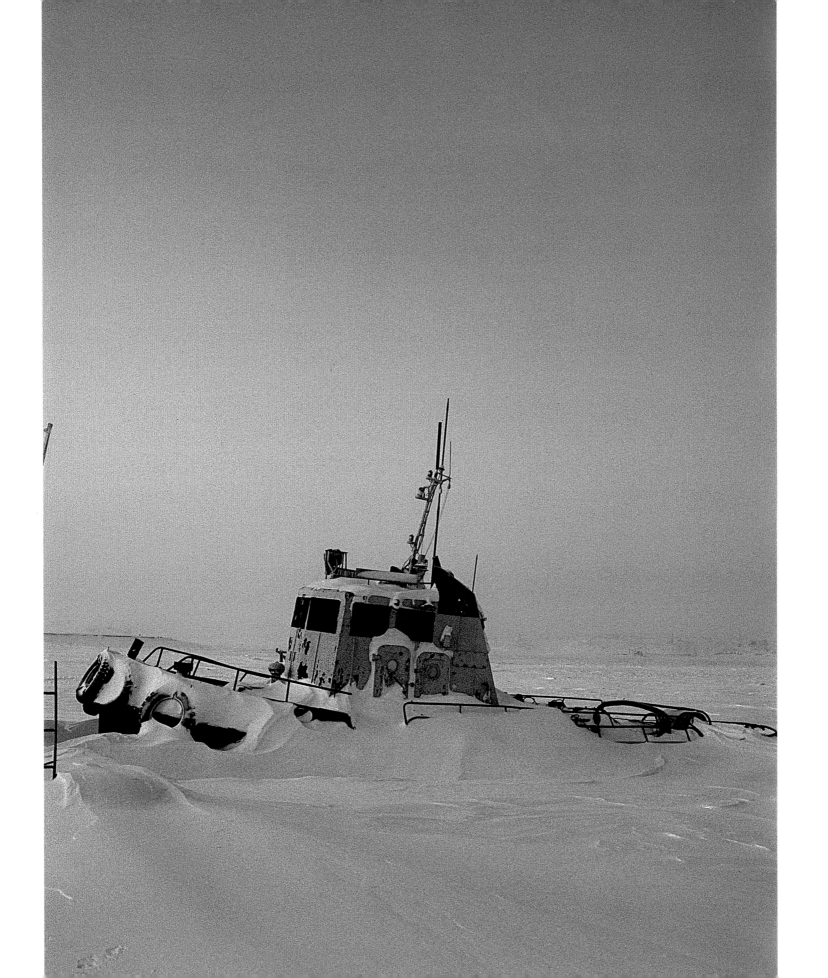

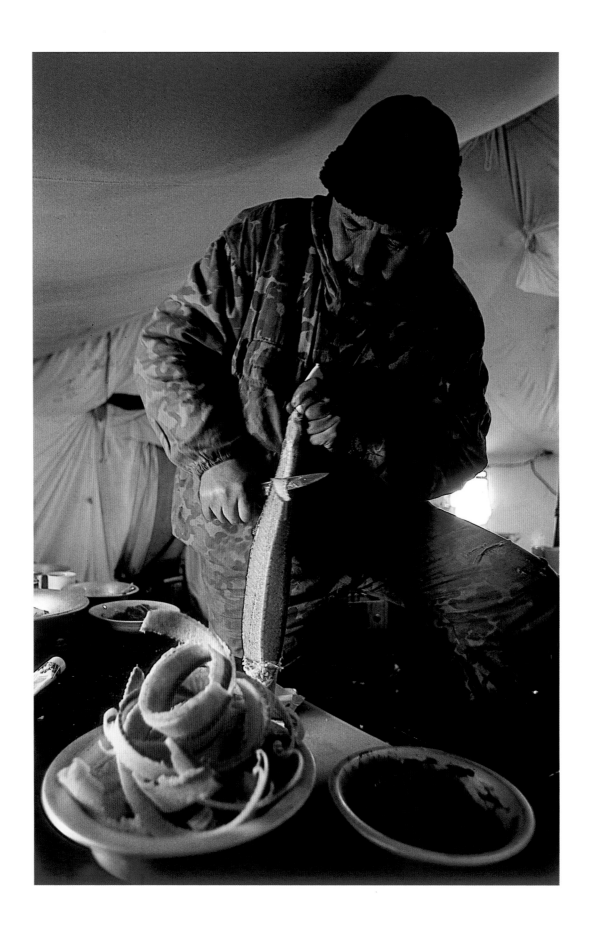

Stroganina, frozen raw fish cut in thin slices and eaten with salt and pepper, is a traditional Siberian delicacy.

▷ At the geographical North Pole, the blizzard is over. The tents of the Russian research expedition— pitched on the drifting ice for three months—must be dug from a snowdrift.

▷▷ Midnight: A snowstorm whirls across the tundra while the sun lingers perpetually on the horizon.

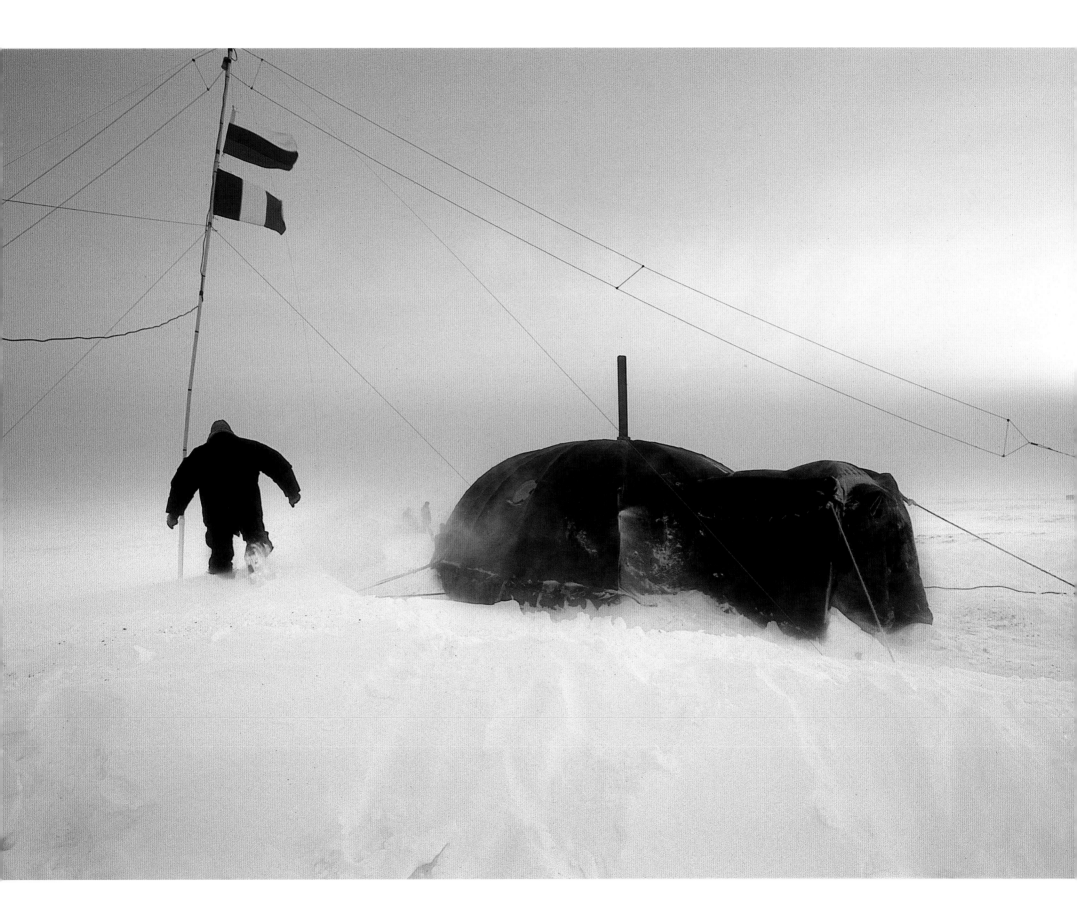

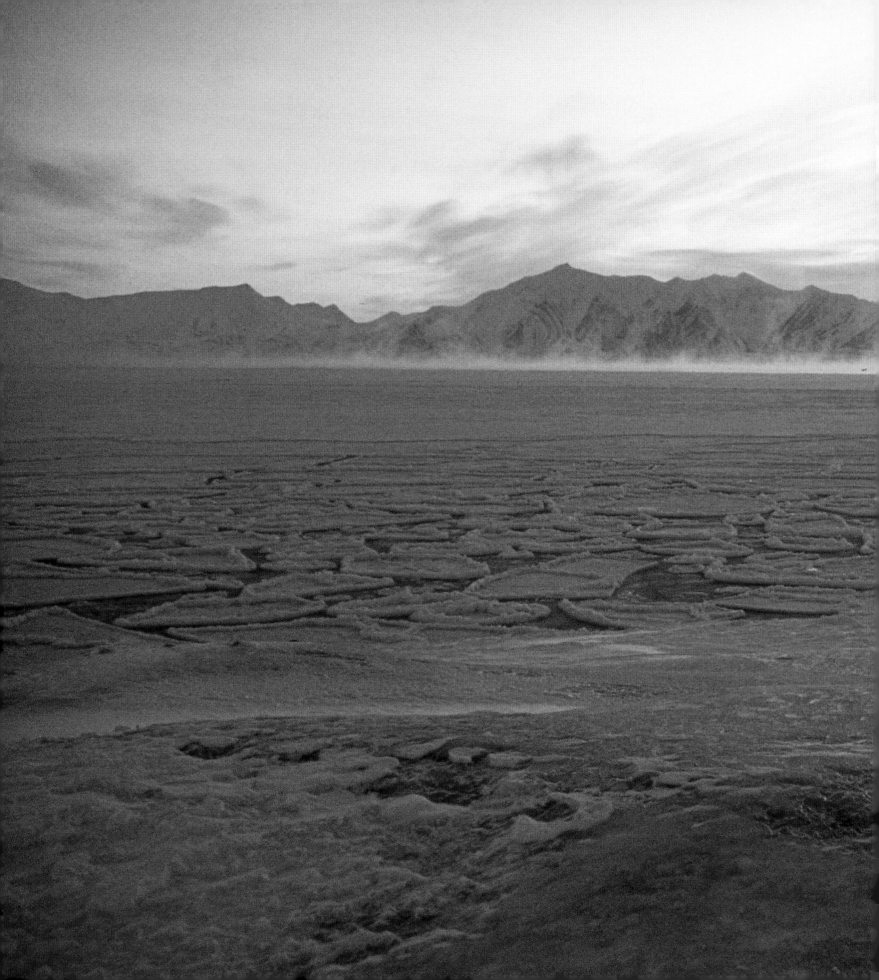

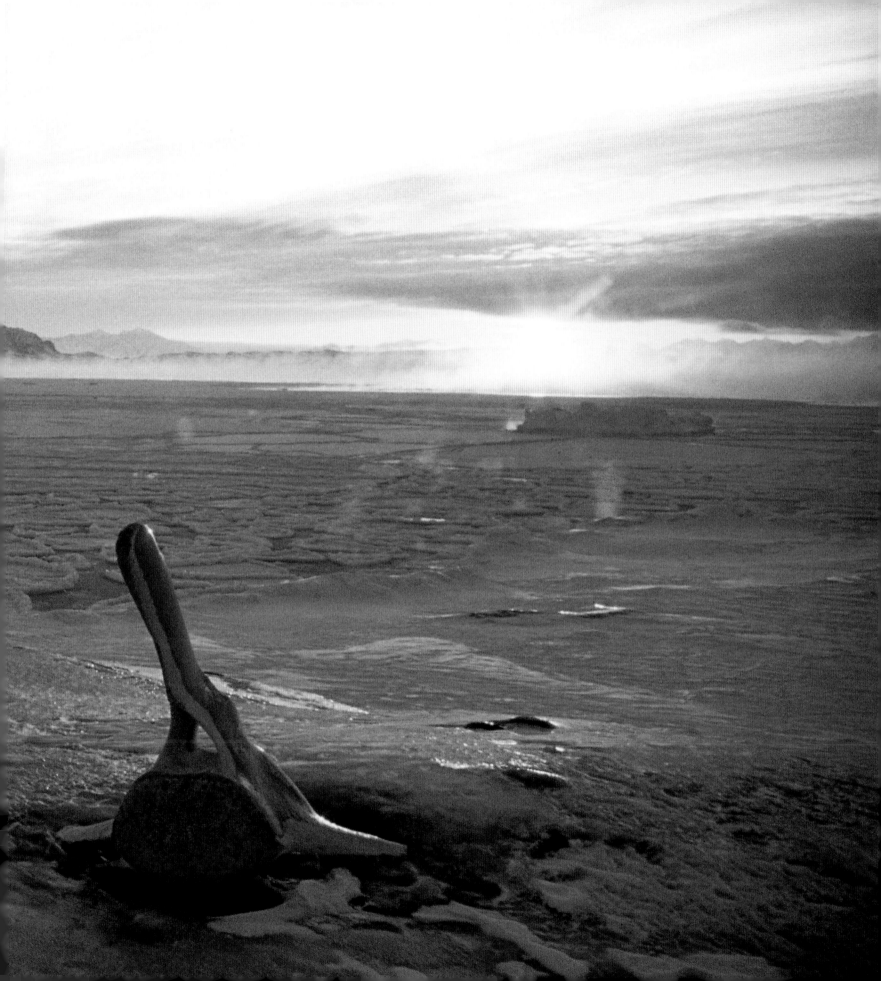

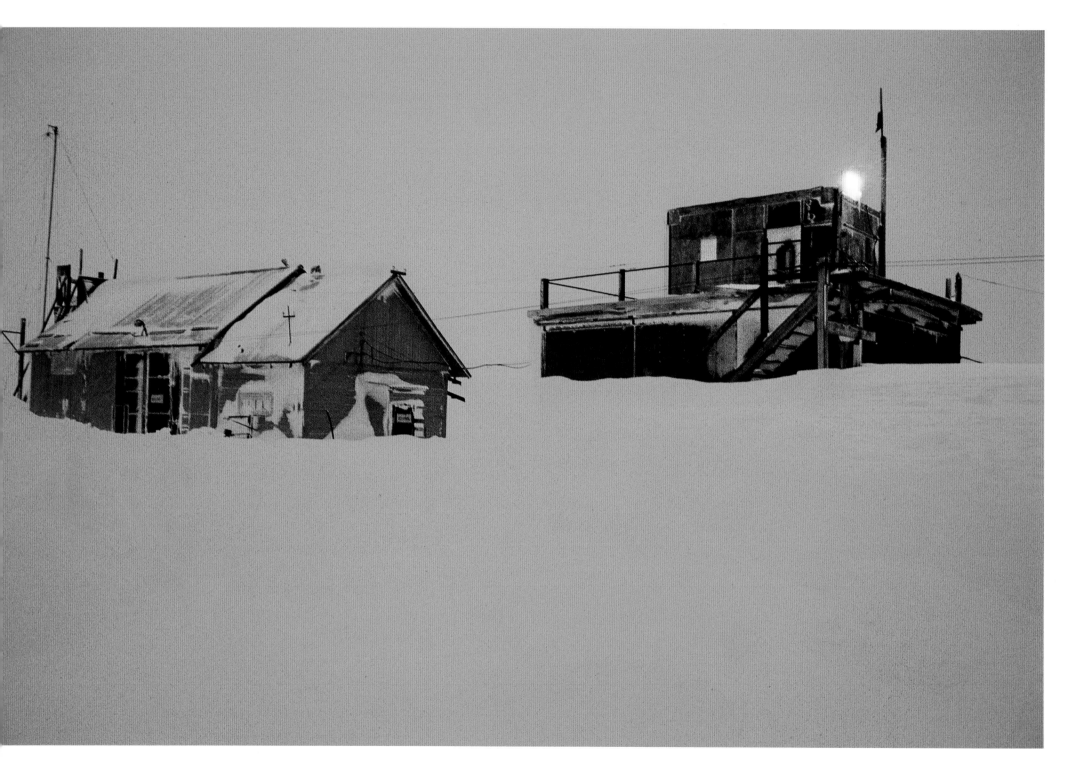

Franz Josef Land, the northernmost weather station in the world. Every day engineers brave extreme conditions to launch their sounding balloons and record weather statistics that are vital to fellow meteorologists in the temperate zones.

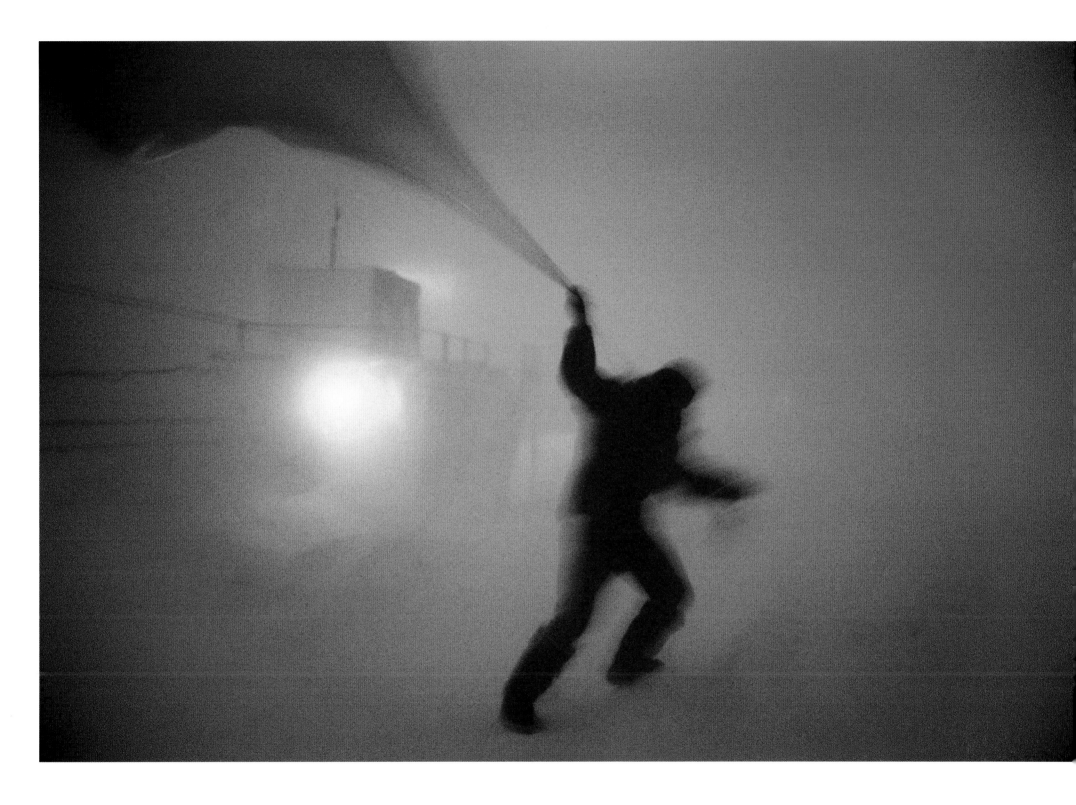

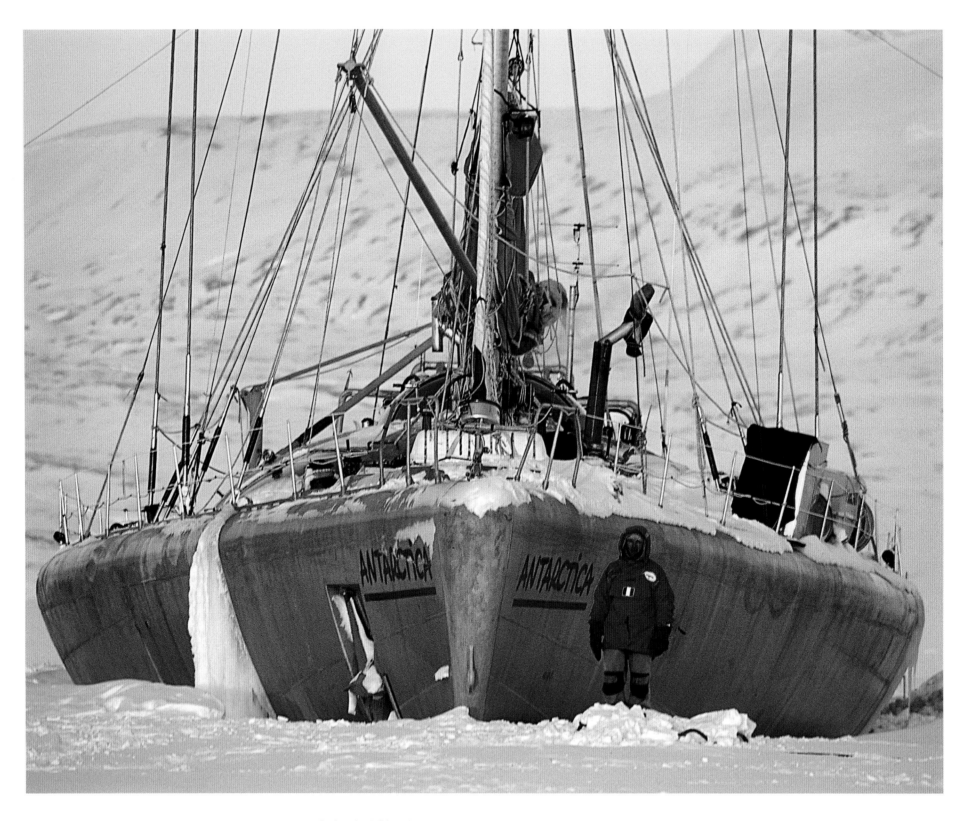

Dr. Jean-Louis Etienne's schooner *Antarctica:* A winter locked in the Spitzbergen ice.

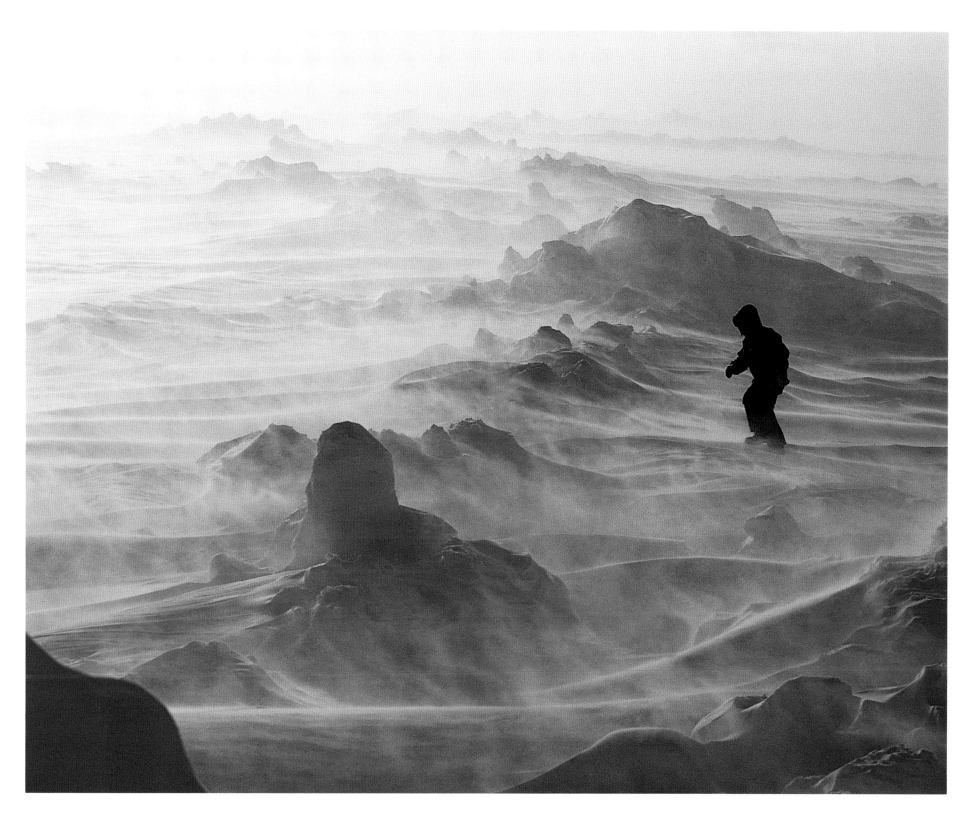

Jean-Louis Etienne struggling through a snowstorm during his mission to the ice shelf (Mission Banquise).

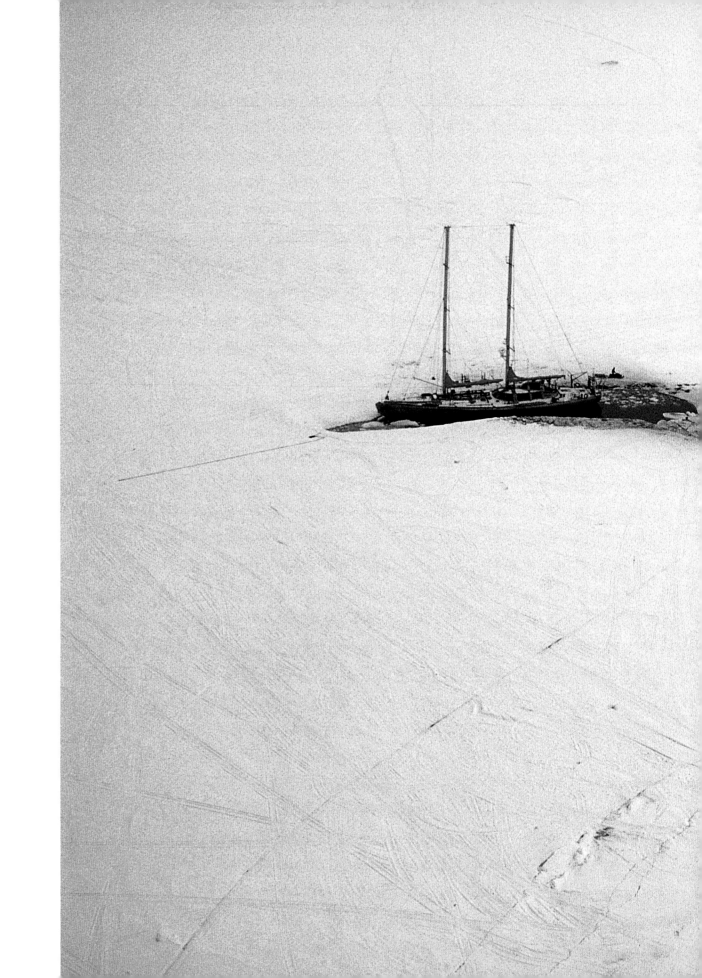

Remaining dormant for eight months in a frozen Spitzbergen fjord, the polar schooner *Antarctica* finally broke loose at the beginning of summer and made her way to open water.

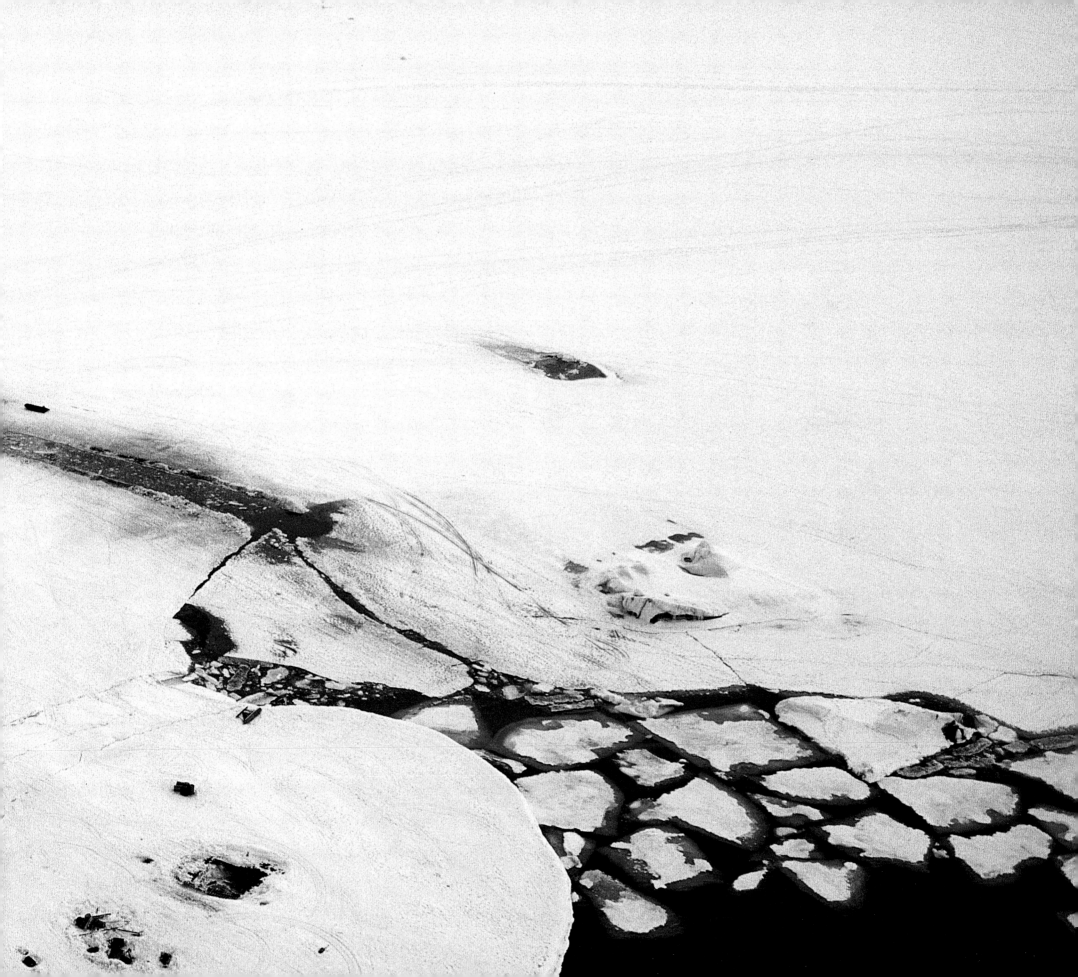

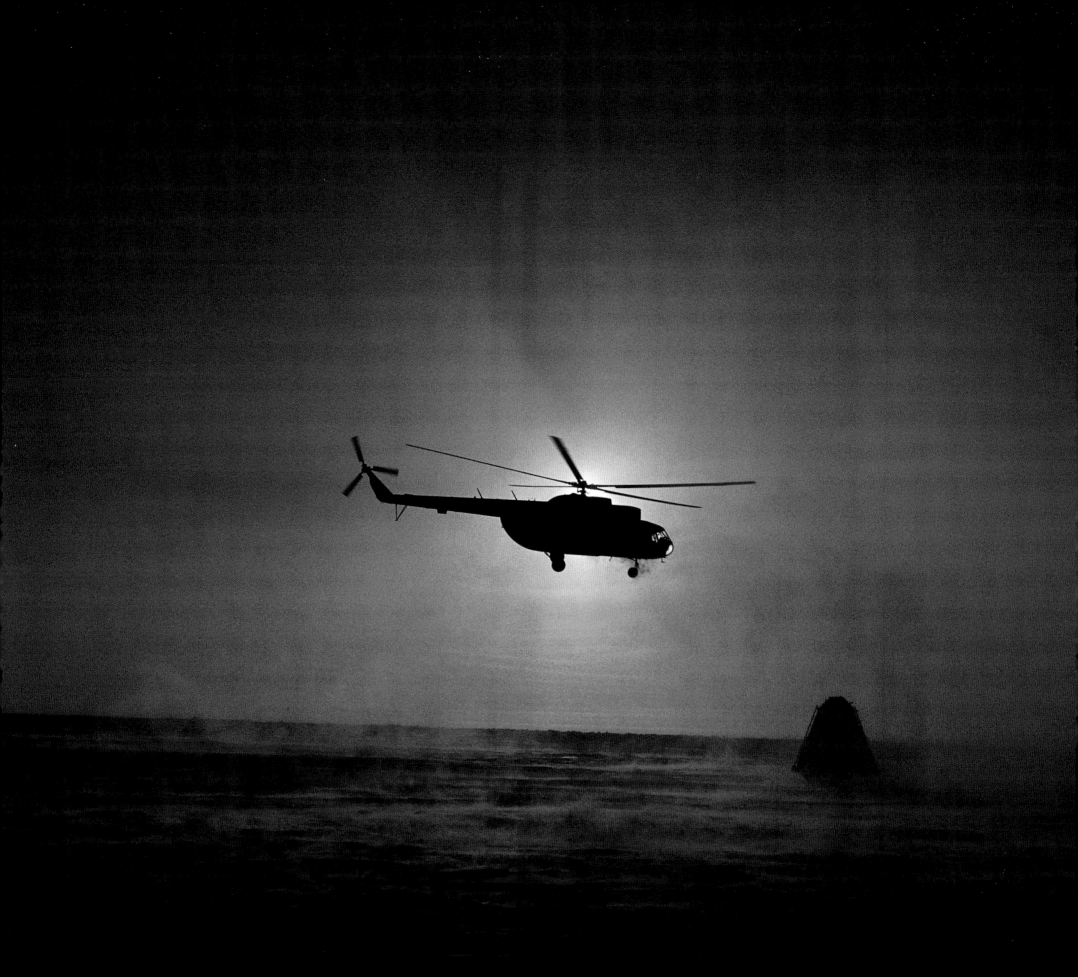

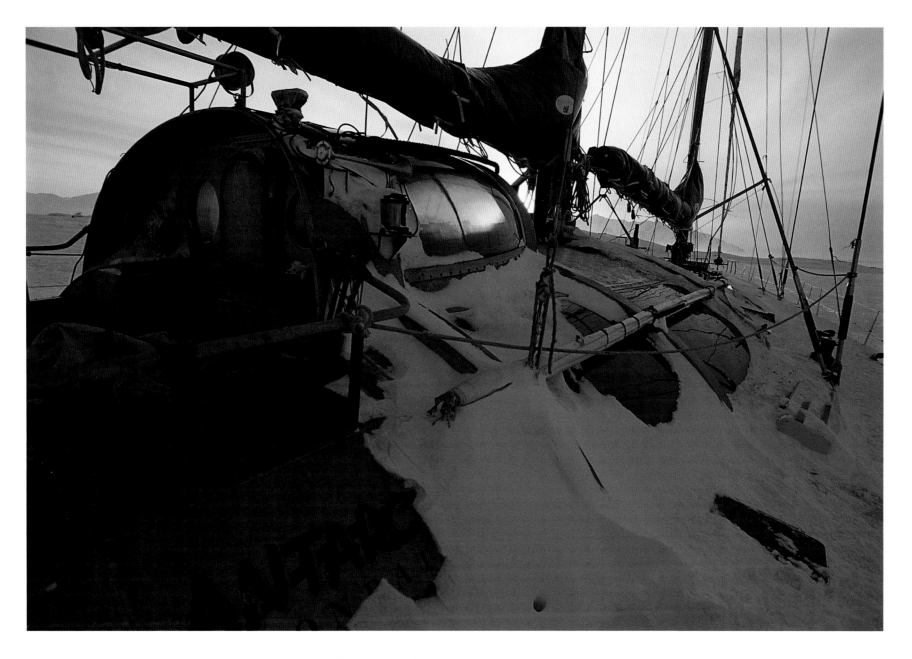

△ Jean-Louis Etienne's imprisoned vessel and her crew survived months of extreme winter
conditions on the Spitzbergen ice.

◁ In April 2002, supplies for Jean-Louis Etienne's Mission Banquise to the geographic
North Pole were flown in by helicopter.

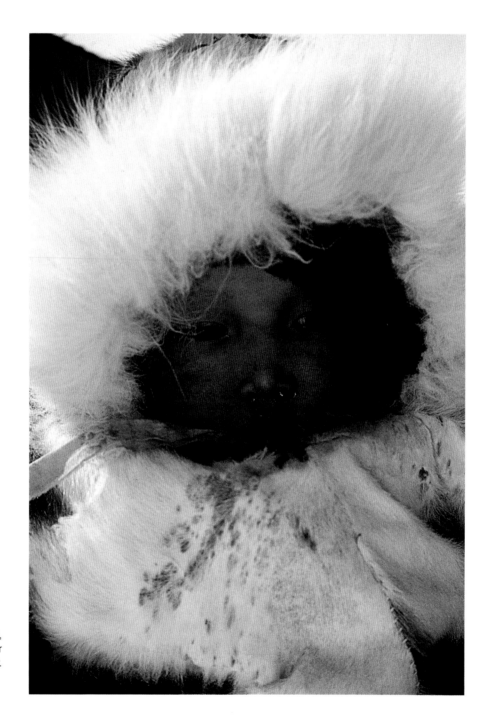

A baby in Tiksi, Yakutsk, swaddled in furs for her daily walk in the open air.

▷ At the Krenkel Polar Station in Franz Josef Land, scientists battle the elements to collect meteorological data.

▷▷ Mist in the Arctic is a sign that spring is on the way; mist arises from water evaporation caused by the first warm rays of sunshine.

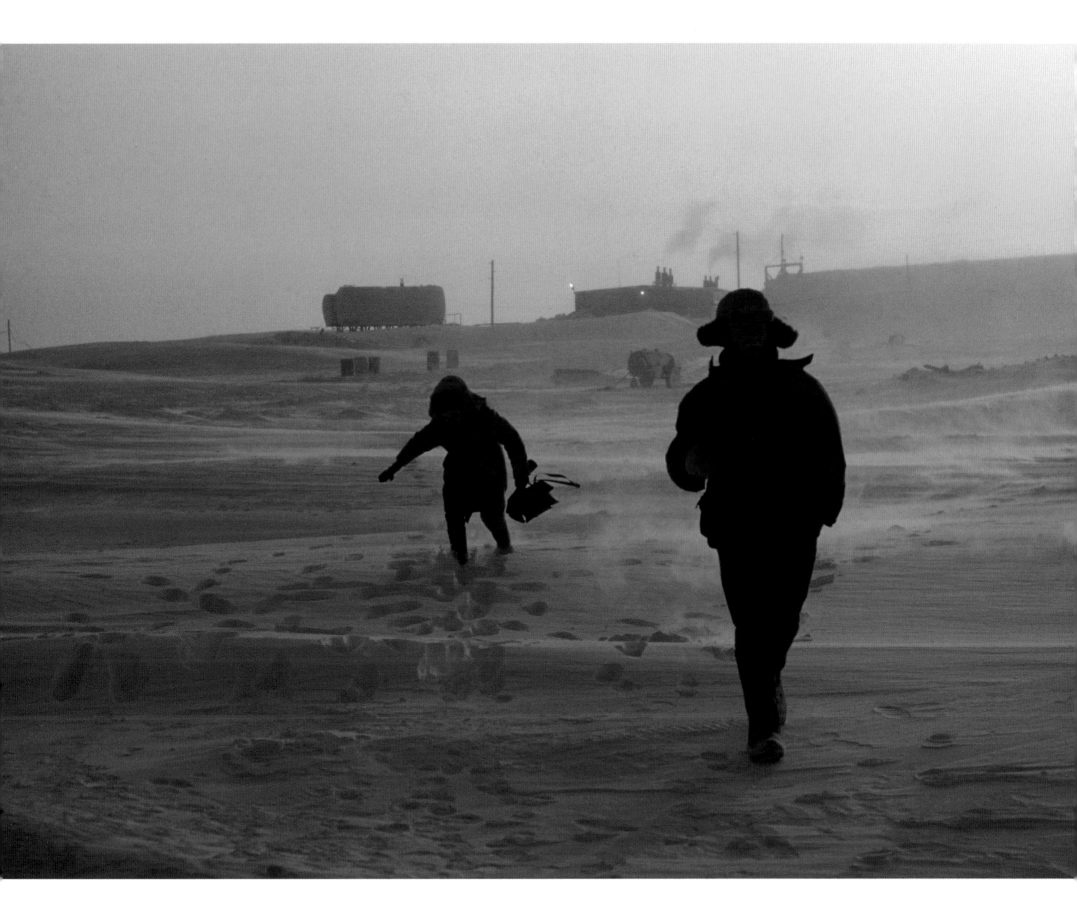

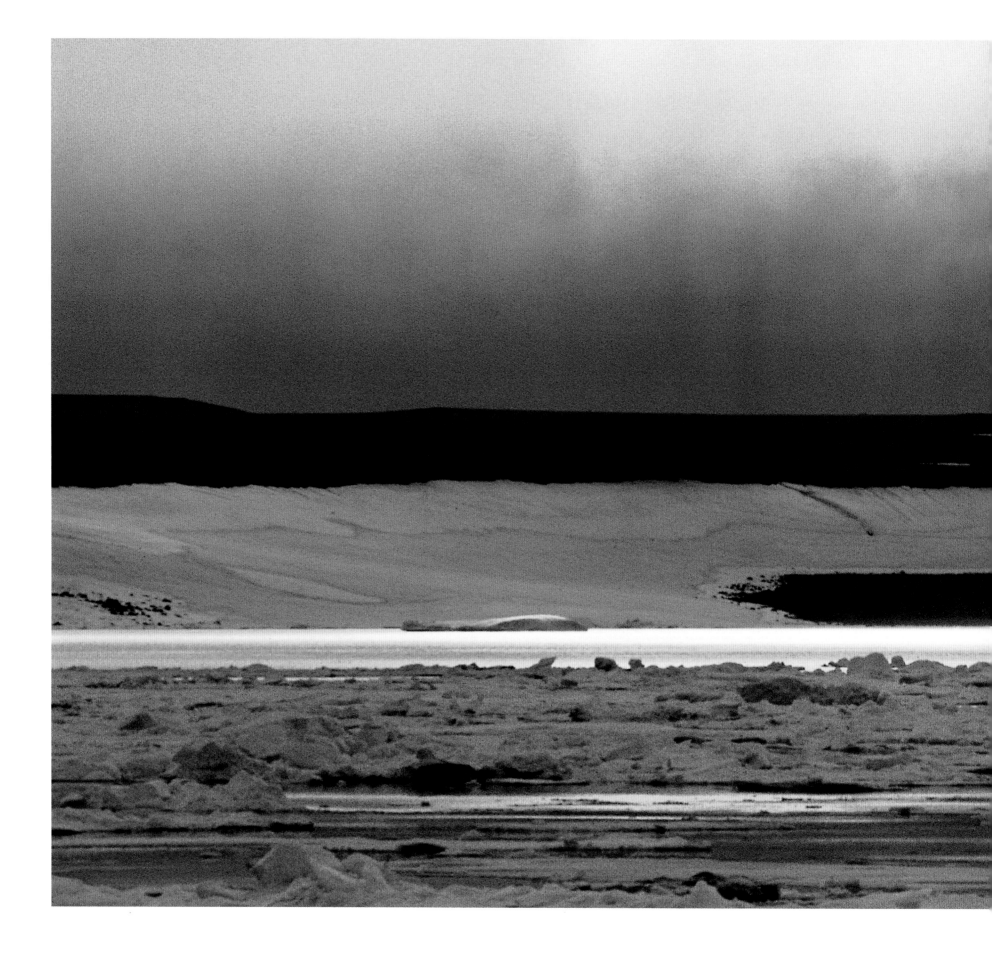

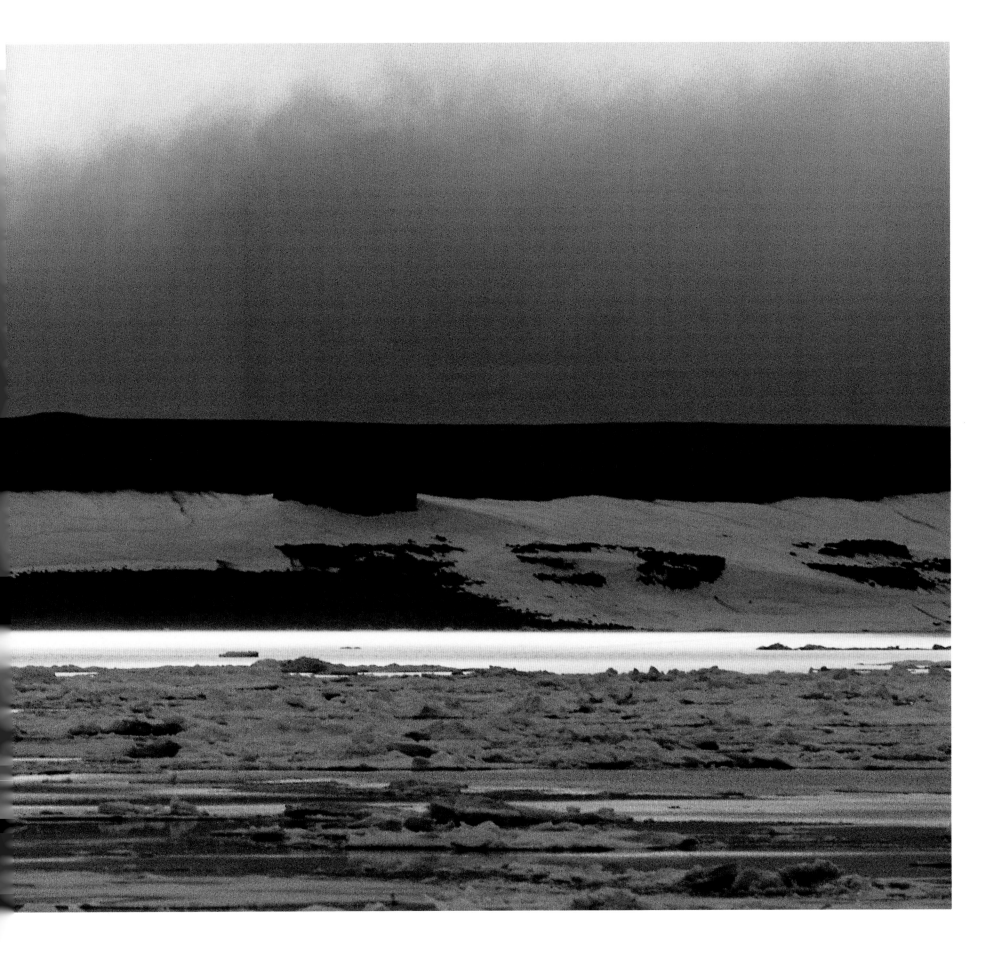

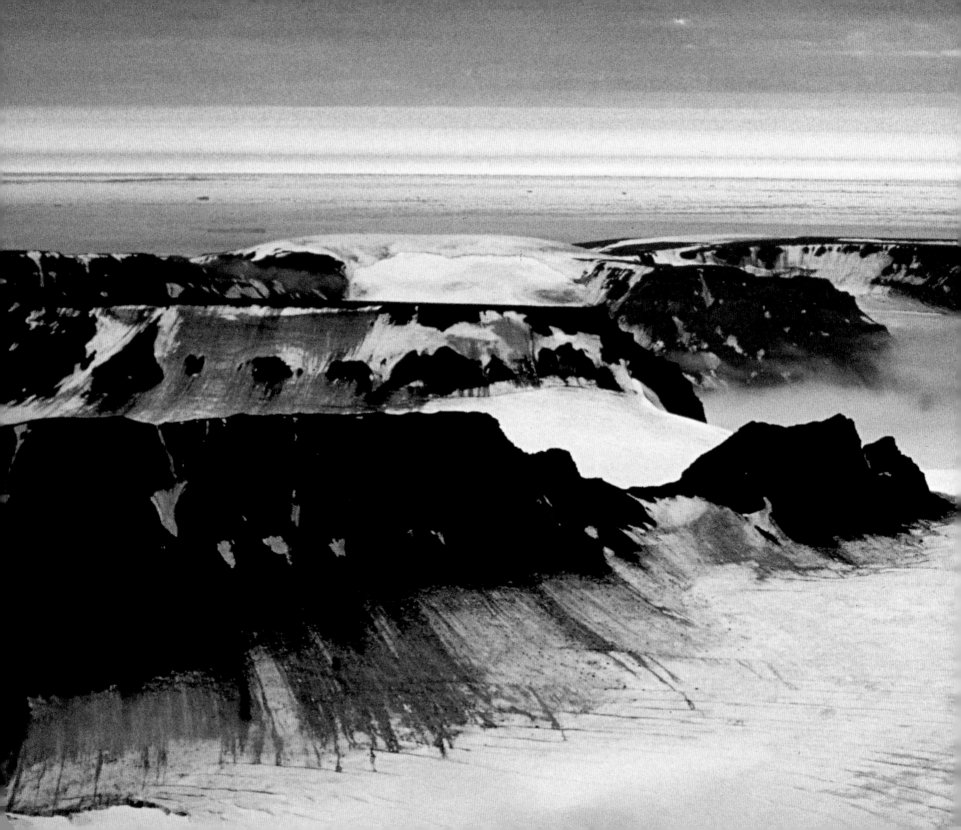

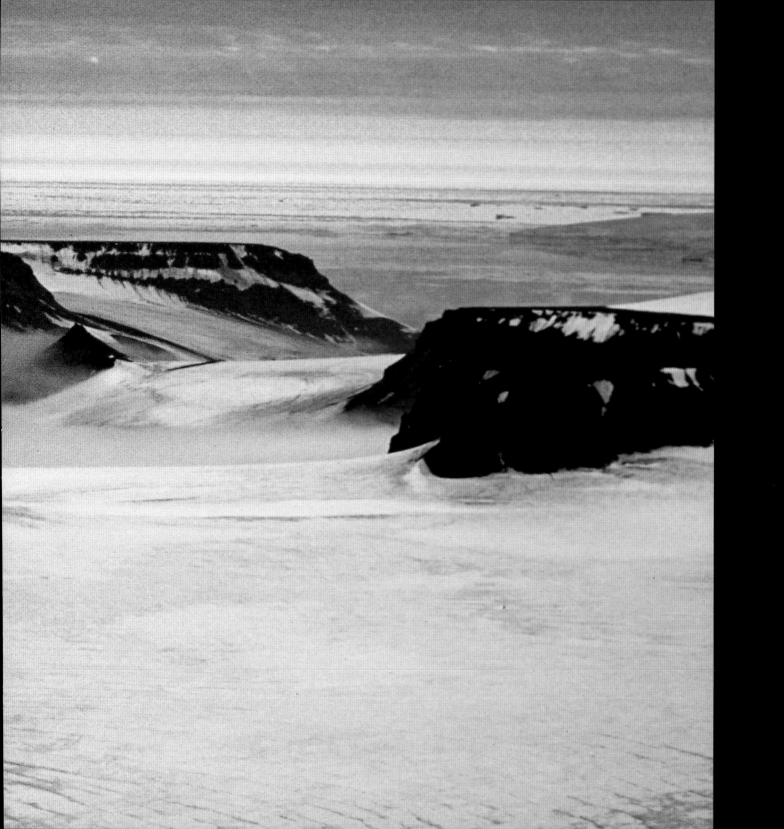

The biggest glaciers in the Northern Hemisphere are found in the mountains of Greenland. Due to global warming, they are beginning to melt, which makes the climate imbalance even more serious.

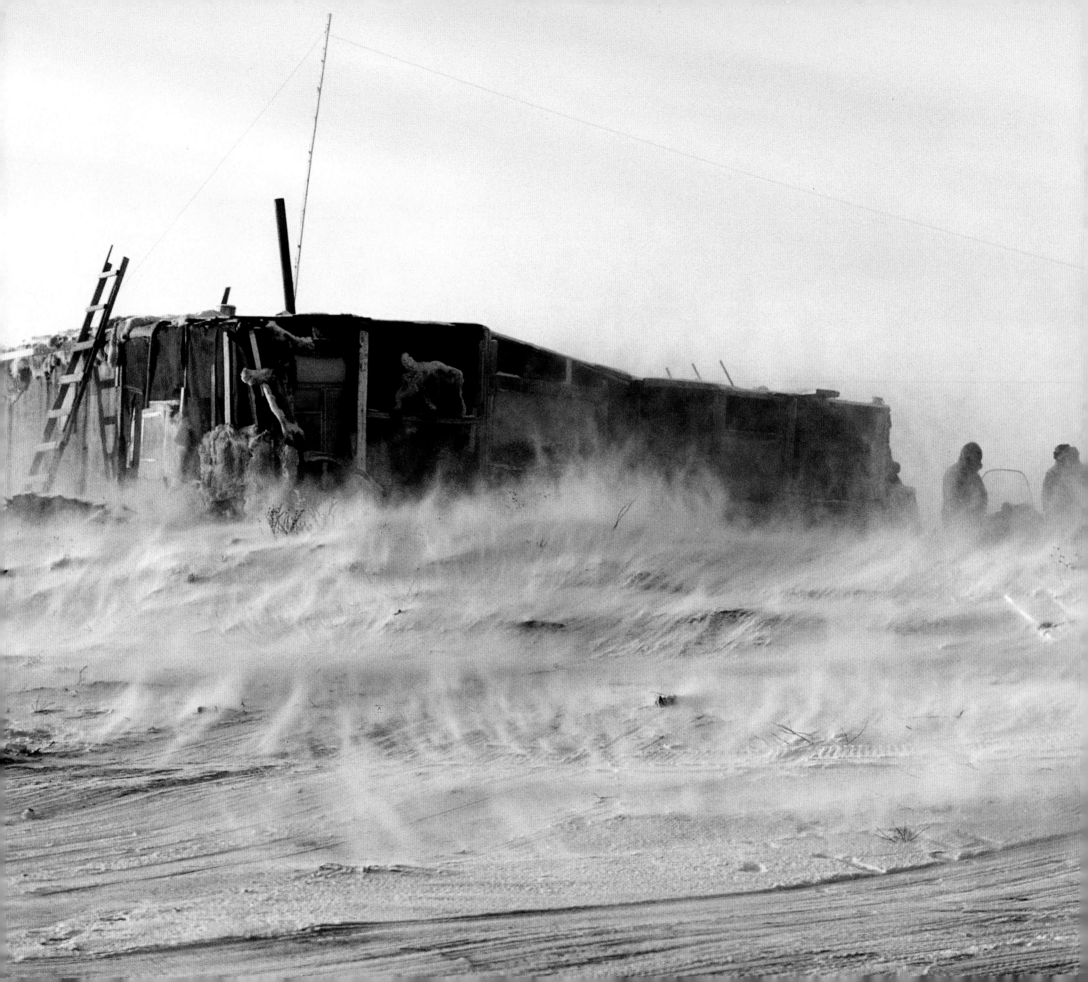

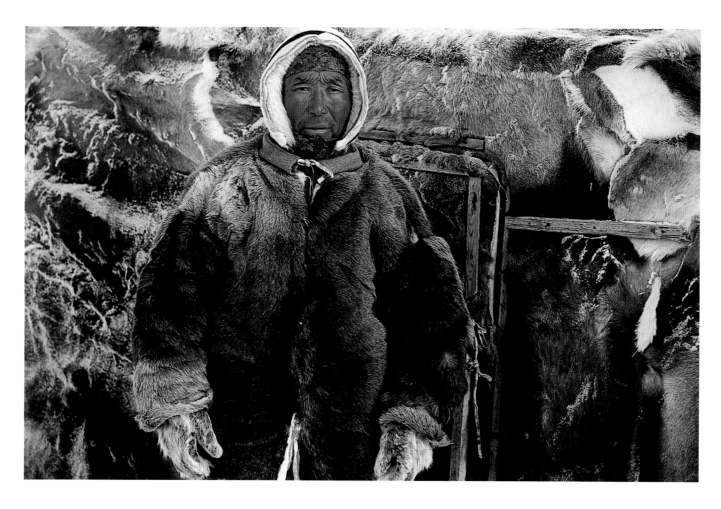

△ Piotr, a Dolgan patriarch, views the reindeer as his people's heritage. The animal is raised for meat and its skin, which is used to make clothing and sled-borne houses (*balok*s).

◁ A cabin on the bank of the Popigay River in Northern Siberia; it's used as a refuge by fishermen and hunters coming in from the tundra.

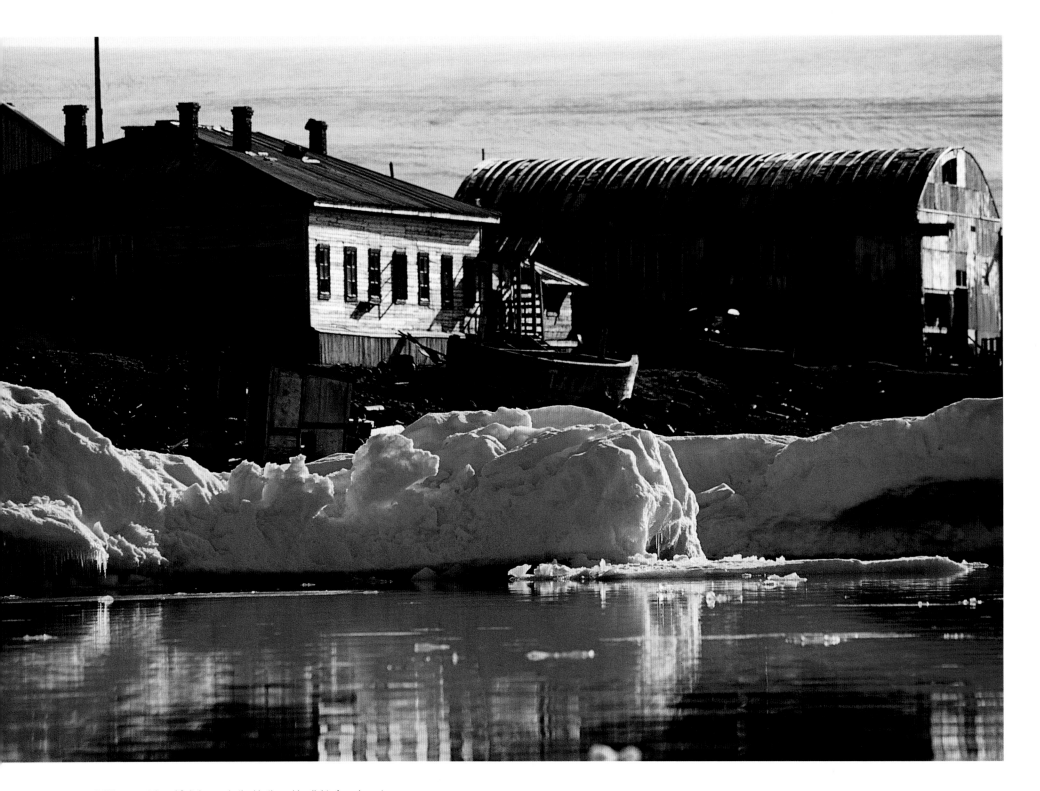

◁◁ The mountains of Spitzbergen bathed in the golden light of a polar autumn.

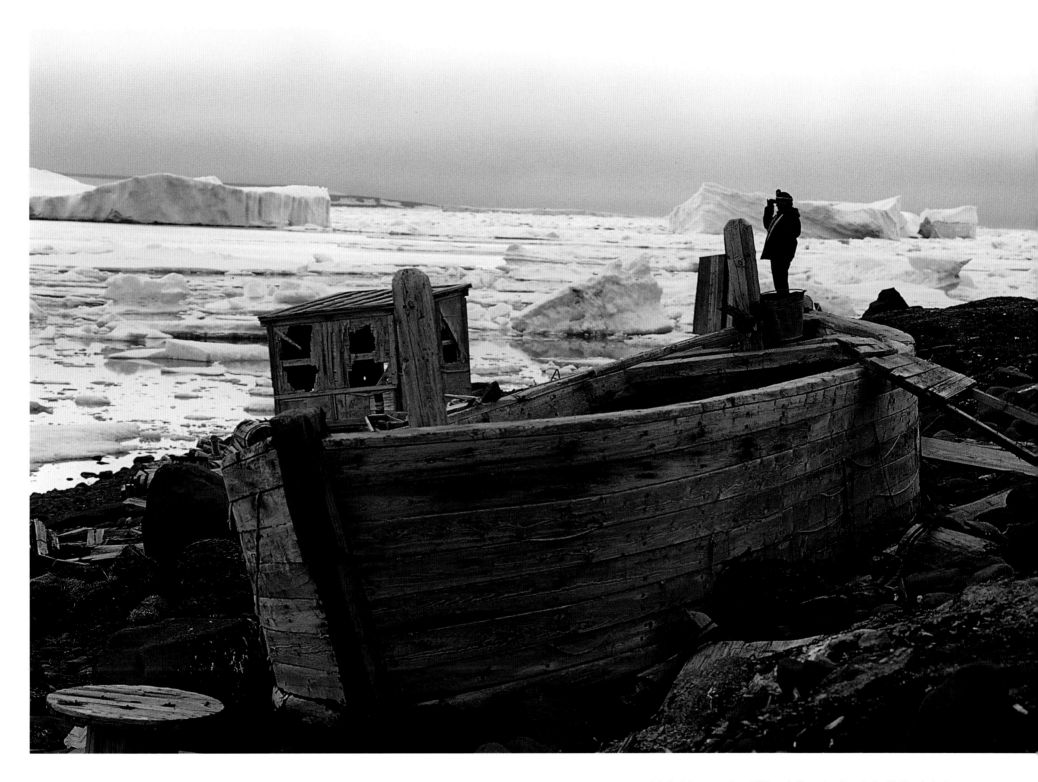

◁ △ Soviet-era remains at Tikhaya in Franz Josef Land attest to the strategic presence of military and scientific bases.

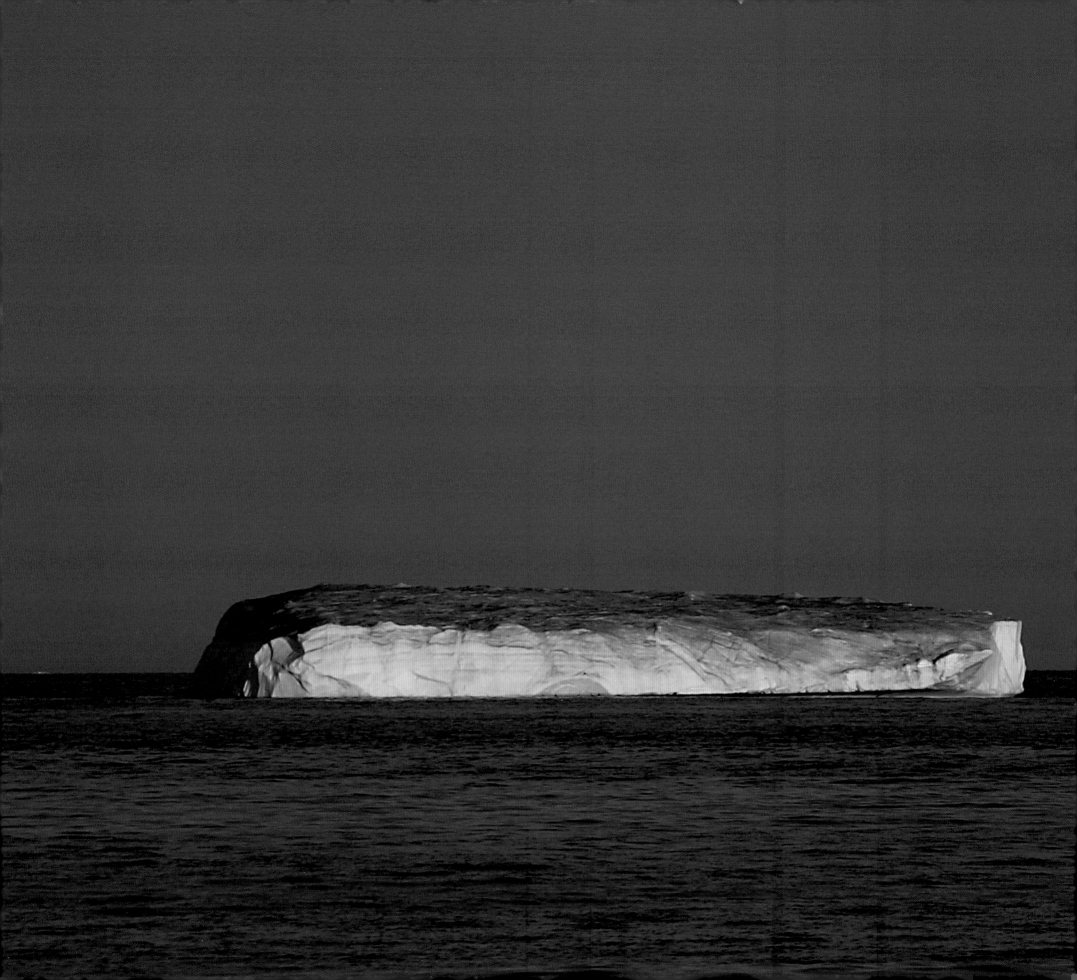

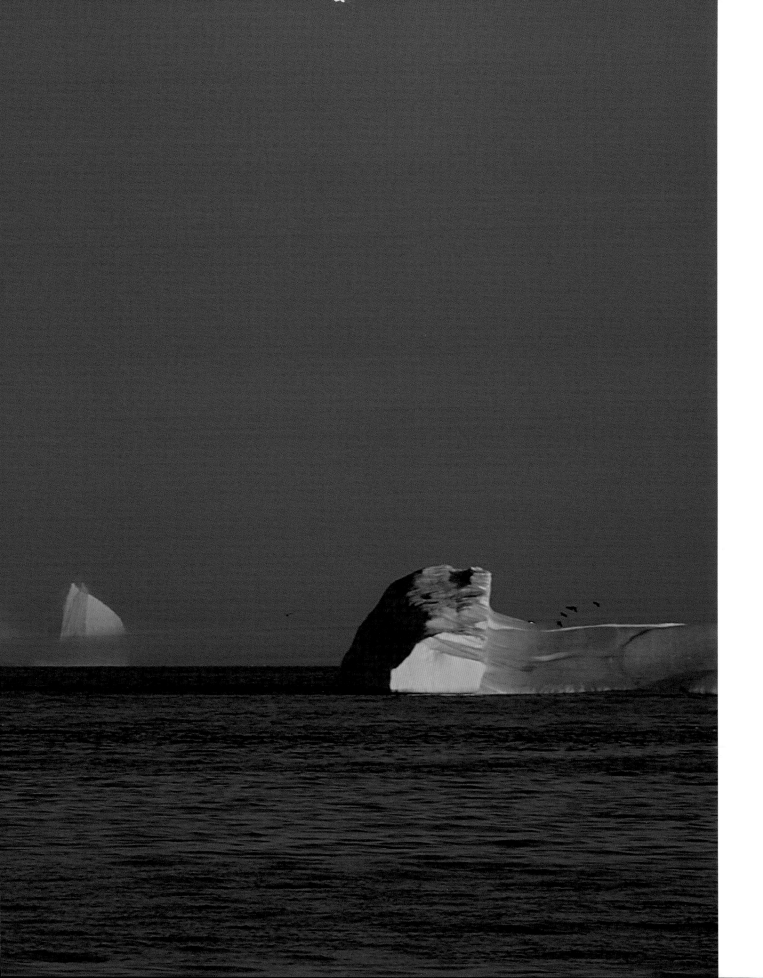

The Davis Strait between Canada and Greenland has many icebergs that have broken away from great glaciers of the Northwest. One of these, the Humboldt glacier, is more than sixty miles long.

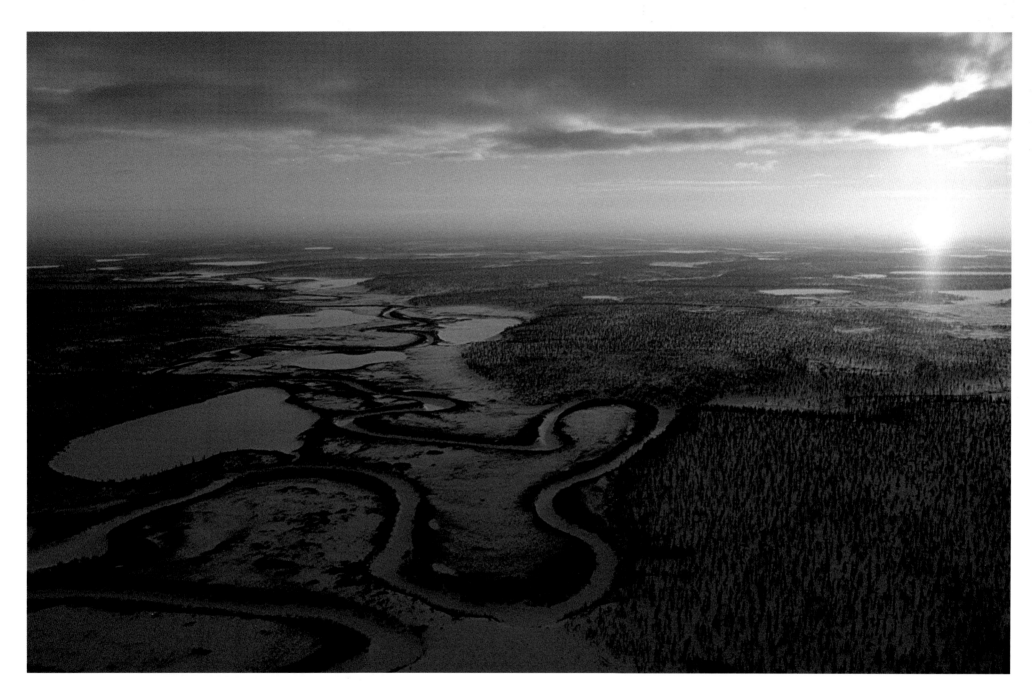

The Arctic autumn arrives with the first snowfall on the Siberian tundra—
a frozen plateau traversed by thousands of meandering watercourses.

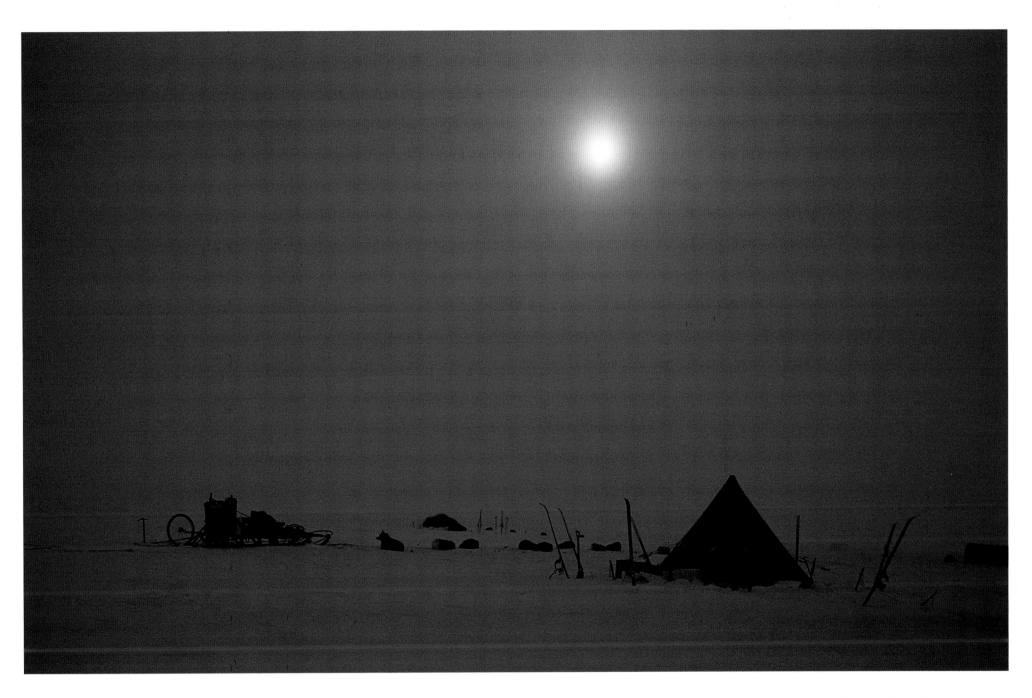

Encamped on the ice shelf, an expedition heading to the North Pole.

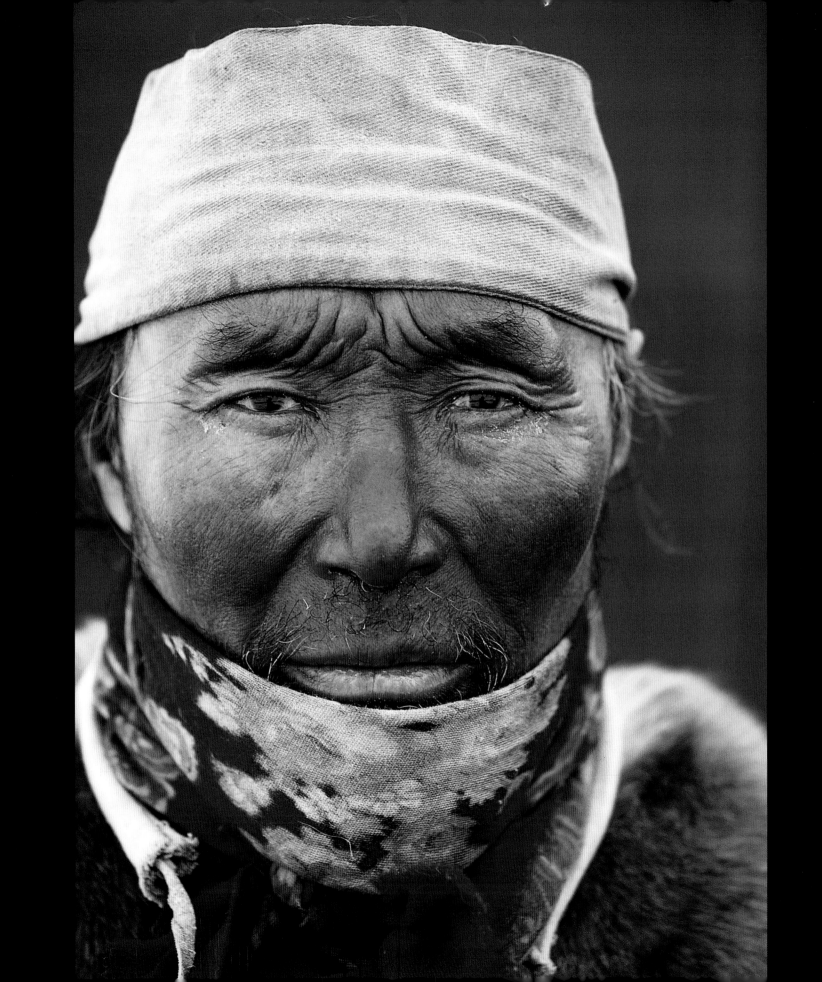

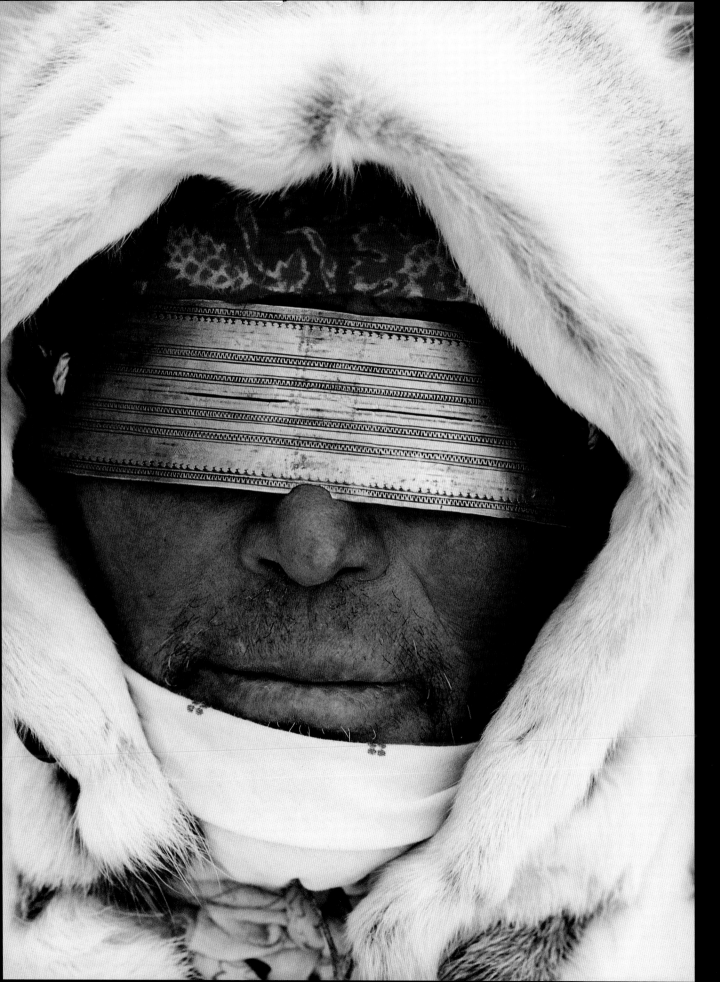

A Dolgan sage, equipped with traditional eye protection against particles of ice whipped up by blizzards and sunlight reflected off the snow.

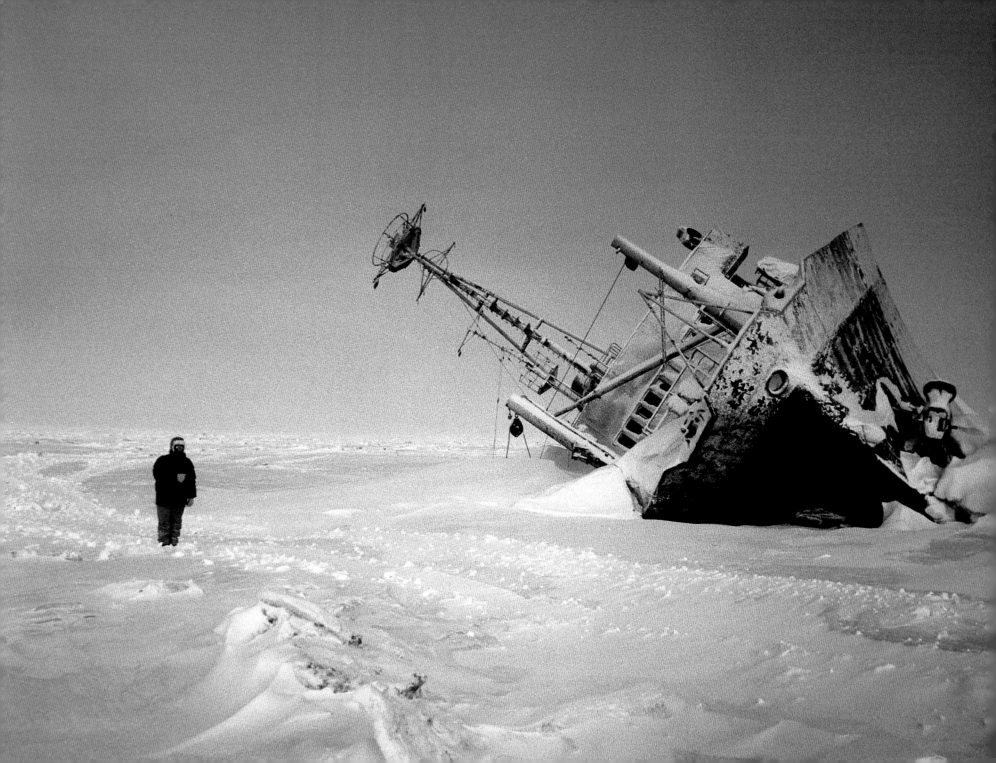

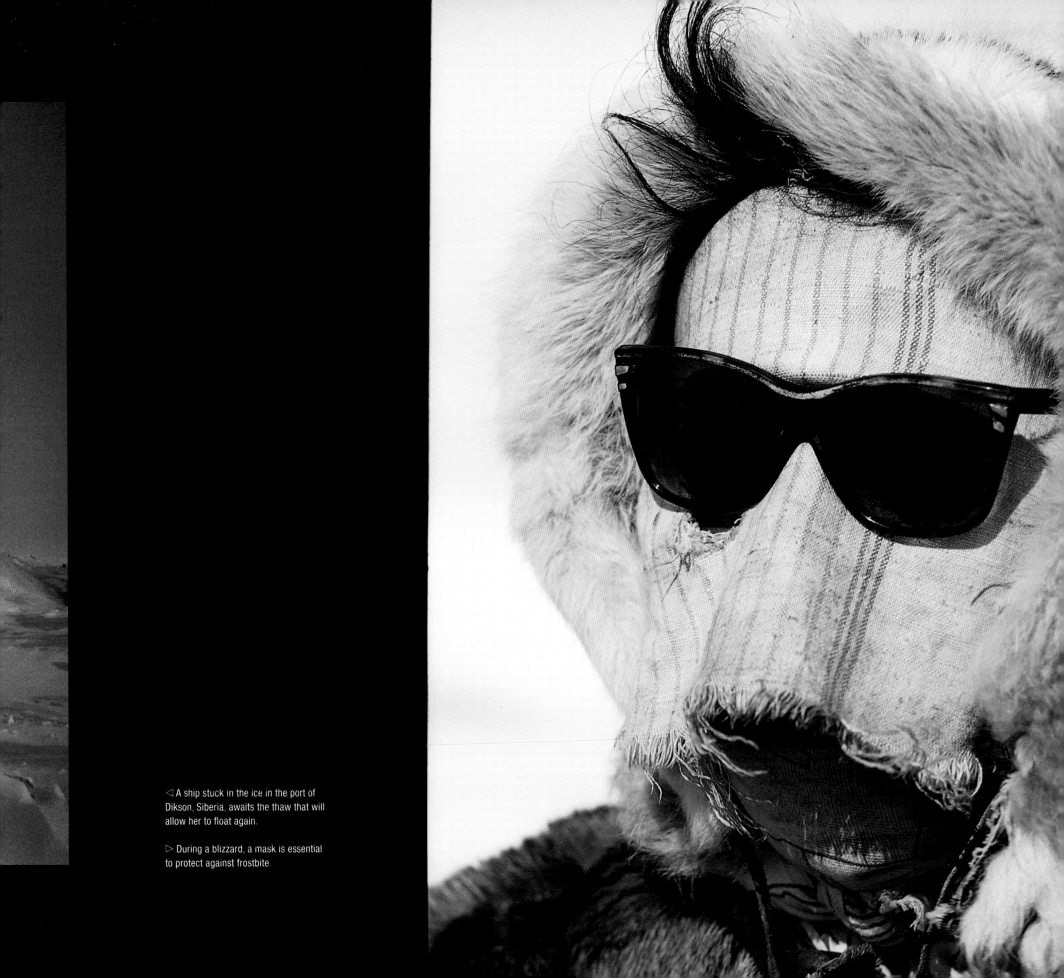

◁ A ship stuck in the ice in the port of
Dikson, Siberia, awaits the thaw that will
allow her to float again.

▷ During a blizzard, a mask is essential
to protect against frostbite.

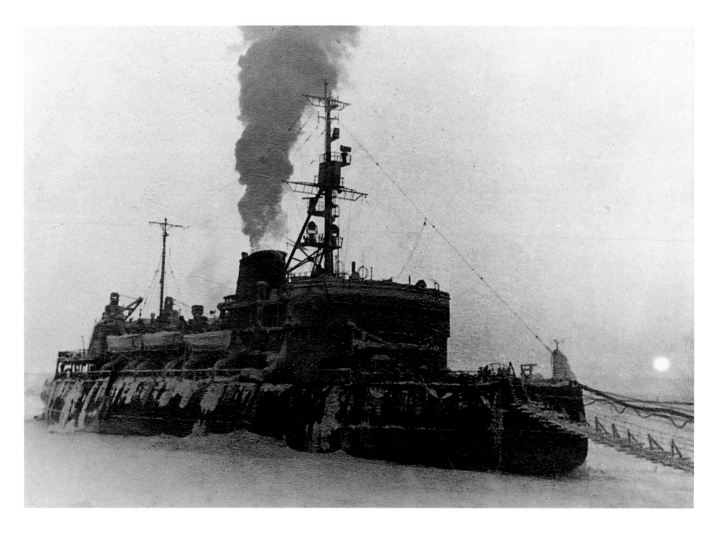

Another ship imprisoned in the Arctic ice.

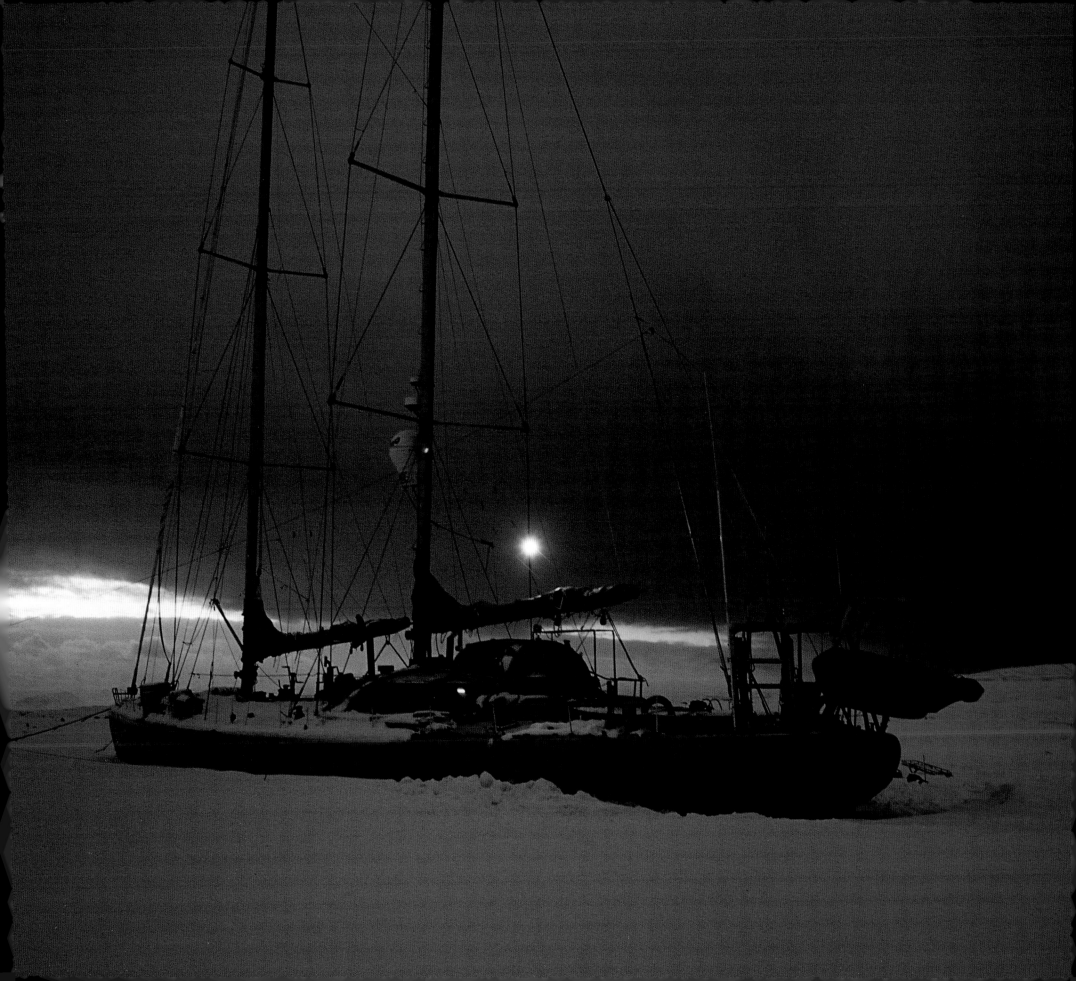

△ A blizzard on a Spitzbergen glacier. In conditions like these, there is no hope of traversing on foot.

▽ At the first hint of a thaw, migrant birds come to nest in the rich northern fishing grounds.

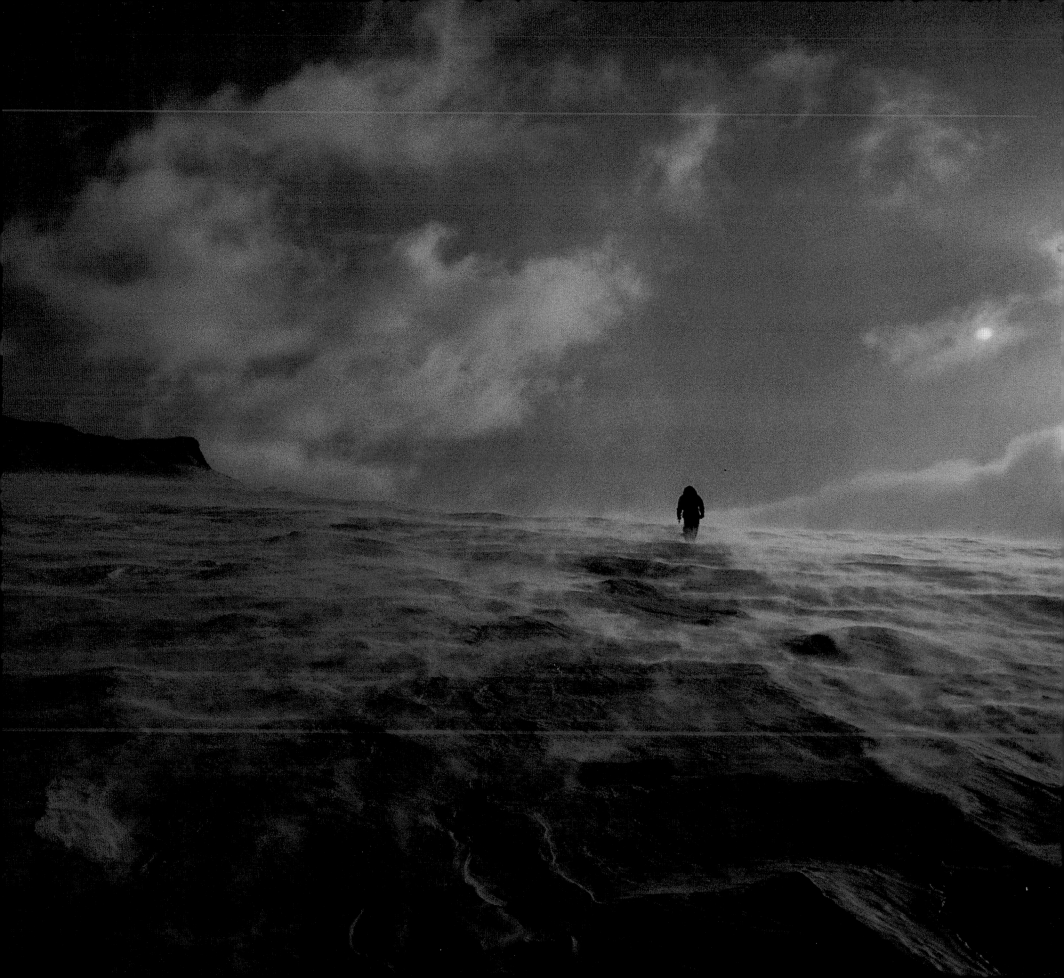

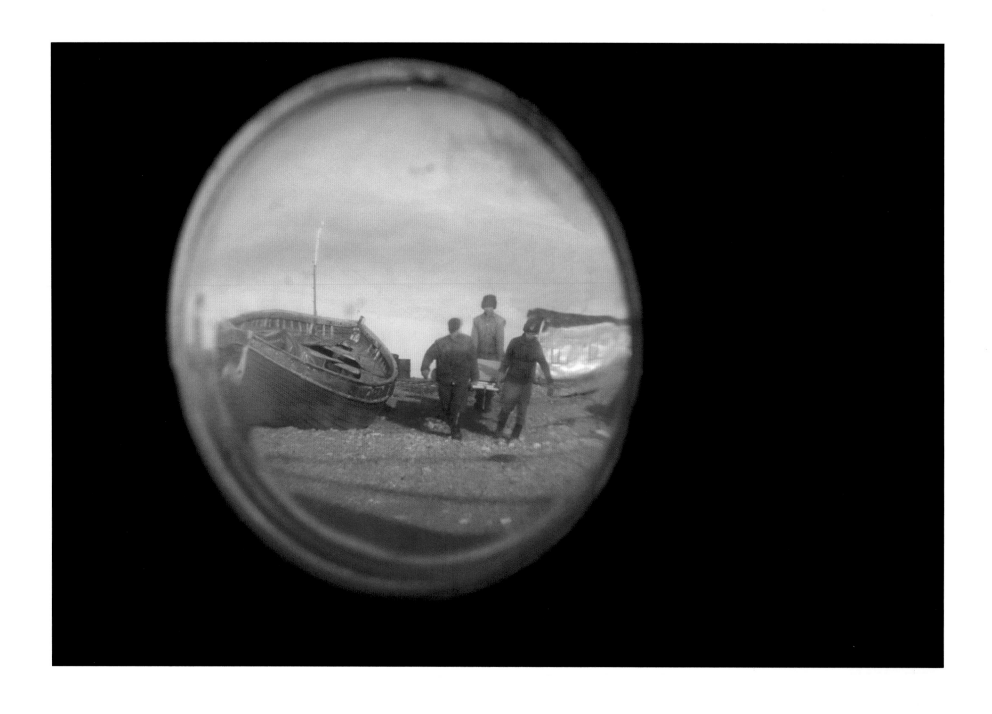

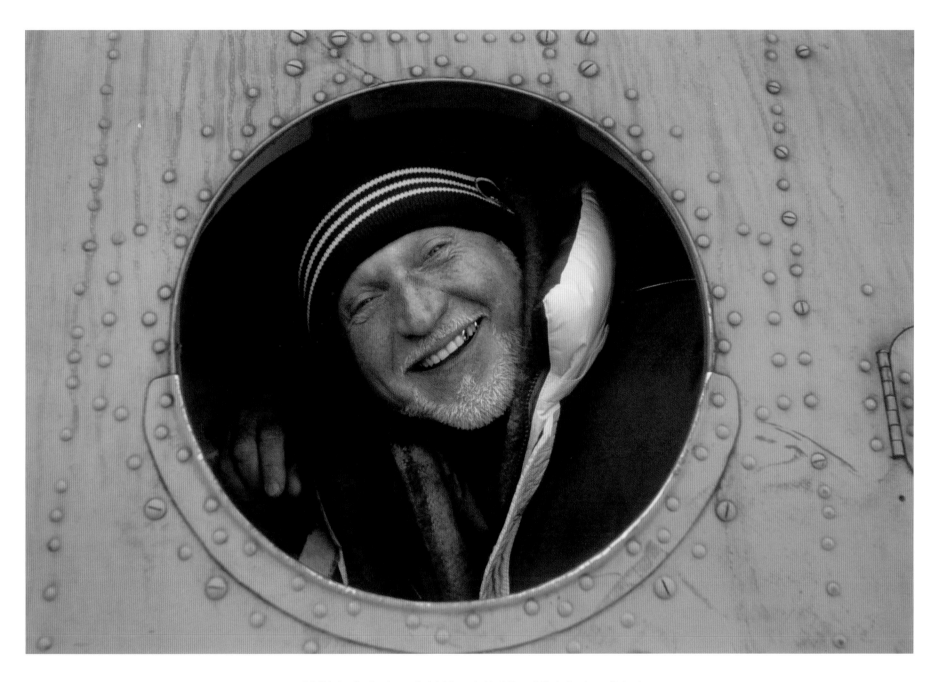

◁ △ Volodya, the Russian geologist, takes a last look through the helicopter porthole at the encampment that was his home for a season of research in the tundra.

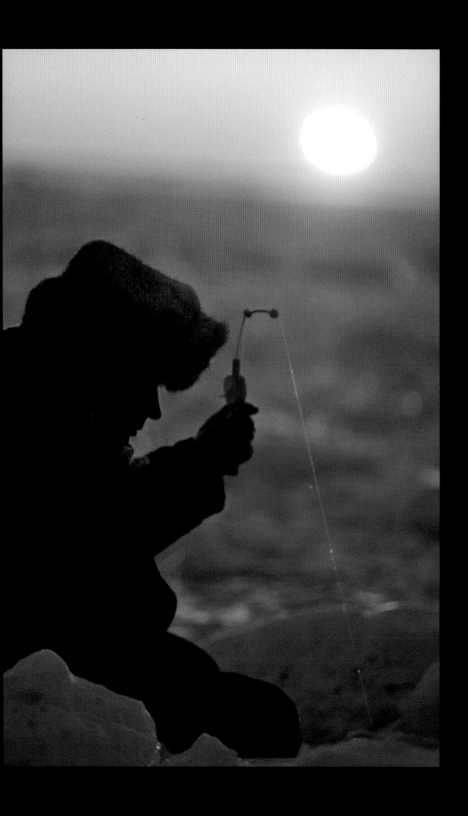

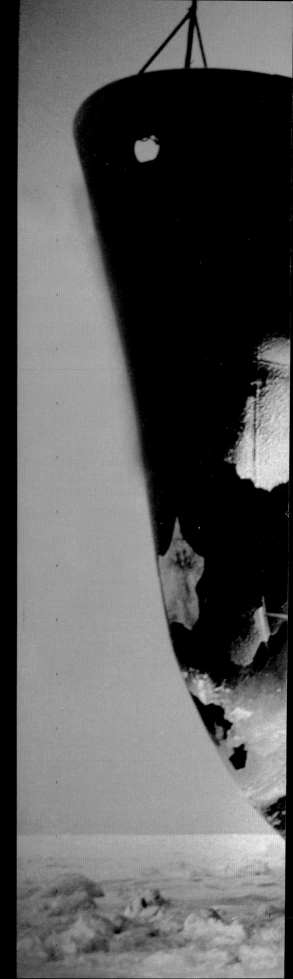

◁ Ice fishing is a national sport in Siberia.

▷ The *Russia*, one of the country's most powerful nuclear icebreakers. Her turbines can generate 75,000 horsepower, making her capable of smashing through the Arctic ice all the way to the geographic North Pole.

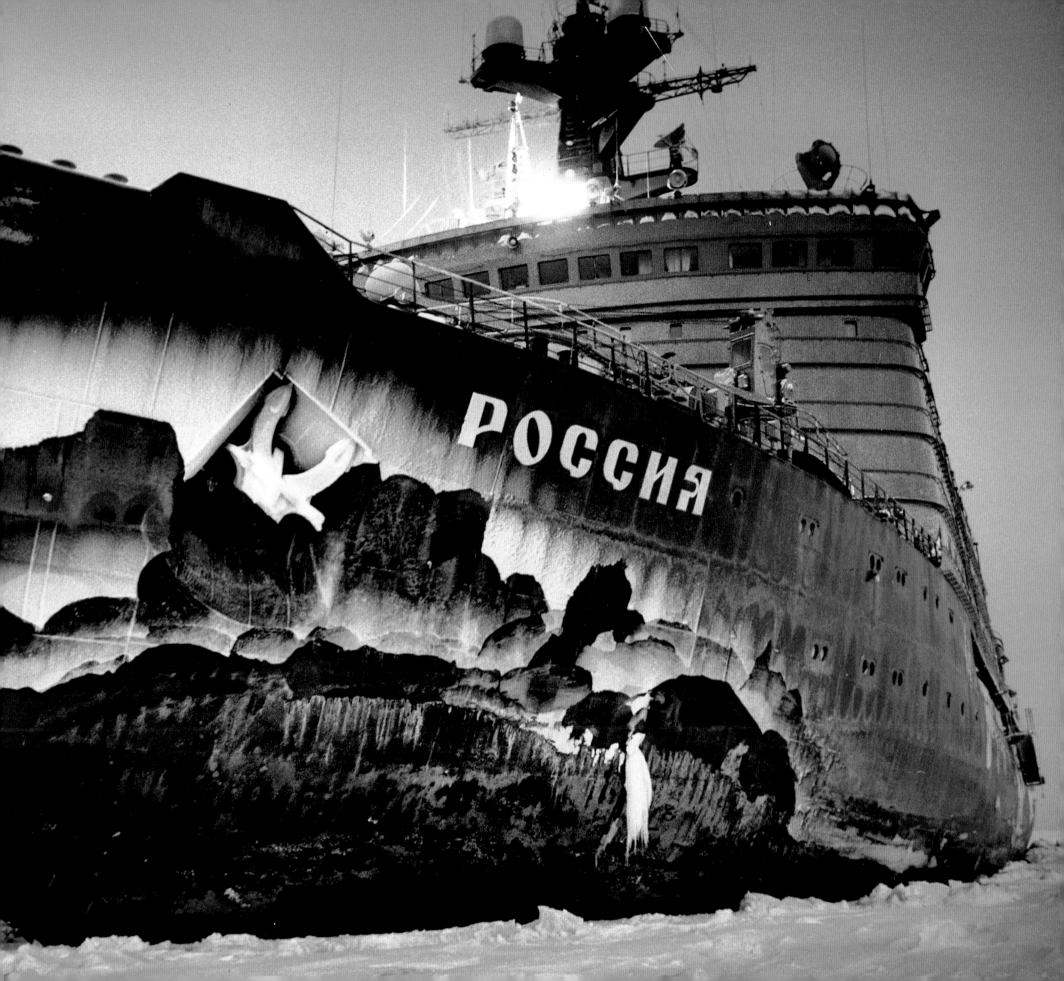

△ Portait of Sergei, musher and sled driver.

▷ A helicopter ferries Dr. Jean-Louis Etienne's capsule aboard the
Russian icebreaker *Yamal* in July 2002.

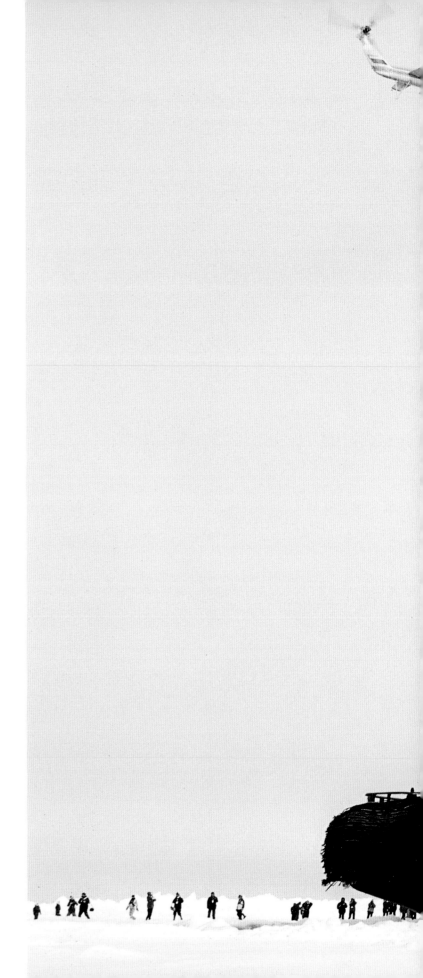

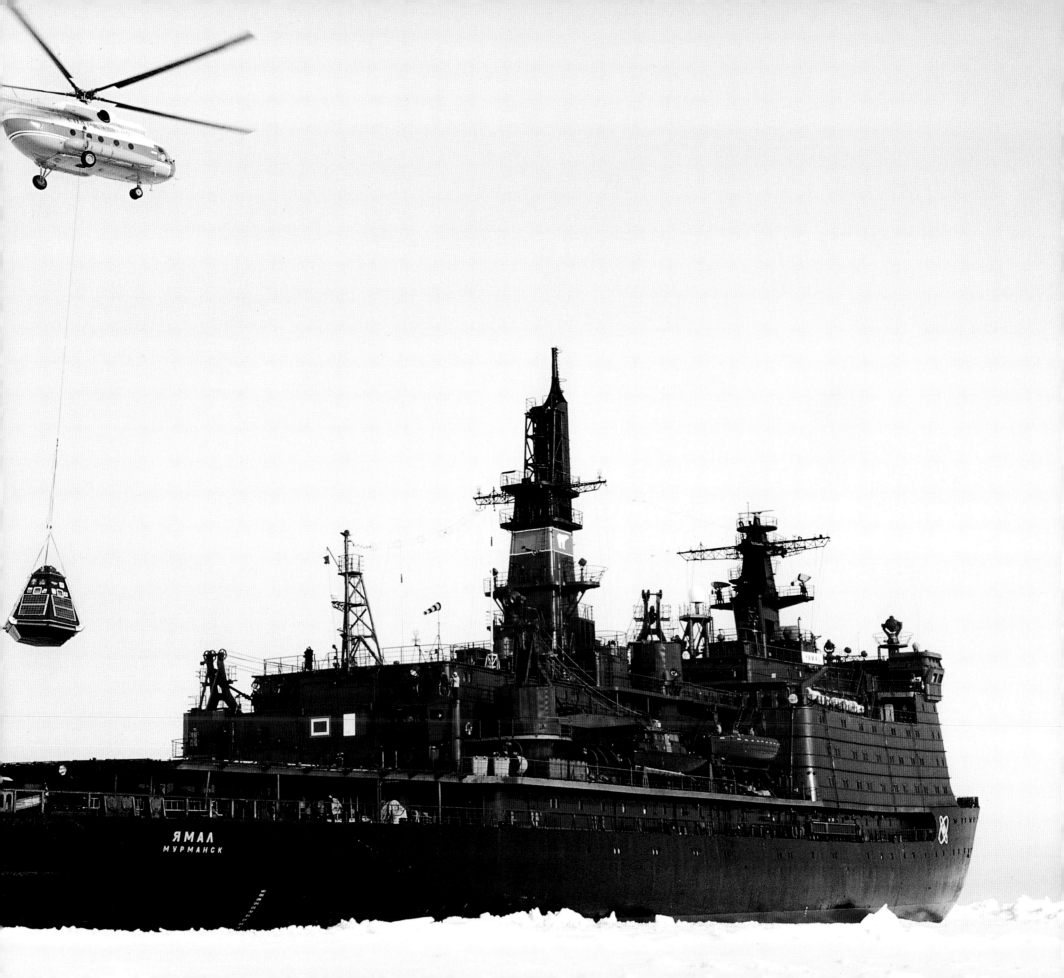

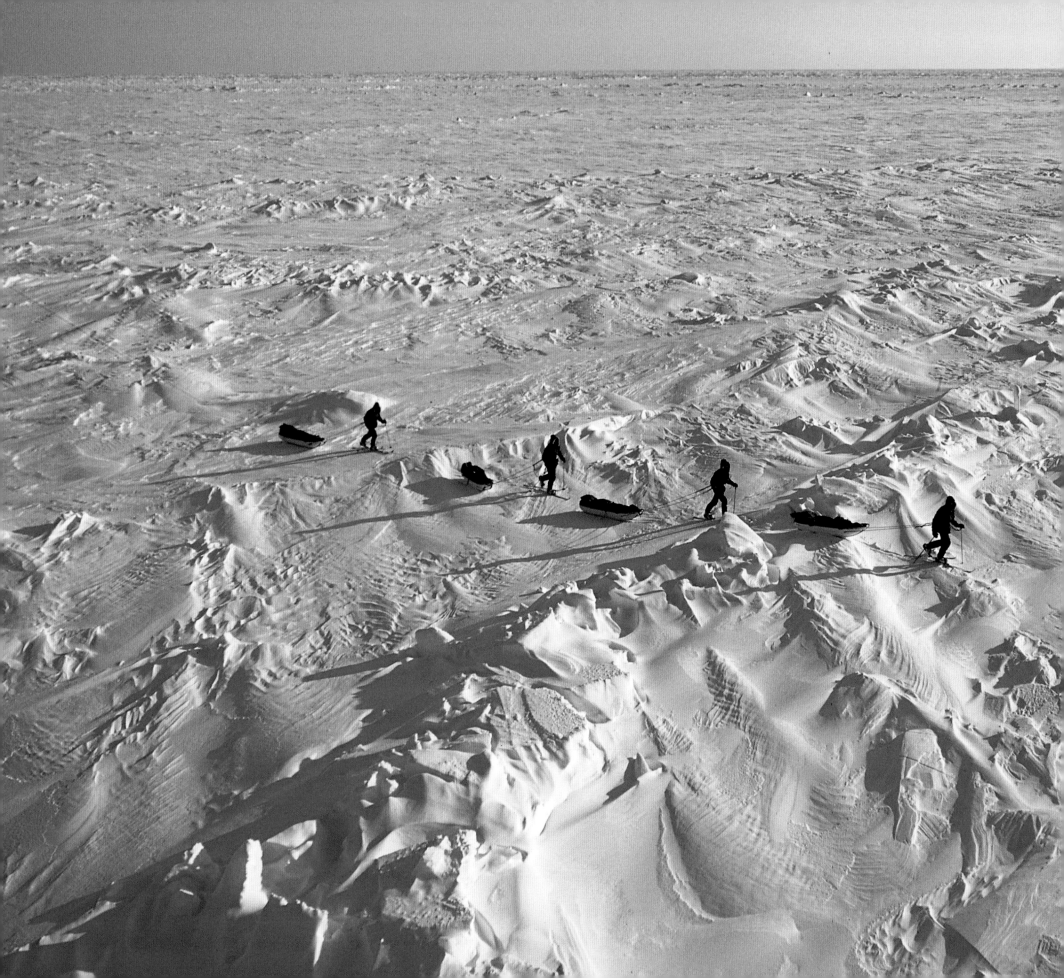

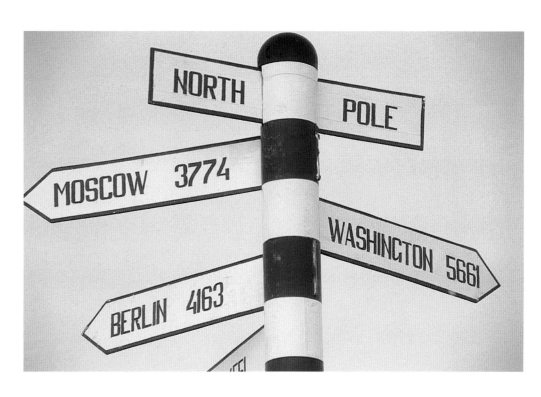

A French army expedition of specialist mountain troops reaches
the geographic North Pole after a sixty-day march. All meridians
converge at this point—the apex of planet Earth.

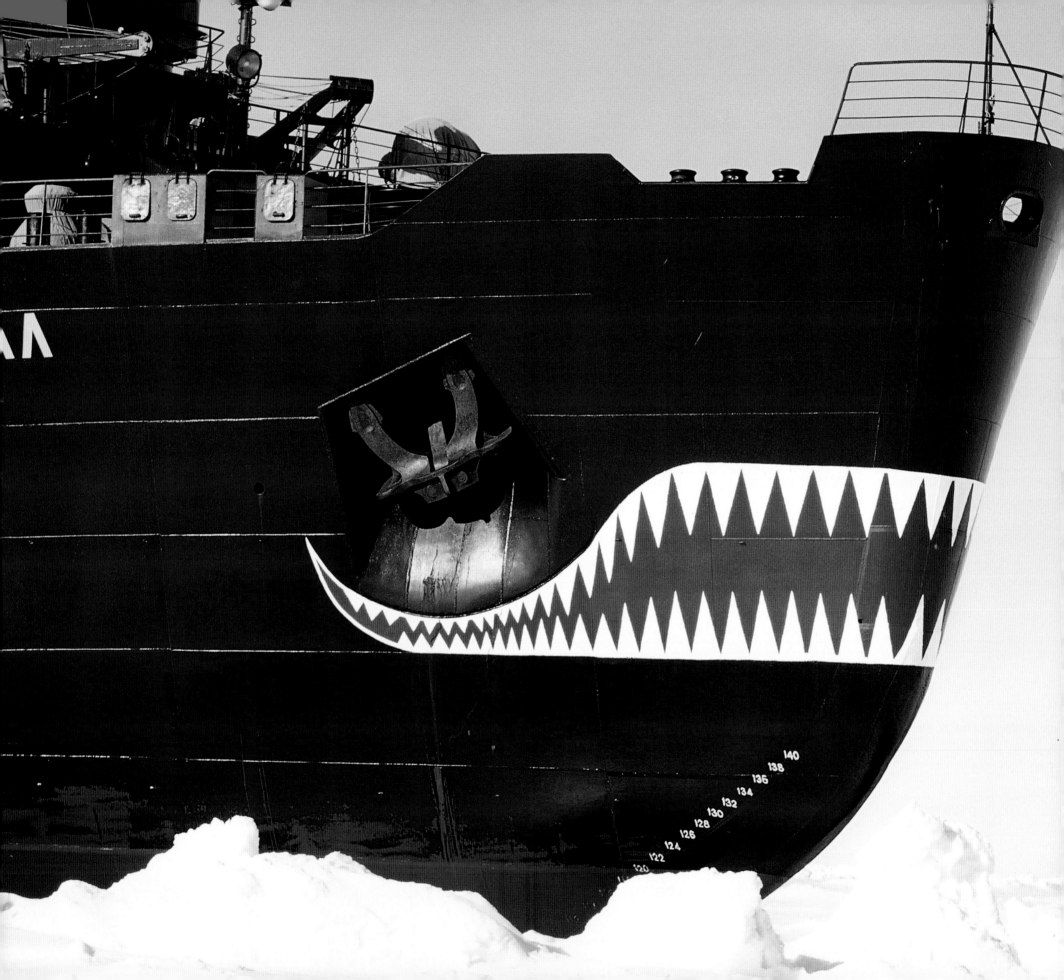

◁ The Russian icebreaker *Yamal*, a cable's-length from the North Pole. With her massive turbines, she can free herself from the grip of the Arctic ice pack.

▽ Members of a polar expedition pause for a meal en route.

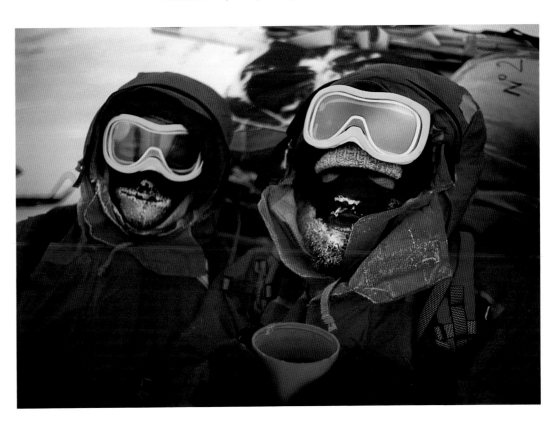

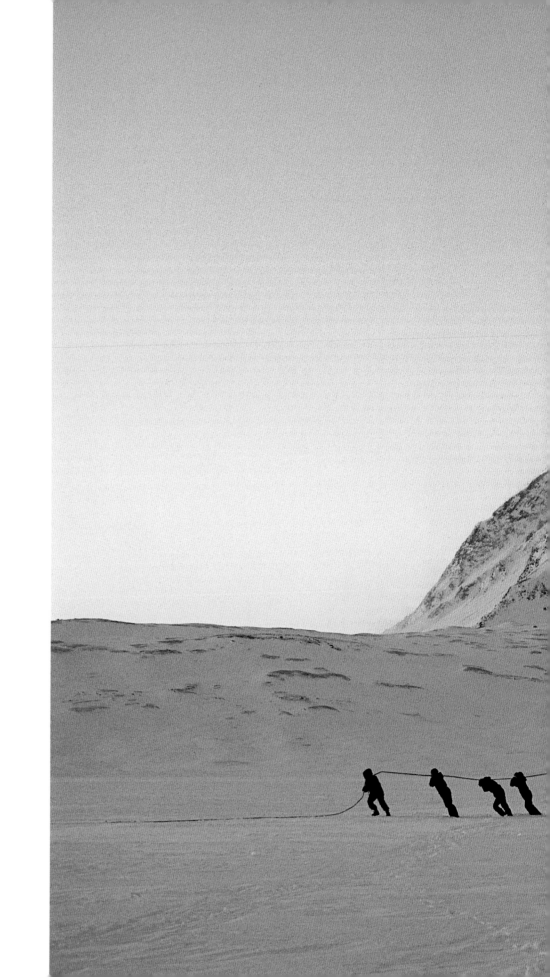

▷ *Antarctica* was stuck in the Spitzbergen ice for many months. When the first signs of spring arrived, her crew began to extricate their frozen vessel.

▷▷ The first rays of spring sunshine fall on Agarbukta Bay, east of Spitzbergen, after more than four months of polar night.

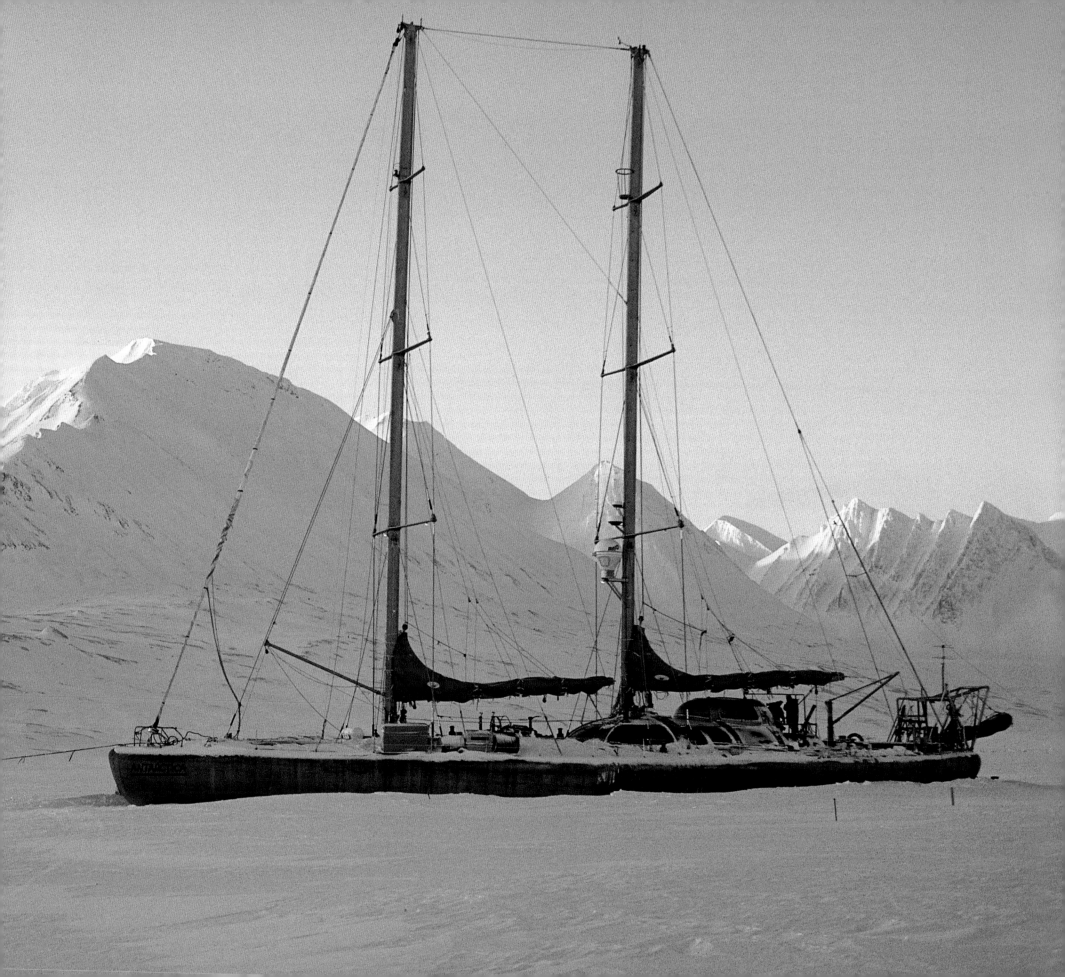

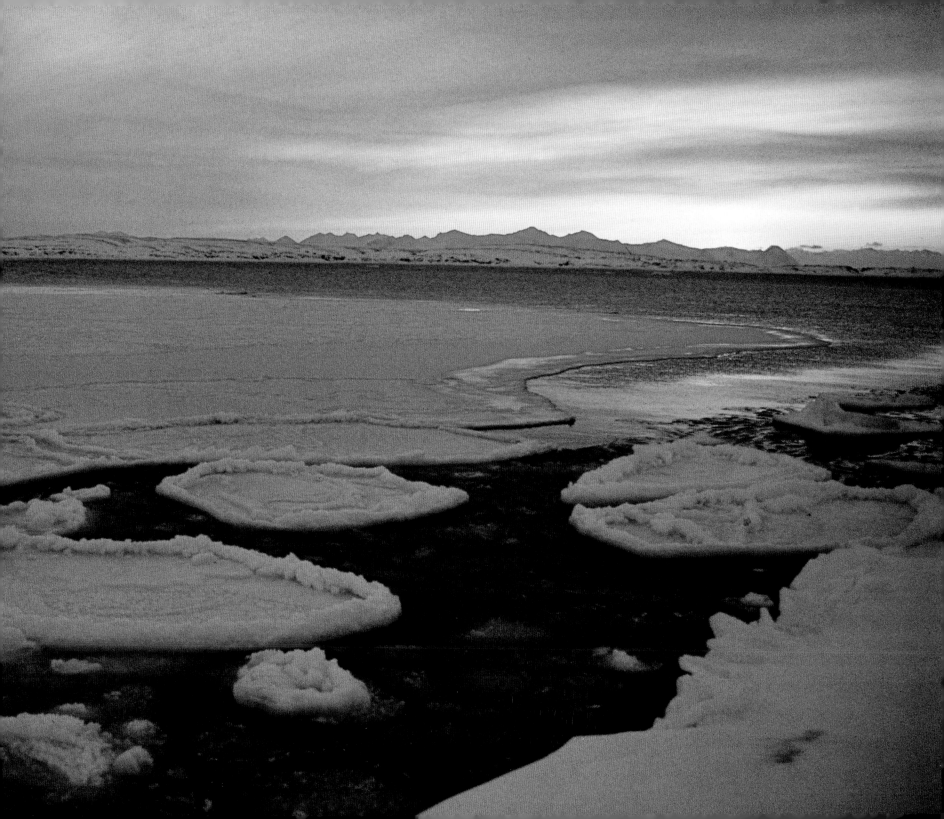

An old man and a boy take their daily walk around a square in Yakutsk, the regional capital.
The temperature stands at −22°F.

Acknowledgments

I wish to extend my heartfelt thanks to Hervé de la Martinière and his staff; and especially to Brigitte Govignon, Juliette de Trégomain, and Florent Roger. My thanks also go to Benoit Nacci for his sensitivity and talent, and to Valérie Roland for her excellent work on the layout of this book. In addition, I would like to acknowledge the contributions of Jean-Louis Etienne, my polar godfather; of Bernard Buigues, without whom this book would never have seen the light of day; of Etienne Bourgois and the magnificent polar schooner *Tara*; of Christian de Marliave; of Clémence, Laurent, and Martine Latreille; and of Catherine Guigon.

My gratitude is also due to Gameth Agamirzaev, Yves Andreys, Bruno Baudry, Guy Bourreau, Francois Bernard, Pascal Briard, Yuri Bourlakov, Philippe Bourseiller, Christian Boyer, Valery Chevelkin, Guillaume Clavières, Cyril Drouhet, Sylvie Duboué, Jean-Louis Festjens, Jean-François Gallois, Olivier Gilg, Brigitte Huard, Nicole Lattès, Claude Lorius, Alain Mingam, Jean-Philippe Réza, Brigitte Sabord, Marc Simon, Hélène Santander, Romain Troublé, Jean-Pierre Vallin, and Francois Vikar.

I also wish to express my appreciation of the invaluable help given to me by the Central Color and Urgence Images photo laboratories.

All the silver-image photos in this book were captured on FUJIFILM professional film.

Pictures taken with CANON equipment:
On EOS 1N, EOS 1v, silver-image
On EOS 20D, EOS 5D, digital

Design: Benoit Nacci

Project Manager, English-language edition: Magali Veillon
Editor, English-language edition: David Bourgeois
Designer, English-language edition: Neil Egan
Jacket design, English-language edition: Rachel Misdrachi-Kapon
Production Manager, English-language edition: Colin Hough Trapp

English translation copyright © 2006 Abrams, New York

© 2006 Éditions de La Martinière

Martinière Groupe, Paris (France)

© 2006 KAPON EDITIONS (English edition in Greece)
ISBN 960-7037-82-0
23-27 Makriyanni Str., 117 42 Athens, Greece, Tel./Fax: 0030 210 9214 089
www.kaponeditions.gr e-mail: kapon_ed@otenet.gr

Printed and bound in Italy